Christian Tico Seifert
with Peter Black, Stephanie S. Dickey
Patrick Elliott, Donato Esposito
M.J. Ripps & Jonathan Yarker

REMBRANDT
BRITAIN'S DISCOVERY
OF THE MASTER

National Galleries of Scotland
Edinburgh

Published by the Trustees of the National Galleries of Scotland
to accompany the exhibition *Rembrandt: Britain's Discovery of the Master*
held at the Scottish National Gallery, Edinburgh
from 7 July to 14 October 2018.

© The Trustees of the National Galleries of Scotland, 2018

ISBN 978 1 911054 19 1

Project Manager, picture research and production for this title: Gillian Achurch
Copy-editor: Abigail Grater
Proofreader: Ivor Normand
Indexer: Ann Barrett

PUBLISHING TEAM
Publishing Manager: Ann Crawford
Publishing Projects Editor: Gillian Achurch
Publishing Co-ordinator: Jennifer McIlreavy
Publishing Assistant: Hannah Killoh

Designed and typeset in Indigo and Magma by Dalrymple
Printed in Belgium on GardaMatt Ultra 150gsm by Albe De Coker

Front cover: Rembrandt, *Girl at a Window*, 1645
(detail of fig.33) Dulwich Picture Gallery, London

Back cover: Glenn Brown, *01* from *Half-Life (after Rembrandt)*, 2017
(detail of fig.71) Courtesy the artist and Paragon | Contemporary Editions Ltd

Frontispiece: Rembrandt, *Landscape with the Rest on the Flight into Egypt,* 1647
(detail of fig.23) National Gallery of Ireland, Dublin

This exhibition has been assisted by the Scottish Government
and the Government Indemnity Scheme.

The proceeds from the sale of this book go towards supporting the
National Galleries of Scotland. For a complete list of current publications,
please write to: National Galleries of Scotland Publishing at Bridge Lodge,
70 Belford Road, Edinburgh EH4 3DE or visit our website:
www.nationalgalleries.org

National Galleries of Scotland is a charity registered in Scotland
(no.SC003728)

CONTENTS

LENDERS

The Albertina Museum, Vienna
The Bellany Estate
British Museum, London
Buccleuch Collection
Chatsworth House Trust
Collection of Daniel and Linda Bader
The Courtauld Gallery, London
David Alexander
Dulwich Picture Gallery, London
Elton Hall Collection
Fondation Custodia – Collection Frits Lugt, Paris
Gemäldegalerie, Staatliche Museen zu Berlin
Glasgow Life (Glasgow Museums) on behalf of Glasgow City Council
Glenn Brown
Guildhall Art Gallery, City of London
The Hunterian, University of Glasgow
Kupferstichkabinett, Staatliche Museen zu Berlin
Mauritshuis, The Hague
Musée du Louvre, Paris
Museum Boijmans Van Beuningen, Rotterdam
Museum of Fine Arts, Boston
The National Gallery, London
National Gallery of Art, Washington
National Gallery of Ireland, Dublin
National Museums Liverpool, Walker Art Gallery, Liverpool
Nicholas Stogdon
Paragon | Contemporary Editions Ltd
Rijksmuseum, Amsterdam
Royal Academy of Arts, London
Tate
Teylers Museum, Haarlem
Trustees of the Chatsworth Settlement
Victoria and Albert Museum, London
William Zachs
York Museums Trust, York
as well as lenders who wish to remain anonymous.

FOREWORD

There have been many Rembrandt exhibitions and publications, highlighting different aspects of the Dutch master's remarkable career and endlessly rewarding work. However, *Rembrandt: Britain's Discovery of the Master* has a special status. This exhibition, which is only shown at the National Galleries of Scotland in Edinburgh, is the first to tell the exceptionally rich story of Rembrandt's art and fame in Britain over almost four centuries. It reveals how the taste for his paintings, drawings and prints evolved; from his lifetime it grew into a mania that gripped collectors and art lovers across the country, reaching a fever pitch in the late eighteenth century. The exhibition also shows the profound impact of Rembrandt's art on the British imagination, by exploring the wide range of native artists whose work has been inspired by his extraordinary achievement up to the present day.

The show brings together key works by Rembrandt which remain in British collections, as well as treasures that have left the country. Some of the exhibits have never been on public display before, while others return to Britain for the first time in decades or even a century or more. Such an ambitious exhibition has only been made possible through the outstanding generosity of our lenders, both individual and institutional, at home and abroad, to whom we offer our most sincere thanks.

For the National Galleries of Scotland, the project has been brilliantly conceived and realised by our colleague Dr Tico Seifert, Senior Curator of Northern European Art. He is the key contributor to this catalogue, which has also been enriched by the work of a number of very distinguished scholars, to whom we are extremely grateful. Thanks are also due to colleagues across the National Galleries, who include Julie Duffy, Louise Rowlands, Gillian Achurch, the Art Handling and Conservation teams and the interns Charlotte Hoitsma and Pieter Duits.

Ambitious projects of this sort are dependent on very generous and imaginative support, and this has been provided from the players of the People's Postcode Lottery and the Friends of the National Galleries of Scotland. Along with all the many visitors who will visit this inspiring exhibition, we are most grateful to them.

SIR JOHN LEIGHTON
Director-General, National Galleries of Scotland

CHRISTOPHER BAKER
Director of European and Scottish Art and Portraiture,
National Galleries of Scotland

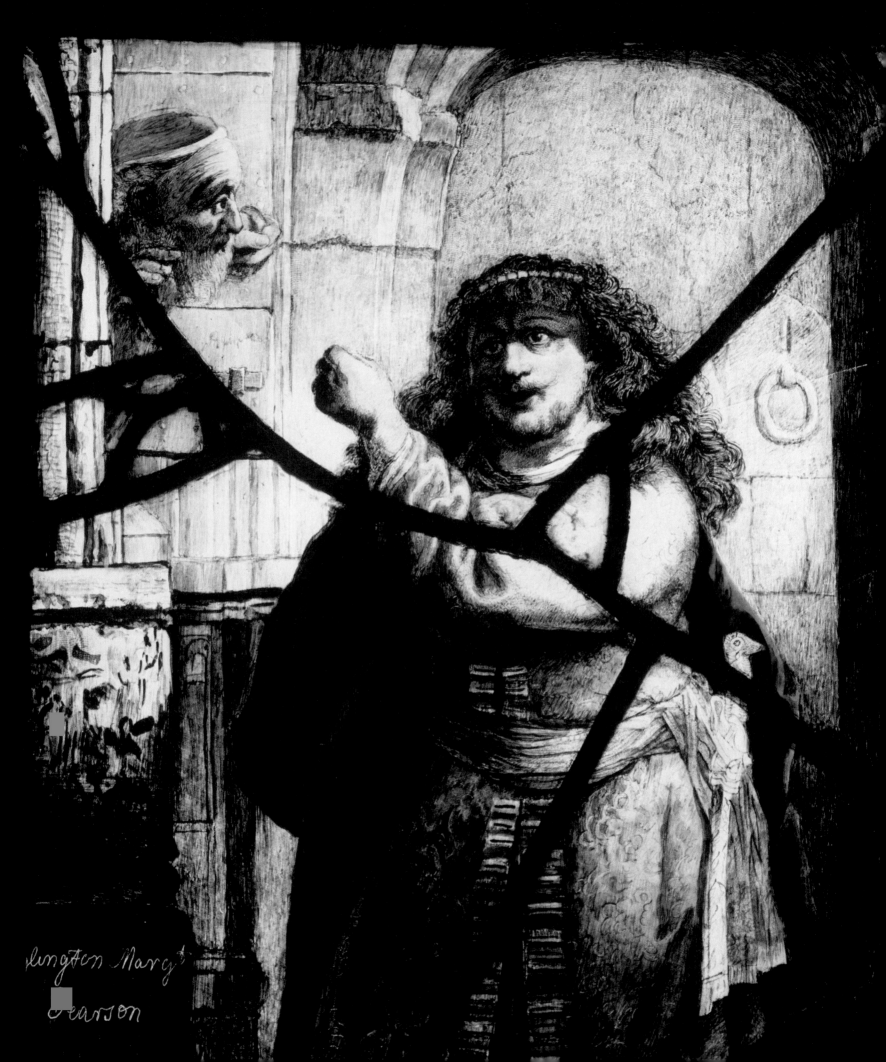

INTRODUCTION

Rembrandt Harmensz van Rijn (1606–1669), who spent his entire career as a painter, draughtsman and printmaker in the Dutch Republic, enjoyed considerable fame beyond his home country and throughout Europe during his lifetime, and that has continued ever since. In recent decades, his imagery has become ubiquitous, making him a global brand like few other artists in history.

The son of a miller, Rembrandt was born and trained in Leiden, where he spent his early career. From 1631 he also worked in Amsterdam, mainly as a portrait painter, and he settled there permanently in 1633. Rembrandt married the following year and enjoyed a successful career as painter and printmaker, covering all subject matters and receiving important private and public commissions. He oversaw a busy workshop with many pupils. Rembrandt nevertheless ran into financial difficulties – most likely due to an enormous mortgage on his house and substantial expenditure on his art collection – and was declared insolvent in 1656. After his large house and possessions had been sold, he continued to work in Amsterdam until his death. Contrary to what is widely believed, Rembrandt did not die in poverty, although he never again prospered as he had done at the height of his career.

The story of Rembrandt's art in Britain, and of how it inspired collectors, artists and writers, is exceptionally rich.[1] There is still a wealth of paintings, drawings and prints by Rembrandt to be found in British collections, but the number of his works that have been here at some point in their history is simply staggering, and surpasses any other country apart from the Netherlands, where they originated. Moreover, no other nation has witnessed a similarly passionate, and sometimes eccentric, enthusiasm for Rembrandt's (or indeed any artist's) works, particularly in the eighteenth century.

In the seventeenth century, Rembrandt was predominantly known for his etchings. Few paintings or drawings seem to have been in the country before the final decade, when the art market in London grew to international importance and the taste for Rembrandt's art began to develop. The eighteenth century was marked by his wider discovery and sophisticated collecting, culminating in what contemporaries described as a 'craze' for Rembrandt's works. The nineteenth century saw a re-evaluation of Rembrandt's reputation, combined with widening access through public collections, exhibitions and mass reproductions, including photography and, towards 1900, the sale of many prized paintings to Germany and the United States. Rembrandt was the main stimulus for the etching revival, which continued into the twentieth century. Many modern artists were attracted to Rembrandt, as are a number of contemporary artists, evidence that the Dutch master continues to inspire in the twenty-first century.

The first essay here gives an overview of Rembrandt's fame in Britain until around 1900; the second, by Patrick Elliott, continues the story to the present day. Five additional essays by international scholars deepen our knowledge of important aspects of the collecting of Rembrandt's art and its reception in Britain.

CHRISTIAN TICO SEIFERT

1 Eglington Margaret Pearson, after Rembrandt,
Samson Upbraiding his Father-in-law, c.1800
Detail from fig.47

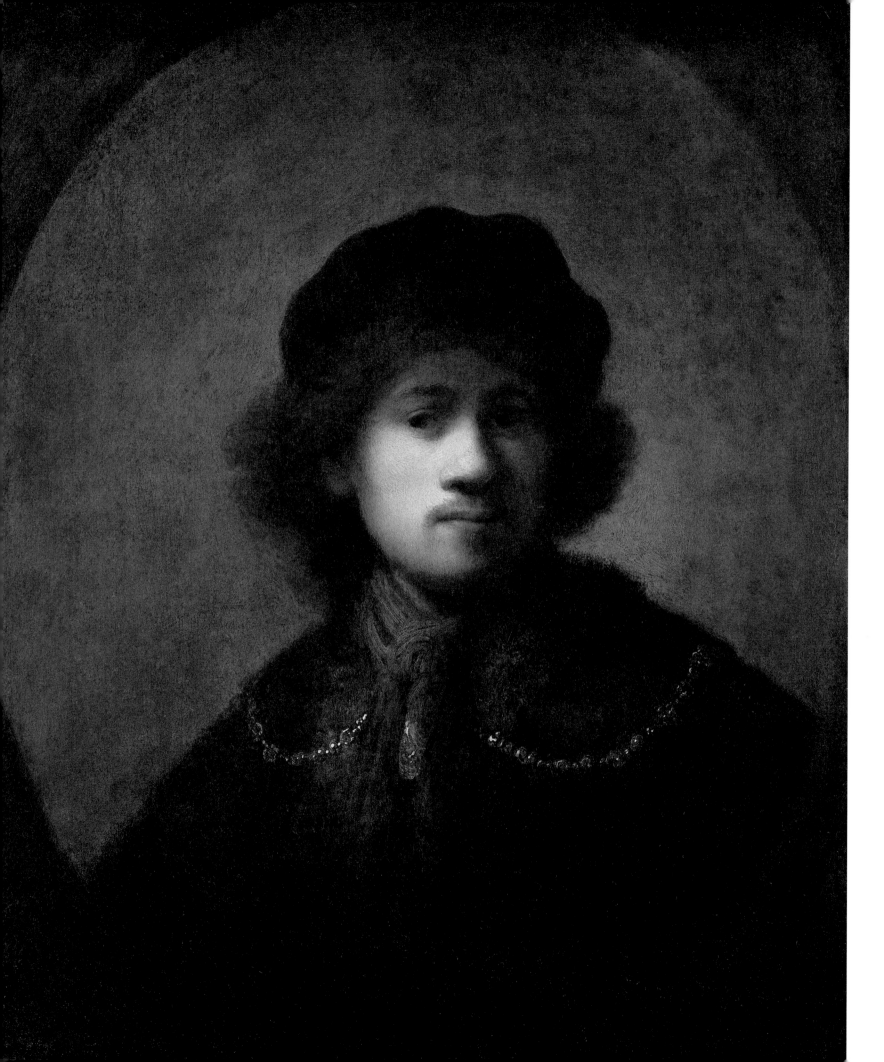

1

REMBRANDT'S FAME IN BRITAIN, 1630–1900: AN OVERVIEW
CHRISTIAN TICO SEIFERT

A SLOW START: THE SEVENTEENTH CENTURY

Evidence for paintings by Rembrandt in seventeenth-century Britain is scarce. King Charles I (r.1625–49), who amassed one of the greatest art collections of all time and employed the court artists Sir Peter Paul Rubens (1577–1640) and Sir Anthony van Dyck (1599–1641), probably took little notice of Rembrandt, the emerging star of the Dutch Golden Age. Yet, by serendipity rather than through ambition, he became the first collector to own paintings by Rembrandt not only in Britain but anywhere beyond the Dutch Republic.

Between 1637 and 1639 Abraham van der Doort, Keeper of the King's Cabinet Room, compiled an inventory of the paintings in the Royal Collection.[1] He recorded three pictures by Rembrandt in the Long Gallery at Whitehall. His pioneering, meticulous catalogue, the first of its kind compiled in Britain, allows us to identify two of them: *Self-portrait* [fig.2] and *An Old Woman* (Royal Collection); the third one, an interior with a young scholar, is now lost.[2] According to Van der Doort, these three works were 'Done by Rembrant & given to the kinge by my lorde Ankrom'.[3] A label on the reverse of *An Old Woman* mentions Robert Kerr.[4]

Sir Robert Kerr, who was created Earl of Ancrum in 1633, visited the Netherlands on a diplomatic mission in January 1629, and it is widely assumed that he acquired the three paintings on this occasion.[5] However, it is difficult to reconcile such an early date for the two surviving paintings – neither of which bears either signature or date – with Rembrandt's dated works from 1628–29. The attribution of these two works to Rembrandt has also been contested by some scholars in recent years. For stylistic reasons, the *Old Woman* has been attributed to Jan Lievens (1607–1674) and dated to about 1631–32, and the *Self-portrait* to Rembrandt's pupil Isaac de Jouderville (c.1612–1645/48) and dated to about 1630–31.[6]

Kerr probably acquired the three paintings through the Stadtholder's secretary Constantijn Huygens, who knew Rembrandt and sat for a portrait by Lievens around the time of Kerr's visit.[7] It seems unlikely that Huygens would have confused the authorship of the paintings. Also, Lievens worked in London from 1632 to 1635 and must have seen the three pictures in the Royal Collection. Would he not have told Van der Doort if one or more of them were his (or Jouderville's) work rather than Rembrandt's?[8] There is no easy solution to the mystery of seemingly contradictory evidence. The question of authenticity, which recurs throughout the history of collecting Rembrandt's art and still endures today, was already encapsulated in those first arrivals to Britain.[9]

Such uncertainties never befell Rembrandt's only portraits of sitters from Britain: a pair, both signed and dated 1634 [figs 3 & 4]. The Revd Johannes Elison and his wife Maria Bockenolle lived in Norwich, where he was a minister in the Dutch Reformed Church. Around 1634 they visited their son Joan (Johannes) in Amsterdam, and he probably commissioned the two full-length portraits from Rembrandt. Such expensive and ostentatious portraits are uncommon for clerics (and indeed rare in Rembrandt's work) and presumably reflect the status of their son, a successful merchant, more than the sitters' own aspirations. The only visual reference to their home is the distinctly English hat Maria is wearing.[10]

Elison and his wife returned to Norwich, where he died in 1639; his monument in Blackfriars Hall survives to the present day.[11] Sometime after his death, Maria Bockenolle relocated to Amsterdam and moved in with her son Joan; she was buried there in 1652.[12] The couple's portraits remained with Joan in Amsterdam, and when he died childless in 1677, they were inherited by his sister Anne in Norfolk, whose husband Daniel Dover – one of the

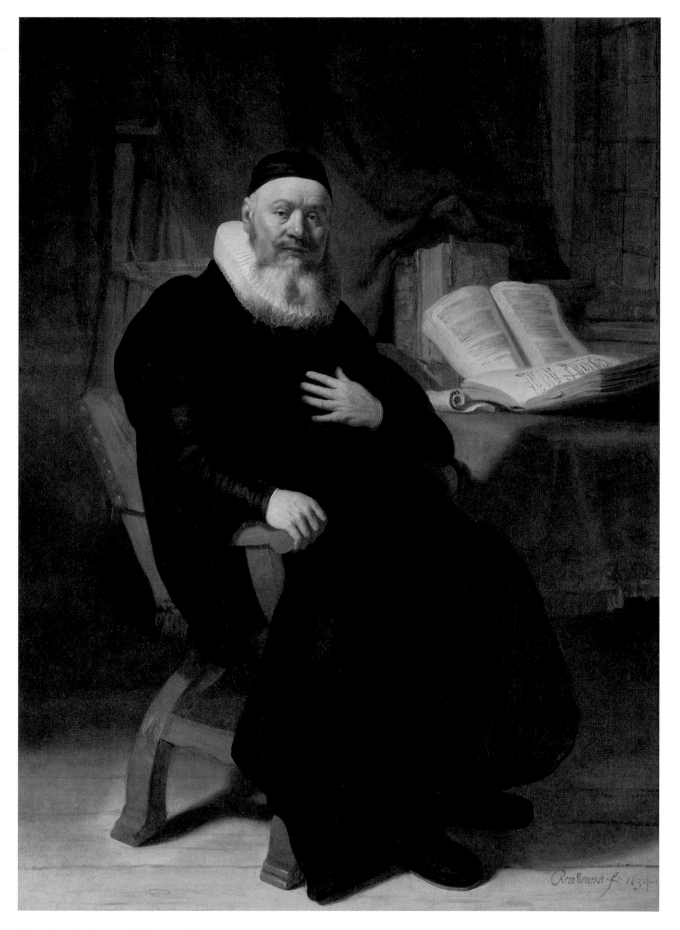

3 Rembrandt, *Reverend Johannes Elison*, 1634
Oil on canvas, 174 × 124.5 cm. Museum of Fine Arts, Boston [cat.2A]

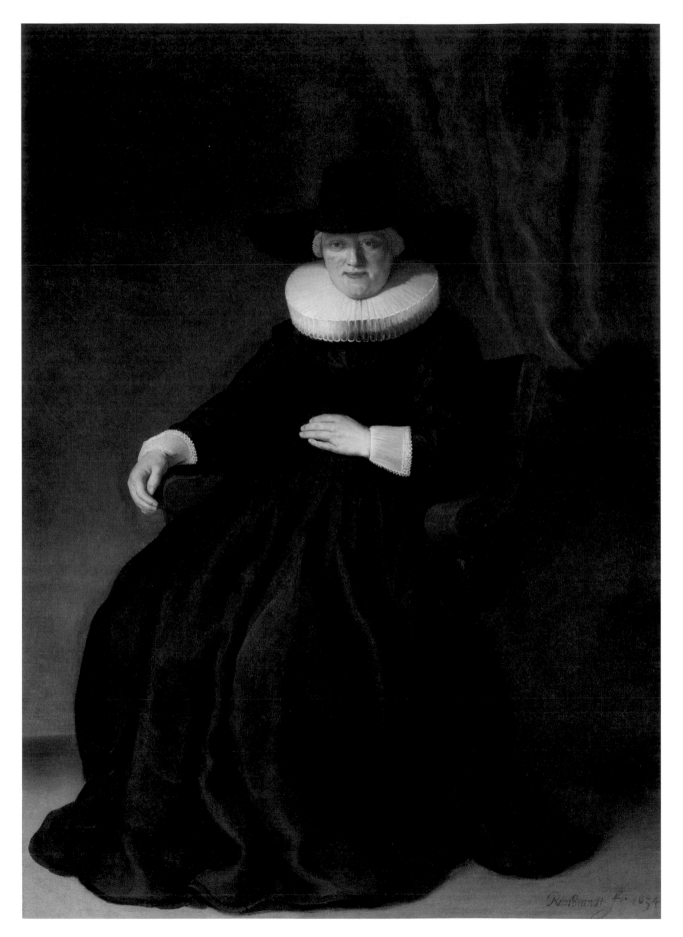

4 Rembrandt, *Maria Bockenolle (Wife of Johannes Elison)*, 1634
Oil on canvas, 174.9 × 124.1 cm. Museum of Fine Arts, Boston [cat.2B]

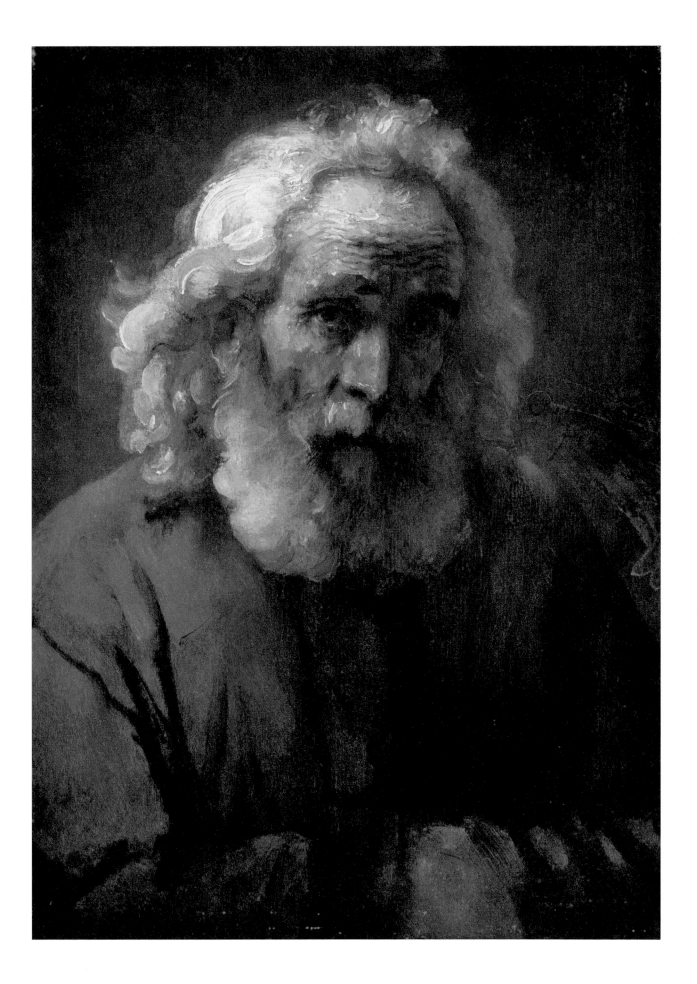

5 Rembrandt, *Head of an Old Man*, 1659
Oil on canvas, 38.1 × 26.8 cm
Collection of Daniel and Linda Bader, Milwaukee [cat.17]

executors of Joan's estate – brought them to Yarmouth in 1680.[13] It is there that they were noted by Horace Walpole in 1763.[14] The portraits remained in the family until they were sold in 1860. They were acquired by the Museum of Fine Arts in Boston in 1956. This exhibition marks the first time they have returned to the United Kingdom since 1929.

Although there is evidence for more paintings claimed as Rembrandts coming to Britain in the later seventeenth century, few of them can now be identified with existing works, and none of those is any longer attributed to him.[15] As early as 1647, John Clerk of Penicuik imported a ship-ment of paintings into Leith harbour, near Edinburgh, containing 'a small head with a gorget, Rembrandt', and in 1665 he possessed a still life by the artist. Among Clerk's papers, a unique handwritten copy of a sale catalogue 'sent to Scotland in December 1668' – just within Rembrandt's lifetime – survives, mentioning a painting 'du Rembrant van Rijn'.[16] A head study by Rembrandt [fig.5] is docu-mented in the family's collection in 1740.[17]

In 1659, Sir Ralph Bankes drew up a list of his pictures, including 'A Coppy of A Turks head from Rainebrand/ The Orriginall is Cardinall Mazarins', which he had purchased for twenty pounds.[18] This painting, still at Kingston Lacy in Dorset, is a copy after Rembrandt's *A Man in Oriental Costume (King Uzziah)* [fig.21], which was acquired in 1742 by the 3rd Duke of Devonshire (see below, p.26). Such purchases clearly illustrate a demand in Britain for Rembrandt's paintings (and, if originals were not available, copies after them) during the artist's lifetime that must have been more extensive than the surviving examples suggest.

A few years after the visit from the Norwich minister and his wife, Rembrandt was again busy exploring English subjects. A group of four drawings depicting English views has been much debated and is exhibited here together for the first time [figs 6, 7, 8 & 9]. They are all about the same size and executed in pen, brown ink and wash, with two of them signed and dated 1640. The controversies have centred around two questions: are they (all) indeed by Rembrandt, and were these views drawn from prints or 'from life', which would suggest that Rembrandt visited England?[19]

Two arguments against his authorship have been discussed heatedly. Firstly, the drawing now in Haarlem

and the two in Vienna show traces of black chalk; but the consensus among scholars is that Rembrandt did not use chalk for preliminary sketches. In the case of these draw-ings, though, the few visible chalk lines do not appear to be preliminary as such: some seem to add information to the pen-and-ink drawing, such as, for example, on the roof in the Haarlem drawing; others seem to sit on top of the ink.

Secondly, the authenticity of the signatures has been doubted.[20] However, although there are some differences between those in the drawings and Rembrandt's signa-tures on letters and legal documents, most prominently regarding the shape of the letter 'R' and the way the letters are linked or separated, his are much less uniform than we might wish.[21] This is not the place to discuss the attribu-tions in detail, but I would caution against rejecting the signed drawings too easily. The most important aspect for our story is that, on stylistic grounds, all four drawings must have been created in Rembrandt's studio in about 1640. This raises the intriguing question of Rembrandt's source for these views.

The locations – St Albans Cathedral, Windsor Castle and London with Old St Paul's – are clearly identifiable. However, there are inaccuracies regarding details of the buildings and the topography. For example, the transept of St Albans has been transformed into a monumental entrance with broad stairs and an open hall, while the Keep and St George's Chapel at Windsor Castle have been amal-gamated into one enormous church.[22] It seems unlikely that Rembrandt (or any Dutch artist of this period) would have taken such liberties on site.

Despite all efforts, no prints have been identified as Rembrandt's models; it is more likely that he relied on drawings. Could Lievens have supplied Rembrandt with such views? On his return from London, he had settled in Antwerp; but he was working in Leiden, about twenty-five miles from Amsterdam, in 1639, just around the time the four drawings were made.[23] Rembrandt clearly had an interest in 'exotic' architecture, often found in his paintings of biblical subjects, and may have kept the models for the four English views in the album 'filled with drawings of all Roman buildings and views by all the most excellent masters', recorded in his inventory in 1656.[24]

The knowledge of Rembrandt's art in Britain in the seventeenth century, and almost all writings on it, rely on

6 Rembrandt (attributed to), *View of St Albans Cathedral*, 1640
Pen and brown ink, brown wash and black chalk, 18.4 × 29.5 cm
Teylers Museum, Haarlem [cat.25]

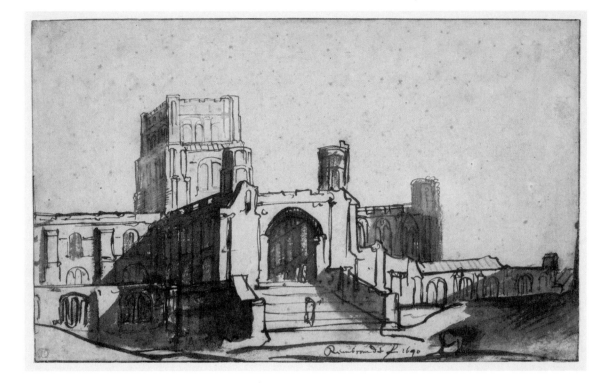

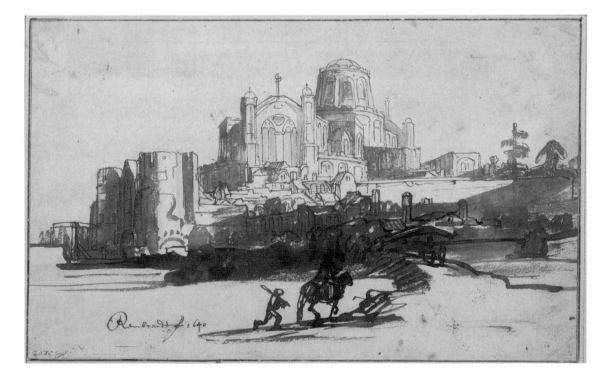

7 Rembrandt (attributed to), *View of Windsor Castle*, 1640
Pen and brown ink, brown wash and black chalk, 18.3 × 29.7 cm
The Albertina Museum, Vienna [cat.27]

8 Rembrandt (workshop of), *View of London with Old St Paul's*, *c*.1640

Pen and brown ink, brown wash and white bodycolour, 16.4 × 31.8 cm
Kupferstichkabinett, Staatliche Museen zu Berlin, Berlin [cat.24]

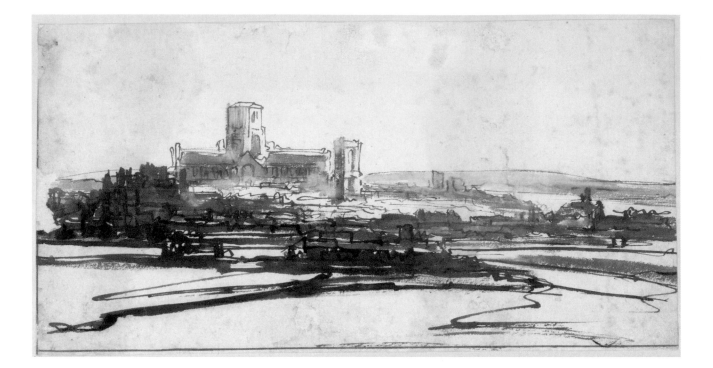

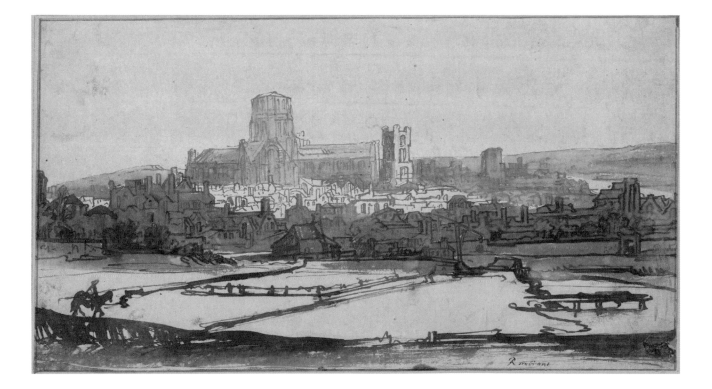

9 Rembrandt (workshop of), *View of London with Old St Paul's*, *c*.1640

Pen and brown ink, brown wash and black chalk, 17.7 × 32.1 cm
The Albertina Museum, Vienna [cat.26]

his etchings. John Evelyn's eulogy, published in 1662 in his *Sculptura*, the first history of printmaking ever, reflects an appreciation that we must assume was gained first-hand. He was the earliest English writer to refer to individual etchings in Rembrandt's oeuvre:

To these [printmakers] *we may add the incomparable Reinbrand, whose Etchings and gravings are of a particular spirit; especially the Old Woman in the furr: The good Samaritan, the Angels appearing to the Shepheards; divers Landskips and heads to the life; St. Hierom, of which there is one very rarely graven with the Burine; but above all, his Ecce Homo; descent from the Cross in large; Philip, and the Eunuch, &c.*[25]

Evelyn's comment on the *Saint Jerome* – most likely to be identified with a print by Jan Gillisz van Vliet (1605–1668) after a lost painting by Rembrandt – reveals an interest and discerning eye for technique that was shared by his contemporary Edward Browne.[26] In a letter to his father, written from Amsterdam in 1668, Browne – the medical doctor and future physician to Charles II – remarks: 'here [in Amsterdam] are divers good ones of Rembrandt and some upon Indian paper that look like washing, though scratched after his manner'.[27] Rembrandt is the only artist mentioned in this letter. More importantly, it contains the earliest reference to the artist printing on oriental papers, which was then a highly unusual habit that Rembrandt had started in about 1647 (see figs 10, 78, 80 & 116). The way Browne writes about Rembrandt seems to indicate that he was a household name to both father and son.[28]

The evidence for collecting Rembrandt's etchings in Britain in the seventeenth century is, again, limited but confirms the existence of two different types of print collectors which can broadly be described as 'image collectors' and 'works collectors'.[29] The former were predominantly led by what prints depicted, the latter by which artist had made or designed them. For both types, albums and bound sets of prints would have been part of their libraries, their collections often encompassing a wide range of natural and man-made objects, including artworks, varying considerably in scope and size.[30]

The most famous in the first category is the collection of Samuel Pepys (1633–1703), preserved virtually unaltered at Magdalene College, Cambridge.[31] Arranged basically by subjects such as portraits and views, his prints were mostly inexpensive contemporary productions. Two albums put together in 1700 contain prints illustrating the scriptures, including eight prints by and after Rembrandt.[32]

The two early impressions of the *Ecce Homo* and *The Three Crosses* [fig.11], on Japanese paper and vellum respectively, are of remarkable quality.[33] However, in the index, compiled by Pepys himself, the former is described as a 'very old drawing' and the latter as 'a drawing'. In neither case did he record the artist's name as he usually did. We may assume that he was unaware that they were by Rembrandt, neither print bearing a signature in the first state. Pepys's classification may seem astonishing today, but it underlines that, for him, the image was more important than the artist.[34] Taking these two major drypoint prints for drawings also echoes Edward Browne's remark about 'washings', noting that Rembrandt's etchings on oriental papers resembled washed drawings.

The other, much smaller 'image collection' from this period still in existence (although some prints have been extracted from the albums) is that of Dean Henry Aldrich at Christ Church, Oxford.[35] It has a strong emphasis on sixteenth-century Italian and architectural prints, and Aldrich seems to have used large parts of his collection for designs and the monthly *Oxford Almanack* he edited for many years. His four etchings by Rembrandt, three of them portraits, are distributed across three albums.[36]

For Sir Hans Sloane, whose vast encyclopaedic collection became the cornerstone of the British Museum in 1753, his print collection was first and foremost visual reference material, although it did include albums of works of individual artists such as Albrecht Dürer (1471–1528), Jacques Callot (1592–1635) and Wenceslaus Hollar (1607–1677).[37] Interestingly in the light of Browne's remark on Japanese paper, Sloane had two albums of various specimens of paper and vellum.[38] An unquantified number of Rembrandt etchings featured in the albums Sloane described in lists between 1705 and 1709.[39]

The majority of these albums came from William Courten, or Charleton, a voracious collector of prints, who bequeathed his entire collection to Sloane in 1702.[40] Courten had spent many years on the Continent before returning to London in 1684, and it seems likely that he assembled much of his print collection abroad. He kept

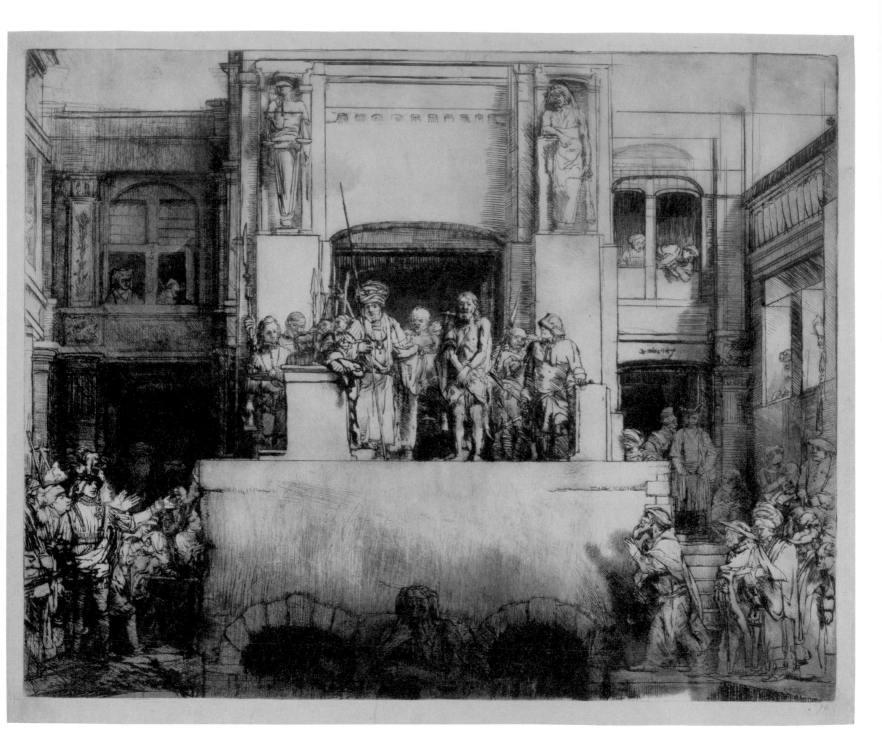

10 Rembrandt, *Christ Presented to the People* (oblong plate), 1655

Drypoint on Japanese paper, 38.3 × 45.5 cm
Fondation Custodia, Collection Frits Lugt, Paris [cat.56]

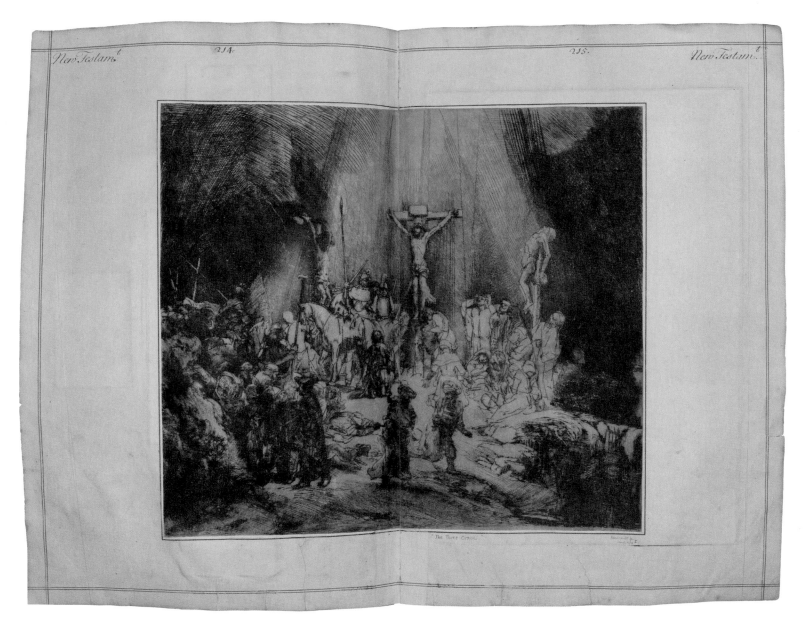

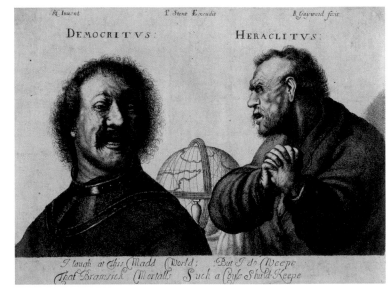

11 Rembrandt, *The Three Crosses*, in Samuel Pepys' album of prints, 1653

Drypoint on vellum, 37.7 × 43.6 cm
Magdalene College, Cambridge

12 Richard Gaywood, after Jan van Vliet, after Rembrandt, *Democritus Laughing and Heraclitus Weeping in front of a Globe*, c.1650–60

Etching, 24 × 32.3 cm
British Museum, London [cat.85]

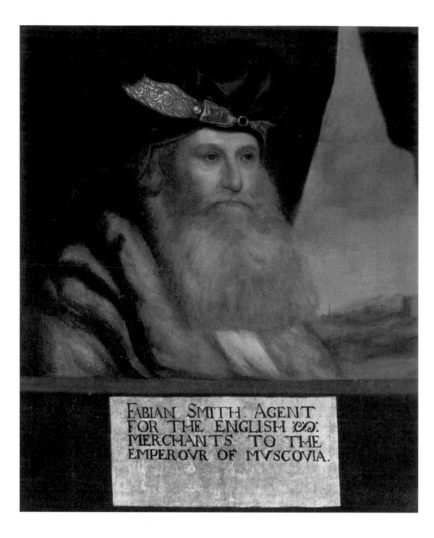

FABIAN SMITH. AGENT
FOR THE ENGLISH *so*:
MERCHANTS TO THE
EMPEROVR OF MVSCOVIA.

13 Unknown artist, *Portrait of Fabian Smith (Ulyanov), Agent for the English Merchants to the Emperor of Muscovia*, c.1666–80
Oil on canvas, 76 × 64 cm. Guildhall Art Gallery, City of London [cat.129]

14 Rembrandt, *Bearded Man Wearing a Velvet Cap with a Jewel Clasp*, 1637
Etching, 9.4 × 8.2 cm. The Hunterian, University of Glasgow, Glasgow [cat.41]

lists; and one, from 1687, specifies twenty-two etchings by Rembrandt which he had extracted from his albums for sale. Courten's descriptions allow us to identify individual prints; and he annotated them with prices, the earliest we have for Rembrandt etchings in Britain. The most expensive one, the *Portrait of Joannes Wtenbogaert*, he listed at two shillings and sixpence, with others at one shilling or less.[41] These are modest sums compared to the priciest objects on his list – Dürer and Italian Renaissance engravings – which he valued at up to £4 each.

While Courten had an album devoted to Rembrandt's etchings, we do not know which and how many prints it contained beyond the listed ones he meant to sell. When Richard Maitland, 4th Earl of Lauderdale, sold his enormous collection of about 10,000 prints in 1689 – certainly one of the largest compiled in Britain to that date – the auctioneer listed one lot 'Renbranti Opera integra, four hundred and twenty Figures'.[42] This is the first evidence in Britain for an album or portfolio that contained the entire oeuvre of Rembrandt's prints, an extraordinary feat. Presumably it also included prints after his designs or paintings, and possibly multiple impressions of different states or on various supports (Courten had at least one

counterproof – an offset taken from a wet impression, often for the artist's own purposes). Such a comprehensive collection had surely been acquired en bloc in or from the Netherlands.[43]

The earliest traces of Rembrandt's impact on British art all refer to his etchings. Richard Gaywood's *Democritus Laughing and Heraclitus Weeping in front of a Globe* [fig.12] is a pastiche in mirror-image after two etchings by Jan Gillisz van Vliet (after Rembrandt's design), adding the globe and inscription.[44]

A fascinating and perhaps unique case of appropriating an etching by Rembrandt is the portrait of Fabian Smith, agent from 1613 to his death in 1631/32 of the Muscovy Company that held exclusive privileges in trade between Britain and Russia [fig.13]. It has been suggested that an earlier portrait of Smith, who was known as Fabian Ulyanov in Russia, was lost in the Great Fire of London in 1666 and that the present one was commissioned soon after by the company as a replacement. As Smith's features were no longer known, the artist modelled it on Rembrandt's etching [fig.14], perhaps attracted by the beard and exotic attire which seemed to fit a successful merchant who had spent much of his time in Moscow.[45]

15 Edward Lutterell, after Rembrandt,
*Self-portrait of Rembrandt, c.*1700
Chalks and bodycolour, 32.8 × 25 cm
British Museum, London [cat.103]

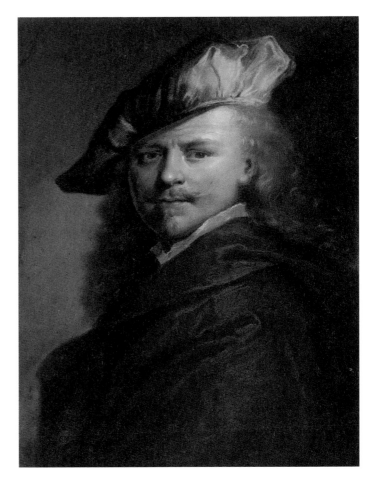

Edward Lutterell (*c.*1650–before 1737) produced a
number of pastels, often on small copper plates, after
Rembrandt etchings [fig.15].[46] He was one of the first
artists to respond to an obviously rising demand for
'coloured' Rembrandt imagery that seems to have antici-
pated the increasing appetite for paintings by the master
towards the end of the seventeenth century. It is interesting
to note that Lutterell's pastels are smooth and finished
works – quite the opposite of the 'rough manner' often
associated with Rembrandt's paintings.

Marshall Smith in his *The Art of Painting* of 1693 observes
that 'Rembrant had a Bold Free way, Colours layd with a
great Body, and many times in old Mens Heads extraordi-
nary deep Shaddows, very difficult to Copy; the Colours
being layd on Rough and in full touches, though sometimes
neatly Finish'd.'[47] An epigram by the elusive writer John
Elsum, published in London in 1700, likewise refers to a
head study painted in Rembrandt's rough manner:[48]

An Old Man's Head, by Rembrant. EPIG. CXIX.

WHAT a coarse rugged Way of Painting's here,
Stroaks upon Stroaks, Dabbs upon Dabbs appear.
The Work you'd think was huddled up in haste,
But mark how truly ev'ry Colour's plac'd,
With such Oeconomy in such a sort,
That they each other mutually support.
Rembrant! thy Pencil plays a subtil Part,
This Roughness is contriv'd to hide thy Art.[49]

It has been suggested that Elsum might have known the
Portrait of an Elderly Man, though it seems unlikely that this
painting would have been described as a 'head' [fig.139].[50]
More likely, the epigram describes a head study such as that
from the Clerk of Penicuik collection [fig.5]. Remarkably,
both, Marshall and Elsum praise Rembrandt's technique
(rather than the subject), offering a glimpse into what
collectors might have sought in Rembrandt's paintings –
and found on the London art market around 1700.[51]

'THE CRAZE': THE EIGHTEENTH CENTURY

The eighteenth century saw a constantly growing European
art market, albeit with occasional dips resulting from wars,
and London soon became its centre.[52] It remains difficult
to this day to determine the exact relationship between
taste and economics within the art market. Demand follows
taste, which in turn is shaped by discourse and also by
supply, and more generally by availability of and acces-
sibility to art. Collectors needed direction to develop their
taste and to navigate the market.

Rembrandt's reputation rose out of the shadow of the
heroes of Italian and – in smaller number – French art, such
as Raphael (1483–1520), Titian (*c.*1485/90–1576), Correggio
(1489–1534) and Claude (1604/5–1682), who remained
on their pedestals throughout the period covered here.
The taste for Rembrandt's art had developed first in the
Netherlands and then in France, and the earliest biography
and critical assessment of his work to be published in
English was Roger de Piles's *The Art of Painting*, translated
from the French in 1706.[53] Reflecting earlier writers, he
criticised Rembrandt's lack of interest in the ancient and
Italian masters, chiefly Raphael, as well as his preference
for 'nothing more than to imitate nature'. However, more
importantly, he described the merits of Rembrandt's paint-
ings, drawings and etchings, emphasising his powerful

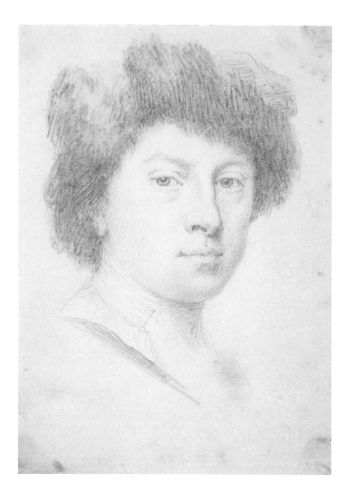

16 Jonathan Richardson the Elder, *Self-portrait at the Age of Thirty*, 1734–35
Graphite on parchment, 14.7 × 11.6 cm
The Samuel Courtauld Trust, The Courtauld Gallery, London [cat.123]

colouring and chiaroscuro. His portraits – for which British collectors would develop a lasting preference – are 'expressive and lively' and praised for their 'truth of likeness', his 'touches […] so a-propos, that they express both the flesh and the life'.[54] These characteristics shaped the perception of Rembrandt's art for nearly two centuries.

From about 1720, the towering figure of Rembrandt's discovery in Britain was Jonathan Richardson the Elder (1667–1745),[55] whose eminence chiefly rests on his writings and his substantial collection of drawings by the artist.[56] Richardson's own work as a portrait painter does not acknowledge Rembrandt's art. However, an intimate self-portrait [fig.16] clearly pays homage to Rembrandt's etched *Self-portrait in a Heavy Fur Cap: Bust*, 1631 [cat.35] and demonstrates that Richardson's fascination with the Dutch master started before 1700.[57] In his writings, he celebrated Rembrandt's inventions, expression and composition and added critical praise on individual artworks, some of which, such as *The Hundred Guilder Print* [fig.80], were in his collection.[58] Others, such as *The Holy Family at Night* ('*The Cradle*') [fig.107], were seen by his son Jonathan Richardson the Younger in Paris, in the collection of the Duc d'Orléans (the elder Richardson never left Britain).

Richardson also owned a painting which was then attributed to Rembrandt [fig.95] and etchings by the master [cat.53]. His collection of Rembrandt drawings, one of the finest ever assembled in Britain, included *The Calumny of Apelles* [fig.17], a copy after a drawing by Mantegna which was probably in Rembrandt's own collection. Richardson elaborately annotated the backing sheet, noting the provenance as well as summarising the story depicted. Later owners including Arthur Pond (*c.*1701–1758) and John Barnard (1709–1784) added further comments, while others, such as Benjamin West (1738–1820) and Sir Thomas Lawrence (1769–1830), left only their collector's marks. Richardson's Rembrandt drawings were particularly sought after by artist-collectors; for example, his *The Incredulity of Saint Thomas* [fig.109] was acquired by fellow artists Thomas Hudson (1701–1779) and Sir Joshua Reynolds (1723–1792).[59]

These works epitomise the rising fame of individual drawings. The marks left on them by their owners – from Richardson onwards – created a pedigree that confirmed authenticity and importance, as well as increasing their value [fig.18].[60] The same practice was also common with print collectors and sometimes exploited by dealers adding false marks, such as Robert Dighton (*c.*1752–1814).[61] Richardson's Rembrandt drawings were predominantly of figures, including a group of prized copies after Moghul miniatures.

The other important collection of Rembrandt drawings of this period was dominated by landscapes. In 1723, William Cavendish, 2nd Duke of Devonshire (1672–1729), acquired at least 225 drawings from Nicolaes Flinck (1646–1723), whose father Govert Flinck (1615–1660) had trained with Rembrandt in the 1630s. Nicolaes Flinck's collection in Rotterdam was regarded as one of the best in all of Europe and included an unparalleled group of landscapes by Rembrandt [figs 19 & 22].[62]

The relatively late appearance of important groups of drawings by Rembrandt in Britain probably resulted from a limited supply. Rembrandt was declared bankrupt in 1656, and his estate, including his collection, was sold at auction two years later. By his death in 1669 he possessed an unspecified number of drawings, presumably his production after 1658. Large groups of his drawings seem to have remained together until the early eighteenth century.[63]

Increasingly, British collectors turned to Dutch painting, inspired by the French taste for Dutch (and Flemish) genre

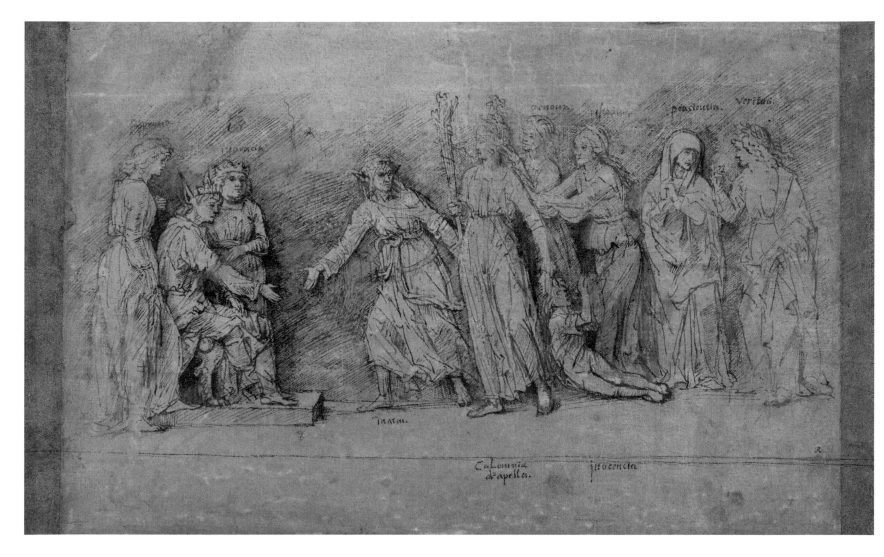

17 Rembrandt, after Andrea Mantegna, *The Calumny of Apelles*, c.1652–54
Pen and brown ink with brown wash on paper prepared with brown wash, 26.3 × 43.2 cm
British Museum, London [cat.33]

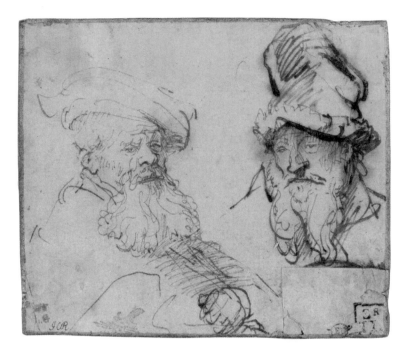

18 Rembrandt, *Two Studies of Old Men's Heads*, c.1639
Pen and brown ink, 8.1 × 9.4 cm
British Museum, London [cat.22]

19 Rembrandt, *A Man Sculling a Boat on the Bullewijk,
with a View toward Ouderkerk*, c.1648–50
Reed pen and brown ink, brown wash and touches of white
bodycolour, 13.3 × 20 cm
Trustees of the Chatsworth Settlement [cat.29]

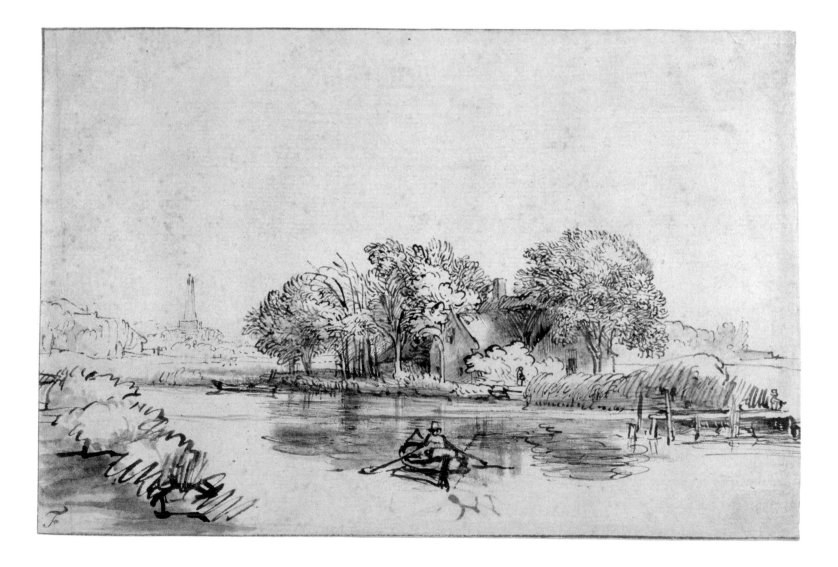

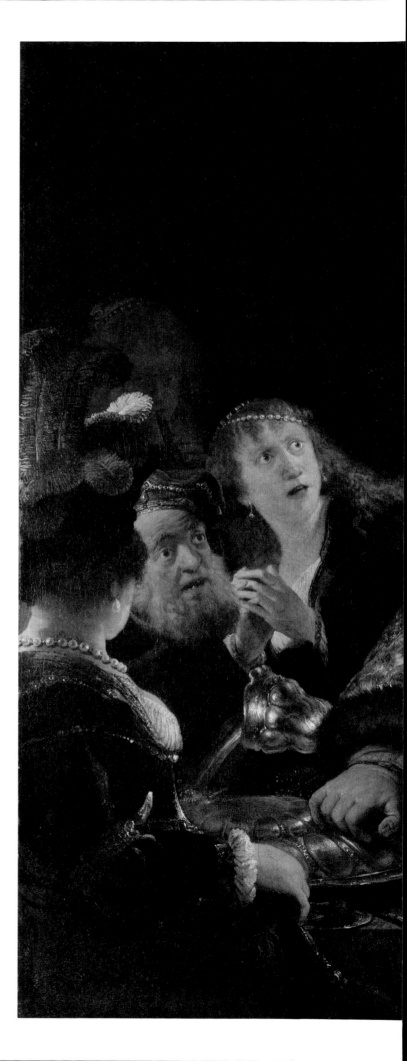

20 Rembrandt, *Belshazzar's Feast, c.*1636–38
Oil on canvas, 167 × 209.2 cm
The National Gallery, London [cat.4]

pieces and, moreover, discovering portrait and landscape
as their favourite subjects. However, while works by
Gerrit Dou (1613–1675), Gerard ter Borch (1617–1681),
Jacob van Ruisdael (1628/29–1682) and Aelbert Cuyp
(1620–1691) were sought after and, from mid-century,
sold for stellar prices, these artists never received the same
celebrated status (as well as criticism) as Rembrandt.

The first major paintings by Rembrandt began
appearing in Britain from about 1720: a little trickle
that would grow into an enormous surge during the
following decades. This included the late *Self-portrait,*
1669 (The National Gallery, London), which arrived
before 1722; *The Circumcision,* 1661 (National Gallery
of Art, Washington), which followed before 1724; and
Belshazzar's Feast, which came in about 1729–30 [fig.20].[64]
Abraham's Sacrifice, 1635 (Hermitage, St Petersburg),
one of the grandest pictures ever to enter Britain, was
acquired by Sir Robert Walpole in about 1736 and sold by
his grandson to Catherine the Great in 1779.[65]

A Man in Oriental Costume (King Uzziah) [fig.21],
bought for Cardinal Mazarin's collection, was imported
from Paris and sold in London to the 3rd Duke of
Devonshire in 1742.[66] Pictures with notable previous
owners such as this certainly enjoyed some fame among
collectors and connoisseurs by the time they reached
Britain. The engraver and chronicler of the art world
George Vertue (1684–1756) saw the painting at the newly
built Devonshire House in London shortly after its arrival
and praised it as 'a most excellent picture'.[67]

Arthur Pond, a portrait painter like Richardson, was
the other eminent champion and collector of Rembrandt's
art in early Georgian London.[68] His *Self-portrait* [fig.24]
was described by Vertue as 'etchd & scratch'd Renbrant's
manner – from a painting of Vanderbank very like – good
taste. An excellent mimmick of the manner.'[69] The same
year, Pond also portrayed Dr Richard Mead, contro-
versially without his wig and, again, in Rembrandt's
manner. This time, Vertue was less appreciative and
found him 'like an old mumper, as Rhimebrandts heads
usually do' and observed that 'such kind of works give
pleasure to Virtuosi but not to the publick Eye'.[70] Vertue's
remarks seem to confirm that working in Rembrandt's
manner was appreciated as long as the rules of decorum
were followed.

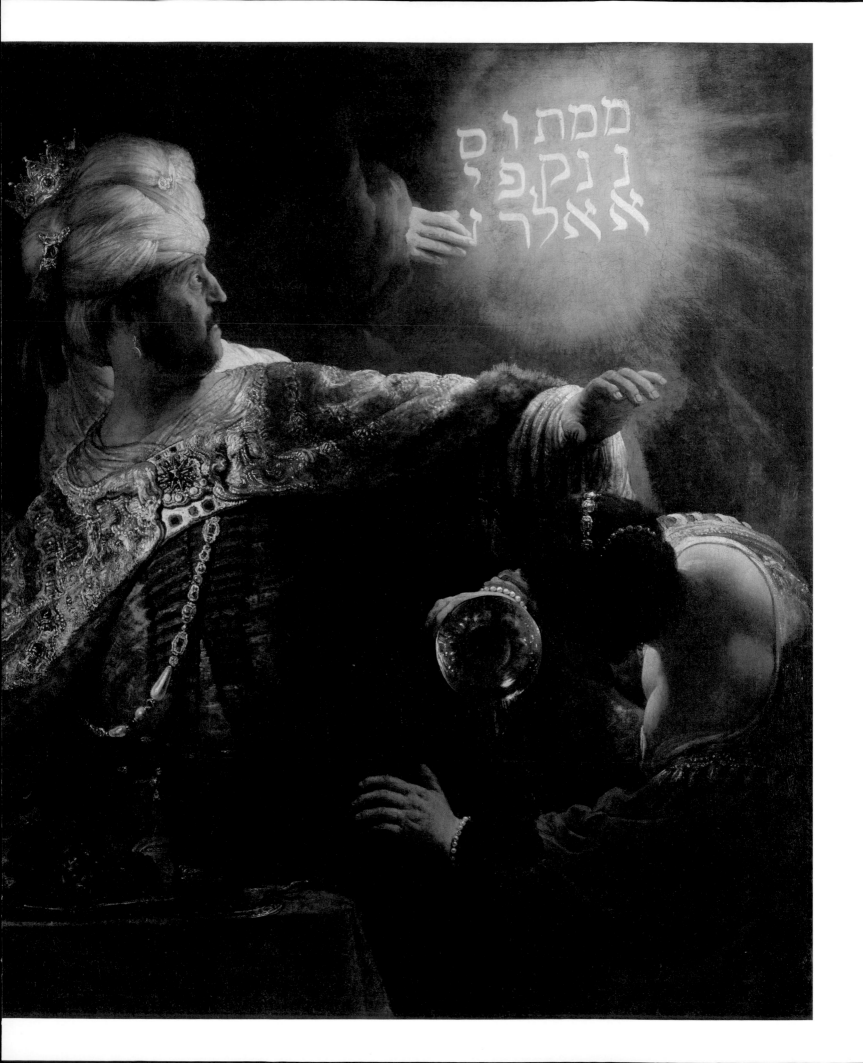

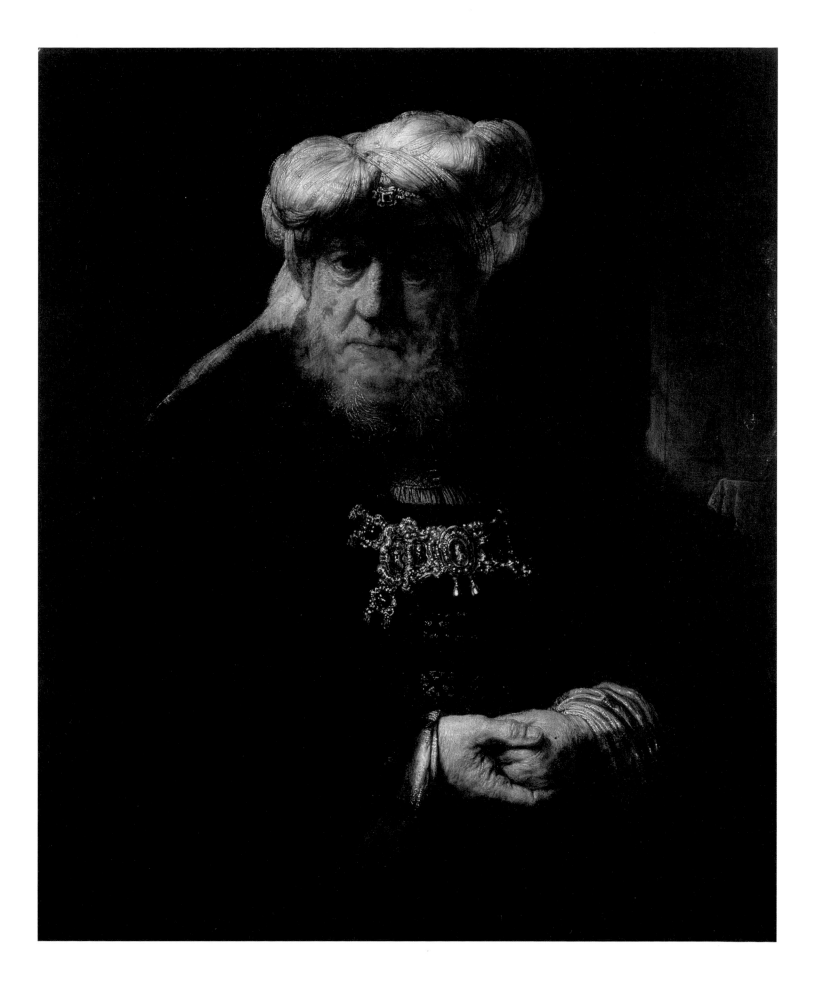

21 Rembrandt, *A Man in Oriental Costume (King Uzziah)*, c.1639
Oil on panel, 102.8 × 78.8 cm
Chatsworth House Trust [cat.5]

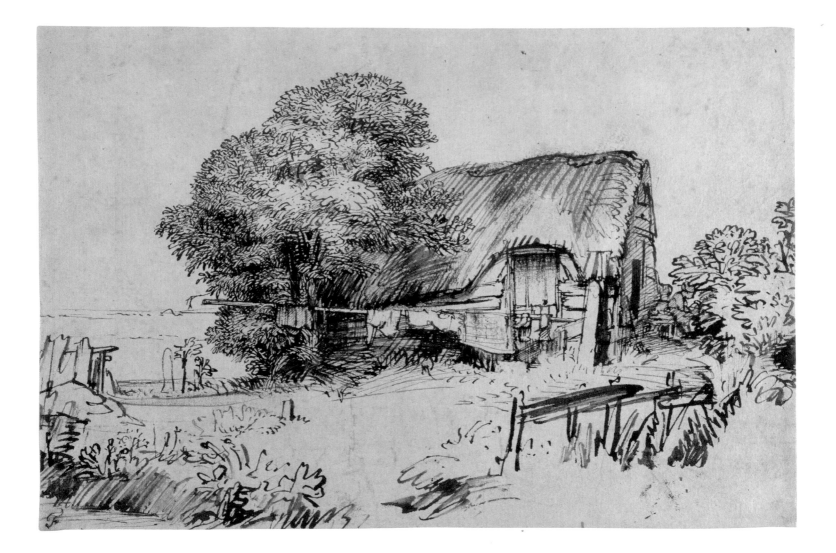

22 Rembrandt, *A Thatched Cottage by a Large Tree*, c.1648–50
Reed pen and brown ink, 17.5 × 26.7 cm
Trustees of the Chatsworth Settlement [cat.31]

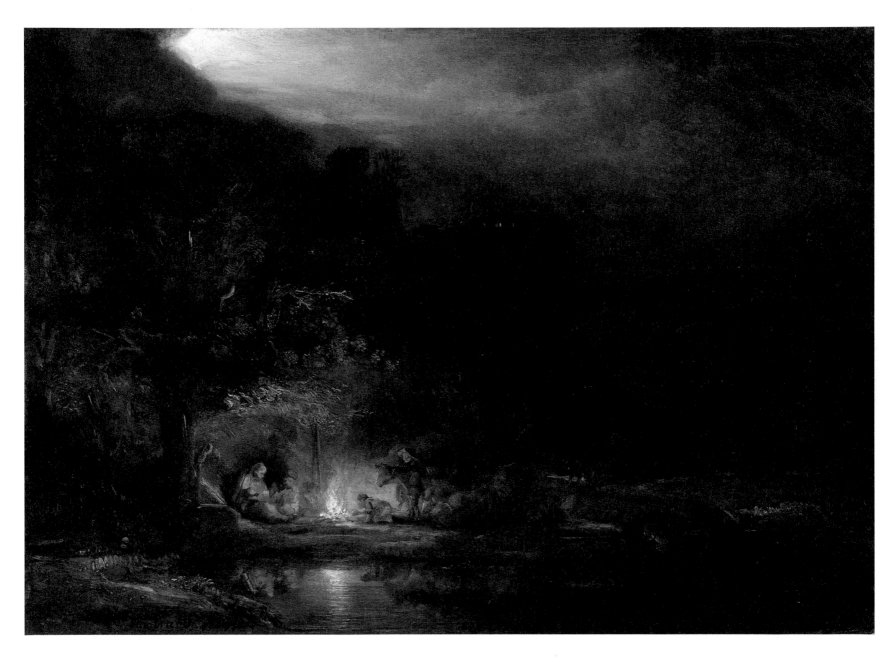

23 Rembrandt, *Landscape with the Rest on the Flight into Egypt*, 1647

Oil on panel, 34 × 48 cm
National Gallery of Ireland, Dublin [cat.10]

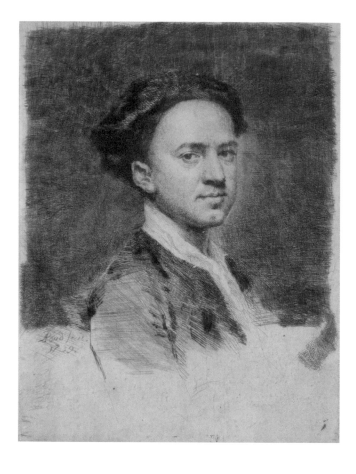

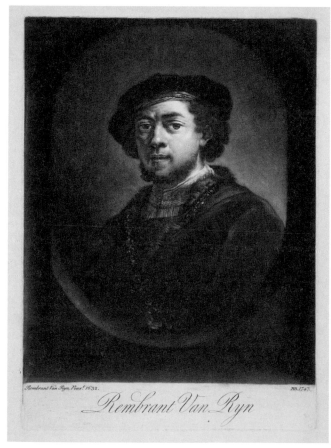

Pond is most famous for one of the finest collections of the master's etchings ever formed. Widely travelled and well connected on the Continent (he had learnt Dutch and was praised by the eminent print dealer Pierre-Jean Mariette), Pond acquired major collections of Rembrandt etchings from the printmaker Jacobus Houbraken (1698–1780), incorporating the collection of Willem Six (1662–1733), nephew of Rembrandt's patron Jan Six (1618–1700), in Amsterdam and the one formerly owned by the Parisian dealer Pierre Remy (1715–1797) [cat.43]. Pond himself sold his print collection en bloc to Sir Edward Astley (1729–1802) [fig.10], but single Rembrandt etchings were sold to John Barnard and other eminent collectors of the day.[71]

Pond was also a shrewd businessman and recognised the huge potential of printmaking to multiply images of artists' paintings and drawings.[72] His first enterprise, in collaboration with the portrait painter George Knapton (1698–1778), was *Prints in Imitation of Drawings*, published in 1736.[73] It included a print after Rembrandt's drawing *Saint Peter's Prayer before the Raising of Tabitha*, which came from Richardson's collection and was praised by him for its sublime qualities [fig.92].[74] Pond also commissioned single-sheet prints, such as one by Joseph Wood after Rembrandt's *Landscape with the Rest on the Flight into Egypt* [fig.23]. Often, the lettering on prints is the first proof of paintings having entered a British collection; in this instance Henry Hoare's at Stourhead, in 1752. However, Pond commissioned Wood in July 1749, confirming that the painting was in Britain by then.[75]

Wood used engraving, but increasingly printmakers discovered that mezzotint was particularly well suited to capturing the chiaroscuro of Rembrandt's paintings [fig.25].[76] Mezzotint shares expressive qualities with Rembrandt's etchings in the 'dark manner', and he was sometimes (erroneously) credited with the invention of this technique.[77] The dissemination of prints such as these rose steeply from around the middle of the century, making Rembrandt's imagery available to a much wider and less wealthy audience.[78]

By this time, a veritable Rembrandt mania was in full swing, particularly where his etchings were concerned. This was so much the case that it, and Rembrandt's art, became the target of criticism and satire.[79] Vertue observed in 1751 that 'lately the prints Rhnebrandt being here much

esteemed and collected at any price. some particularly sold at sales very extraordinary. this put several on collections all the wild scrabbles skratches &c. done by him or thought to be done by him.'[80] The artist and scientist Benjamin Wilson (1721–1788) infamously deceived Thomas Hudson and others, including Pond, in 1751 with a fake Rembrandt etching he himself had fabricated [fig.75].[81] In the aftermath of this spoof, fellow artist William Hogarth (1697–1764), a friend of Wilson, issued a subscription ticket (a print sold for a receipt, as a down-payment for another, more elaborate and expensive, print) ridiculing Dutch art, which proved so popular that he reprinted it, lettered 'Design'd and Etch'd in the rediculous manner of Rembrant' [fig.26].[82]

The dramatist Samuel Foote (1720–1777) wrote a burlesque comedy on ignorant collectors and the corrupt art trade: entitled *Taste*, it was first performed at London's Drury Lane in 1752. In it, Puff, a ruthless auctioneer who deceives his clients with copies and fakes, sneers at 'Two of Rembrant's etching by Scrape [a forger] [...]; a paultry Affair, a poor ten Guinea Job' (five guineas for a print was an enormous price).[83]

Edme-François Gersaint's critical catalogue of Rembrandt's etchings was translated into English in the same year.[84] Collectors now had a tool to identify different states, copies [cat.70] and forgeries [fig.75]. At the same time, Gersaint's book fuelled the craze for rarities such as corrected proof impressions and counterproofs [cat.37], and impressions on oriental papers and vellum (a practice revived and commercially exploited during the etching revival). To fulfil this desire for the uncommon, printers who were fortunate enough to have access to the original plates pulled new editions, sometimes creating collectors' items that Rembrandt himself never produced; for example, impressions on satin or in red ink [cat.40 & fig.27].[85]

Reprints and copies catered to the huge demand for Rembrandt's etchings in a competitive market, with dwindling resources of the ever-more-expensive originals.[86] Richard Houston (*c.*1721–1775) produced two copies in mezzotint [cats 94 & 95] after Rembrandt's *Portrait of Jan Six* [fig.78], one the same size, the other one reduced, aimed at a lower segment of the market (as well as at keen collectors who would buy both). The lettering of the former described it as 'Done from that Celebrated and Scarce Etching by Rembrandt, which has been frequently Sold for 30 Pounds, and upwards'.[87]

Copyists and imitators included Thomas Worlidge (1700–1766) [fig.79]; James Bretherton (*c.*1730–1806) [cat.70], whose etchings are most deceptive and certainly were sometimes mistaken for Rembrandt's work; and amateurs such as Sophia Hume (active 1808), David Deuchar (1743–1808) [cat.80], Heneage Finch, 4th Earl of Aylesford (1751–1812), and John Clerk of Eldin (1728–1812) – the latter two distinguished Rembrandt collectors.[88]

Captain William Baillie (1723–1810) infamously acquired the worn plate of *The Hundred Guilder Print*, one of Rembrandt's most famous etchings. He reworked it and printed a limited edition [fig.28], thereafter cutting the plate into four pieces and continuing to print from these mutilated fragments [fig.81], on selected supports, such as Indian or Japanese papers, or satin.[89] Baillie regarded Rembrandt's 'Way of Etching being an Invention never yet well imitated tho there have been a great many pretenders'.[90] Baillie himself was one of them; he also copied, among other etchings, *The Three Trees* [fig.43]. One of Rembrandt's most admired prints, it was copied at least six times by different British printmakers before 1826.[91]

This 'Madness to have his [Rembrandt's] Prints'[92] was ridiculed by the famed writer and connoisseur Horace Walpole (1717–1797), who complained that 'he [Rembrandt] is so well known, and his works [are] in such repute, that his scratches, with the difference only of a black horse or a white one, sell for thirty guineas'.[93] Walpole also commented on a somewhat mysterious claim that Rembrandt may have visited Hull in 1661:

Vertue was told by old Mr. Laroon, who saw him in Yorkshire, that the celebrated Rembrandt was in England in 1661, and lived 16 or 18 months at Hull, where he drew several gentlemen and seafaring persons. Mr Dahl had one of those pictures. There are two fine whole lengths at Yarmouth [the Elison/ Bockenolle portraits, figs 3 & 4], *which might be done at the same time. As there is no other evidence of Rembrandt being in England, it was not necessary to make a separate article* [in his book on painters in England] *for him.*[94]

Walpole himself seems to have doubted this story, not least because he must have realised that Marcellus Laroon the Elder (1653–1702), whom he believed to be

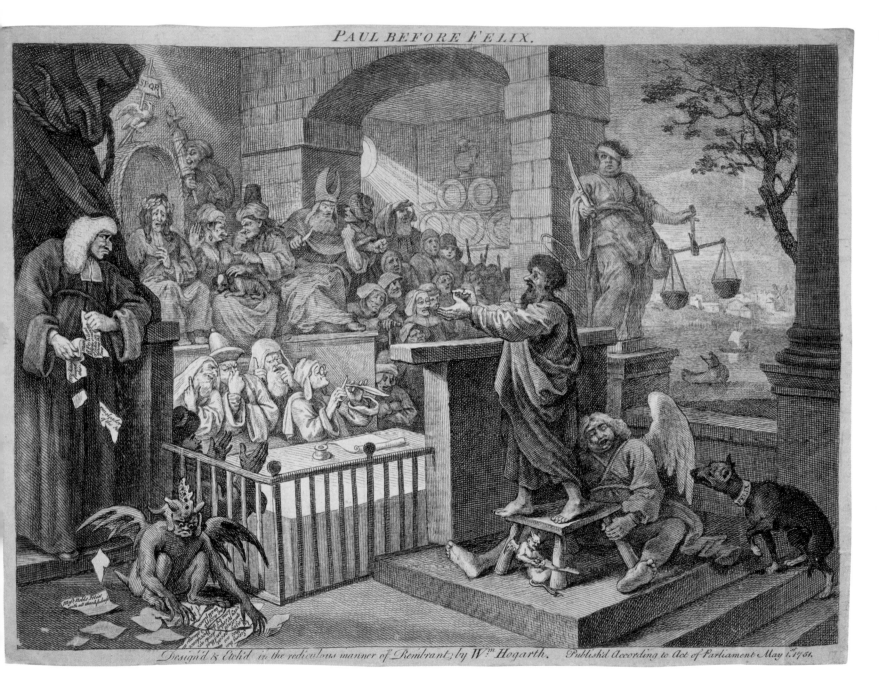

PAUL BEFORE FELIX.

Design'd & Etch'd in the rediculous manner of Rembrant; by Wm Hogarth. Publish'd According to Act of Parliament May 1751.

26 William Hogarth,
Paul Before Felix Burlesqued, 1751
Etching with mezzotint tone, 26.7 × 35.6 cm
National Galleries of Scotland, Edinburgh [cat.93]

27 Rembrandt, *Portrait of the Preacher Jan Cornelis Sylvius*, 1633

Etching, printed in red ink, 16.4 × 14 cm
National Galleries of Scotland, Edinburgh [cat.38]

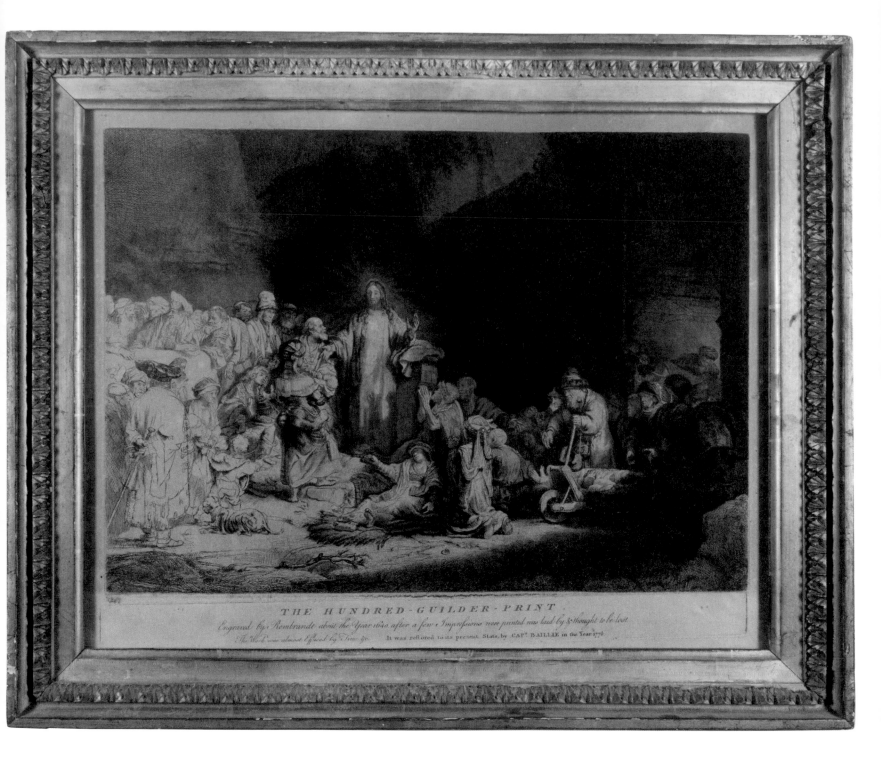

28 Rembrandt, reworked by William Baillie, *The Hundred Guilder Print*, c.1648 and 1775
Etching and engraving, 28.2 × 39.8 cm
Nicholas Stogdon [cat.51]

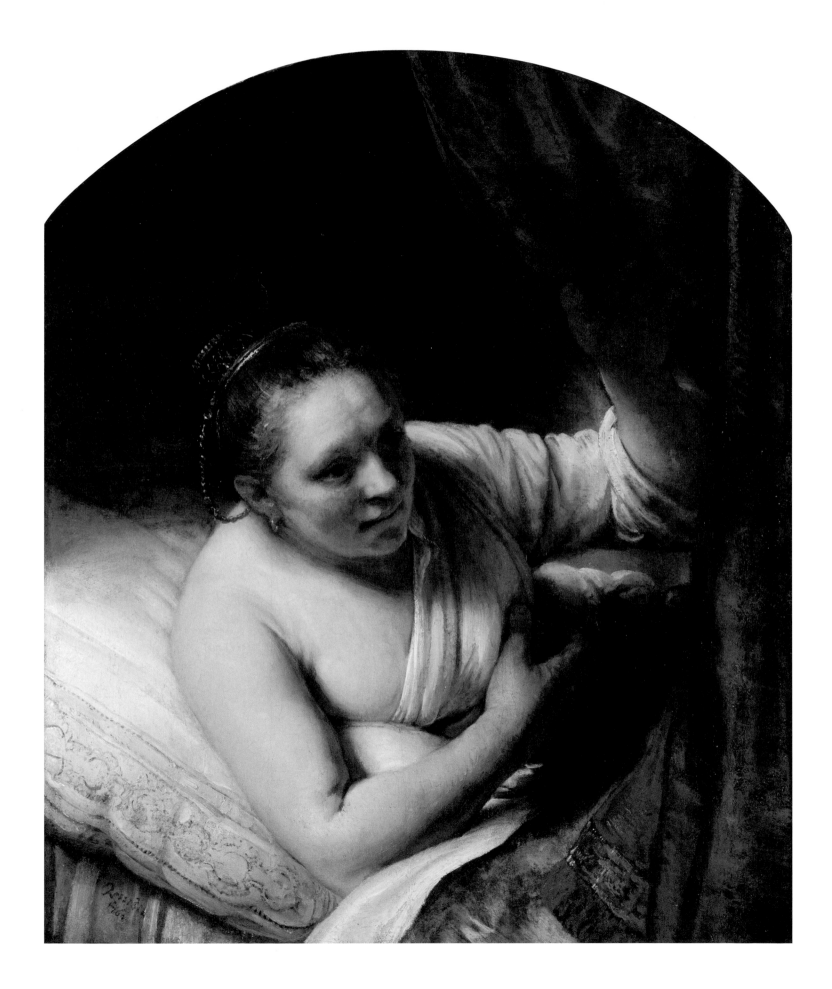

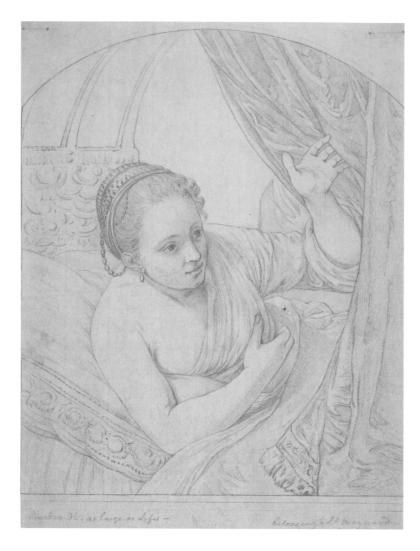

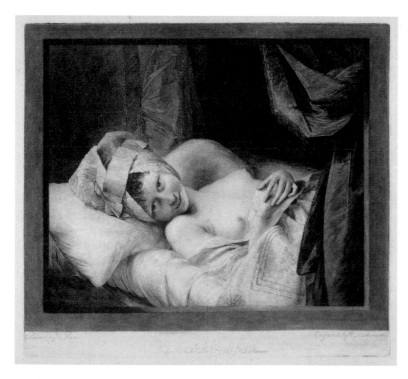

29 Rembrandt, *A Woman in Bed (Sarah)*, c.1647
Oil on canvas, 81.1 × 67.8 cm. National Galleries of Scotland, Edinburgh [cat.9]

30 Richard Cooper the Younger, after Rembrandt, *A Young Woman Leaning Forward ('Rembrandt's Mistress')*, c.1781
Pencil, 27.6 × 20.4 cm
National Galleries of Scotland, Edinburgh [cat.76]

31 William Dickinson, after Matthew William Peters, *Lydia*, 1776
Mezzotint, 30.4 × 33.3 cm. William Zachs [cat.81]

Vertue's source, would only have been about eight years old when meeting Rembrandt.[95] Moreover, in 1661–62, Rembrandt was working on two major public commissions in Amsterdam – *The Conspiracy of the Batavians under Claudius Civilis* (Nationalmuseum, Stockholm) and *'The Syndics'* (Rijksmuseum, Amsterdam) – as well as several other paintings, and it seems highly unlikely that he would have left Amsterdam during this busy period.[96] It should be noted, though, that Vertue's remark dates from 1713, before any significant wider interest in Rembrandt was manifest in Britain. However, there is no circumstantial, let alone documented, evidence to support Vertue's report, and none of Rembrandt's English biographers seems to have picked up on this after Walpole's publication in 1763.

Meanwhile, it was observed that by 1770 'genuine works of this master [Rembrandt] are rarely to be met with, and whenever they are to be purchased they afford incredible prices. Many of them are preserved in the rich collections of the English nobility.'[97] This emphasis on the shortage of genuine works implies an increasing number of doubtful attributions and forgeries under Rembrandt's name.

During this period, however, some prized pictures were acquired by British collectors, such as *An Old Woman Reading* [fig.32] before 1765, *Girl at a Window* [fig.33] before 1774, and *A Woman in Bed (Sarah)* [fig.29] about 1776. James McArdell (1728/29–1765), an Irish printmaker working in London, produced a mezzotint of the first [cat.104], selling them for two shillings apiece, a modest price. Richard Cooper the Younger (1740–1814) published one of the latter [cat.77]. On his preparatory drawing [fig.30], he noted '[I] made the face handsomer than in this original', a reflection of Rembrandt's reputation for ugliness, particularly in nudes, which originated with Gersaint and persisted into the twentieth century.

An Old Woman Reading was identified as Rembrandt's mother, while Cooper styled the 'sitter' as 'Rembrandt's Mistress', underlining the wish to identify family members in Rembrandt's works which would culminate in the Romantic period.[98] Whatever shortcomings contemporaries might have found, the latter painting almost certainly inspired the Revd Matthew William Peters (1741/42–1814) for his courtesan portrait *Lydia* [fig.31], which appeared as a print in 1776, about the time that Rembrandt's painting had been shipped from Paris to the London dealer Thomas Moore Slade.

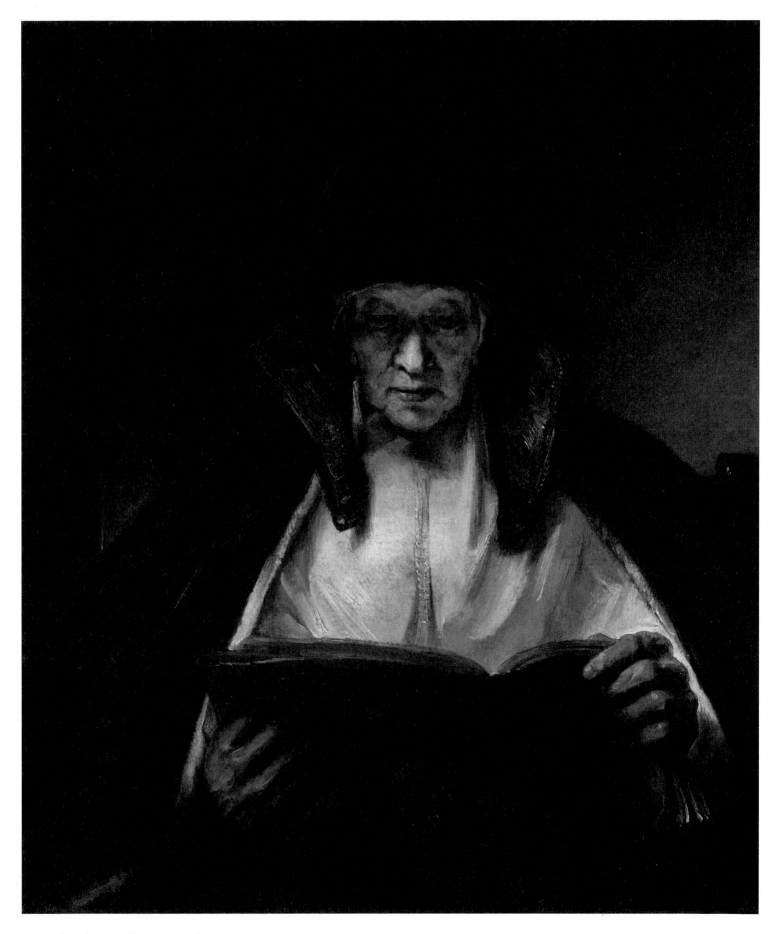

32 Rembrandt, *An Old Woman Reading*, 1655

Oil on canvas, 78.7 × 66 cm. Buccleuch Collection [cat.14]

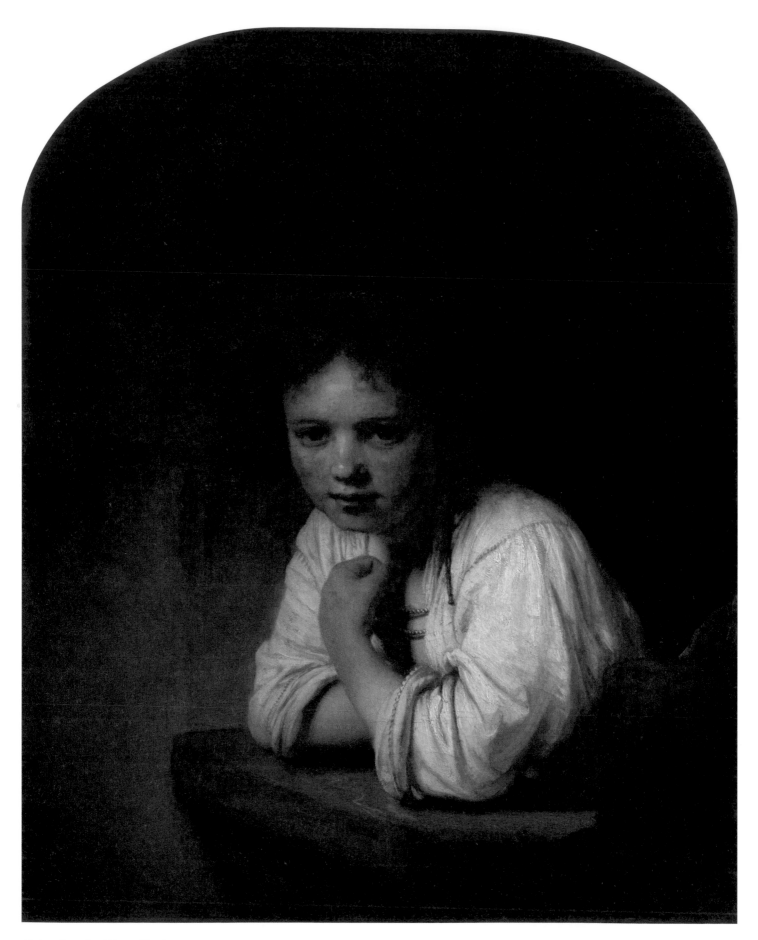

33 Rembrandt, *Girl at a Window*, 1645

Oil on canvas, 81.8 × 66.2 cm. Dulwich Picture Gallery, London [cat.7]

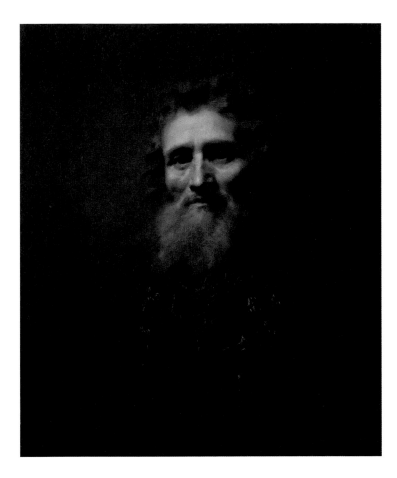

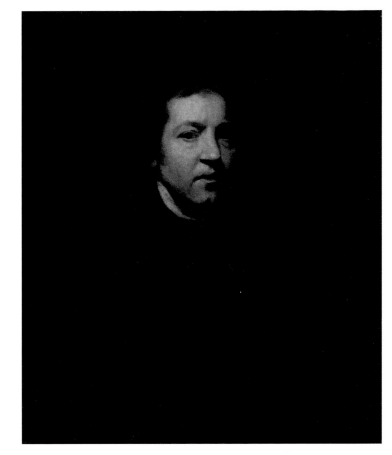

The most celebrated (and most copied) mezzotint after Rembrandt was William Pether's (*c*.1738–1821) *A Jew Rabbi* [cat.113], published by the highly successful John Boydell in 1764. William Gilpin praised it in his *An Essay upon Prints* (1768) for the engraver's skill.[99] The print was hugely successful – Pether had to produce a second plate in 1778, probably because the first was worn out – and enhanced the reputation of the painting, then at Devonshire House in London.[100] The success of mezzotints after Rembrandt's paintings peaked around 1780, although many of them continued to be sold into the nineteenth century.

What impact did the massively enhanced exposure to Rembrandt's imagery have on artists in Britain? With the exception of *The Mill* [fig.91], which had such a lasting effect on landscape artists in the nineteenth century, British painters chiefly took inspiration from Rembrandt for portraits and self-portraits.[101] From William Hogarth, Thomas Hudson, Joseph Wright of Derby (1734–1797) [fig.98] and Allan Ramsay (1713–1784) to Sir Henry Raeburn (1756–1823) [fig.34] and Sir Thomas Lawrence, painters were, in different ways, inspired by Rembrandt's technique, motifs and, above all, colouring and chiaroscuro.[102]

His impact manifested itself in a wide range of ways, from subtle hints in colouring and the distribution of light and shade to recognisable references and outright plagiarism. However, these works tend to be isolated in the respective artists' oeuvres. It is only with the young John Opie (1761–1807), whom contemporaries called 'the English Rembrandt', that a more consistent emulation of the Dutchman's art can be observed, although Opie went on to abandon this style later in his career.[103]

Above all, it was Sir Joshua Reynolds, 'the most thorough and intelligent Rembrandtist of the century', who absorbed Rembrandt as an artist, writer and collector.[104] His Rembrandt collection was one of the most distinguished in Britain (see figs 65, 106, 110 and 134).[105] While he seems to have collected Rembrandt's works throughout his career, the strongest impact on Reynolds as a portraitist lasted from about 1745 to about 1770. The *Portrait of Giuseppe Marchi* [fig.36], Reynolds's chief studio assistant, and his *Self-portrait when Young* [fig.35], both show strong chiaroscuro combined with warm colouring and – in the former – fancy oriental costume, all reminiscent of Rembrandt's paintings.[106]

Reynolds had a keen interest in the master's technique, and recent technical examination of Rembrandt's paintings from his collection has found evidence that he repainted these, although the degree to which he did so remains under discussion [fig.134].[107] In his *Discourses*, delivered to young artists and dominated by Italian and, to a lesser degree,

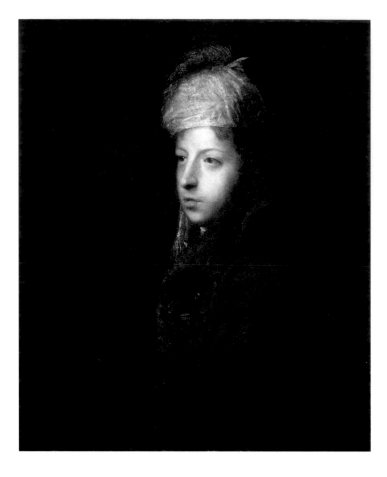

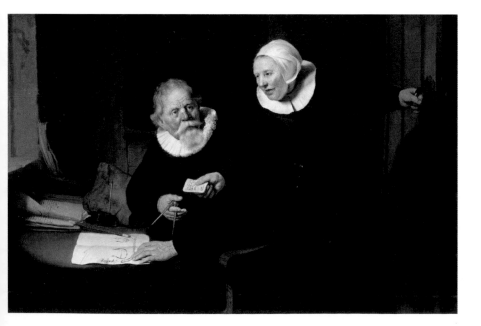

34 Henry Raeburn, *Portrait of a Jew*, 1814
Oil on canvas, 76.2 × 63.5 cm. National Galleries of Scotland, Edinburgh [cat.117]

35 Joshua Reynolds, *Self-portrait when Young*, c.1753–58
Oil on canvas, 73.7 × 61.6 cm. Tate [cat.120]

36 Joshua Reynolds, *Portrait of Giuseppe Marchi*, 1753
Oil on canvas, 77.2 × 63.6 cm. Royal Academy of Arts, London [cat.119]

37 Rembrandt, *Portrait of Jan Rijcksen and his Wife, Griet Jans* or *The Shipbuilder and his Wife*, 1633
Oil on canvas, 113.8 × 169.8 cm. Royal Collection Trust, London

At the end of the eighteenth century, which had seen such a meteoric rise of Rembrandt's art and its reputation in Britain, the market was flooded with dubious works under his name.[109] The introduction to Daniel Daulby's Rembrandt catalogue of 1796 remarks that 'if a picture possess any thing of the manner of Rembrandt, it is usually attributed to him, either to inhance the value, or to flatter the possessor'.[110] The anonymous author of an article in the *London Chronicle* titled 'Hints to collectors of pictures' put it more bluntly: 'if you lay hold of a little pannel, plaistered over with a dirty compound, the colour of chalk and charcoal, without it being possible to discover a form, or guess what the artist intended, call it a Rembrandt'.[111] The market was overheated, and the craze drew to a close.

RE-EVALUATIONS: THE NINETEENTH CENTURY

Collecting of Rembrandt's works continued of course, and benefited from the repercussions of the French Revolution and the Napoleonic Wars, which released an enormous number of artworks from distinguished collections onto the British market. The most famous of these collections was that of the Duc d'Orléans, which included Rembrandt's *The Mill*. Among other prized paintings, the Bridgewater *Self-portrait* [fig.38] and *Titus at his Desk* [fig.39] were also first documented in Britain around 1800.

Many of these treasures were acquired by a new class of wealthy collectors, such as the Barings, who sold their collection to King George IV (r.1820–30), and John Julius Angerstein (1732–1823), whose bequest became the foundation of the National Gallery in London. George IV, 'the most acquisitive British monarch since Charles I', was the first to collect paintings by Rembrandt.[112] (Charles I (r.1625–49) and George III (r.1760–1820) had 'accidentally' acquired works by the artist, the latter when he purchased the collection of Consul Smith from Venice in 1762.)[113] George IV had started buying paintings by Rembrandt when he was Prince of Wales, his celebrated trophy being *The Shipbuilder and his Wife* [fig.37], purchased in 1814 for a staggering 5,000 guineas.[114]

Sir Thomas Lawrence's fabulous collection of drawings, one of the finest ever assembled in Britain, included

French art, Rembrandt unsurprisingly only features a few times and as an example to avoid rather than to follow. Likewise, when Reynolds visited the Netherlands in 1781, he was much more taken by Rubens than by Rembrandt, whose *The Night Watch*, 1642 (Rijksmuseum, Amsterdam) he found 'the worst of him I ever saw'.[108]

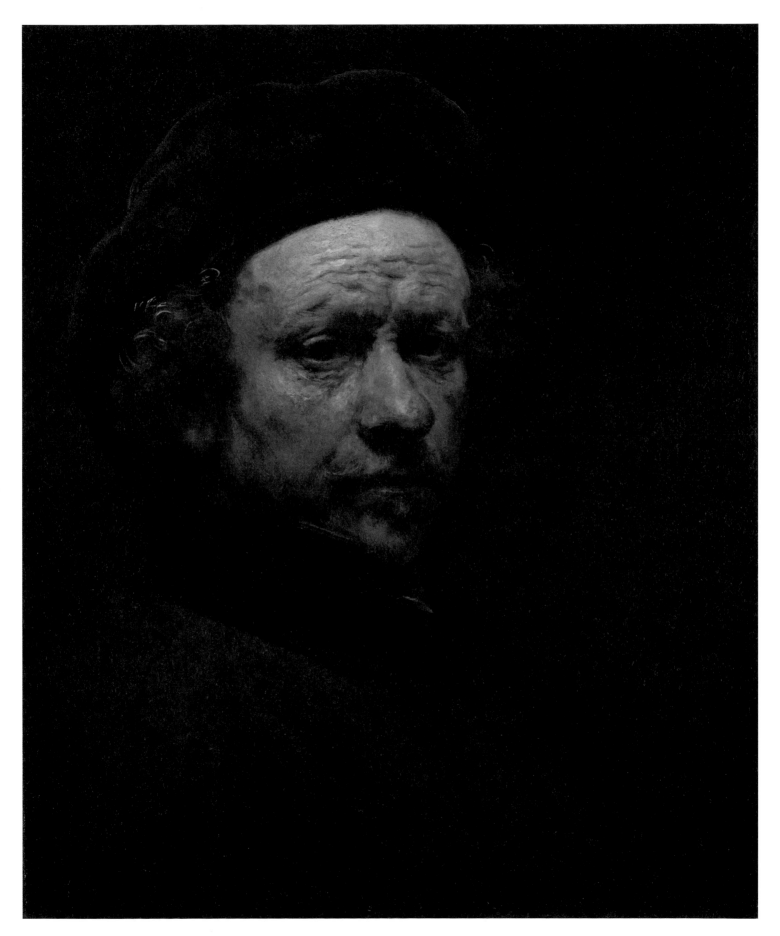

38 Rembrandt, *Self-portrait,* c.1655

Oil on canvas, 52.7 × 43 cm. Bridgewater Collection Loan, National Galleries of Scotland, Edinburgh [cat.16]

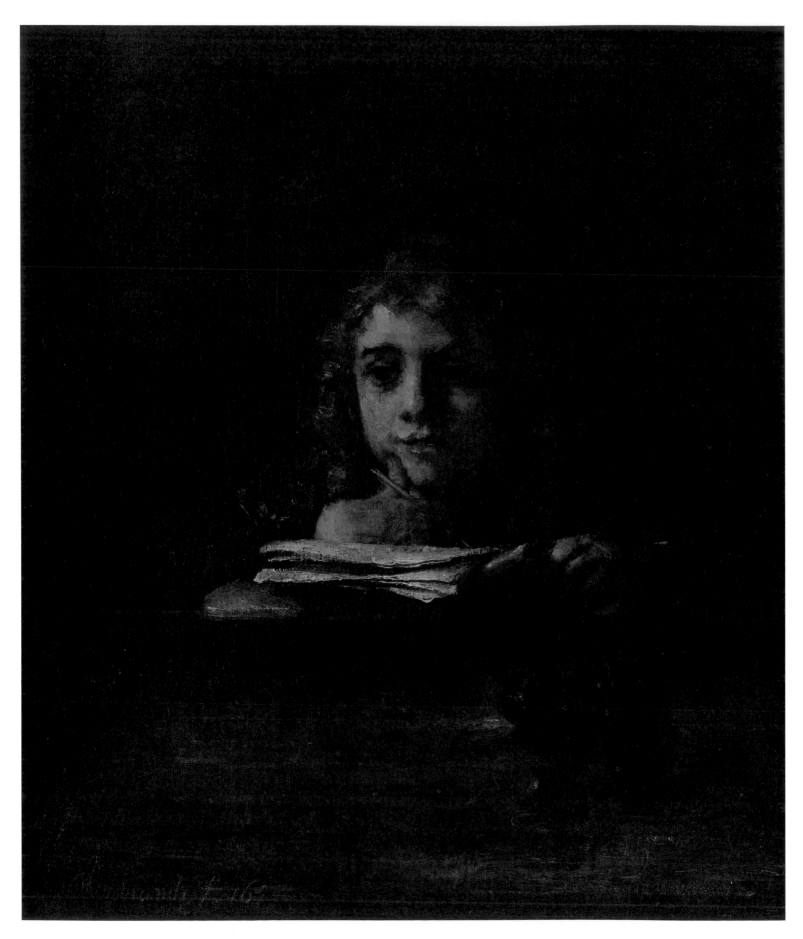

39 Rembrandt, *Titus at his Desk*, 1655

Oil on canvas, 77 × 63 cm. Museum Boijmans Van Beuningen, Rotterdam [cat.15]

40 Rembrandt, *The Amsteldijk near Meerhuizen*, c.1648–50
Pen and brown ink, brown wash and white bodycolour, 14.8 × 26.9 cm
Musée du Louvre, Paris [cat.30]

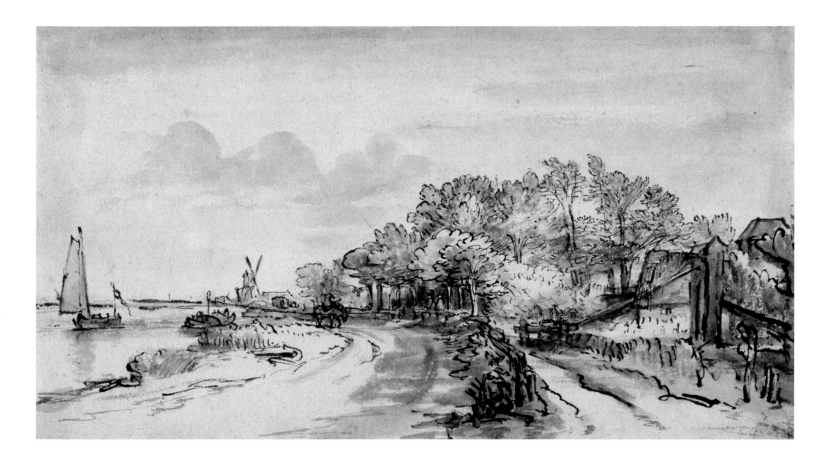

many cherished Rembrandts [fig.40]; it was dispersed in 1830.[115] The eminent collector Richard Payne Knight (1751–1824), who also owned *The Holy Family at Night* ('*The Cradle*'), c.1642–48 [fig.107], bequeathed his collection to the British Museum in 1824; it included sixty-three drawings then regarded as by Rembrandt.[116]

Collecting of Rembrandt's etchings continued to flourish, albeit without the craziness of the mid-eighteenth century. Famous collections formed in these decades were sold in London.[117] In 1829, the dealer Samuel Woodburn acquired the stellar collection of Baron Dominique Vivant Denon – one of the finest and most complete collections of Rembrandt etchings ever compiled – for Thomas Wilson, who based his critical catalogue of Rembrandt's etchings of 1836 on it. Large parts of it went to the 5th Duke of Buccleuch, who sold them at auction in 1877.[118]

Despite some losses, such as the London-based print-maker and dealer Christiaan Josi's sale of rare Rembrandt impressions to the Rijksmuseum in Amsterdam in 1827, British collections overall tended to grow until the latter part of the century, when many of them came onto the market and considerable numbers of paintings, drawings and prints by Rembrandt left the country.[119]

Two major shifts dominate the reception of Rembrandt's art in the nineteenth century: his changing reputation and an exponential rise in access to his art through public collections and reproductive images. Rembrandt's reputation, simplified, was transformed by liberation from academic rules, which ultimately allowed his elevation to a universally celebrated genius.[120]

From de Piles to Reynolds, Rembrandt's achievements, chiefly in colouring, chiaroscuro and expression, had been contrasted with his shortcomings in design, vulgar subject

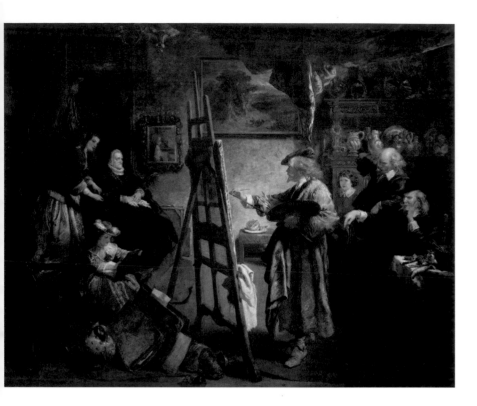

the *real'* – a perception that would dominate the Romantic view.[122] Rembrandt finally had 'burglariously entered the Temple of Fame by the window', as Opie observed, tongue-in-cheek – an elevated place Rembrandt enjoys to the present day.[123]

This legitimised an increased interest in Rembrandt's personality – although anecdotes from his life had been known from de Piles, Gersaint and others – and fuelled the urge to discover the person through his art and interpret the artworks as products of Rembrandt's life (rather than the complex social, historical and cultural context that he was part of). The Romantic image of Rembrandt, as well as his art, thus began to emerge. In his novel *The Antiquary* (1816), Sir Walter Scott (1771–1832) invoked a figure in a dream by comparing it to 'the burgo-masters of Rembrandt' (which also indicates his assumption that such images would be familiar to his readers).[124]

Ultimately, Rembrandt himself became the subject in art and popular culture.[125] The Victorian era produced sumptuous paintings depicting imaginary scenes from the artist's life [fig.41] as well as occurrences such as artist Sir John Lavery (1856–1941) dressing up as Rembrandt on the occasion of the Grand Costume Ball organised by the Glasgow Art Club in 1889 [fig.42].[126]

At the same time, access to Rembrandt's artworks beyond the circles of collectors and connoisseurs was constantly widened through the foundation of museums and galleries, and through exhibitions.[127] In 1799, the British Museum received the bequest of the Revd Clayton Mordaunt Cracherode, which included some 500 etchings by Rembrandt, about half the present holdings.[128] Public access and patchy cataloguing were sometimes exploited. Robert Dighton infamously stole a number of rare Rembrandt etchings from the British Museum and sold them with fabricated provenances [fig.43 & cats 48, 59 & 99]; his theft was unravelled in 1806.[129]

The founding bequest of the Dulwich Picture Gallery (1811) included three paintings by Rembrandt; the National Gallery opened in 1824 with two, but acquired another thirteen before 1900. The British Institution started its popular annual loan exhibitions in 1815, and no fewer than nineteen paintings under Rembrandt's name were shown, four of which are included in the present show [figs 32, 33, 91 & 107]. The history painter Benjamin Robert

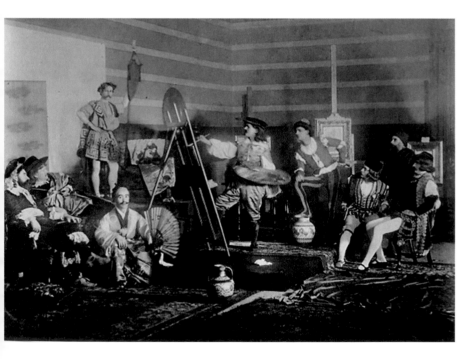

matter and his adherence to nature as opposed to the ideals of ancient and Italian art. Although criticism of, for example, Rembrandt's nudes did not disappear altogether, it became part of the wider notion of a 'gigantic but barbarous genius', as Henry Fuseli (1741–1825) described him in a London lecture in 1802.[121] By 1821, the painter and art critic William Hazlitt (1778–1830) claimed that 'if ever there was a man of genius, he was one' because 'Rembrandt's conquests were not over the *ideal*, but

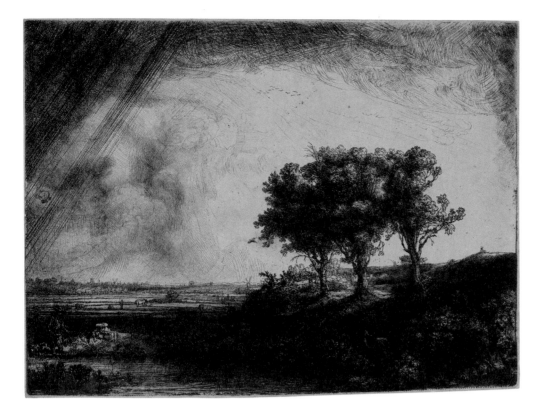

43 Rembrandt, *The Three Trees*, 1643
Etching, drypoint and engraving, 21.3 × 27.9 cm
British Museum, London [cat.46]

Haydon (1786–1846) visited the 1815 exhibition and was overwhelmed: 'How did I enter into Rembrandt, how drink in his excellence, how profit by his beauties!'[130] The artist and philosopher Henry James Richter (1772–1857) was inspired to imagine a most curious conversation between Rembrandt, Rubens, van Dyck and other artists present in the exhibition, combined with philosophical musings:

> I reflected on the lasting fame of the Old Masters whose works hung around me, and imagined how gratifying it must be to the Spirits of these Great Men, to be permitted to witness the admiration still bestowed on them. […] Immediately a voice near me exclaimed, in a hollow tone, 'Mighty gratifying truly!' […] It was Rembrandt himself, surrounded by a group of other figures, whom I immediately perceived to be the principal Painters of this Collection.[131]

Rembrandt's works were a constant presence in these exhibitions; he was represented exceptionally strongly among the *Art Treasures* in Manchester in 1857, and this trend culminated in the monumental Rembrandt exhibition of 1899.[132]

Guidebooks to and surveys of the notable houses of Britain published in the first half of the century charted the collections across the country.[133] The dealer John Smith compiled the first catalogue raisonné of Rembrandt's paintings (1836); it remained the standard reference book into the early twentieth century.[134] In response to Rembrandt's 'Romanticised' image, the English translation of Pieter Scheltema's ground-breaking

biography was published in 1867, the first to be based on extensive archival research.[135]

Prints had been the prime medium for disseminating Rembrandt's imagery since the mid-eighteenth century, but the introduction of cheap reproduction techniques allowed for an unprecedented popularisation.[136] The invention of photographic processes allowed for ever more reliable reproductions which were increasingly used to illustrate books [cat.69].[137] Wilhelm von Bode's monumental catalogue of Rembrandt's paintings, published in eight volumes between 1897 and 1906, was the first to illustrate all works in heliogravure.[138]

What did all this mean to artists in the nineteenth century? Traditionally, British portraitists had been taking inspiration from Rembrandt's art. This, of course, did continue, from Thomas Barker (1769–1847) to Thomas Duncan (1807–1845) and William Strang (1859–1921; cat.127).[139] Perhaps starting with Joseph Mallord William Turner (1775–1851) [fig.44], landscape painters – by way of turning to nature rather than to Claude, to overly simplify – discovered Rembrandt.[140] *The Mill* epitomises this more than any other landscape painting, inspiring artists throughout the century, including Turner, John Crome (1768–1821) and John Constable (1776–1837) [fig.90].[141]

Etchers had imitated Rembrandt's prints from their early days, but Edward Thomas Daniell (1804–1842; fig.45) and David Charles Read (1790–1851) demonstrated an understanding of his use of drypoint and motifs rarely found before the etching revival.[142] Andrew Geddes (1783–1844) absorbed Rembrandt's art (which he collected) across all

44 Joseph Mallord William Turner, *Limekiln at Coalbrookdale*, c.1797
Oil on panel, 28.9 × 40.3 cm
Yale Center for British Art, Paul Mellon Collection, New Haven

45 Edward T. Daniell, *Craigmillar Castle* (the small plate), 1831
Etching, 9.1 × 15.3 cm
The Hunterian, University of Glasgow, Glasgow [cat.79A]

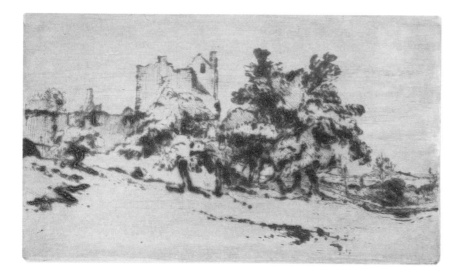

media [fig.46 & cat.86].[143] He was also present when four impressions were printed from an original Rembrandt etching copperplate in 1826 [cat.44].

Rembrandt's copperplates, of which a considerable number have survived, had been reprinted ever since the artist's lifetime, producing a flood of posthumous 'originals'. The steadily declining quality, due to wear of the plates, and the rise of photographic reproductions ultimately deprived the plates of their commercial value. They were rediscovered as collectors' items in the early 1900s [cat.47].[144]

Beyond portraiture and landscape, Rembrandt also became the model for history painters such as Sir David Wilkie (1785–1841), whose *Burying of the Scottish Regalia* [fig.50] was inspired by *The Entombment*, c.1633–34, that William Hunter had bequeathed to the University of Glasgow in 1783.[145] A study by Robert Scott Lauder (1803–1869) for *Christ Teacheth Humility*, c.1847 [cat.101] was inspired by *The Hundred Guilder Print* [fig.28].[146]

Rembrandt had become an all-embracing artistic model, sanctioned by publications such as *Practical Hints on Light and Shade in Painting* (1826), by John Burnet, a printmaker who worked for Wilkie.

Rembrandt impressed even artists whose oeuvre shows hardly any impact of his art. The young William Holman Hunt (1827–1910), one of the founders of the Pre-Raphaelite Brotherhood, had been paid to copy Rembrandt's *Christ and the Woman Taken in Adultery*, 1644 (The National Gallery, London) in 1845.[147] Half a century later, he declared: '[Rembrandt is] the greatest of Dutch painters. No man that ever held a brush more ably drew the face before him or better represented honest humanity.'[148] Rembrandt also became the model for applied arts, such as stained glass, porcelain plaques and ivory carvings [figs 47 & 48]. Early portrait photography was often compared to Rembrandt's works. David Octavius Hill (1802–1870) and Robert Adamson (1821–1848) created personality and atmosphere through tonality and chiaroscuro, and

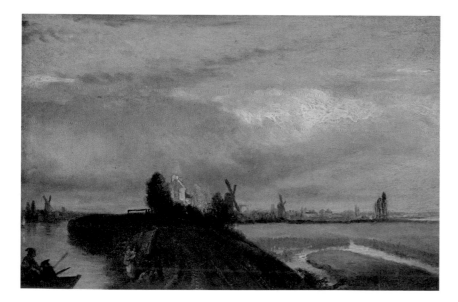

46 Andrew Geddes,
Landscape in the Manner of Rembrandt, c.1839
Oil on paper, laid on panel, 20 × 29.6 cm
National Galleries of Scotland, Edinburgh [cat.87]

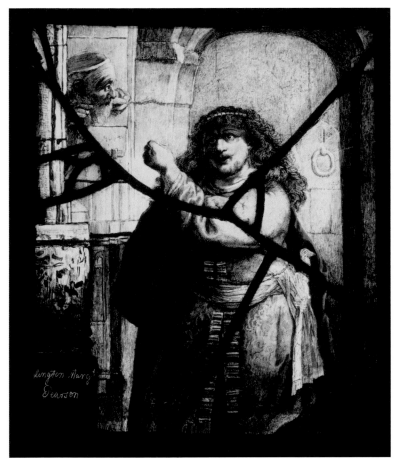

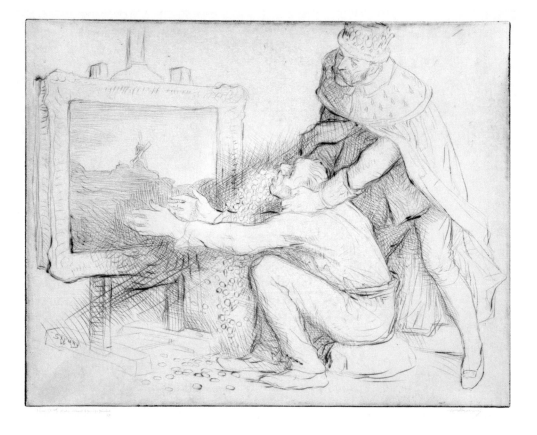

47 Eglington Margaret Pearson, after Rembrandt,
Samson Upbraiding his Father-in-law, c.1800

Stained glass, 22 × 18.5 cm
Victoria and Albert Museum, London [cat.112]

48 Richard Cockle Lucas, after Rembrandt,
The Descent from the Cross, c.1840–65

Ivory, 13.3 × 9.7 cm
Victoria and Albert Museum, London [cat.102]

49 William Strang, *Rembrandt's Mill*, 1911

Drypoint, 30.3 × 37.8 cm
National Galleries of Scotland, Edinburgh [cat.128]

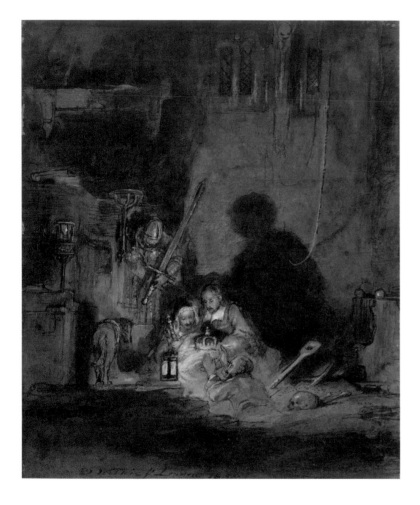

Hill described the portrait of Spencer Compton [fig.51] as 'a singularly Rembrandtish & very fine study'.[149]

The dominating phenomenon of the second half of the century – and in fact of the first decades of the 1900s – was the etching revival.[150] One of the protagonists of its second generation, Sir David Young Cameron (1865–1945), collected Rembrandt etchings, some of them superb impressions included in this exhibition. He strongly opposed the sale of *The Mill* to the United States and advocated a last-minute public appeal, himself offering to contribute £200 to its acquisition.[151] His efforts were in vain, and fellow printmaker William Strang published a satire on the attempt to save the picture for the nation with public funding: the 5th Marquess of Lansdowne, the owner,

extracting money from a poor taxpayer longing for *The Mill* [fig.49]. Finally, as a bittersweet farewell, Charles Brooke Bird (1856–1916) produced a colour mezzotint of the painting, which in a clever commercial move was published simultaneously in London and New York [cat.67].

Growing from modest beginnings to craziness for his works and subsequent re-evaluation – and despite the loss of many important works by Rembrandt from this country – the remarkable story of Rembrandt's art and its reception in Britain continued in the twentieth century and, in fact, does so to the present day, as highlighted in the following essay.

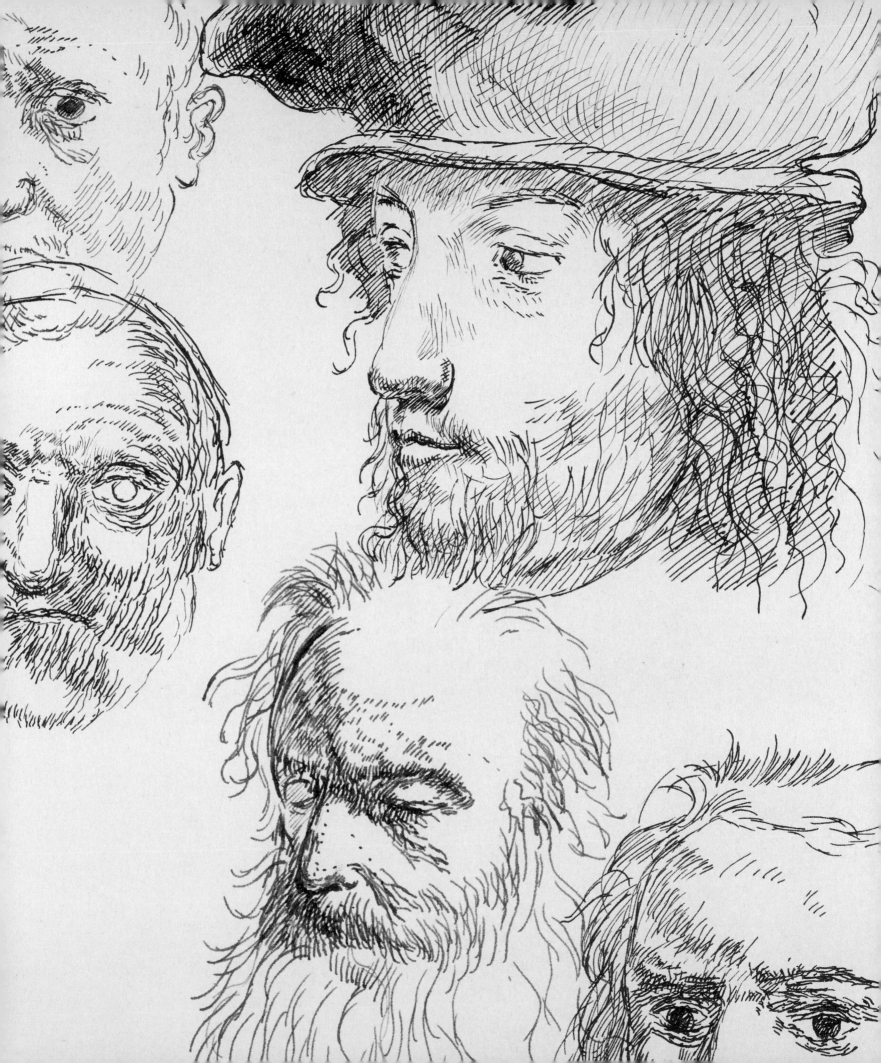

2

REMBRANDT AND BRITAIN: THE MODERN ERA
PATRICK ELLIOTT

There are various ways of paying homage to the art of the past. Paintings can be copied and the precise source imagery and process of transformation laid bare for all to see. At the other end of the spectrum, an artist can digest another artist's style and reimagine and represent it in new ways, so that the original source is hidden. Rembrandt has provided food for virtually every Western artist of note in the modern era, particularly in Britain, where his work is so well represented in public institutions, and where his standing has always been high. He has been copied by some and reconfigured by others. There are periods when he was a vital source of inspiration, in the late 1890s and early 1900s, and then again in the 1960s, and periods where his pathos, attachment to the human figure and expressive brushwork have seemed less relevant. But the ageing process and the business of self-examination face us all, and, since Rembrandt is the master of both, there is probably no other artist of the past who has affected modern artists so deeply. His style is so individual, so resonant of upmarket museum art, that homages can easily turn into callow pastiche. Artists have therefore been attracted to him and repelled in equal measure over the past 120 years.

The events which did most to galvanise interest in Rembrandt in the modern era occurred late in 1898, when the Stedelijk Museum in Amsterdam, and then in 1899 the Royal Academy in London, mounted the biggest ever exhibitions of Rembrandt's work. Arguably the first 'blockbuster' old-master exhibitions, they were, oddly, organised separately.[1] The Amsterdam show (8 September–31 October 1898), which featured 124 paintings and over 350 drawings (the etchings were shown separately at the Rijksmuseum), was staged to coincide with the coronation of the young Queen Wilhelmina. Queen Victoria's agreement to lend two paintings prompted other British private lenders to follow suit; forty of the paintings in the Amsterdam show came from British collections, the highest proportion from any nation, illustrating the esteem in which Rembrandt was

held in Britain. The London show (2 January–11 March 1899) featured 102 paintings and over 100 drawings, filling four large rooms.

This was an unmissable and irresistible opportunity to see Rembrandt's work in depth, and some British artists could not wait for the London show to open. Augustus John (1878–1961) was particularly keen to see the show: his *Moses and the Brazen Serpent*, 1898 (University College London), which offers an odd conflation of Rembrandt and Fragonard, had won the Slade School of Fine Art's Summer Composition prize earlier that year. Together with his fellow students at the Slade, Ambrose McEvoy (1878–1927) and Benjamin Evans (dates unknown), he headed off to the Netherlands in the autumn. John later wrote:

When a centenary exhibition of Rembrandt was held at Amsterdam, at Evans's suggestion we all three decided to visit it. This was a great event. As I bathed myself in the light of the Dutchman's genius, the scales of aesthetic romanticism fell from my eyes, disclosing a new and far more wonderful world.[2]

What was it he was after? Partly it would have been Rembrandt's stylistic idiosyncrasies – his way of dealing with light and shade, the heavy chiaroscuro and the painterly brushwork – but a key appeal for John seems to have been the intense, interrogatory quality of the self-portraiture. Rembrandt's influence in John's work is most keenly felt in his smaller etchings and drawings, for example *Tête Farouche* [fig.53], which is one of about ten self-portrait etchings by John.

Gwen Raverat (1885–1957) also saw the exhibition at the Stedelijk Museum, and it left an indelible mark upon her:

I was just thirteen when I was first taken abroad; we passed through Amsterdam, where a big Rembrandt exhibition was being held. I went absolutely mad, and set out to copy as many of the paintings as I could, in pencil, in a grubby little sketchbook. After that, someone gave me a little book of reproductions of

53 Augustus John, *Tête Farouche (Portrait of the Artist)*, c.1901
Etching, 21.3 × 17.1 cm
National Galleries of Scotland, Edinburgh [cat.98]

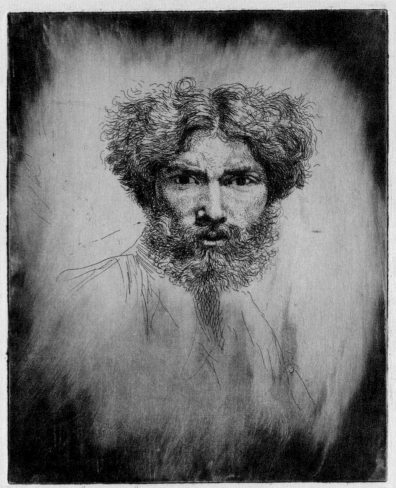

Rembrandt's drawings and etchings, and I carried it about in my pocket and slept with it by my bed for several years.[3]

Wood engraving – Raverat's chosen field – did not accommodate itself easily to Rembrandt's golden, painterly effects, and it was above all the Dutch master's subject matter that appealed to her: 'If I had been asked then what I wanted to do in later life, I should have answered: "to make pictures of people doing things" ie. working […] Rembrandt remained my God'.[4]

Some of the largest pictures shown in Amsterdam – such as *The Night Watch*, 1642 (Rijksmuseum, Amsterdam) and *The Anatomy Lesson of Dr Nicolaes Tulp*, 1632 (Mauritshuis, The Hague) – were too precious and fragile to travel to the Royal Academy, but the selection shown in London included many new loans from private collections.[5] Reviewing the Royal Academy show, *The Studio* reported that: 'Rarely have art lovers in this country had so valuable an opportunity of studying a comprehensive series of entirely representative works by a master who has scarcely an equal in the history of art'.[6] Curiously, though, in terms of visitor numbers, the Rembrandt exhibition was only a little more popular than the Royal Academy's Frederic, Lord Leighton (1830–1896) show of 1897, and it had fewer visitors than the Sir John Everett Millais (1829–1896) exhibition of 1898.[7] Equally, while the organisers of the Amsterdam show were delighted with their 50,000 visitors, the figures look modest by today's standards.[8]

Overlapping with the Royal Academy show, in March 1899 the British Museum staged an exhibition of some 300 prints and drawings by Rembrandt and his circle, accompanied by a catalogue written by Sidney Colvin.[9] Coinciding with this explosion of interest in Rembrandt, a number of books on the master appeared in English. Hermann Knackfuss's monograph on Rembrandt, originally published in German in 1895, appeared in an English translation in 1899. There was also Irene Weir's monograph in the Great Artists series (1899), *Rembrandt van Rijn and His Work* by Malcolm Bell (1899), Edgcumbe Staley's *The Charm of Rembrandt* (1900), Auguste Bréal's *Rembrandt: A Critical Essay* (1902), and plenty more. To complete this 'Rembrandt Fest', in 1899 the National Gallery in London purchased Rembrandt's celebrated pair of portraits of Jacob Trip and his wife, Margaretha de Geer, both of about 1661.[10]

John was not the only Slade School artist to fall under Rembrandt's spell. William Orpen (1878–1931), a friend and fellow student of John, saw the Royal Academy exhibition. His biographer Bruce Arnold reports that 'For William Orpen […] the experience was climactic […]. It was the Dutch master who instilled in him that sense of life, of people, of human drama and human feeling.'[11] Orpen's masterpiece in the Rembrandt mould is *The English Nude* [fig.54] – essentially a homage to Rembrandt's *Bathsheba at her Bath*, 1654, which he had seen in the Musée du Louvre in Paris in 1898.[12] It is a portrait of Emily Scobel, a model who worked at the Slade and was at one point engaged to Orpen.

Orpen produced several paintings which are clearly indebted to Rembrandt, the largest and most dramatic of which is *The Play Scene from Hamlet*, 1899 (private collection). But the aspect of Rembrandt's work that really struck him, and remained with him throughout his career, was self-portraiture. Starting with slightly awkward, self-interrogatory drawings around 1899 [cat.110], he then embarked upon a long line of bold, assured self-portraits – often, depicting himself, as Rembrandt had done, in character and

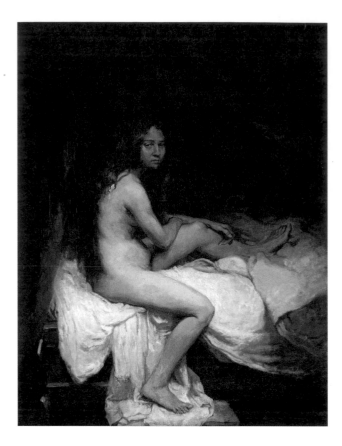

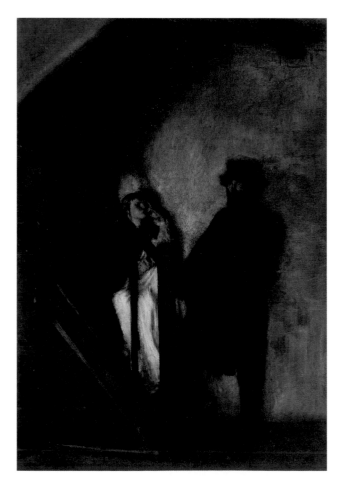

54 William Orpen, *The English Nude*, 1900
Oil on panel, 92 × 72 cm
Mildura Arts Centre, Mildura

55 William Rothenstein, *The Doll's House*, 1899–1900
Oil on canvas, 88.9 × 61 cm
Tate

in costume, sometimes holding paints and palette.

Others who were roughly the same age as John and Orpen, and moved in the same circles, and whose work touched upon Rembrandt around the same time at the turn of the century, include Sir William Nicholson (1872–1949), Sir William Rothenstein (1872–1945; fig.55), Charles Conder (1868–1909), James Pryde (1866–1941), Charles Shannon (1863–1937), Sir George Clausen (1852–1944), Charles Ricketts (1866–1931) and William Strang (1859–1921). None of them copied or slavishly imitated Rembrandt, but one notes, in their works done around 1900, certain Rembrandt-esque tropes and mannerisms – vast, dark interiors which dwarf the figures; penetrating, stagey stares; moody candle lighting; yellow, red and brown glazes; and painterly brushwork.

What is striking is that this interest in Rembrandt was brief: it is characteristic of British painting of the late 1890s and early 1900s, and then fizzles out. There was no painter in Britain who closely followed Rembrandt for a sustained length of time into the twentieth century. The nearest example is perhaps Mortimer Menpes (1855–1938), an Australian-born artist, who spent most of his career in Britain. He made copies after Rembrandt, and also wrote a popular book on him, but the main body of his work has more to do with Whistler. This dearth of committed followers is perhaps due to two factors. In the first place, Rembrandt's work was so famous and his style so individual (albeit often confused with work by his studio and followers) that later imitators were on a hiding to nothing. Secondly, the 1910s and interwar period saw the rise of other, rival styles and factions. Edwardian portrait artists such as Sir John Lavery (1856–1941), John Singer Sargent (1856–1925) and Philip de László (1869–1937) were more interested in the fiery, flashy brushwork of Frans Hals (c.1580/85–1666) and Édouard Manet (1832–1883); progressive artists of the middle ground like Philip Wilson Steer (1860–1942) and Wilfrid de Glehn (1870–1951) were devoted to the light tones of Impressionism; and graphic realism was on the rise among artists such as Gerald Leslie Brockhurst (1890–1978), Meredith Frampton (1894–1984) and Sir Stanley Spencer (1891–1959). The avant-garde – from the Vorticists through to the Surrealists – viewed Rembrandt as an historically important forebear, but not as an artist who was directly relevant to them.

(1883–1959), Sir David Young Cameron (1865–1945), Sir Muirhead Bone (1876–1953), William Strang and Frederick Griggs (1876–1938), to name but a few.[17] Nevinson examined Rembrandt's etchings closely in the British Museum, and wrote to Malcolm Salaman, a print historian, to tell him how much he had benefited from this close study.[18] The moody landscapes of the 'etching revival' artists, done with drypoint and plate tone, as well as surface tone, were much in fashion among specialist print collectors and fetched huge prices in Europe and America. An impression of Cameron's *Ben Ledi* [fig.56] sold for £640 in 1929, making it more expensive than many original Rembrandts.[19] Such prices allowed the artists to collect Rembrandt's work: Cameron, McBey and Shannon all did so.[20] Photographers did, too: the Glasgow photographer James Craig Annan (1864–1946) collected Rembrandt etchings and left them to Glasgow Art Gallery (now the Kelvingrove Art Gallery and Museum). The passion among printmakers for emulating the old masters was such that they sought out old paper on which to print their etchings. McBey found, in an old Amsterdam bookshop, a bound volume of antique sheets of paper which, he subsequently learned, had belonged to Rembrandt and had been used by him as a kind of scrap book.[21] But the Wall Street Crash of 1929 and the global financial collapse which ensued brought about a parallel collapse in the print market and all but snuffed out the mania for Rembrandt-esque etchings.

Broadly, in the 1930s, Rembrandt was viewed as an historical figure whose work was admired, and whose lessons were judiciously appropriated – particularly in the genre of self-portraiture – but who was rarely copied or directly quoted. His admirers were many, but the borrowings are almost covert. Perhaps surprisingly, one of his greatest advocates during this period was a sculptor, Sir Jacob Epstein (1880–1959). For him, Rembrandt was 'the greatest of all artists. He had every quality – all the plastic qualities and all life as well.'[22] Epstein name-checks Rembrandt fourteen times in his autobiography – more times than any other artist, living or dead.[23] It was Rembrandt's 'soul', his humanism, his empathy for the poor that appealed:

Edward Wadsworth (1889–1949) pompously lectured Spencer on the superiority and advancement of his training and saw Rembrandt as an essential stepping stone, but really as a passage to other, higher things: 'I have had experience, you have not. I have passed through all the stages an artist can go through; Rembrandt and all the rest.'[13] In his Vorticist manifesto, Wyndham Lewis (1882–1957) was dismissive of many of the giants of the past, but his comment on Rembrandt was almost respectful, noting that 'The Rembrandt Vortex swamped the Netherlands with a flood of dreaming'.[14] When working on his *Harvest of Battle*, 1918–19 (Imperial War Museum, London), a vast First World War painting of the muddy battlefields, Christopher Richard Wynne Nevinson (1889–1946) said that he wanted to use oil paint (as opposed to tempera) and chiaroscuro 'in the manner of Rembrandt, Velázquez and Goya', because war was dramatic, not decorative.[15] Rembrandt's old-master style could give his painting a certain authority and grandeur *because* it was old-fashioned.

When Herbert Furst came to review the great Rembrandt exhibition held in Amsterdam in 1932, he remarked: 'Twenty or thirty years ago Rembrandt's name shone more brightly … Today, he is in the eyes of some, a "mere" Romantic, a scatterer of emotive fragments.'[16] That may have been true for British painting, but in terms of etching, Rembrandt was the gold standard throughout the early decades of the twentieth century, in the work of so-called 'etching revival' artists including James McBey

*His great heart seemed to warm towards the men and women
who sat for him, and he seemed to penetrate into their inner
selves and reveal their very souls […] A beggar in the hands of
Rembrandt is some ancient philosopher […] a manservant in
a borrowed cloak becomes a King.*[24]

Epstein's fingered modelling technique acts as a sort of
analogue to Rembrandt's vital brushwork. One of his
sitters even came out looking like the Dutch master:
when modelling Albert Einstein's bust [fig.57], Epstein
commented that 'His glance contained a mixture of
the humane, the humorous and the profound. This was
a combination which delighted me. He resembled the
ageing Rembrandt.'[25]

But, with a few exceptions like Epstein, Rembrandt
was too famous to follow. Instead, homages took the form
of cigarette cards (a set of forty was issued by Splendo

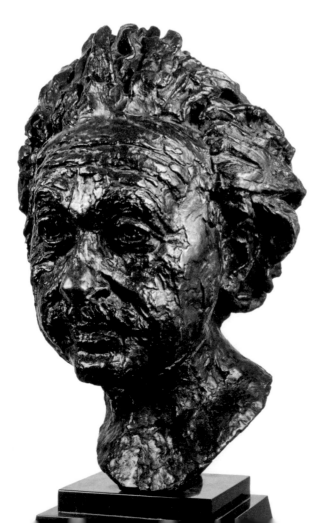

Cigarettes in 1914), films (Charles Laughton played him
in the eponymous 1936 film; the English Surrealist artist
John Armstrong (1893–1973) designed the costumes), and
his name was appropriated as a byword for quality, to sell
artists' products (*pace* the 'Rembrandt Intaglio Printing
Co.', established *c.*1895). The Rembrandt Head Gallery,
which specialised in prints, operated in central London at
5 Vigo Street, from about 1880 to 1930; a bronze bust of
the artist is still in situ, high above the entrance door.[26]
The Edinburgh gallery Doig, Wilson & Wheatley had
'Rembrandt Edinburgh' as its telegram address. Much later,
Rembrandt's name and face were used to sell things as
various as beer, toothpaste and kitchen appliances.

During the Second World War, the pictures at the
National Gallery in London were sent to safe storage
in Wales. But in 1941, when Rembrandt's *Portrait of
Margaretha de Geer, c.*1661 (a smaller version of the portrait
bought by the gallery in 1899) was acquired, a letter to
The Times prompted its display, alone, in an otherwise
picture-less National Gallery.[27] The experiment proved so
popular, so heartening to the people of London who had
been bereft of art, that a 'Picture of the Month' scheme was
initiated, whereby, throughout the War, a single painting
was shown at the Gallery for a month, on a rotating basis.
When Sir Eduardo Paolozzi (1924–2005) was studying
at the Ruskin School of Art in Oxford during the War,
he actually lived in the Ashmolean Museum for a while,
being stationed there as a night-time fire officer. It was
to Rembrandt that he turned for instruction and perhaps
solace. He made copies of facsimile reproductions of
Rembrandt's etchings in the Ashmolean library [fig.58].[28]
In her post-war paintings of run-down Glasgow interiors,
Joan Eardley (1921–1963) twice included reproductions
of Rembrandt's works in the backgrounds of her own:
*The Fireplace, c.*1955 (Perth Museum and Art Gallery),
features a postcard of Rembrandt's *A Woman Bathing in
a Stream* [fig.63]; and in *A Glasgow Lodging* [fig.59] three
reproductions of Rembrandt paintings are stuck up on the
wall. Rembrandt was the natural artist to turn to in times
of adversity.[29]

Through some ninety self-portrait paintings and
etchings, which span his whole career, Rembrandt is the
artist *par excellence* of ageing, decay and death. He is the
artist to whom artists look when considering their own

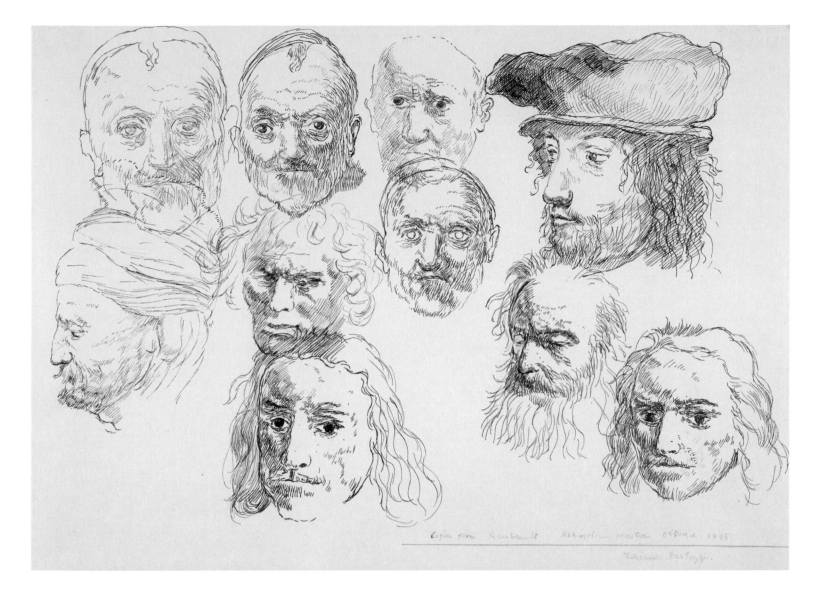

Copies from Rembrandt Ashmolean museum Oxford 1945

Eduardo Paolozzi.

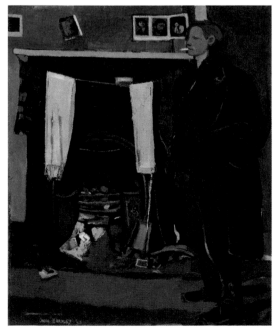

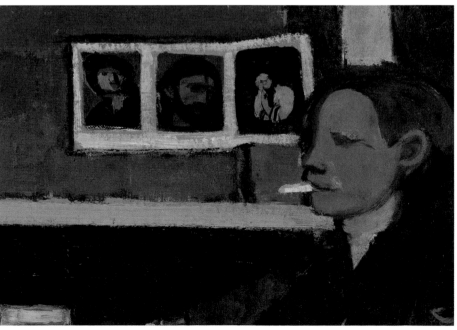

58 Eduardo Paolozzi, *Copies from Rembrandt*, 1945
Pen and black ink, 26.9 × 36.8 cm
National Galleries of Scotland, Edinburgh [cat.111]

59 Joan Eardley, *A Glasgow Lodging*, 1953, and detail
Oil on canvas, 112.9 × 92.8 cm
Glasgow Life (Glasgow Museums) on behalf of Glasgow City Council

60 Henryk Gotlib, *Rembrandt in Heaven*, c.1948–58
Oil on canvas, 133.3 × 163.2 cm
Tate [cat.89]

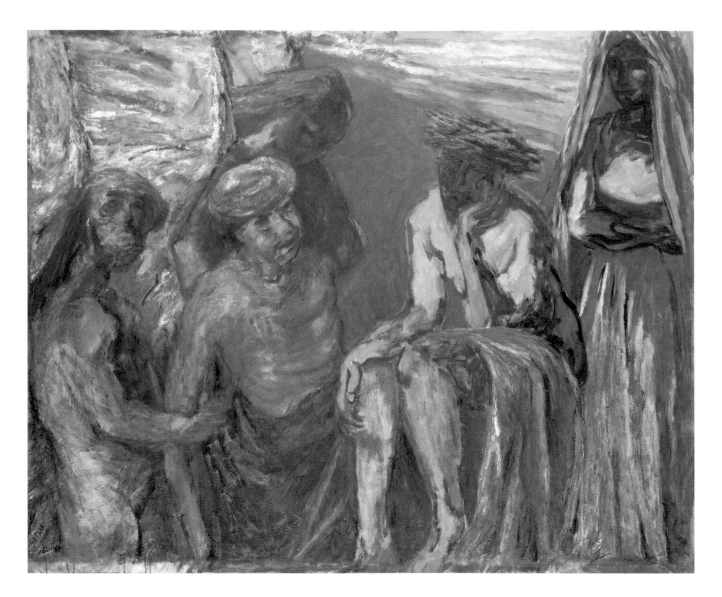

mortality. Henryk Gotlib (1890–1966) began his homage to Rembrandt, *Rembrandt in Heaven* [fig.60], in 1948, when he was seriously ill and approaching death (or so he thought: the diagnosis turned out to be wrong); he said that before dying he wanted to pay homage to Rembrandt.[30] David Bomberg's (1890–1957) last self-portrait (Pallant House Gallery, Chichester), painted just months before his death, shows him holding palette and brushes, probably in direct reference to Rembrandt's celebrated, late self-portrait at Kenwood House, London.[31]

In the 'Swinging Sixties', the era of supermarkets, motorways, multi-storey car parks and miniskirts, Rembrandt began to look old-fashioned – too earnest and heartfelt for the times. For the new breed of Abstract Expressionist and Pop Artist, he was a museum artist, of little relevance to their own work and lives. But abstraction and, later, conceptual art did not reign supreme. Among a hard-core group of figurative artists who emerged in the 1950s, the so-called 'School of London' group, Rembrandt was profoundly relevant. Francis Bacon (1909–1992)

61 Leon Kossoff, *From Rembrandt:*
A Woman Bathing in a Stream, 1982
Oil on board, 58.4 × 48.3 cm. Private collection [cat.100]

62 Frank Auerbach, *Drawing after Rembrandt's*
'A Woman Bathing in a Stream (Hendrickje Stoffels?)', 1988
Felt-tip pen on paper, 38.9 × 29.4 cm
The National Gallery, London [cat.62A]

opposite
63 Rembrandt, *A Woman Bathing in a Stream*
(Hendrickje Stoffels?), 1654
Oil on panel, 61.8 × 47 cm
The National Gallery, London [cat.12]

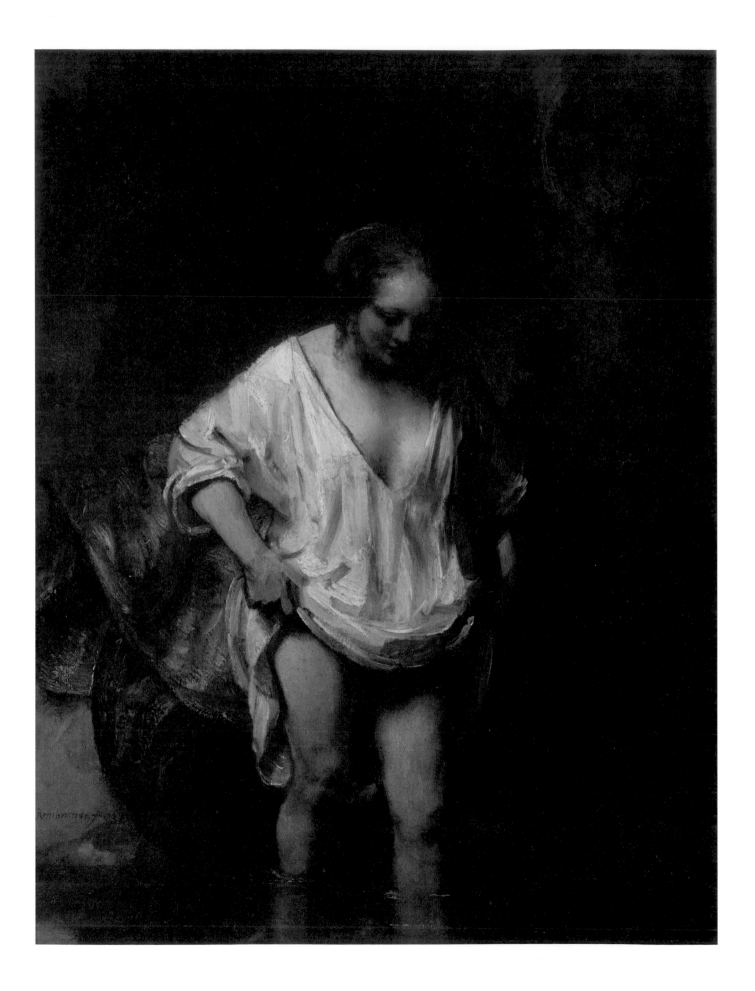

64 Frank Auerbach,
*Study after Deposition
by Rembrandt II*, 1961
Oil on board, 180.3 × 121.9 cm
Private collection

65 Rembrandt,
*The Lamentation over the
Dead Christ*, c.1635
Oil on paper and pieces of
canvas, mounted on panel,
31.9 × 26.7 cm
The National Gallery,
London [cat.3]

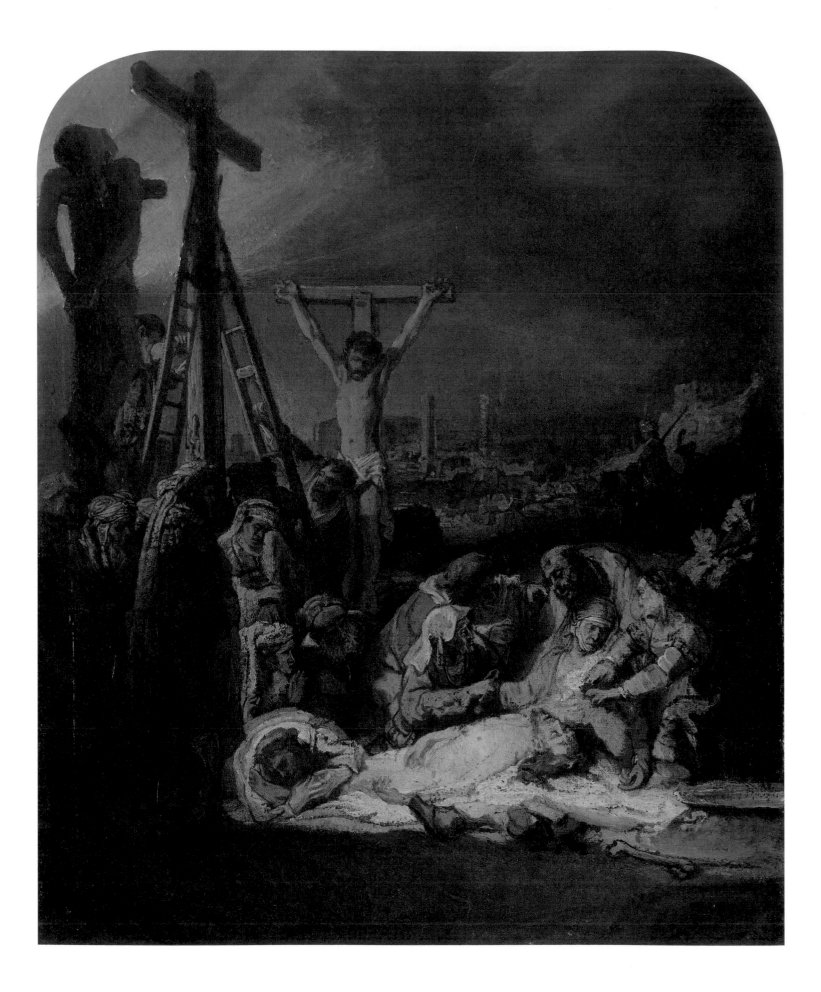

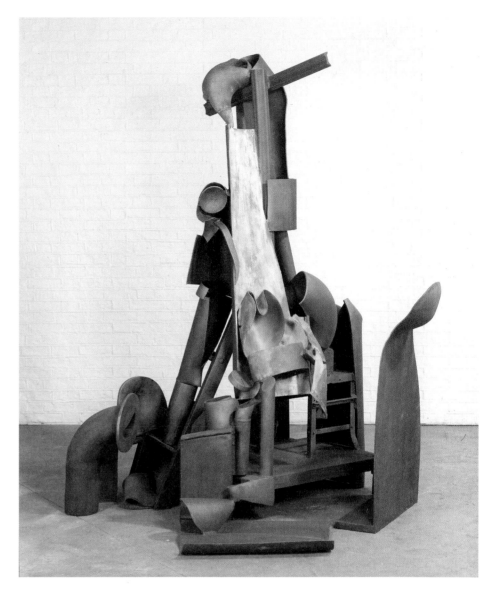

66 Anthony Caro, *Descent from the Cross II – After Rembrandt,* 1988–89
Steel, rusted and waxed, 228.5 × 183 × 175 cm
Annely Juda Fine Art, London

acknowledged that while much of his inspiration came from photographs:

> *I do nevertheless go a great deal to look at [the paintings] in the National Gallery, because I want to see the colour, for one thing. But if I'd got Rembrandts here all round the room I wouldn't go to the National Gallery. [...] There are very few paintings I would like to have but I would like to have Rembrandts.*[32]

Rembrandt's preoccupation with self-portraiture is mirrored in Bacon's work: both were obsessed with mortality and decay. What appealed to him about Rembrandt's technique was that the brush-marks seem abstract, but they coagulate almost magically into a representational image. Bacon, who had no interest in abstract art, sought to do something of this sort in his own paintings, to create works that had abstract qualities, yet were defiantly representational. One of the Rembrandt self-portraits he most admired, he commended for being 'almost completely anti-illustrational'.[33] He dismissed abstraction as decorative: 'Rembrandt [...] tried to make a head or portrait of somebody, whereas action painters are nearly always trying to make a decorative pattern'.[34] It was in particular Rembrandt's portraiture and self-portraiture that appealed to him, because there is no self-conscious composition or allegory, whereas he was indifferent to Rembrandt's bigger, more stagey compositions: 'The *Night Watch* [...] has never really meant anything at all to me'.[35] It has been said that Bacon's work was too emphatically pessimistic, that it spoke of meat and flesh rather than of the 'soul'; but Bacon's pessimism is really Rembrandt's humanism seen through a different lens.

For Lucian Freud (1922–2011), Rembrandt was one of the undisputed giants, and an artist he liked to measure himself up to. When he was painting the Duke of Devonshire, he had difficulty portraying the Duke's silk shirt, and rather than just accept the fact, he got the Duke to return to London to sit for him again: 'Rembrandt would have done it, and I'm damn well going to do it too,' Freud observed.[36] He never copied Rembrandt, but he certainly was inspired by him. Geordie Grieg, Freud's regular breakfast companion, noted that when talking of artists of the past, 'top of his list were Rembrandt and Velázquez'.[37] There was an exhibition uniting etchings by Freud and Rembrandt in Toronto's Art Gallery of Ontario in 2010 but, as has often been remarked, where Rembrandt concentrated on the essential humanity of man, Freud's world is one of ungodly existentialism.

Freud never copied Rembrandt, but Leon Kossoff (b.1926) and Frank Auerbach (b.1931), who have been close friends for more than sixty years, have done so, voraciously, over many decades. Over his long career, Kossoff has made many hundreds of drawings and prints after the old masters, and Rembrandt has long been a particular favourite. An etching of *Joseph Telling his Dreams*, inspired by but not accurately following Rembrandt's painting of the same title, was made in 1952–53; for many years, Auerbach had a copy of it pinned to his studio wall.[38] Kossoff has made drawings and etchings after several paintings by Rembrandt in the National Gallery collection, including *The Lamentation over the Dead Christ* [fig.65], the two portraits of Margaretha de Geer, and *Ecce Homo*, 1634.[39] He also made an oil-painting and an etching after *A Woman Bathing in a Stream* [figs 61 & 63]. Speaking broadly of his

interest in copying the old masters, Kossoff stated: 'My attitude to these works has always been to teach myself to draw from them, and, by repeated visits, to try to understand why certain pictures have a transforming effect on my mind.'[40]

Like Kossoff, Auerbach has spent a lifetime scrutinising the art of the past. Both artists have been fanatical visitors to the National Gallery since the 1950s, diligently, obsessively and humbly learning the craft of painting from the old masters. Such dedication was once viewed as old-fashioned and quaint, but as their reputations grew, so they were given special out-of-hours access to the National Gallery in Trafalgar Square so that they could draw there in peace. Auerbach's favourites have included Hals, Titian (c.1485/90–1576), Caravaggio (1571–1610) and Georges

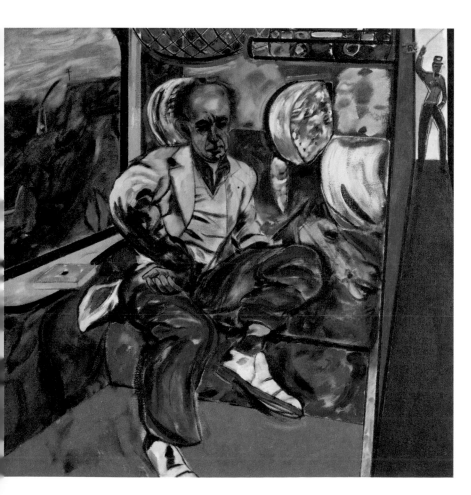

Seurat (1859–1891), but above all Rembrandt: 'Rembrandt at the National Gallery. I went every day, for a long time. I drew from paintings then drew them as if I'd drawn them myself.'[41] Works that he has copied, or made variants after, include *A Woman Bathing in a Stream* [fig.62], *Belshazzar's Feast* [fig.20] and the smaller *Portrait of Margaretha de Geer*, 1661.[42] He defined Rembrandt's greatness as 'the absolute grandeur of the absolute ordinary'.[43] Perhaps his most famous variant after Rembrandt is *The Lamentation over the Dead Christ*: the original is a little over 30 centimetres tall, while Auerbach's version, painted in 1961, measures some 180 centimetres tall [figs 65 & 64]. Auerbach felt that there was so much magic crammed into Rembrandt's original that he couldn't hope to make any sort of equivalent on the same small scale. Auerbach did in fact paint another version first, and then painted the 180-centimetre-tall one after that, so it is in effect a version after a version. In the process, the figures became lost and the scene took on the appearance of the London building sites which Auerbach was painting at the time. Asked about the old masters, Auerbach observed: 'When I was young I felt like I was in the ring with them. Now I just need their help. […] Unless you try and do something in the shadow of these great people then it's all pointless.'[44] The National Gallery in London exhibited Auerbach's works after the old masters in 1995, and in 2014 he was given the ultimate accolade, when a small group of his paintings was hung in the Rijksmuseum alongside Rembrandt: he was the first living artist to receive such an honour.[45]

Sculptors have also been indebted to Rembrandt's work, and Henry Moore (1898–1986) was a great admirer. Commenting on Rembrandt's *An Old Man in an Armchair*, 1652 (The National Gallery, London), which he also copied, twice, in charcoal, he noted with characteristic Yorkshire wisdom: 'The reality of form comes to the fore. One feels that one could touch that forehead, knock on it. It is like a loaf of bread.'[46] Sir Anthony Caro (1924–2013) made sculptures which respond directly to Rembrandt: *Conspiracy*, 1976–77, which takes Rembrandt's *Conspiracy of the Batavians under Claudius Civilis*, 1661–62 (Nationalmuseum Stockholm), as its point of departure, and two versions of *Descent from the Cross* [fig.66], created in 1988–89 after Rembrandt's 1632–33 painting of the same name (Alte Pinakothek, Munich).[47] He has made other sculptures

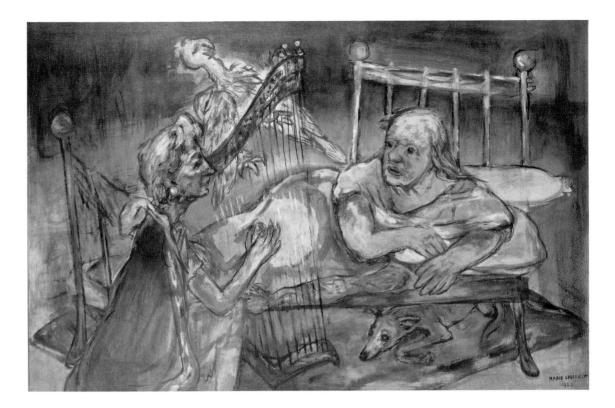

68 Marie-Louise von Motesiczky,
The Old Song, 1959

Oil on canvas, 101.7 × 152.6 cm
Collection Marie-Louise von Motesiczky Trust,
London

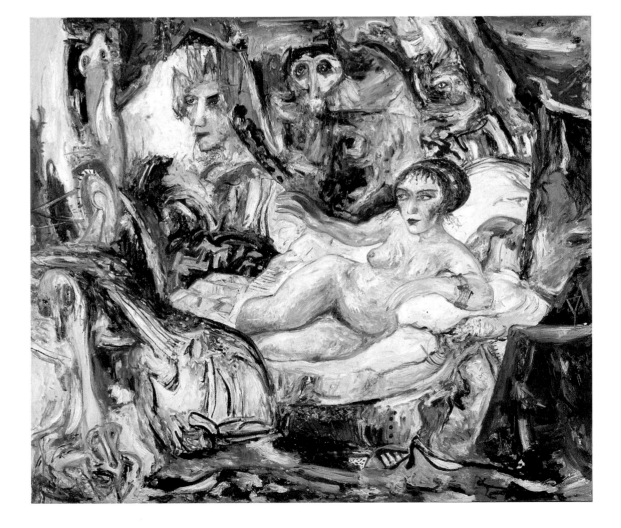

69 John Bellany, *Danae:
Homage to Rembrandt II*, 1991

Oil on canvas, 183 × 213.5 cm
The Bellany Estate [cat.65]

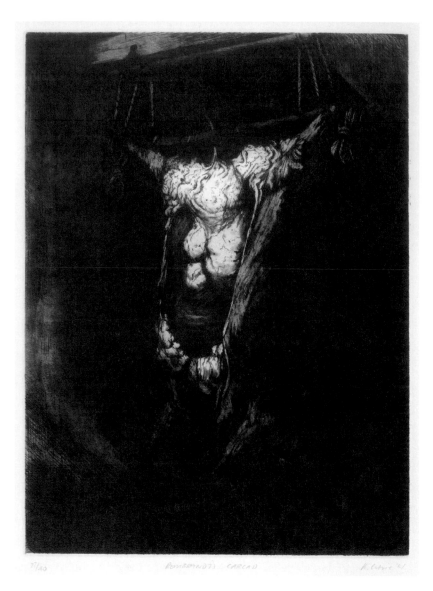

Auerbach, Gotlib and other Rembrandt aficionados, such as Josef Herman (1911–2000), came to Britain to escape the Nazis; the families of Kossoff and Kitaj had left Germany at an earlier date. They were all inheritors of that central European, Expressionist approach that was antithetical to most British artists; and they all had friends and family who were taken by the Nazis. Rembrandt appealed to them on many levels. Of Jewish heritage, Marie-Louise von Motesiczky (1906–1996) fled Austria for England in 1939. Her paintings, which often treat old age, have frequently been compared to Rembrandt. *The Old Song* [fig.68], von Motesiczky's largest painting, is loosely based on Rembrandt's *David Playing the Harp before Saul, c.*1630 (Städel Museum, Frankfurt).[51] The figure in bed is her ageing mother, who came to England with her, while a family friend plays the harp. There is, it has been argued, a specific reference to Jewish refugees here, too. From a wealthy, cultured Austrian family, the balding mother has been forced from her homeland and is reduced to listening to a friend play the harp, while she sits up in an old bed.[52]

Many others have borrowed from Rembrandt in recent years. John Bellany (1942–2013) did so in paintings of flayed fish, which echo the painting from Rembrandt's workshop, *Slaughtered Ox, c.*1640 (Kelvingrove Art Gallery and Museum, Glasgow), as well as in direct homages such as *Danae: Homage to Rembrandt II* [fig.69], and above all in self-portraits, which chart years of alcoholism, illness and recovery.[53] In an interview shortly before his death, Bellany pointed to one of his own self-portraits as the work which summed up the vicissitudes of his life: 'It's like one of Rembrandt's last paintings. It's about approaching the Almighty, because really you are in that netherworld between life and death when you are seventy.'[54] Similarly, while Ken Currie (b.1960) has borrowed Rembrandt's subject matter on occasion – for example in his 1991 etching after the aforementioned *Slaughtered Ox* in Glasgow [fig.70] – it is his self-portraits that offer the keenest homage to the Dutch master.

Jenny Saville (b.1970) is one of comparatively few British artists of her generation who has looked to the work of the old masters, especially Titian, Diego Velázquez (1599–1660), Sir Peter Paul Rubens (1577–1640) and Rembrandt, without a hint of irony. An important moment in her life came in her teenage years when her uncle, an artist, took

'after' paintings, and once commented: 'I like the mental jump needed to learn from pictures.'[48]

If Kossoff and Auerbach have treated Rembrandt as a sort of sparring partner, from whom much can be learned in terms of technique and construction, R.B. (Ronald Brooks) Kitaj (1932–2007) used Rembrandt's work more for its iconographic and allegorical value. His *Jewish Rider* [fig.67], a portrait of the art historian Michael Podro, is loosely based on Rembrandt's *The Polish Rider, c.*1655, in the Frick Collection in New York.[49] Kitaj stated: 'Unlike Rembrandt's masterpiece, there is no mystery about who posed for me or where he's going. My Rider, I believe, is on his way to visit the sites of the Death Camps in Poland, many years after the war.'[50]

It is intriguing that so many Jewish artists have been attracted to Rembrandt: partly it may be down to Rembrandt's interest in Old Testament subject matter and his portraits of Jewish sitters, but it is largely, surely, to do with his innate humanism in the face of adversity. Freud,

71 Glenn Brown, *Half-Life (after Rembrandt)*, 2017
Series of six etchings, each 89.4 × 68.2 cm
Courtesy the artist and Paragon | Contemporary Editions Ltd [cat.72]

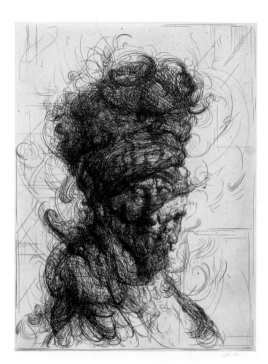
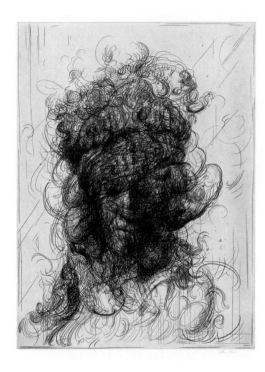
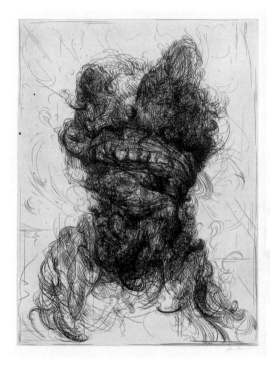
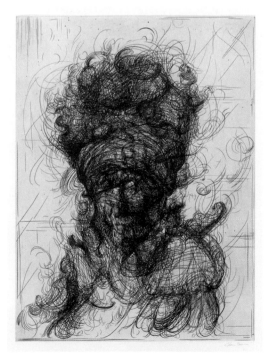
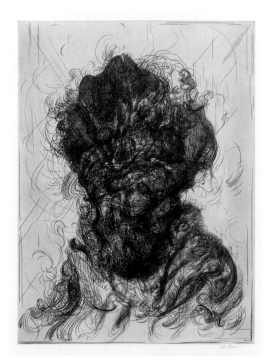
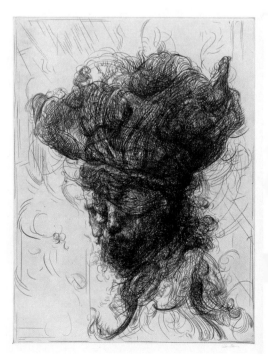

her to the Netherlands to study the work of Rembrandt. Other artists of her generation have viewed Rembrandt in a way that may seem cynical or disrespectful, but which turns out to be the opposite. Glenn Brown (b.1966) has made painted, drawn and etched variants after Rembrandt since 1996 [figs 71 & 73]. He began with *I Lost My Heart to a Starship Trooper* (Limousin, Fonds Régional d'Art Contemporain collection).[55] The title comes from a 1970s disco classic, but the painting is actually a copy after one formerly attributed to Rembrandt in the Wallace Collection in London.[56] Brown tackles the surface appearance of the works, highlighting the curious relationship that exists in paintings between style and subject. He replicates the swirling brushwork and coruscated paint with infinite care, yet the authorship of the works he is copying is often in doubt, as scholarly attributions send them yo-yoing in and out of the Rembrandt canon. Rembrandt is often called 'expressive', but if the identity of the artist is unclear, and if fakes abound, who is doing the expression and what is being expressed? The process of replication employed by Brown involves computer technology, and Rembrandt would surely have been interested

in it had he been alive today. It is a backhanded but deeply felt homage. As indeed is Banksy's *Rembrandt* [fig.72] – a copy after Rembrandt's *Self-Portrait at the Age of Sixty-Three*, 1669 (The National Gallery, London), but with 'googly eyes' attached.[57] It is partly a joke, of course, but it is also partly a jolt. Rembrandt's work is so ubiquitous in terms of reproduction, and so sanctified by talk of his profound humanity and his enormous prices, that it is good to have this all punctured now and again, so that we can look at the works afresh.

72 Banksy, *Rembrandt*, 2009
Googly eyes and acrylic on canvas, 102.3 × 77 × 9.3 cm
Private collection

73 Glenn Brown, *Unknown Pleasures*, 2016
Oil on panel, 164 × 105.5 cm
Courtesy the artist [cat.71]

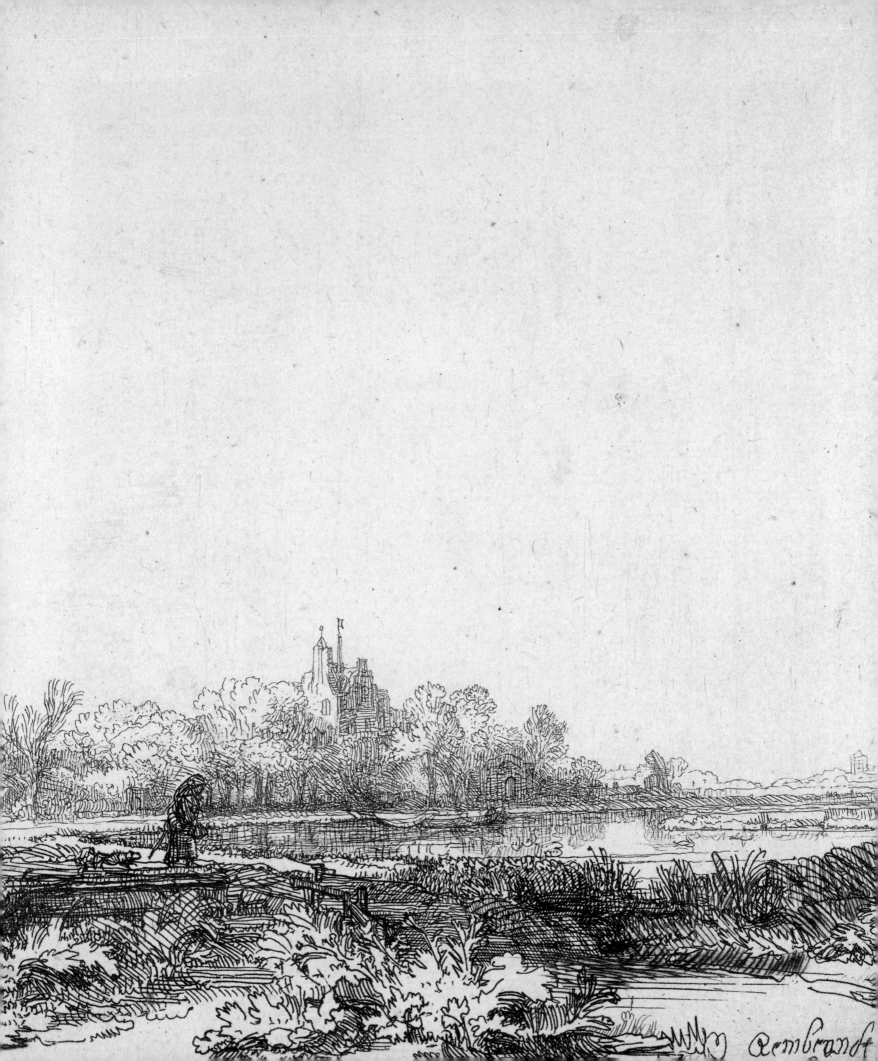

74 Rembrandt, *Landscape with a Cottage and a Hay Barn,* 1641
Detail of fig.77

3

'THE FINEST POSSIBLE STATE': CATALOGUING AND COLLECTING REMBRANDT'S PRINTS, c.1700–1840

STEPHANIE S. DICKEY

Rembrandt's etchings have always had an international reach: within the artist's lifetime, they were sought by collectors from Italy to Poland.[1] From 1751 to 2013, twenty systematic catalogues have attempted to parse the complexities of Rembrandt's graphic oeuvre, nearly all originating outside the Netherlands. In Britain, John Evelyn (1620–1706) was among the first to praise Rembrandt as an 'incomparable' etcher, and in the eighteenth and nineteenth centuries a network of connoisseurs competed to acquire and study the rarest impressions.[2] Key figures among them are the London civil servant John Barnard (1709–1784), the Liverpool brewer Daniel Daulby (1745/6–1798) and the London solicitor Thomas Wilson (1787–1863), the latter two as authors of catalogues raisonnés (published in 1796 and 1836). At a time when the pursuit of art history and theory was largely the province of artists, art dealers and an emerging class of museum curators, these British amateurs played a valuable role in an international process of research and taste formation.

In early modern Europe, the rise of printed images brought a new, accessible component to the expanding art market. Often collected for their informational value, prints occupied libraries as well as art cabinets.[3] Around 1700, Samuel Pepys (1633–1703) engaged assistants to arrange his prints by subject. In one album, preserved in the Pepys Library at Cambridge University, a first state of Rembrandt's magisterial drypoint, *The Three Crosses* [fig.11], is folded in among prints of diverse quality illustrating the Passion of Christ.[4] Yet Rembrandt has always belonged to a select canon of masters whose prints are valued as expressions of a powerful artistic personality. Richard, 7th Viscount Fitzwilliam (1745–1816), was one of the first enlightened connoisseurs to arrange his collection by

printmaker. Many of his 198 albums are still preserved in the Fitzwilliam Museum at Cambridge. His Rembrandt collection was one of the best of his time.[5]

The idea of documenting a printmaker's oeuvre began with Edme-François Gersaint (1694–1750), the Parisian dealer in art and curiosities known for his association with the painter Jean-Antoine Watteau (1684–1721).[6] Beginning in 1733, Gersaint published descriptive catalogues of art and naturalia designed to educate consumers, thus broadening his market. That he turned next to Rembrandt's etchings is not so surprising: like the seashells displayed in curiosity cabinets, prints existed in multiples ostensibly designed to be identical, yet individual specimens were seldom exactly the same.[7] This is especially true for Rembrandt: while most printmakers sought to exploit the repeatable nature of printed images by producing uniform editions, he pioneered creative practices such as publishing multiple states (in which a plate is revised and reprinted), combining techniques (etching, engraving, drypoint), selective inking for tonal effect, and printing on varied papers.[8] After Rembrandt's death, reprints of his copperplates flooded the market with impressions that grew weaker as plates wore out and were reworked by later hands.[9] Meanwhile, imitations and copies proliferated, especially in the period 1750–1850; some are remarkably deceptive [cat.70].[10]

All of this created a minefield for consumers seeking authenticity and value for their investments. This helps explain why the concept of a descriptive oeuvre catalogue originated with the study of prints, and why Rembrandt became its first case. Gersaint's catalogue, edited by his associates P.C.A. Helle and J.B. Glomy, was published in Paris in 1751.[11] A year later, an English edition appeared in London.[12] It was not until 1836 that John Smith added a

75 Benjamin Wilson, *Landscape with a Road and Two Houses in the Centre*, 1751

Etching and drypoint, second state, 6.1 × 17.3 cm
British Museum, London [cat.135]

76 Philips Koninck, formerly attributed to Rembrandt, *The Coach Landscape*, c.1650–60

Etching with black wash and touches of brown, 6.3 × 17.8 cm
British Museum, London [cat.99]

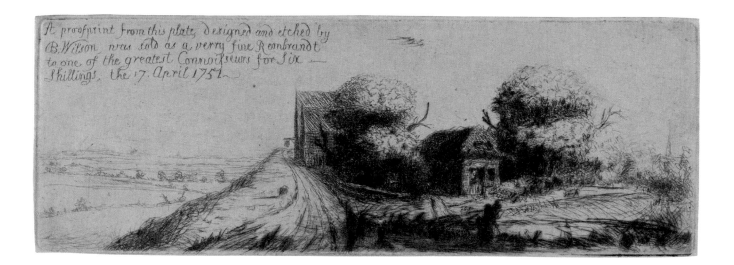

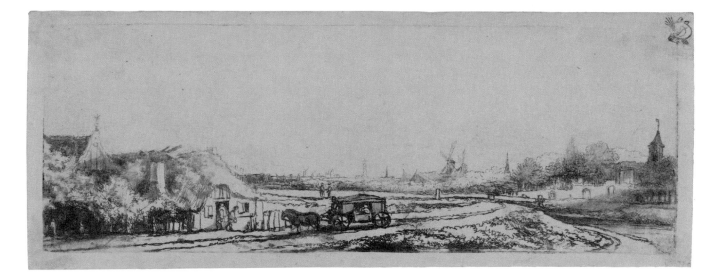

catalogue of Rembrandt's paintings to his encyclopaedic study of Dutch, Flemish and French masters.[13] The difficult task of distinguishing Rembrandt's drawings from those of his many followers only became feasible when advancements in photography facilitated close analysis; Cornelis Hofstede de Groot published the first catalogue of Rembrandt's drawings in 1906.[14] Meanwhile, the study of Rembrandt's prints continued on both sides of the Channel: Pierre Yver's supplement to Gersaint (Amsterdam, 1756) was followed by Daulby's catalogue (Liverpool, 1796, with English translation of Yver) and those of Adam von Bartsch (Vienna, 1797), Ignace-Joseph de Claussin (1824 and 1828), Wilson (1836) and Charles Blanc (1859–61). Later, between 1877 and 1879, Sir Francis Seymour Haden (1818–1910) and the Revd Charles Henry Middleton (1828–1915) hotly debated Rembrandt attributions in the context of the etching revival.[15] Modern scholars have built on these accounts, particularly Bartsch. The *New Hollstein* catalogue of 2013 offers the first fresh approach since 1751.[16]

77 Rembrandt, *Landscape with a Cottage and a Hay Barn*, 1641
Etching, 12.9 × 32.1 cm
National Galleries of Scotland, Edinburgh [cat.45]

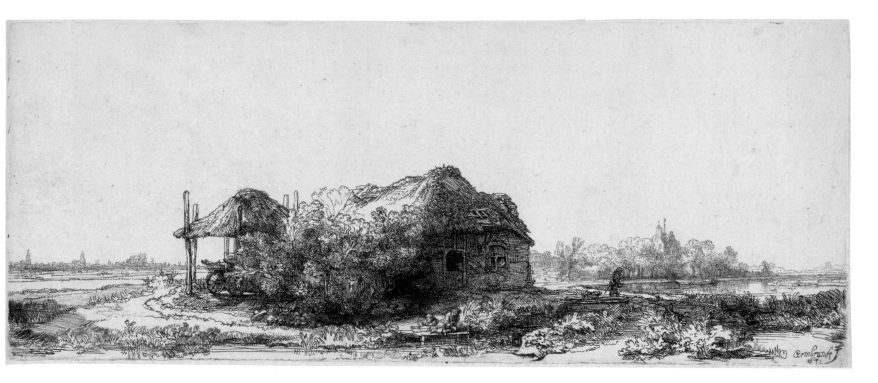

Amateurs were always on the lookout for novel acquisitions. A notorious hoax poking fun at their obsession was orchestrated by William Hogarth (1697–1764) and his friend Benjamin Wilson (1721–1788), who tricked the painters Thomas Hudson (1701–1779) and Arthur Pond (*c*.1701–1758) and several other self-professed experts into accepting etchings Wilson had just printed as newly discovered Rembrandts, then triumphantly exposed their gullibility [fig.75]. For Hogarth, this prank expressed frustration with an art market that privileged 'old masters' over the works of contemporary British artists like himself.[17] Ironically, Wilson modelled one of these prints on *The Coach Landscape* [fig.76], then considered the most valuable of Rembrandt's landscape etchings but now recognised as the work of Philips Koninck (1629–1688).[18] Today, neither seems a convincing emulation of Rembrandt's atmospheric style (as demonstrated by his *Landscape with a Cottage and a Hay Barn*; fig.77), but this incident took place just before the London publication of Gersaint's catalogue, when consensus on the scope of Rembrandt's oeuvre had yet to form.[19]

The prompt appearance of an English edition of Gersaint testifies that by 1752, London had become a centre of the market for Rembrandt's prints. This development was fostered by an international network of collectors. Gersaint had studied the collection of the Dutch printmaker Jacobus Houbraken (1698–1780), whose father, Arnold (1660–1719), a pupil of Rembrandt's pupil Samuel van Hoogstraten (1627–1678), wrote an influential biographical survey of Dutch art (the first to describe the lively market for Rembrandt's etchings).[20] Houbraken's collection came from the family of Rembrandt's patron Jan Six (1618–1700), the subject of the exquisite etched portrait of 1647 [fig.78].[21] Eighteenth-century connoisseurs considered it the pinnacle of Rembrandt's achievement as a portraitist, capturing with innumerable layers of cross-hatching the tonal effects that English printmakers were exploring through the newer medium of mezzotint. Among several imitations, the most memorable is the portrait etched by Thomas Worlidge (1700–1766) in 1762 casting the print collector Sir Edward Astley (1729–1802) in the role of Six [fig.79].[22]

Linking back to Rembrandt's milieu, the Houbraken

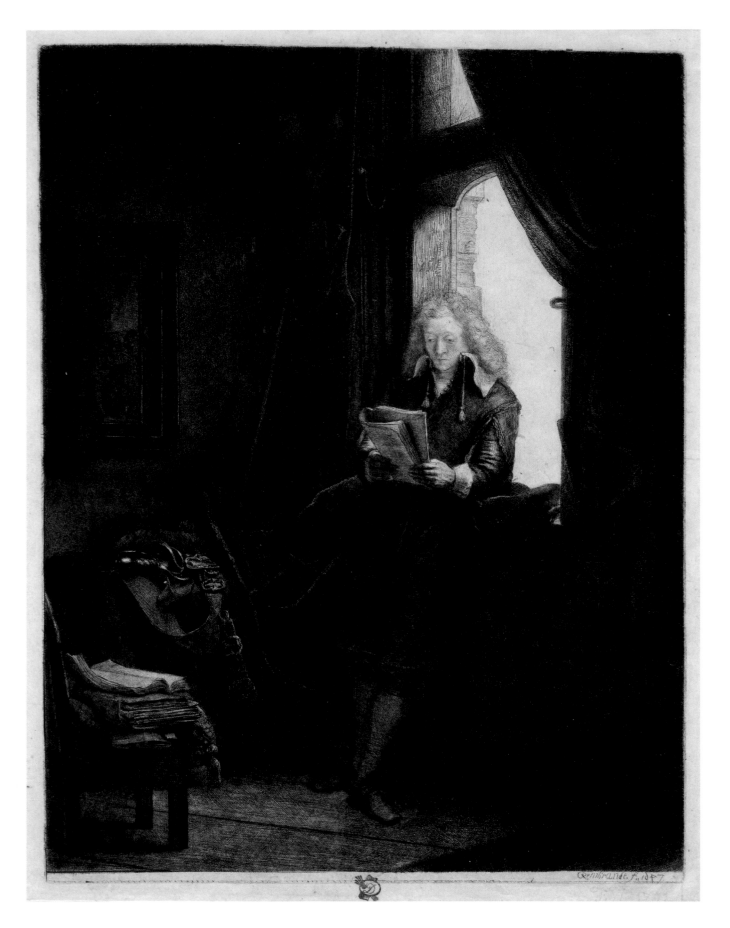

78 Rembrandt, *Portrait of Jan Six*, 1647

Etching, drypoint and engraving on Japanese paper, 24.6 × 19.1 cm
British Museum, London [cat.48]

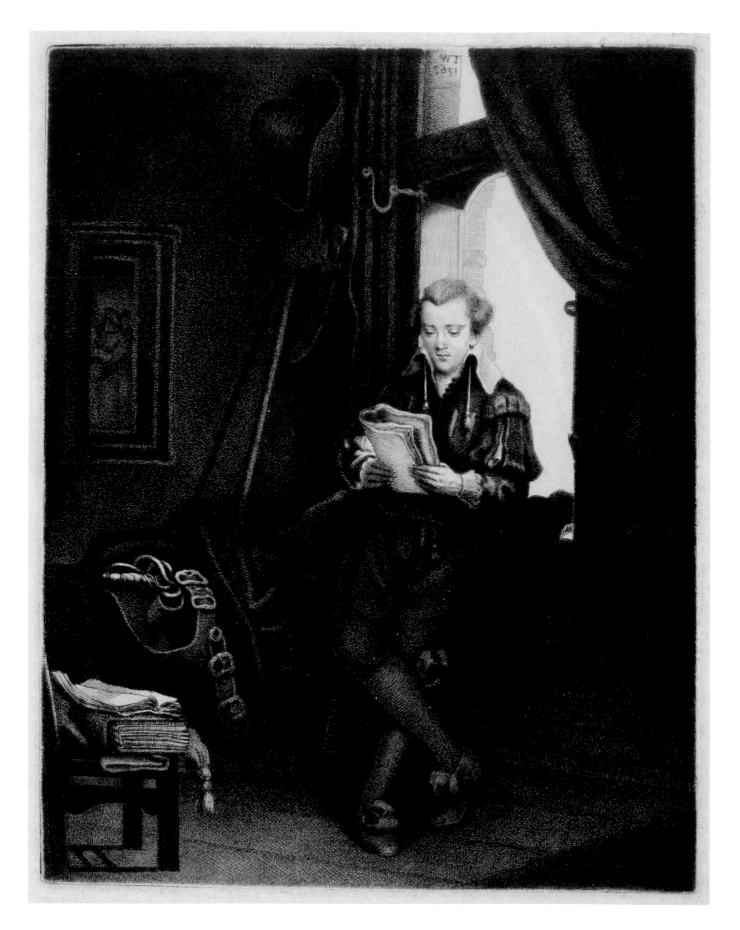

79 Thomas Worlidge, *Portrait of Edward Astley as Jan Six*, 1762

Etching and drypoint, 23.6 × 15.4 cm

Nicholas Stogdon [cat.140]

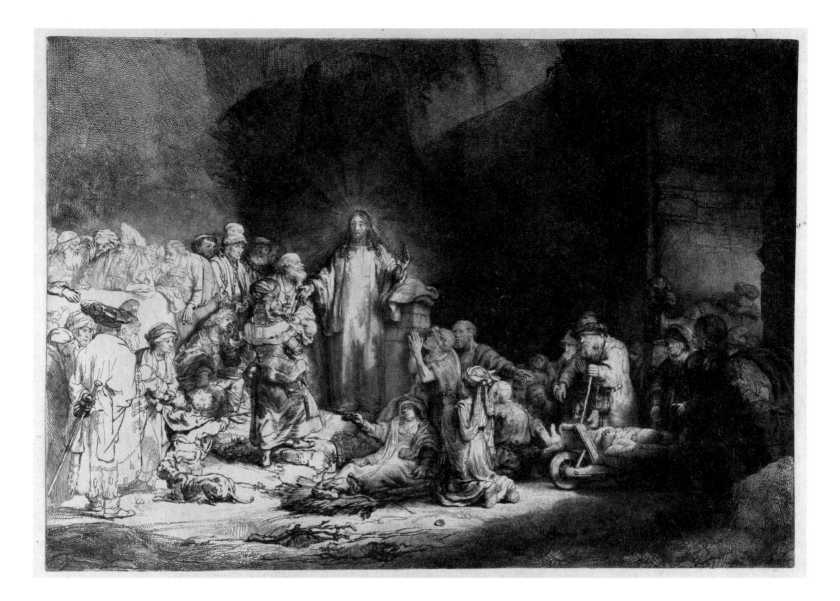

connection gave credibility to Gersaint's account. According to their English preface, Helle and Glomy added 'several Pieces … found in other Collections, especially in a very fine one which was lately compleated at a great Expence to be carried into England … This Collection was brought over by Mr. Major … and is now the Property of Mr. Pond.'[23] The engraver Thomas Major (1720–1799), grandfather of Thomas Wilson, was in Paris from 1745 to 1748 and maintained contacts there.[24] The portraitist, printmaker, merchant and art collector Arthur Pond actively promoted the taste for Rembrandt in Britain. He collaborated with Jacobus Houbraken on a series of print portraits of British worthies, and he sold his celebrated collection of Rembrandt prints to Astley, who had already disposed of it by the time Worlidge portrayed him in 1762.[25] Rembrandt's etchings appeared frequently at auction, but the finest impressions were acquired by wealthy amateurs such as Barnard, the Revd Clayton Mordaunt Cracherode (1730–1799) and John Sheepshanks (1787–1863), and artist-collectors such as Pond, Hudson and Sir Joshua Reynolds (1723–1792).[26] In 1829, the dealer Samuel Woodburn (1786–1853) acquired a substantial collection for Thomas Wilson, whose 1836 catalogue calls it 'remarkable as one of the very few formed by a contemporary of our great artist' (probably Jan Pietersz Zomer, 1641–1724).[27] Through this intergenerational network of art lovers, a surprising number of Rembrandt's unfinished proofs, early impressions on Japanese (then called 'India') paper, and other rarities made their way into England, often passing from one distinguished owner to another.[28]

In 1775, Captain William Baillie (1723–1810) advertised his acquisition and reworking of the plate that was 'generally esteemed … the *chef d'oeuvre* of Rembrandt, being highly finished, the characters full of expression, and the effect of the *chiaro-scuro* very fine' [fig.80 & cat.50].[29] Collectors knew that its nickname, *The Hundred Guilder Print*, referred to the high price it fetched even in Rembrandt's lifetime.[30] After publishing his own edition

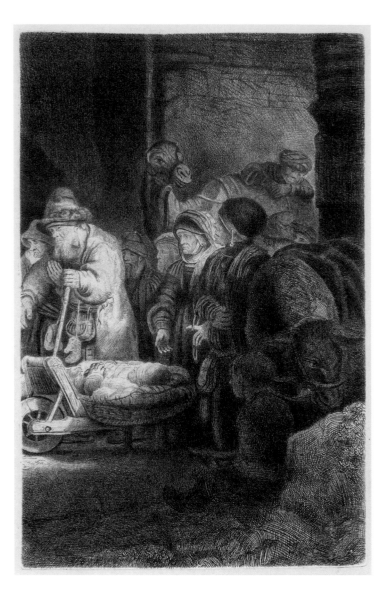

according to Daulby's 1796 catalogue raisonné, but significant corrections are noted. Although Barnard had died in 1784, many of these astute observations must have been his own.[35] Rembrandt's development of *Woman Sitting Half-dressed beside a Stove* had long intrigued collectors; Arnold Houbraken described the zealous search for impressions with and without the model's white cap and the stove key [figs 82 & 83].[36] While other differences have been observed, debates have revolved around these two motifs, which seem to come and go across subsequent states. Gersaint, Daulby, Bartsch and Wilson all had opinions, but Barnard was the first to recognise the sequence accepted today: the stove key appears only after several preliminary states in which the woman is already wearing the white cap; then, in the final state, Rembrandt removes the cap to reveal her prim coiffure.[37] Daulby too revised Gersaint's ordering and state descriptions, but Barnard had the unique opportunity to study no fewer than six impressions together in his own collection.[38]

Connoisseurs gained pleasure and knowledge by comparing their holdings and competing to acquire the best examples. While some may have hoped to profit from shrewd purchases, their enthusiasm reflects the culture of curiosity central to early modern intellectual life. Daulby and Wilson studied Gersaint and other continental catalogues, but they also pored over their own and friends' collections, consulted with dealers and visited auction rooms.[39] Many amateurs marked up their catalogues with handwritten notes that track prices and comment on factors such as scarcity, condition, quality and provenance. Annotated copies of Gersaint and Daulby became collectibles in their own right, documenting a grass-roots campaign to grapple with the complexity of Rembrandt's production and the many imitations it inspired.[40]

Masterpieces like *The Hundred Guilder Print* posed fewer problems than rare oddities. Rembrandt produced an especially large number of trial proofs around 1630 when he was just beginning to master the medium.[41] One youthful experiment is a small, shadowy self-portrait, etched on an irregular scrap of copper marked by traces of another composition. The only complete impression known bears Astley's collector's mark [fig.84].[42] Daulby revised Gersaint's entry on it, describing the strong effect of light and shade that plays over the face. The sense that

[fig.28], sold internationally by subscription, Baillie cut the plate into four pieces and printed those [fig.81]. While his actions provoke horror today, some contemporaries admired them.[31] Such reprints made renowned compositions accessible to modest consumers, while the price for early impressions continued to climb. At the Barnard sale in 1798, an impression of *The Hundred Guilder Print* 'very fine, on India paper' brought £33 1s 6d while Baillie's reprint (on his own fake version of 'India paper') went for £2 12s 6d.[32] 'A most brilliant impression' of *The Hundred Guilder Print* 'on India paper, in the finest possible state' fetched £163 at the Pole Carew sale in 1835, another £1,100 three decades later.[33]

John Barnard spent fifty years building a print cabinet in which the collection of Rembrandts was 'justly considered as the most *choice and compleat* in the kingdom'.[34] The catalogue of his sale lists numerous early states, counterproofs and impressions on 'India paper', many with a Six and Houbraken provenance. The Rembrandts are numbered

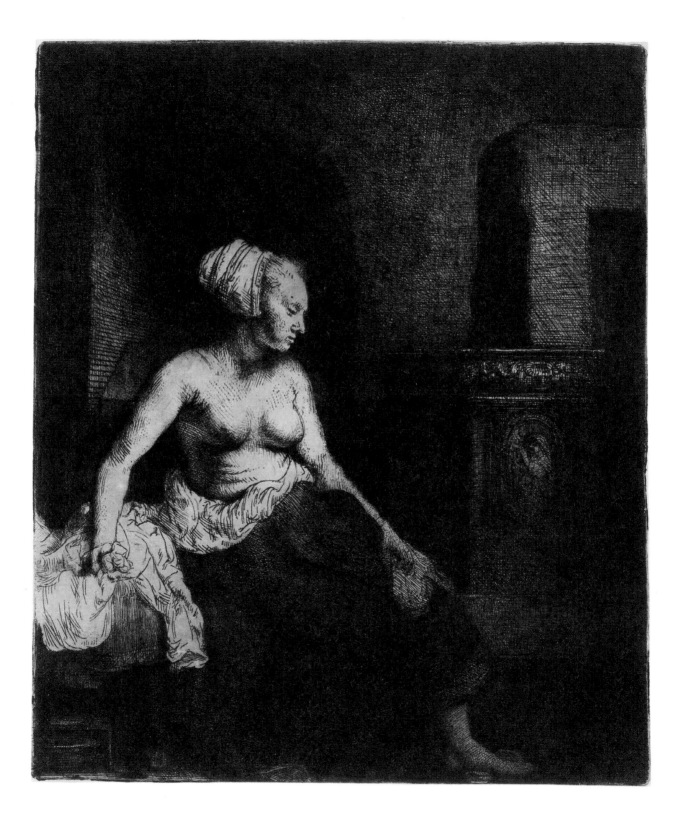

82 Rembrandt, *Woman Sitting Half-dressed beside a Stove*, 1658

Etching and drypoint, third state, 22.5 × 18.6 cm
Rijksmuseum, Amsterdam

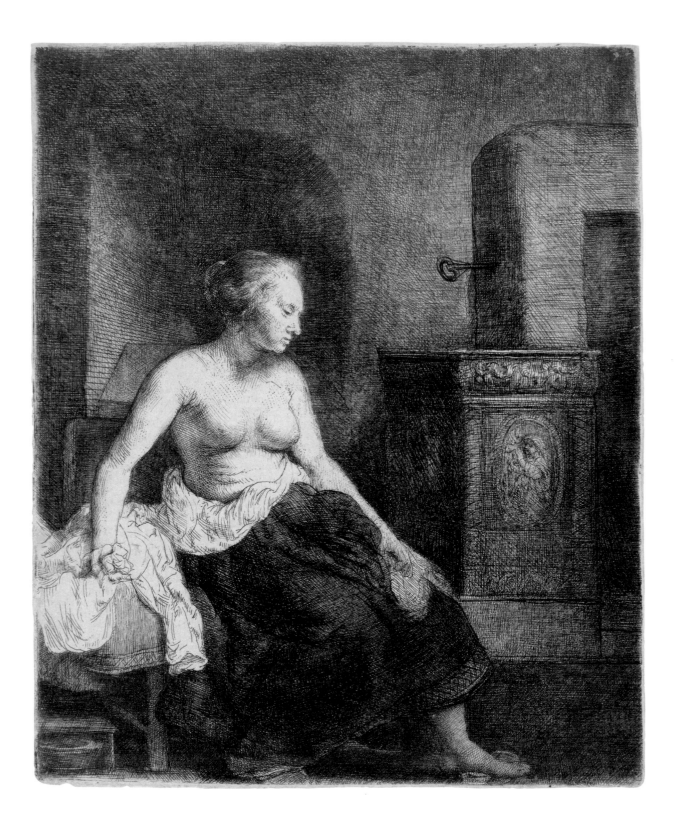

83 Rembrandt, *Woman Sitting Half-dressed beside a Stove*, 1658
Etching and drypoint, sixth state, 22.8 × 18.7 cm
The Morgan Library & Museum, New York

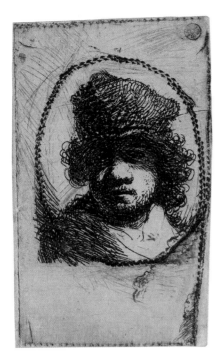

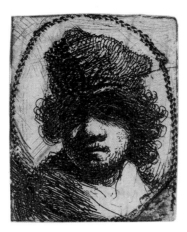

84 Rembrandt, *Self-portrait in a Fur Cap, in an Oval Border: Bust*, c.1629
Etching, 9 × 5.4 cm (irregular). British Museum, London

85 Rembrandt, *Self-portrait in a Fur Cap, in an Oval Border: Bust*, c.1630
Etching, 5.7 × 4.7 cm. British Museum, London

he studied the print first-hand is confirmed by remarks he later penned in the margin of his own catalogue:

> *Mr. Barnard's impression of this print is etched with a fine stroke, and is perhaps unique. It had been in Six's and Pond's collections. This Piece has been the subject of much dispute among the connoisseurs. Mine was in the collection of Mr. Blackburne; Mr. Philipe the printseller had one the same, which Mr. Barnard would not allow to be the work of Rembrandt (his being a different one) and he laid Mr. P. a wager that he had been deceived as old Harding was by Wilson, and that he would soon show him plenty of Impressions. Mr. Barnard was however mistaken, tho' he had been a collector nearly half a Century & his Collection contained many prints which were supposed to be Unique in the King of France's Collection. I was favoured with the permission of copying his manuscript Remarks in Gersaint's Catalogue, which I found of essential service in compiling mine. There were likewise some manuscript Remarks of Capt. Baillie's.*[43]

Here, several notes ring together: Daulby's acquaintance with Barnard, Baillie and fellow Liverpudlian Jonathan Blackburne (1721–1786); Barnard's acquisition of rarities from Pond; Benjamin Wilson's hoax (Harding being another victim); and information shared through annotations. Barnard's impression turns out to be a trimmed sheet, not a fake or a separate state [fig.85].[44] Were there others? Where is Daulby's impression, once owned by Blackburne?[45] Small plates like this one posed large questions for curious connoisseurs.

Enthusiasm for Rembrandt was not confined to London. In Liverpool, Daniel Daulby built an art collection that encompassed contemporary as well as old masters. He owned paintings by Joseph Wright of Derby (1734–1797) and Henry Fuseli (1741–1825) as well as Rembrandt's imposing *Portrait of a Man with Arms Akimbo* (now Agnes Etherington Art Centre, Kingston, Ontario; fig.86).[46] He shared these interests with his brother-in-law, the banker and politician William Roscoe (1753–1831). Author of the first biography in English of the Italian Renaissance statesman Lorenzo de' Medici (1449–1492), Roscoe hoped to make of Liverpool a new Florence, where culture and commerce could thrive in harmony.[47] Roscoe wrote the introduction to Daulby's catalogue, in which his Italianate bias is clear; he finds Rembrandt's colourism enchanting, but the lifelike nudes (such as figs 82 and 83) are dismissed as 'meagre, squalid, and vulgar'.[48] Nevertheless, as a collector, Roscoe was willing to pay ten guineas for *The Hundred Guilder Print*, the highest price he is known to have spent for any single print.[49] It is intriguing that, in an age when classicism prevailed, Rembrandt's etchings were coveted even by collectors unsympathetic to his earthy style.[50]

On 19 May 1796, Roscoe sent a copy of Daulby's catalogue to the distinguished connoisseur Horace Walpole, 4th Earl of Orford (1717–1797), whose response reflects a similar ambivalence:

> *The Description of Rembrandt's Works has amused a few of my irksome Hours very agreeably; not, I confess, from admiration of Rembrandt, who is far from being one of my favourite Painters, but I am greatly pleased with the strict and just Impartiality of the Editor, who fairly allows those Defects which always disgusted me: it is very new to discern so many Blemishes in a Painter, whose works he admired enough to write a quarto volume about him.*[51]

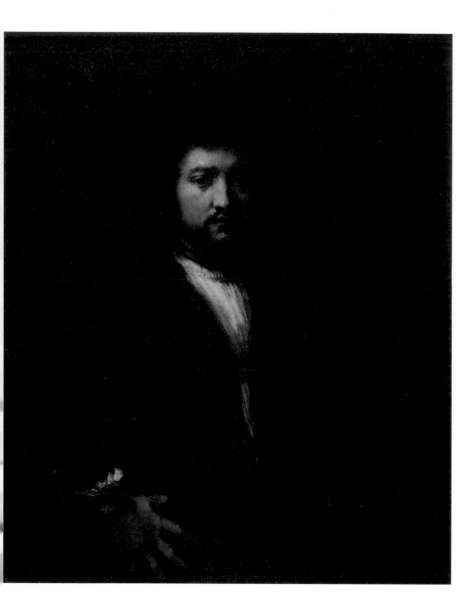

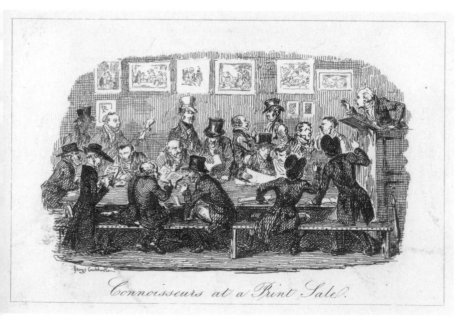

86 Rembrandt, *Portrait of a Man with Arms Akimbo*, 1658
Oil on canvas, 107.4 × 87 cm
Agnes Etherington Art Centre, Queen's University, Kingston, Ontario

87 George Cruikshank, *Connoisseurs at a Print Sale*, 1828
Etching, 6.9 × 10.5 cm
Rijksmuseum, Amsterdam

Walpole's acknowledgement marks Daulby's work as a step towards modern, objective inquiry.

On the continent, Bartsch's catalogue quickly eclipsed earlier publications, but, for British readers, Daulby remained a respected source.[52] In 1867, Joseph Cundall still used Daulby's text for the first book illustrated with photographs of Rembrandt prints.[53] Yet, by 1836, Thomas Wilson could write that 'Since the period of *Daulby*, much has been discovered to interest the collector' so that 'numerous corrections and additions are required in almost every part, to render it [Daulby's catalogue] creditable to England, as those of *Bartsch* and *De Claussin* are to Germany and France'.[54] In 1828, Wilson had published an account of his earlier holdings of old-master prints, illustrated with several witty vignettes by George Cruikshank (1792–1878) [fig.87].[55] He based his Rembrandt catalogue on 'the experience of observation, [and] comparison of the various catalogues, and of the editor's collection' with several others.[56] He was the first cataloguer to ponder Rembrandt's prints in chronological order, writing: 'I think I can … see his rise from the pleasing to the astonishing, and from thence to the sublime'.[57] In rejecting thirty plates accepted by earlier cataloguers, some of which he attributed to Ferdinand Bol (1616–1680), he opened a debate later taken up by Haden and Middleton.[58] Bankrupted by a bad investment, Wilson sold most of his collection and emigrated in 1838 to Australia, where he continued to lecture and write about art.[59]

The meticulous discoveries made by connoisseurs like Barnard, Daulby and Wilson may not radically alter our understanding of Rembrandt as a printmaker, but they contribute to an ongoing quest for clarity. They also reflect the enduring appeal of Rembrandt's etchings for British collectors. In 1768, William Gilpin predicted that the fashion for Rembrandt might soon be over.[60] Nothing could be farther from the truth.

4

FROM STUDIO TO ACADEMY: COPYING REMBRANDT IN EIGHTEENTH-CENTURY BRITAIN
JONATHAN YARKER

In a famous depiction of the interior of the British Institution made by the Swiss artist Alfred Edward Chalon (1780–1860) in 1806, a clutch of amateur and professional artists are shown copying old-master paintings that had been borrowed for the purpose [fig.89]. In the centre of the drawing, towards the back of the room, is a figure in a top hat and overcoat who is in the process of replicating Rembrandt's great landscape *The Mill* [fig.91] which can be seen on another easel behind the copy. The figure is identifiable as the then President of the Royal Academy of Arts, Benjamin West (1738–1820). Chalon's satirical image commemorates the enthusiasm for copying celebrated old masters which accompanied the opening of the first British Institution loan exhibition in 1806. West was not alone in choosing *The Mill* to copy: contemporary accounts record James Ward (1769–1859), Samuel William Reynolds (1773–1835), Nicholas Pocock (1740–1821) and John Constable (1776–1837) at work on their own replicas [fig.90].[1] This does raise the question of why artists, even established painters, felt the need to make copies. In the context of this essay, it begs the more focused question of why artists wanted to copy a painting by Rembrandt, and what that tells us about Rembrandt's reputation in Britain.

Recent scholarship on artistic reception and reputation tends to rely on the written testament of artists and art theorists.[2] For those painters who clustered round Rembrandt's *The Mill* at the British Institution, we can turn to their own words to understand their interest in the painting. Constable, for example, delivered a series of lectures on *The History of Landscape Painting* at the Royal Institution, where he praised *The Mill*, stating that it 'is the first picture in which a sentiment has been expressed by chiaroscuro only'.[3] But earlier in the century we have less literary evidence for where artists sought inspiration or instruction. In Britain before the foundation of the Royal Academy in 1768, most writing on art was based on a limited group of French theoretical texts. These books tended to offer an exiguous group of Italian painters as models. Rembrandt, if he was mentioned at all, received qualified praise for his use of colour but criticism for his drawing.[4] And yet, in the informal world of the British studio, Rembrandt featured prominently, and a substantial body of copies after his works survives. This essay will use the evidence of these surviving copies to contribute to the story of how Rembrandt was viewed and understood by artists in Britain during the eighteenth century.

It is worth beginning by thinking about the practice of copying. At its simplest level, copying was the acknowledged method for learning to draw and paint.[5] At most European academies, it was considered a central element of artistic training; it was one of the mandatory exercises (or *envois*) undertaken by winners of the Prix de Rome at the French Académie, viewed as essential for teaching the young painter – after an initial training rooted in drawing – to handle colour. Britain lacked the same structures before the foundation of the Royal Academy, but copying was nevertheless key to most painters' early careers, featuring as an exercise in most productive studios. It also served an intellectual role, as the method by which artists gathered material to aid them in the process of imitation. The concept of imitation was central to all continental art theory, which held that to learn the disciplines of design, composition and invention an artist had to study closely the greatest artists of the past.[6] As a result, much ink was spilt on defining which artists and which works should form suitable models for the attention of young painters.

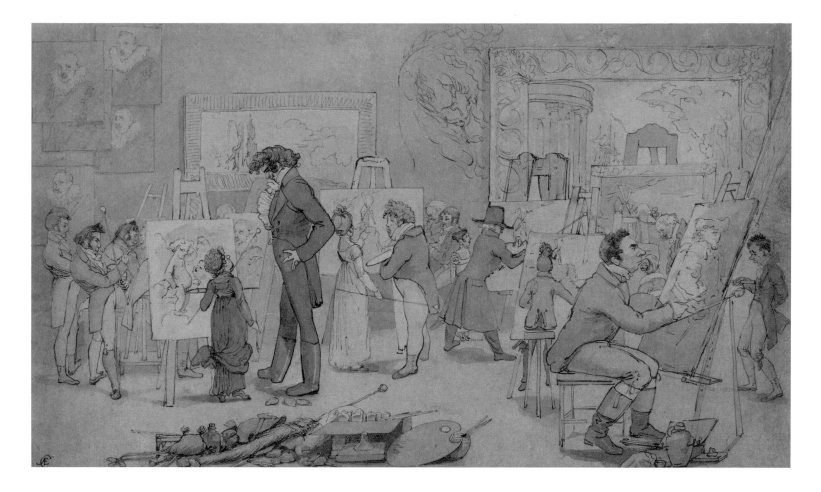

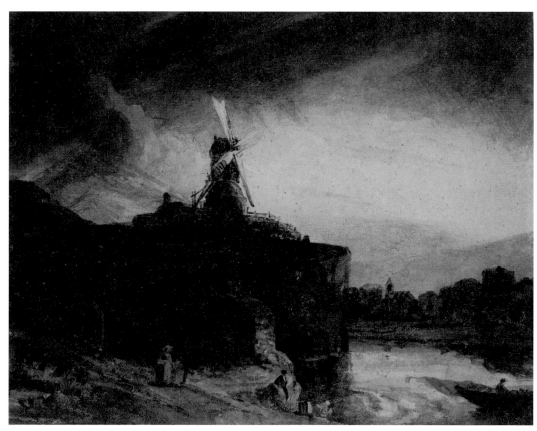

89 Alfred Edward Chalon,
Students at the British Institution, 1806
Pen and brown ink, with watercolour, 31.5 × 53.1 cm
British Museum, London [cat.74]

90 John Constable, after Rembrandt,
The Mill, 1806
Watercolour, 19.6 × 24.5 cm
Private collection

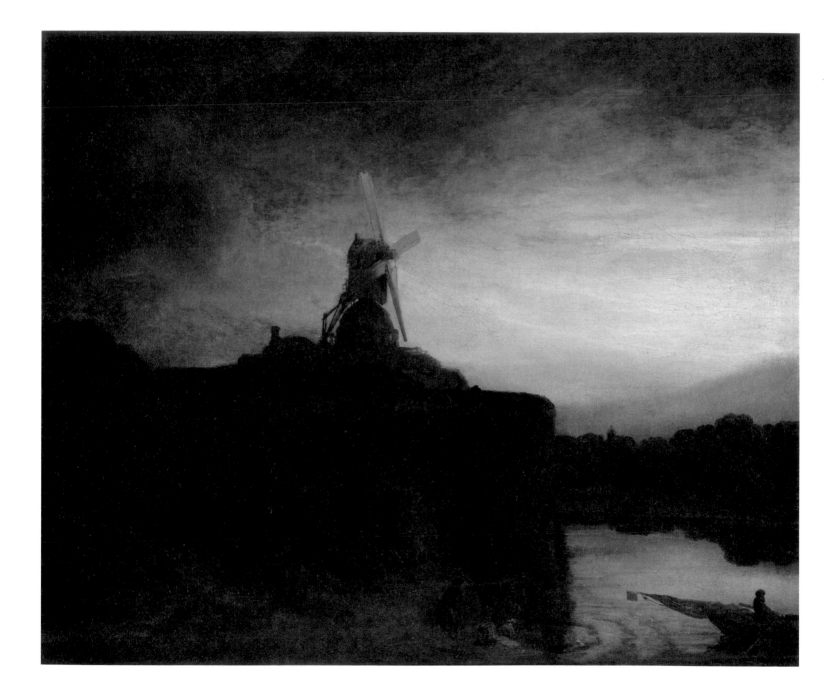

91 Rembrandt, *The Mill*, 1645/48

Oil on canvas, 87.6 × 105.6 cm
National Gallery of Art, Washington [cat.8]

92 Arthur Pond, after Rembrandt, *Saint Peter's Prayer before the Raising of Tabitha*, 1736
Etching and aquatint, 20.7 × 21.7 cm
Nicholas Stogdon [cat.115]

93 Richard Phelps, after Rembrandt, *Figure of Christ from 'The Hundred Guilder Print'*, c.1740
Pen and brown ink, 15.9 × 15 cm
British Museum, London

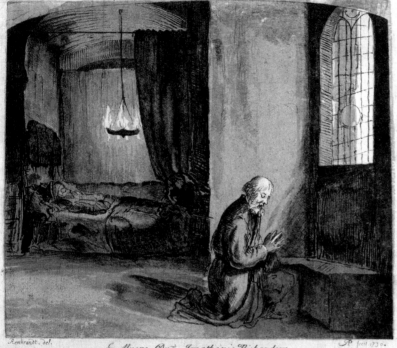

In France, this debate was carried out in print largely by connoisseurs rather than by painters. The most significant texts were by André Félibien (1619–1695) – who wrote the first discussion of Rembrandt's works in French – and Roger de Piles (1635–1709).[7] It was de Piles who deviated from prevailing art theories which privileged design over all else, championing artists who used colour and chiaroscuro. De Piles wrote a celebrated biography of Sir Peter Paul Rubens (1577–1640) and provided consistent commentary on Rembrandt. In Britain, de Piles's writing had a profound impact upon Jonathan Richardson (1667–1745). Richardson's *Essay on the Theory of Painting*, which was published in 1715, was the first attempt to give the principles of academic, continental art theory a form and emphasis that would render them applicable to a British painter.

Richardson was a prodigious and celebrated collector of paintings, prints and, most spectacularly, drawings. His argument in the *Theory of Painting* is punctuated by observations on sheets from his own collection. What makes his text particularly revealing is that, unlike de Piles or Félibien, he was a hugely successful portrait painter and wrote with the authority of a practising artist. As Carol Gibson-Wood points out, 'Richardson maintained a profound and precocious appreciation of Rembrandt', which took the physical form of a substantial collection of drawings and prints that he referred to throughout his writings.[8] In the *Theory of Painting*, Richardson recommends Rembrandt as one of the best painters to study for his invention, expression and composition, and celebrates him as an artist whose 'surprising Beauties are Overlook'd in a great measure, and Lost with Most, even Lovers of Painting and Connoisseurs'.[9] This statement suggests that in 1715 Rembrandt's works were a minority interest; it therefore makes Richardson's consistent commendation of Rembrandt's prints and drawings particularly striking. Talking about 'variety', Richardson praises *The Hundred Guilder Print* [fig.80 & cat.50]; and in a remarkably acute

94 Richard Phelps, after Rembrandt,
Two Studies of Saskia Sleeping, c.1740
Pen and brown ink, 14.8 × 16.7 cm
British Museum, London

discussion of 'the sublime', he describes a drawing in his collection, *Saint Peter's Prayer before the Raising of Tabitha*, noting that it is 'an Instance of an Important Subject, Impress'd upon our Minds by such Expedients, and Incidents as display an Elevation of Thought, and fine Invention; and all this with the Utmost Art, and with the greatest simplicity; That being more Apt, at least in this Case, than any Embellishment whatsoever'.[10]

But what impact did Richardson's writing have on the practical training of young painters? While there is evidence that Richardson's collection was accessible to artists – Arthur Pond made a print of *Saint Peter's Prayer before the Raising of Tabitha* in 1736, for example [fig.92] – it was not until the next generation of painters that we find the works of Rembrandt being prominently used as examples in studios.[11]

After Richardson's death in 1745, his collection was dispersed by his son Jonathan at a sale two years later. The antiquarian George Vertue (1684–1756) recorded that

'Mr Hudson his son in Law bought much, many drawings to make a collection – also several of his best paintings. That cost good sums.'[12] Sadly, no fully priced copy of the sale catalogue survives, but isolated results show that Hudson acquired the cream of Richardson's Rembrandt drawings for considerable amounts. A strikingly schematic red chalk sheet now in the British Museum depicting *The Entombment*, c.1635, was the star lot of the eighth night of the sale, making £11 5s.[13]

By this date, Thomas Hudson (1701–1779) was a successful portraitist, with a busy and hugely productive studio.[14] While Hudson undoubtedly wanted to preserve his father-in-law's patrimony, his motivation for buying so extensively at Richardson's sale was also prompted by the knowledge that these works of art were more than merely the equipage of a successful painter: they formed an important educative function within the studio. This is confirmed by the fact that Hudson acquired a number of the drawings in partnership with his colleague and collaborator, the Flemish drapery-painter, Joseph van Aken (c.1699–1749).[15]

Evidence of how they were used is contained in a previously unpublished album of drawings made by one of Hudson's apprentices, a little-known portrait painter, Richard Phelps (1710–1785) [figs 93 & 94].[16] Preserved in the British Museum, the drawings offer important evidence for the active role to which Hudson put his Rembrandt drawings in teaching his apprentices. We know from early biographers that when Joshua Reynolds (1723–1792) was apprenticed to Hudson in 1740, one of his first tasks was to replicate drawings from Hudson's collection. Writing about Reynolds's training, James Northcote (1746–1831) recorded that Hudson, 'instead of directing him to study from the antique models, […] recommended to him the careful copying of Guercino's drawings, thus trifling his time away'.[17] Rather than Hudson's Guercinos, Phelps was directed towards the Rembrandt works; the album includes thirty-six sheets after prints and drawings by or attributed to Rembrandt from Hudson's collection.

Amongst them are focused studies of figures from *The Hundred Guilder Print* suggesting that Richardson's observations from the *Theory of Painting* remained current [fig.93]. What is particularly striking about the drawings is the way in which Phelps attempts to capture the technique of the original. In one of Rembrandt's most informal drawings

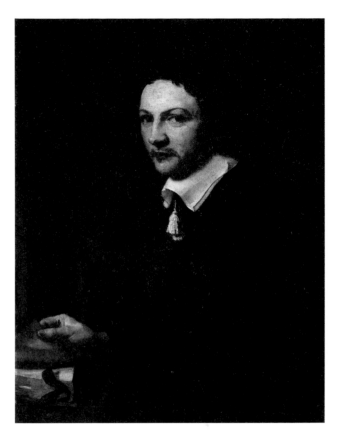

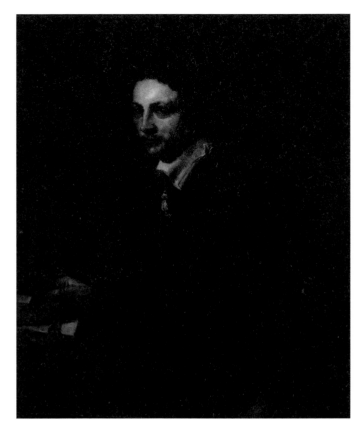

95 Willem Drost, *Portrait of a Young Scholar*, c.1654
Oil on canvas, 83 × 64.5 cm
Musée du Louvre, Paris [cat.82]

96 Thomas Worlidge, after Willem Drost,
Portrait of a Young Scholar, c.1750–60
Oil on canvas, 108 × 83.8 cm
Elton Hall Collection [cat.138]

97 Thomas Worlidge, after Willem Drost,
Portrait of a Young Scholar, c.1757–58
Etching, 19.5 × 14.3 cm
National Galleries of Scotland, Edinburgh [cat.139]

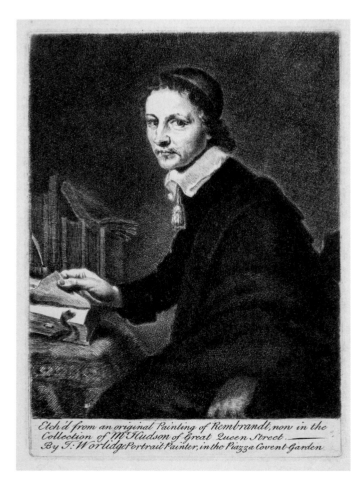

– *Two Studies of Saskia Asleep*, from the 1630s, now in the Morgan Library & Museum, New York[18] – Phelps has carefully tried to replicate the fluid use of line and subtle modelling in brown wash, distinct from the more graphic lines of Rembrandt's etchings [fig.94]. A pair of studies show how Phelps tried to understand the mechanics of a drawing of a seated man, isolating the figure in one and then applying wash in the second; the original, identified as by a follower of Rembrandt and now in the Courtauld Institute of Art in London, had been given to Richardson by Sir James Thornhill before passing to Hudson. While this kind of copying taught the young painter the discipline of observation and the basic method of transposing a composition, it did not equip him with the imitable

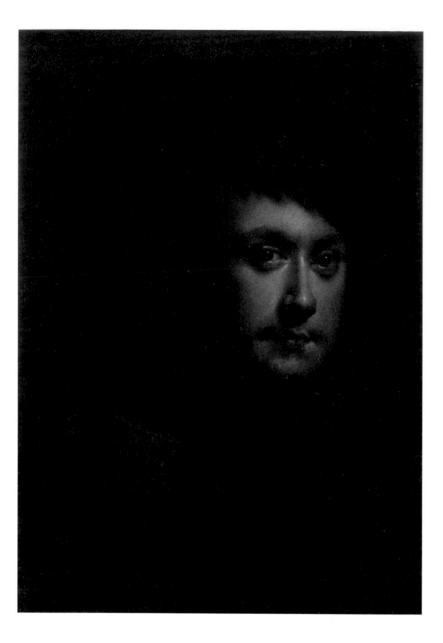

98 Joseph Wright of Derby, *Self-portrait in Feathered or Fur Hat*, *c.1767*
Charcoal heightened with white chalk, 53.3 × 36.8 cm
Derby Museum and Art Gallery, Derby

printed essays in Rembrandt's style. Worlidge evidently had access to Hudson's studio in Great Queen Street, London, where he produced a careful oil copy of a painting of a young scholar then attributed to Rembrandt [fig.96]. Hudson had acquired the painting at Richardson's sale, and it was included in Hudson's posthumous sale in 1785, where it made the substantial sum of 115 guineas; it is now in the Louvre, Paris, identified as the work of Rembrandt's pupil Willem Drost (1633–1659) [fig.95].[21] Worlidge made an etching after the painting – a technique chosen as a conscious homage to Rembrandt – where he specifically advertises Hudson's ownership on the plate [fig.97].

Hanging in the studio, the picture would have been of use to a young portrait painter such as Phelps. The pose – the sitter is shown seated in profile at a desk, his hand turning the page of a book, looking directly out at the viewer – offered precisely the kind of model Hudson encouraged his students to collate in preparation for their independent careers as portraitists. A remarkable archive of drawings recording portrait poses made by Joseph Wright when he was in Hudson's studio is preserved in Derby. Wright evidently knew the Hudson portrait, as he adopts the same pose in his early portrait of *Samuel Rastall*, 1762 (private collection), showing the young man with a porte-crayon rather than a book.

The rise of interest in Rembrandt resulted in an outpouring of prints after his paintings, drawings and etchings. Worlidge produced a number of prints both directly after Rembrandt's designs and in imitation of his work. In 1762 he published a print of his patron, the collector Sir Edward Astley (1729–1802), in the guise of Rembrandt's great benefactor, Jan Six (1618–1700) [fig.79]. Astley had recently acquired (and sold) Arthur Pond's substantial collection of Rembrandt impressions, many of which had come from the Six collection itself in Amsterdam; and Worlidge's conceit – to rework the portrait of Six as Astley – relied upon his audience recognising Rembrandt's etching.[22] The idea of audience recognition was a fundamental element of imitation as conceptualised in the eighteenth century. Alexander Gerard observes in his 1759 *Essay on Taste*: 'when imitation is intended, our admiration of the skill and ingenuity of the artist diffuses itself over the effect from which that skill is inferred, and compleats, the delight which the work inspires'.[23]

vocabulary to practise as a painter in his own right.

The idea of imitating Rembrandt's style gained currency in the 1740s as the market for his paintings, drawings and prints increased. So popular was Rembrandt by the end of the decade that George Vertue noted several collectors sought 'all the wild scrabbles skratches &c. done by him or thought to be done by him', adding that there were two very able artists who 'immitate or mimick his manner'.[19] Vertue identifies the first as the portraitist Benjamin Wilson (1721–1788), who exploited the mania for Rembrandt by playing an infamous trick on Hudson, selling him a landscape etching of his own invention which he claimed to be by Rembrandt.[20] The second Vertue names as Thomas Worlidge (1700–1766), a portrait painter and engraver who worked in London and Bath. Worlidge had a particular affinity with and interest in Rembrandt's work; he produced intelligent painted and

99 Thomas Hudson, *Charles Erskine (1716–1749)*, 1747
Oil on canvas, 75.5 × 62.2 cm
National Galleries of Scotland, Edinburgh [cat.96]

100 Thomas Worlidge, after Rembrandt, *Self-portrait*, c.1747–50
Etching, 21 × 15.9 cm
National Galleries of Scotland, Edinburgh [cat.136]

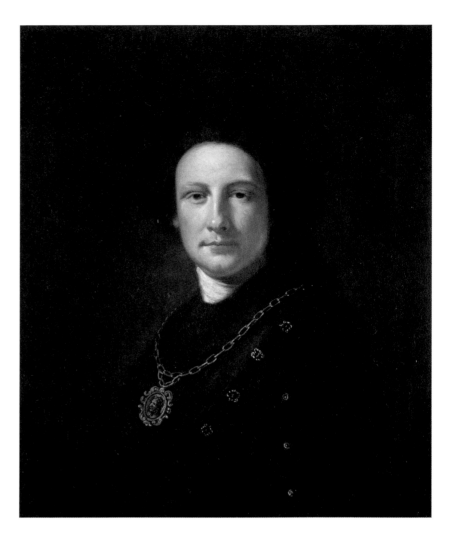

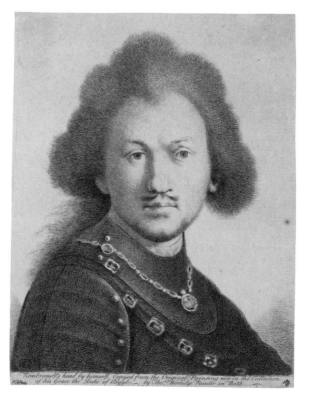

Around 1747–50, Worlidge etched a print after a painting in the collection of the Duke of Argyll purporting to be a Rembrandt self-portrait [fig.100].[24] Hudson used the same portrait as the basis for a 1747 portrait of *Charles Erskine* [fig.99], preserving the fur hat, gold chain and lighting effect of the original. A series of portraits by Hudson's pupils and friends show that there was a collective awareness of Rembrandt's self-portraiture. In a number of works, Wright shows himself dressed in a fur cap or turban, in dark costume and deliberately employing a brooding chiaroscuro [fig.98]. In 1755, William Hogarth (1697–1764) produced a portrait of the publisher and engraver John Pine which explicitly toyed with Pine's physical resemblance to Rembrandt, posing him in the familiar attributes of Rembrandt's self-portraiture: a velvet cap decorated with jewels, a fur collar, and set against a deliberately dark background (see fig.101).

The portrait of Pine is a particularly interesting essay in imitation because Hogarth attempted to capture the painterly qualities of Rembrandt's method. Technique was something which was of increasing interest to British artists as the century progressed. Hudson's most successful student, Joshua Reynolds, had a profound interest in Rembrandt; he put together a significant collection of paintings, drawings and prints.[25] Despite Reynolds's public antipathy towards copying – in his *Discourse II*, he cautioned students against the 'drudgery of copying', which he characterised as a 'delusive kind of industry' – Reynolds made close replicas of the old masters he admired throughout his career.[26] It is clear from these surviving copies that Reynolds's interest was as much in Rembrandt's handling of paint as in his design or composition.

The recent rediscovery of Reynolds's copy of *The Tribute Money*, from about 1770 (private collection), made when it was in the collection of John Blackwood, shows Reynolds's interest in capturing both the colour and paint effects of the original. Shortly after the foundation of the Royal Academy, Reynolds produced a series of characterful head studies which he dramatised as history paintings.[27] Largely painted from the same model, a street mender called George White, these were in effect *tronies*, expressive genre paintings in portrait format, and owe a great deal to Rembrandt in both conception and execution. In Reynolds's 1772 painting of White in the guise of *Dionysius Areopagite* [fig.102], the dramatic, dark palette, the bold, broad application of paint

101 James McArdell, after William Hogarth, *Mr Pine*, c.1755
Mezzotint, 33.4 × 22.5 cm
David Alexander [cat.106]

102 Joshua Reynolds, *Dionysius Areopagite,*
a Nobleman of Athens and Disciple of Saint Paul, 1772
Oil on canvas, 76.3 × 63.5 cm
Private collection

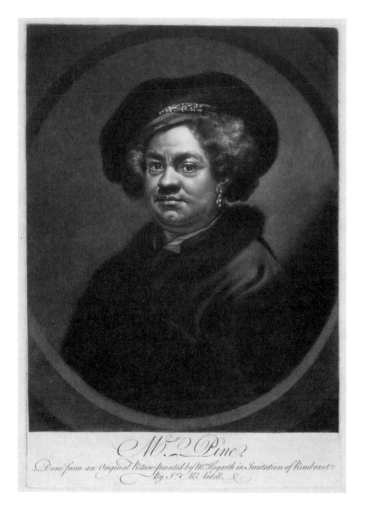

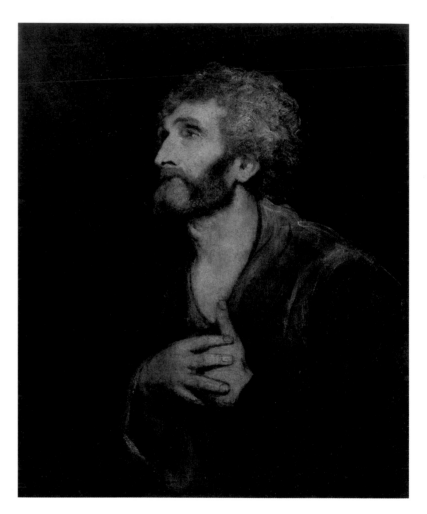

and the almost haphazard application of highlights all recall Rembrandt's handling. Rembrandt's approach was clearly one Reynolds had considered carefully. Writing in *Discourse XII*, Reynolds notes that:

> *Rembrandt, in order to take the advantage of accident, appears often to have used the pallet-knife to lay his colours on the canvas, instead of the pencil. Whether it is the knife or any other instrument, it suffices, if it is something that does not follow exactly the will. Accident in the hands of an artist who knows how to take the advantage of its hints, will often produce bold and capricious beauties of handling and facility, such as he would not have thought of, or ventured, with his pencil, under the regular restraint of his hand.*[28]

In certain areas, it is possible to detect precisely this use of a palette knife and utilisation of 'accidents' to produce a 'bold and capricious' handling. White's hair is thickly painted with impasto, which is consistent with the use of a palette knife. Elsewhere, Reynolds has used a loaded brush to convey a sense of spontaneity: for example, the serpentine line defining White's shoulder. Reynolds has also added thick, dry highlights at the end of the painting process.

For the experienced painter, copying was a way of understanding technique. Thomas Gainsborough (1727–1788) produced a series of careful copies throughout his career, largely as exercises in assimilating approaches of other painters.[29] Around 1780, he made a copy of Rembrandt's portrait of *A Bearded Man in a Cap*, now in the National

103 Thomas Gainsborough, after Rembrandt,
A Bearded Man in a Cap, 1780

Oil on canvas, 77 × 64.1 cm
Royal Collection Trust, London

104 Rembrandt, *A Bearded Man in a Cap*, 1657

Oil on canvas, 78 × 66.7 cm
The National Gallery, London

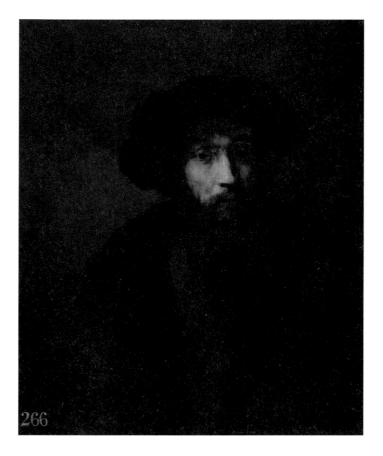

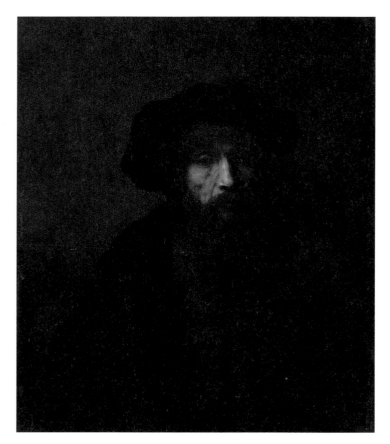

Gallery [figs 103 & 104]. Gainsborough had a habit of borrowing old-master paintings he wanted to copy, and this one was in the collection of his patron John Campbell, 4th Duke of Argyll.[30] Gainsborough's application of paint follows Rembrandt's carefully, particularly the modelling of the face and drawing of the features. Passages such as the dimple in the man's left cheek, suggested by a triangle of darker flesh tone, the highlight on the left eyelid and touches of blue on the bridge of the nose all point to Gainsborough's close engagement with the original canvas. As a portraitist, Gainsborough was interested in Rembrandt's processes and approach.

As the century progressed, the volume of prints made after Rembrandt's paintings increased; both *The Tribute Money* from John Blackwood's collection and the Argyll *Bearded Man in a Cap* appeared as mezzotints. The accessibility of Rembrandt's work to artists was further aided by

the foundation of the British Institution in 1805 and of the Painting School of the Royal Academy in 1816. These two organisations gave painters dedicated spaces in which to copy old-master paintings for the first time.

As we have already seen, the exhibiting in 1806 of Rembrandt's *The Mill* at the British Institution resulted in a number of copies by a range of painters. But the British Institution, in the spirit of Reynolds, was keen for painters not simply to fall into the 'drudgery of copying'. As the rules governing the admission of painters were later to establish, straight copies were discouraged. Instead, artists were encouraged to produce 'Imitations, Studies, and Sketches', and to endeavour to provide 'companions to the pictures lent'.[31] This may seem oddly restrictive, but it should perhaps be read as the sentiment of the directors, who were principally collectors such as Sir George Beaumont (1753–1827) and Sir Abraham Hume

(1749–1838), men still steeped in Reynolds's writings. The preface to the 1815 catalogue of the old-master show at the British Institution restates the aims of the exhibition in decidedly Reynoldsian terms: 'The Directors of the Institution […] hope that such productions may excite in the British artist the ardour of emulation. They offer them to him, not that he may copy, but that he may study them,' adding: 'they wish him to catch the spirit rather than to trace the lines; and to set his mind, rather than his hands, to work upon this occasion'.[32] This was precisely the kind of imaginative engagement with old masters Reynolds had promoted: in *Discourse II*, he urged the students of the Royal Academy to 'enter into a kind of competition, by painting a similar subject, and making a companion to any picture that you consider a model'.[33]

There is evidence that artists did precisely this. James Ward, who is recorded making a copy of *The Mill* in 1806, went on to paint a 'companion' which he exhibited at the British Institution in 1807 with the title *Ashbourne Mill, Painted in Imitation of Rembrandt* (private collection).[34] Ward's 'emulation' was less a sensitive essay on Rembrandtian motifs than a fairly laboured pendant; he

has merely reversed the composition of *The Mill*. But other painters responded more subtly. Joseph Mallord William Turner (1775–1851) wrote powerfully about *The Mill*, noting that Rembrandt had 'thrown that veil of matchless colour; that lucid interval of Morning dawn and dewy light on which the Eye dwells so completely enthrall'd, and it seeks not for its liberty, but as it were, thinks it a sacrilege to pierce the mystic shell of colour in search of form'.[35] In 1810, Turner painted *Southall Mill* [fig.105], which can be viewed, in part, as a response to Rembrandt.[36] Although Turner's palette is closer to the warm light of Aelbert Cuyp (1620–1691), the motif of the mill itself and the crepuscular sense that colour predominates over form suggest he was consciously emulating Rembrandt.

In December 1815, soon after the completion of the Dulwich Picture Gallery south of London to designs by Sir John Soane, the Royal Academy Council minutes record a letter sent to the new institution containing the rules for the new painting school, which they 'have been induced to establish by the liberal offer of the Master, Warden & fellows of Dulwich College'.[37] The offer was for a number of paintings, not exceeding six, from the collection to be used for copying at the Royal Academy each year. The following January, the first six paintings were chosen to hang in the Great Room over the winter. They included works by Rubens, Sir Anthony van Dyck (1599–1641), Nicolas Poussin (1594–1665), Aelbert Cuyp, and Rembrandt's *Girl at a Window* [fig.33].[38] Rembrandt had firmly entered the syllabus of the Royal Academy, and his works were promoted as models for a new generation of painters.

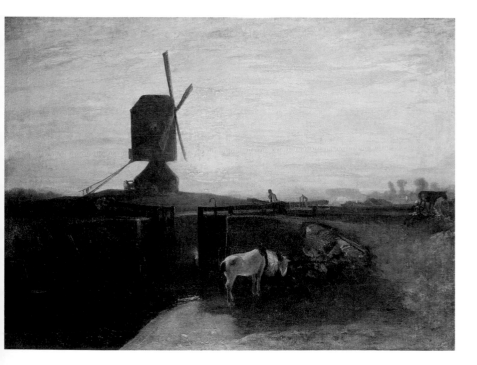

105 Joseph Mallord William Turner, *Southall Mill*, 1810
Oil on canvas, 92 × 122 cm
Private collection

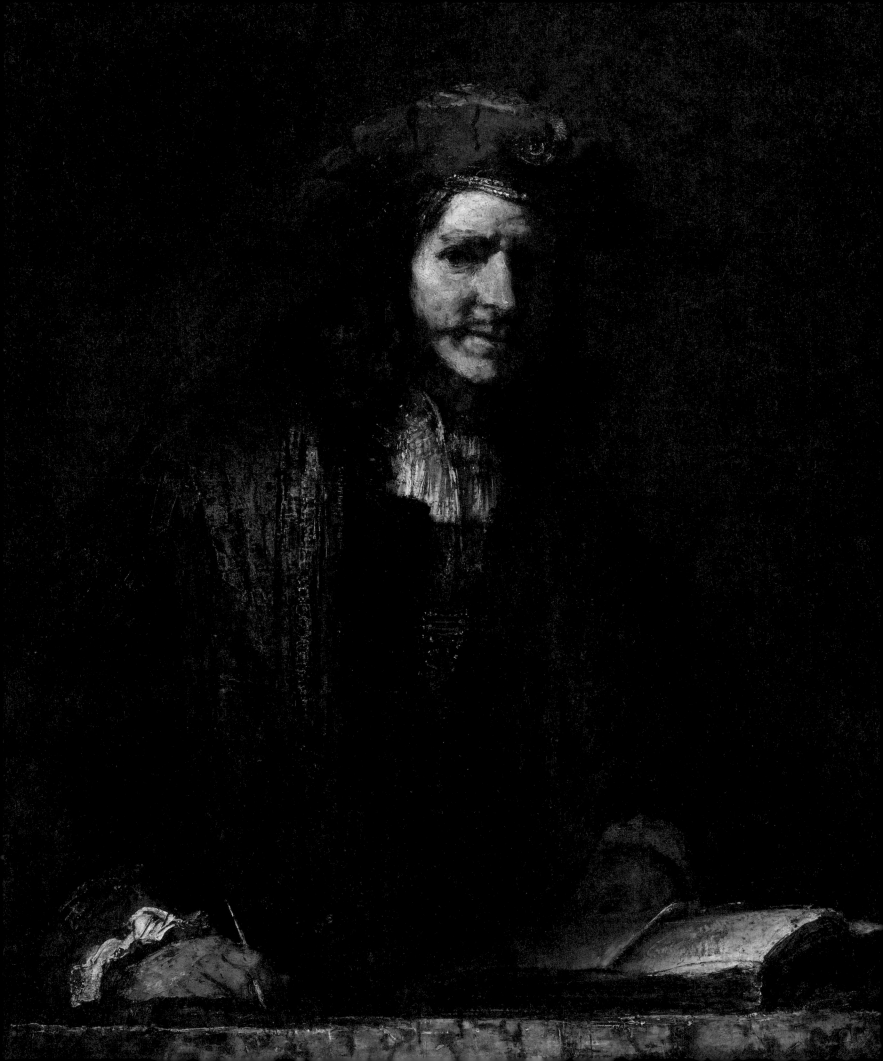

106 Rembrandt (attributed to), *Man with a Red Cap*, c.1660
Oil on canvas, 102 × 80 cm
Museum Boijmans Van Beuningen, Rotterdam [cat.18]

5

REGARDING REMBRANDT: REYNOLDS AND REMBRANDT
DONATO ESPOSITO

Eighteenth-century London provided a lively and competitive atmosphere in which Sir Joshua Reynolds (1723–1792) was able to distinguish himself as a foremost collector. The pupil of Thomas Hudson (1701–1779) – himself a voracious Rembrandt collector – Reynolds returned in 1752 from a sojourn in Italy to launch his successful artistic practice, which would see his meteoric rise as the founding President of the Royal Academy of Arts in 1768, and a knighthood. Throughout Reynolds's long career, Rembrandt was an enduring feature of his early education, artistic sensibility and wide collecting reach. His Rembrandts formed a cluster of work around which his many lives revolved: painter, virtuoso, collector and sometime dealer. Moreover, Reynolds's Rembrandt collection lay at the heart of his influential wider practice.

Reynolds's Rembrandts comprised paintings, prints and drawings by the celebrated Dutch artist together with a group of British and French contemporary prints after his work. It was but one part of a larger collection of several hundred old-master and contemporary paintings, and thousands of books, prints and drawings. Reynolds promoted the keen study of past art through his annual lectures (*Discourses*) to the students at the Royal Academy of Arts in London commemorating its foundation, which were published soon afterwards. His art collection functioned as evidence of the intellectual claims he made upon art, and reveals much about the privileged position he assumed in the cultural and intellectual life of eighteenth-century Britain, and beyond.

His teacher, Hudson, was particularly important for Reynolds, both in terms of artistic practice and collecting: he exposed the young artist under his care to the wide range of his Rembrandt collection, with his many paintings, prints and drawings, including a large group of drawn copies after Moghul miniatures. Reynolds arrived in late 1740, at the age of seventeen, to begin his studies under his fellow Devonian in London. There he was introduced

to the commercial world of auctions, carrying out bids on Hudson's behalf; in this way, the young future collector glimpsed the multitudinous riches that regularly came to the block at London's auction houses, many of which were in or around Covent Garden, where Hudson himself lived, on Great Queen Street. Hudson owned a drawing connected to a once-celebrated painting that was then attributed to Rembrandt, variously called *The Cradle* or *The Holy Family at Night* [fig.107].[1] In 1722 the drawing had been owned by Jonathan Richardson the Elder, when it was referenced in one of his publications, before passing to Hudson sometime before 1755, when it was reproduced as a mezzotint by James McArdell [fig.108 & cat.105]: 'Done from a capital drawing of Rembrandt the same size in the collection of Mr. Hudson. The original picture by Rembrandt in the collection of the Duke of Orleans'. The panel was described as 'exquisite; the colouring warm, and transparent; a vast number of parts put together with the utmost harmony', and was favourably compared to Correggio's nocturnal painting *La Notte* (*The Adoration of the Shepherds*), 1530 (Gemäldegalerie Alte Meister, Dresden), then regarded as one of the most celebrated works in the Western canon.[2] From Hudson, Reynolds obtained many other fine examples, including *The Incredulity of Saint Thomas* [fig.109], with its sparing and emotive draughtsmanship. *The Cradle* was later owned by the noted connoisseur Richard Payne Knight (1751–1824), a friend of Reynolds and from whom he obtained many old-master drawings, which are all now in the British Museum.

It was in 1760, when Reynolds moved into a large townhouse at 47 Leicester Fields (later Leicester Square) where he would remain for the rest of his life, that his collecting began in earnest. There he assembled and displayed for clients and friends his extraordinary collection which encompassed a diverse temporal and geographic spectrum, ranging from Leonardo da Vinci (1452–1519) and Sandro Botticelli (1444/45–1510) to the work of his

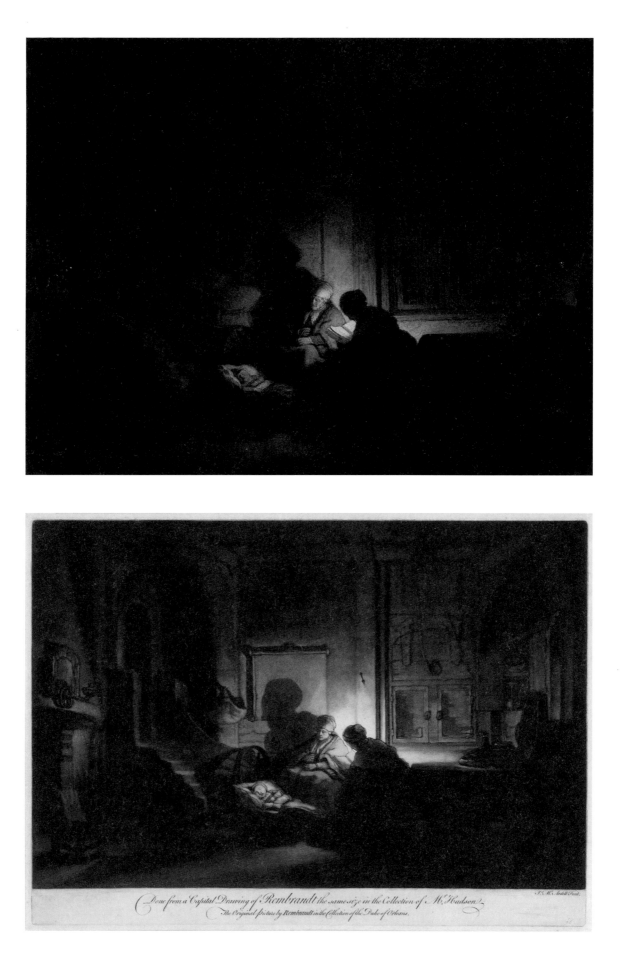

107 Rembrandt (workshop of), *The Holy Family at Night*
(*'The Cradle'*), c.1642–48

Oil on panel, 66.5 × 78 cm
Rijksmuseum, Amsterdam [cat.6]

108 James McArdell, after Rembrandt (workshop of),
The Holy Family at Night (*'The Cradle'*), 1755

Mezzotint, 34.3 × 46.8 cm
Rijksmuseum, Amsterdam

109 Rembrandt, *The Incredulity of Saint Thomas*, c.1652–54

Pen and brown ink and white bodycolour, 15 × 24 cm
Musée du Louvre, Paris [cat.34]

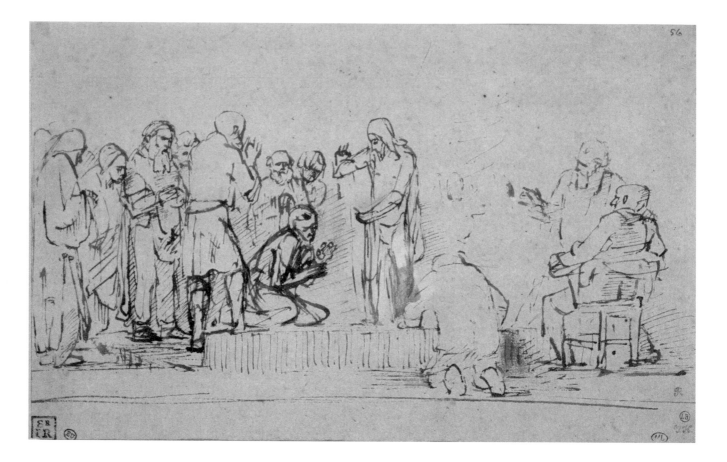

contemporaries, including William Hogarth (1697–1764)
and Angelica Kauffmann (1741–1807). The bulk of his
collection was bequeathed to his favourite niece – Mary
Palmer (1750–1820), later Marchioness of Thomond – and
dispersed in a series of spectacular sales in the 1790s.

The sale of Reynolds's old-master paintings took place
over four days in March 1795 in between larger sales
devoted to 'duplicate' prints in April 1792 and the bulk
of his prints and drawings in March 1798.[3] Reynolds
indicated explicitly that he devoted huge sums towards his
burgeoning art collection: 'I even borrowed money for this
purpose. The possessing [of] portraits by Titian, Vandyck,
Rembrandt, &c. I considered as the best kind of wealth.'[4]

The array of portraits offered in 1795 included
examples painted by great names from the art-historical
canon: Rembrandt, as well as Titian (c.1485/90–1576),
Sir Anthony van Dyck (1599–1641) and Sir Peter Paul

Rubens (1577–1640). These artists were highly regarded by
Reynolds and much praised in his *Discourses* of 1769–90.
The sale of his paintings included Rembrandt portraits,
history paintings and religious works, the latter being the
most numerous.

The religious works included *The Vision of Daniel*
[fig.134], now attributed to the workshop of Rembrandt,
but believed by Reynolds to have been by Rembrandt
himself.[5] Where or when he acquired this picture is not
known, but it might be identical to the canvas sold in
around 1715 in London by the art dealer Peter Anthony
Motteux (1663–1718) as 'Daniel's Vision of the Ram'.[6]
Though no longer attributed to Rembrandt, the sombre
picture attracted some fame in the eighteenth century. It
was exhibited towards the end of Reynolds's life in *Ralph's
Exhibition* in London in 1791, where the critic of the *Public
Advertiser* thought it 'one of the finest pieces of colouring

110 Rembrandt, *A Man in Armour ('Achilles')*, 1655
Oil on canvas, 137.5 × 104.4 cm
Glasgow Life (Glasgow Museums) on behalf of Glasgow City Council [cat.13]

which the art of painting can boast'.[7] Reynolds valued the work for this selling exhibition at the enormous sum of 600 guineas.[8] By comparison, another of Reynolds's Rembrandts – *Susanna and the Elders* [fig.133] – was valued at 350 guineas.[9]

Daniel did not find a buyer at this time for this sum and was consequently returned to Reynolds. The auction catalogue of his posthumous sale in 1795 lavished high praise upon the painting, which was singled out among his many Rembrandts: 'Sir Joshua estimated this picture very highly, stiling [*sic*] it the finest work of REMBRANDT'.[10] Moreover, another anonymous observer noted in a copy of the auction catalogue, now in the Victoria and Albert Museum, that the work displayed a 'grand effect'.[11] Nonetheless, despite these laudatory appellations, it was bought in (having failed to reach its auction reserve) at 170 guineas and was eventually sold the following week to the wine merchant Charles Offley, close friend of the artist Joseph Farington (1747–1821), for just 160 guineas.[12] Recently, conservation has revealed that Reynolds reworked many areas of the canvas.[13]

The group of Rembrandt paintings also included a fine example of the genre of historical portraiture, *A Man in Armour ('Achilles')* [fig.110]. The styling of this 'portrait' as Achilles occurred during Reynolds's lifetime when the painting was published by John Boydell in 1764 as a mezzotint under this title and citing its owner. Reynolds frequently referenced works in his extensive collection to illuminate points in his *Discourses*, and once cited this canvas. Rembrandt came under attack in *Discourse VIII*, delivered in 1778, for his strict adherence to realism at the detrimental expense of artifice:

> *Rembrandt, who thought it of more consequence to paint light, than the objects that are seen by it, has done this in a picture of Achilles which I have. The head is kept down to a very low tint, in order to preserve this due gradation and distinction between the armour and the face; the consequence of which is [...] sacrificed here to this narrow conception of nature...*[14]

Thus, continued Reynolds, the picture was 'so dark' and could only be viewed with 'difficulty'. Perhaps these were the reasons that he sold the picture to George Greville, 2nd Earl of Warwick (1746–1816) in 1790. The aristocrat's father had been a patron of Reynolds, commissioning

family portraits of himself, his eldest son and his eldest daughter. Later, the 2nd Earl of Warwick owned another of Reynolds's Rembrandt paintings, the commanding 1654 portrait of Floris Soop (1604–1657) known as *The Standard Bearer* (The Metropolitan Museum of Art, New York), but obtained after his death in 1792 from another source.[15]

Some of the other portraits that Reynolds owned were, in common with several of his religious works, reproduced in contemporary prints, signalling his appreciation of, and public association with, Rembrandt. One of these featured the 'portrait' *Man with a Red Cap* [fig.106] and depicts a standing scholar (perhaps an evangelist), pen in one hand and the other resting on an open book, before a desk.[16] The sitter's quizzical expression lends the 'portrait', which is essentially a character study in a biblical guise (a so-called *portrait saint*), a compelling quality. The model provided the point of departure into another genre outside of strict portraiture. Reynolds's own fusion of different genres, with multifarious quotations to create his likenesses, has a parallel here in Rembrandt's work. From the publication of the print, we know that Reynolds had come by this painting by 1765. It joined another late Rembrandt *portrait saint* of *The Apostle Bartholomew*, 1657 (Timken Museum of Art, San Diego), which Reynolds had obtained from the sale of the art dealer and connoisseur Dr Robert Bragge (1700–1777) in 1757 for 26 guineas.[17] This latter example was acquired by Reynolds before his grand move in 1760 to his large townhouse in Leicester Fields, and signalled the early ambition of his collecting activities.[18] It remains one of his finest Rembrandts.

Undoubtedly Reynolds's greatest Rembrandts, in number, quality and range, were the many dozens of examples he owned of his prints and drawings, which were sold by auction in 1798. They were sold by Harry Phillips in the spectacular eighteen-day sale in blocks. The subjects were very rarely indicated, but among the first group of etchings was that of *Christ Preaching* ('*The Little Tomb*', as it was known in the eighteenth century).[19] Included with the group were fourteen prints after Rembrandt, some of which were by Captain William Baillie (1723–1810).[20] In the second group was an example of *Adam and Eve* which may be the impression from Reynolds's collection sold in 1922 from the collection of the Revd Hilgrove Coxe, formed by his ancestor General Sir Hilgrove Turner (1764–1843).[21]

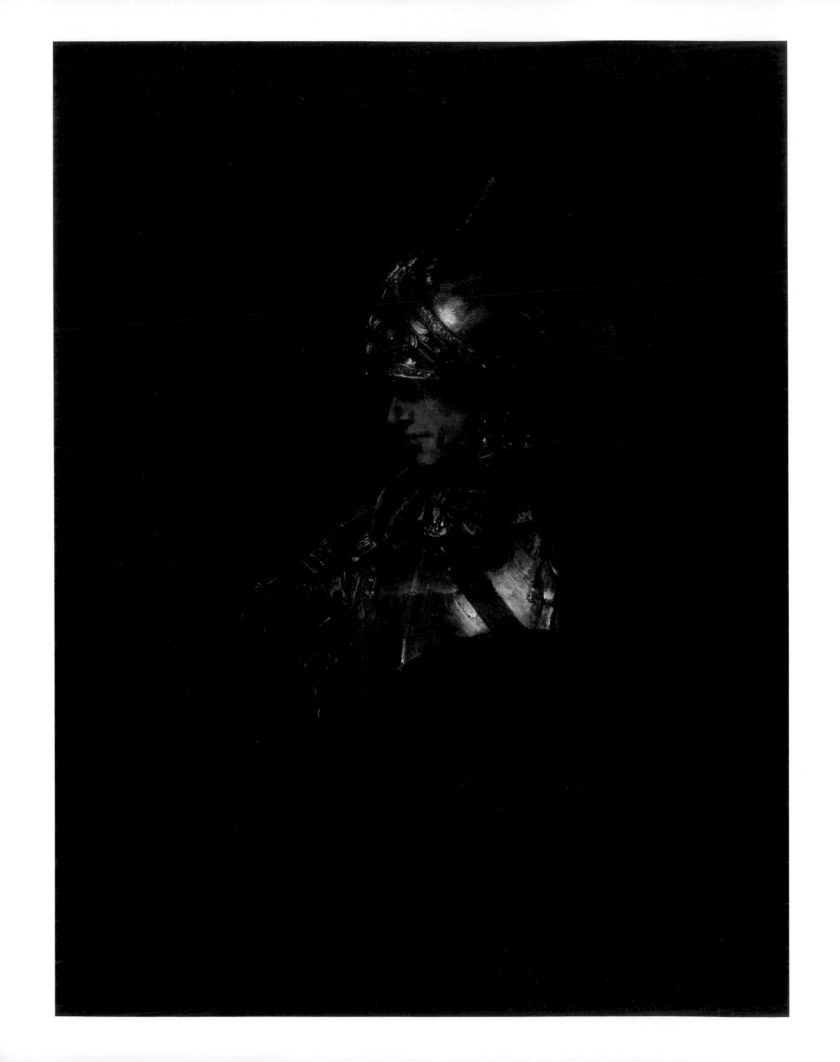

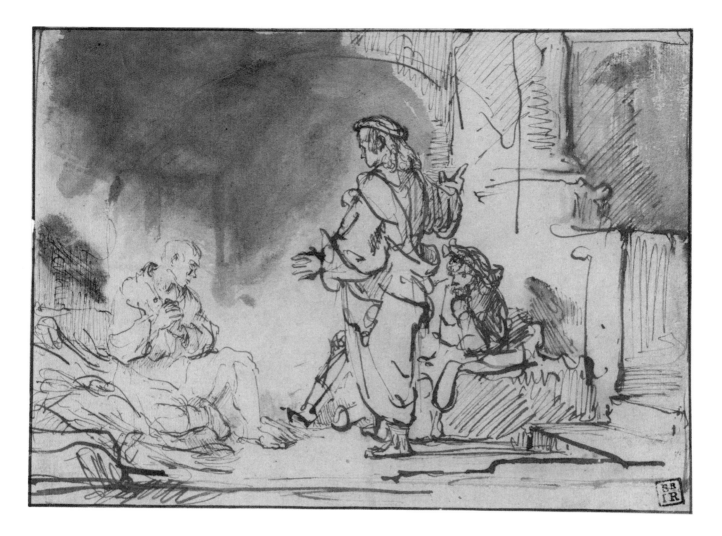

Towards the end of the multi-day sale, the drawings came to the block, but these are never described and were often grouped together.

Reynolds owned an extremely diverse group of Rembrandt drawings. In *Joseph Telling the Dreams of the Prisoners* [fig.111], we find vigorous brushwork with extensive wash to suggest the cavernous prison cell; the work is now attributed to Bol. In other examples that Reynolds owned, the figural relationship and density of the penmanship provides the emotive possibilities, with one work, *The Incredulity of Saint Thomas* [fig.109], signalling the authority but isolation of Christ through carefully constructed spatial dynamics. These works were matched by landscapes and topographical subjects such as a view of the Montelbaanstoren, Amsterdam, of around 1645 [fig.112], appropriately enough now in the collection of the Rembrandthuis, having 'returned' to Amsterdam in 1913. Genre subjects and figure studies in particular must have appealed to the portraitist, with his eye and mind ever seeking new figural relationships. One vividly arresting sheet is a series of studies of an old man, caught in a frozen moment of astonishment or surprise [fig.113].[22] Reynolds had obtained it from the sale of Jonathan Richardson the Younger (1694–1771) at Langford, London in February 1772.

The range and depth of Reynolds's Rembrandt collection meant that he could boast the same subject in different media or else had related drawings for the same work. For example, he owned a first-state impression of the etching *The Star of the Kings*, 1651, now at the Library of Congress in Washington, which he could match with a drawing, now in the Groninger Museum, of the same depiction of the traditional Dutch door-to-door procession by children asking for alms with a lantern shaped like a star (the 'star of the kings', after the biblical episode which guided the Magi to Christ).[23] The greatest pairing in Reynolds's collection was the ownership of *The Lamentation over the Dead Christ* [fig.65], together with a related preparatory drawing now in the British Museum.[24] The painting is a complex mixture of oil on paper and canvas sections mounted on panel. Smith described the work as an 'exquisite gem of art' which, though unfinished, he conceded 'possesses qualities of the highest order'.[25] It fetched 41 guineas at Reynolds's posthumous sale in 1795 as lot 38: 'THE DESCENT FROM THE CROSS, a capital [painted] sketch of this master, engraved by PICART. A particular account is to be seen on the back of it in SIR JOSHUA's hand writing.'[26]

111 Ferdinand Bol, *Joseph Telling the Dreams of the Prisoners*, *c*.1640
Pen and brown ink with brown wash, 16.7 × 22.9 cm
Kunsthalle, Hamburg

112 Rembrandt, *The Montelbaanstoren, Amsterdam*, *c*.1645
Pen and brown ink with brown wash, 14.5 × 14.4 cm
Museum Het Rembrandthuis, Amsterdam

113 Rembrandt, *Three Studies of an Old Man*, *c*.1635
Pen and brown ink on light brown prepared paper, 17.4 × 16 cm
Fondation Custodia, Collection Frits Lugt, Paris [cat.20]

He had obtained the related drawing from the sale of Jonathan Richardson the Younger. Here was Reynolds's interest in process and evidence of the creative struggle. Like he had done during his pupillage under Hudson, Reynolds had in turn sent his pupil James Northcote (1746–1831) to bid for him at Langford in London in February 1772. Under strict instruction, Northcote attended every day of the Richardson sale on behalf of his master:

> I purchased for Sir Joshua those lots which he had marked […] *One drawing in particular I remember, a descent from the cross by Rembrandt; in which were to be discovered sixteen alterations, or pentimenti, as the Italians term it, made by Rembrandt, on bits of paper stuck upon the different parts of the drawing, and finished according to his second thoughts.*[27]

Reynolds made many painted and drawn copies of Rembrandt paintings, drawings and etchings. In two particularly fascinating sheets, now in New Haven,

Reynolds has copied elements from eight Rembrandt etchings including *Abraham Casting out Hagar and Ishmael*, 1637, *The Persian*, 1632, and the portraits of *Cornelis Claesz Anslo, Preacher*, 1641 and *Ephraim Bonus, Jewish Physician*, 1647.[28] Stylistically datable to the early part of his career, they might have been drawn during his time under Hudson, possibly from examples in Hudson's own Rembrandt collection. In these cursory drawings, Reynolds has extracted interesting poses or gestures, removing them from their immediate narrative context. He distilled the essential elements of Rembrandt's etched work. In a few instances on one of these two sheets, he copied the entire compositions of two etchings – *Self-portrait with Saskia*, 1636 and *Self-portrait Etching at a Window*, 1648.[29] He seems to have made these two drawn copies together in one sitting, with the array of Rembrandt etchings before him.

The density of Rembrandts in eighteenth-century London meant that fellow collectors shared many

114 Rembrandt, *The Angel Leaving Manoah and his Wife*, c.1652
Pen and brown ink, with brown wash, 20.8 × 18 cm
Fondation Custodia, Collection Frits Lugt, Paris [cat.32]

115 Govert Flinck, *The Angel Leaving Manoah and his Wife*, c.1632
Pen and brown ink, heightened with white, 18.5 × 25.4 cm
Museum Boijmans Van Beuningen, Rotterdam

116 Rembrandt, *Abraham Entertaining the Angels*, 1656
Etching and drypoint on Japanese paper, 15.9 × 13.1 cm
National Galleries of Scotland, Edinburgh [cat.57]

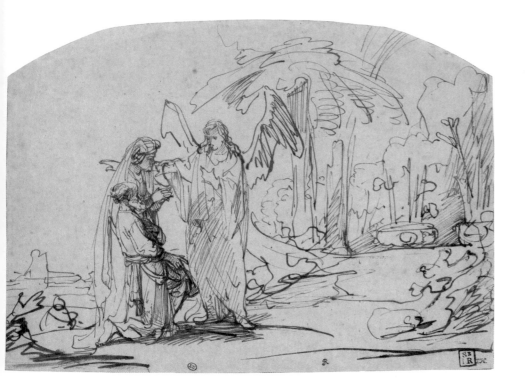

interesting connections or overlaps. A sheet now in Rotterdam of *The Angel Leaving Manoah and his Wife* [fig.115], owned by Reynolds (now given to one of Rembrandt's pupils, Govert Flinck, 1615–1660), was joined by another of the same subject, but dating to around two decades later [fig.114], in the collection of his friend Charles Rogers (1711–1784) and now in Paris.[30] Both had formerly been owned by Richardson the Elder but had become separated, one going to Rogers and the other to Hudson, before the latter ended up with Reynolds.[31] The one now in Paris retains its eighteenth-century mount with its complementary brown-washed ruled borders. In another example, a magnificent impression of the etching *Abraham Entertaining the Angels* [fig.116], owned by Reynolds and now in Edinburgh, paralleled the same subject in a painting of 1646 (private collection). It was described in 1836 as a 'little bijoux of art' and was once owned by the painter, and successor of Reynolds as the President of the Royal Academy, Benjamin West (1738–1820).[32]

The source of Reynolds's artworks is not always clear. He fails to mention a single acquisition in his surviving correspondence. From the many collectors' marks found on his graphic art collection, former owners, especially British ones, can be deduced: Jonathan Richardson the Elder, and his son, Jonathan Richardson the Younger, Hudson, Astley, Nathaniel Hone (1718–1784) and Jan van Rymsdyk (c.1730–c.1788/89). Most of these were painters and reinforced the eighteenth century's painterly fascination with Rembrandt. The latter collector is particularly interesting because it is generally supposed that the dispersal of his collection took place at around the time of his death in 1788–89. No recorded sale is known for him but, judging from the many examples by Rembrandt that passed from Rymsdyk to Reynolds, the latter must have been augmenting his superb Rembrandt collection very shortly before his own death in 1792. The 'Rembrandt' sheets that Reynolds owned from Rymsdyk included *Elijah and the Angel*, c.1651–53 by Willem Drost (1633–1659) in the Rijksmuseum, and one sheet now in Paris, among many others.[33]

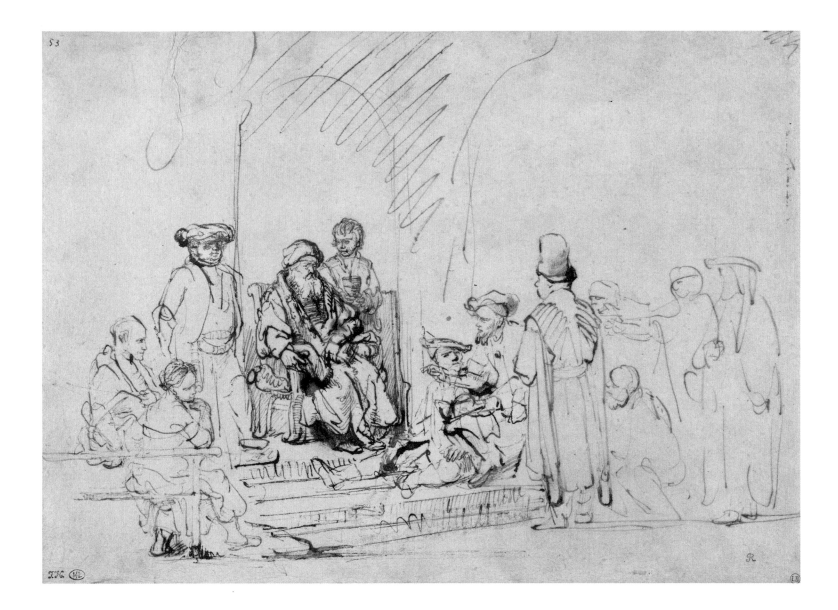

117 Rembrandt, *Jacob and his Sons*, c.1640

Pen and brown ink, brown wash, white bodycolour and red and black chalk, 20 × 27.6 cm
Musée du Louvre, Paris [cat.23]

118 Simon Watts, after Rembrandt, *Joseph Interpreting Pharaoh's Dreams*, from Charles Rogers, *A Collection of Prints in Imitation of Drawings* (Volume II), 1766 (plate); 1778 (published)

Etching and aquatint in brown ink, 29 × 35.5 cm
National Galleries of Scotland, Edinburgh [cat.130]

119 Joshua Reynolds, Manuscript journal of his travels in the Netherlands, 1781

Pen and brown ink and red chalk, 19.4 × 31 cm (double page)
Fondation Custodia, Collection Frits Lugt, Paris [cat.121]

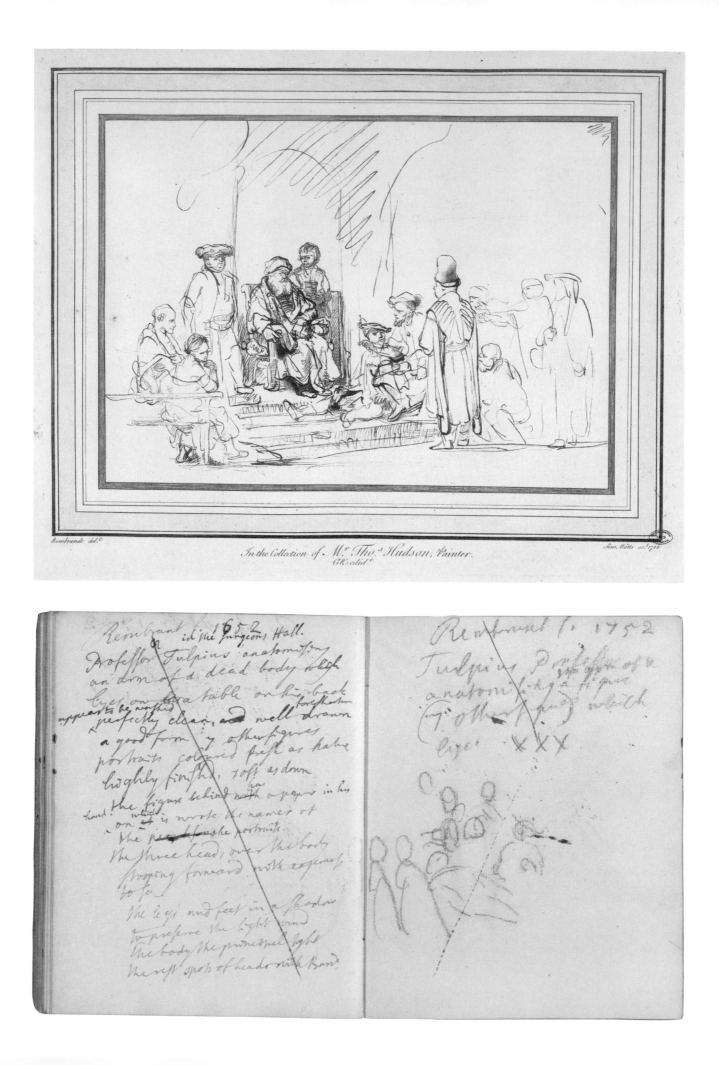

120 Joshua Reynolds, *Self-portrait*, c.1780
Oil on panel, 127 × 101.6 cm
Royal Academy of Arts, London

In parallel with the dissemination of Reynolds's Rembrandt painting collection, his burgeoning and far larger holdings of drawings also began to draw wider public interest. In 1778, his friend Rogers published the two-volume *A Collection of Prints in Imitation of Drawings* [fig.118]. Reynolds had allowed several choice specimens of his Rembrandt drawings to be reproduced in this huge project that was over two decades in the making. The publication set new high standards for the reproduction of drawings. The reproductions carefully replicated the media and technique (and direction) of the drawings, every mark and line (even if incidental), and were printed in the same colour of ink as the originals. Etched lines printed in brown ink reproduced Rembrandt's favoured drawing technique of pen and brown ink, and brown wash was reproduced by aquatint printed in brown ink. Rogers chose the printmaker Simon Watts to reproduce most of the Rembrandts, which he worked on from 1765 to 1767, with William Wynne Ryland and William Hebert producing the others. The range of Rembrandt's drawn output was highlighted with multi-figured biblical narratives contrasting with modest genre subjects composed of single figures. The historic eighteenth-century wash-line mounts, typically edged in gold, around each drawing were also carefully reproduced. These are invaluable, since most of these mounts are now lost. Eight drawings by Rembrandt were included in the influential publication: three each then owned by Hudson and Reynolds (those of the latter were *A Boy Telling his Story*, 1762 (untraced); *An Old Man Knocking at a Door*, 1763 (Szépművészeti Múzeum, Budapest); *An Old Woman Reflecting On What She Has Been Reading*, 1763 (Museum Boijmans Van Beuningen, Rotterdam)); and one each owned by Ralph Willett (*Turks Drinking Coffee*, 1767 (British Museum, London)) and Rogers himself (*A Monk Sitting in his Cell, in Devout Meditation*, 1763 (untraced)).[34] One of Hudson's superb drawings included in the publication is now identified as *Jacob and his Sons* but was then described differently (as 'Joseph Interpreting Pharaoh's Dreams') [fig.117]. Hudson obtained many of his Rembrandt drawings from the sale of the painter and collector Richardson the Elder in 1747. His sale was a major event of the decade and released onto the market a great trove of superb Rembrandt drawings.[35]

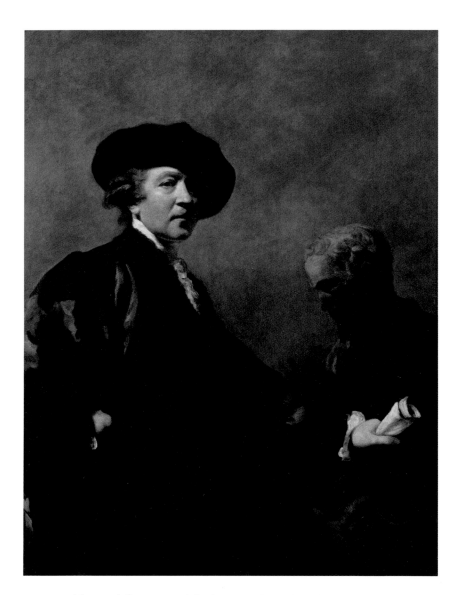

Reynolds was fully aware of the legions of Rembrandt pupils that had trained and worked in a somewhat uniform style under the master. In 1781, Reynolds set off for an extended trip to the Low Countries accompanied by his friend Philip Metcalfe (1733–1818). He made extensive notes in four notebooks, with a view towards publication, one of which is now in the Fondation Custodia, Paris [fig.119]. On the tour of one collection in Düsseldorf, he reattributes a work traditionally thought to be by Rembrandt (and now in the Alte Pinakothek, Munich) to

one of his pupils, Govert Flinck: 'The portraits of Flinks and his wife, said to be of Rembrandt, but I think, from the yellow bad taste of colouring, that they are rather by Flinks himself.'[36] In Amsterdam's Town Hall, Reynolds delivers a crushing verdict on Rembrandt's celebrated *The Night Watch*, 1642, finding it undeserving of 'its great reputation' and even judging it as being 'more of the yellow manner of Boll [*sic*]' than the master himself.[37] He reinforces his opinion in a note made in the Parisian notebook where he thinks the vast canvas is 'the worst of him I ever saw'![38] He did, though, take great delight in citing related works in his own collection to those he encountered in the Netherlands. In The Hague he spotted a work, now in the Mauritshuis, related to his own *Susanna and the Elders*, now in Berlin:

> *A STUDY of a SUSANNA, for the picture by Rembrandt which is in my possession: it is nearly the same action, except that she is here sitting. This is the third study I have seen for this figure. I have one myself, and the third was in the possession of the late Mr. [John] Blackwood. In the drawing which he made for this picture, which I have, she is likewise sitting [...].*[39]

The drawing to which Reynolds refers is now in the Louvre, Paris.[40]

Reynolds is known to have painted four copies after Rembrandt: *Girl at a Window*, c.1780 (Hermitage, St Petersburg), and three others including one after *The Tribute Money*, c.1770 (private collection) and two untraced examples after self-portraits.[41] Rembrandt's self-portraiture in both practice and method was an important touchstone for Reynolds throughout his life, from his earliest encounters in Hudson's studio to his ascendency as head of the Royal Academy for many decades. He clearly wished to establish a painterly lineage from Rembrandt to himself.

Towards the end of his life, Reynolds intended to build a picture gallery for his large art collection and open it up to the public. However, he later decided to offer his collection for sale, except for three Italian paintings which he was loath ever to part with. A display titled *Ralph's Exhibition* was held in April 1791 at 28 Haymarket, in central London, close to Reynolds's home in Leicester Fields. The name of the show derives from Reynolds's former servant, Ralph Kirkley, to whom the profits from the one-shilling admission charge would be directed. For Reynolds it was his last, and very public, expression of his deep affection for Rembrandt, who was represented in the display with several works. Reynolds died less than a year after the close of the exhibition. His devoted pupil Northcote asserted, in his characteristically biased opinion, that Reynolds's mature practice was an amalgam of various influences from both Italy and the Low Countries: 'To the grandeur, the truth, and simplicity of Titian, and to the daring strength of Rembrandt, he has united the chasteness and delicacy of Vandyke.'[42]

Indeed, these 'daring' qualities are evident in one of Reynolds's grand late self-portraits [fig.120]. The self-portrait was a special one, for it was destined to hang in the Assembly Room of the newly relocated Royal Academy of Arts in the sumptuous accommodation of Somerset House.[43] Parallels may be drawn with Rembrandt's *Aristotle with a Bust of Homer* [fig.137] that was once owned by Reynolds's friend Sir Abraham Hume (1749–1838) by 1815, perhaps earlier.[44] The striking composition, tonality and colouring owe much to the Dutch artist. Reynolds's homage to Rembrandt in his imposing likeness intended for his cherished Royal Academy was the summation of his long engagement with Rembrandt's art.

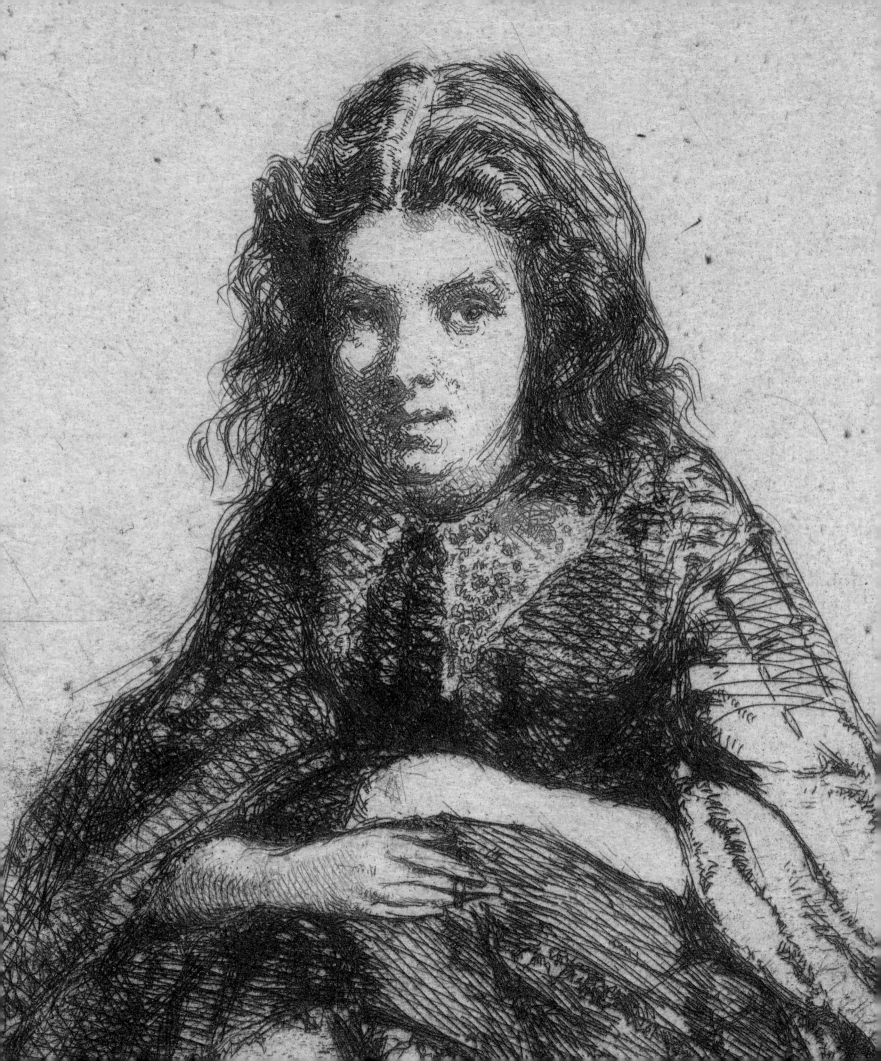

6

REMBRANDT: PARAGON OF THE ETCHING REVIVAL
PETER BLACK

The second half of the nineteenth century witnessed a revival of the practice of etching, an art of which Rembrandt is frequently invoked as the greatest practitioner. The proliferation of etchings that occurred especially in Britain, but also in the Netherlands, the United States and elsewhere, was closely connected with Rembrandt's rising fame, and particularly with increased public awareness of his etchings, through museum displays, exhibitions organised by societies and commercial galleries, and illustrated books. The growing popularity of etching can be attributed, to a large extent, to the much-publicised activities of just two etchers with strong personalities. A significant factor which explains how Rembrandt became such an important source of inspiration for the etching revival – rather than, say, Claude Lorrain (1604–1682) or Sir Anthony van Dyck (1599–1641) – is that one of the two etchers, Sir Francis Seymour Haden (1818–1910), was also a major collector of Rembrandt's etchings. Haden shared his enthusiasm for Rembrandt with the other, the only great artist of the etching revival, his brother-in-law, James Abbott McNeill Whistler (1834–1903), and planted in the mind of the young artist a desire to emulate Rembrandt as an etcher.

Whistler and Haden's shared enthusiasm for Rembrandt's prints began when the fourteen-year-old Whistler was sent to boarding school in England in 1848, soon after Haden's marriage to Whistler's half-sister Deborah. As a surgeon, it was not obvious that Haden would become a vociferous promoter of etching, but he had two important qualifications for that role. Like some doctors of the time, he studied drawing for the purpose of medical research. He had also trained and worked in France, where etching was more commonly practised. He made his first etching in 1845, after which there was a long gap until 1858, when he took it up again inspired by seeing Whistler's 'French Set'. At about the time that Whistler began to visit Deborah and her husband during his school holidays, Haden took up print collecting as a hobby. Many

years later, he stated that his collection began early in his days in private practice. Needing to take regular walks as a distraction from work, he started visiting 'the second-hand print shop kept by a man of the name of Love'.[1] Although Whistler emerges as by far the greater of the two, Haden also rose to fame, and from 1865, when the twenty-five etchings of his *Études à l'eau-forte* were published, he was regarded by many as the leader of the etching revival [fig.122]. Haden was soon outshone by Whistler's impressive etchings – especially the two Venice sets of 1880 and 1886 [fig.123], not to mention hundreds of separate prints, both etchings and lithographs – but Haden's life was dedicated to the art of etching. By 1867, his collection of Rembrandt's etchings was important enough that it was consulted, with that of the British Museum, for examples of Rembrandt's etchings to be reproduced photographically in a book which included the historical biography written by the Amsterdam archivist Pieter Scheltema (1812–1885).[2] Through establishing the Society of Painter-Etchers in 1880, and through his lectures, Haden was responsible to a large extent for creating the conditions in which etching flourished.[3]

Before discussing the significance of Haden's and Whistler's role in promoting etching and the use that they and others made of Rembrandt's etchings, some clarification is needed of the phrase 'etching revival' and an indication of the significance of the phenomenon, which has both an artistic and a business dimension. The following remarks give some historical context. They come from a lecture given in London in 1921 to the Print Collectors' Club by Martin Hardie, who was keeper of prints and drawings at the Victoria and Albert Museum:

It was not until the middle of last century that the new movement really began, and we must recognise that it received its first notable impulse from the etchers of France. In France the period from 1840 to 1865 covers the finest work of Jacque, Millet, Corot,

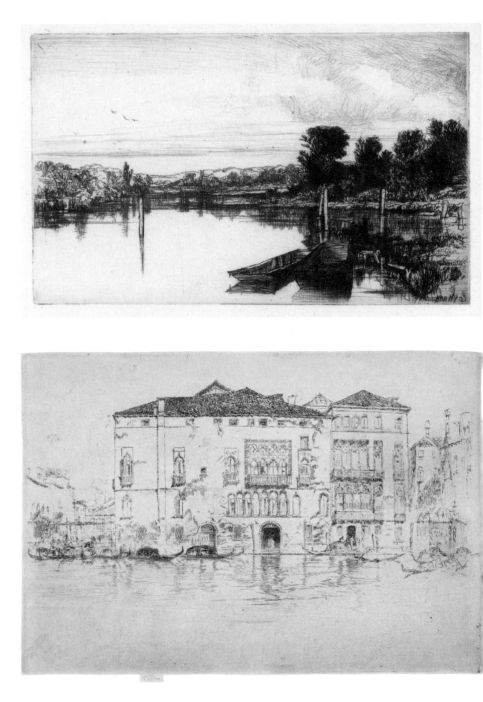

122 Francis Seymour Haden, *Egham*, 1859
Etching and drypoint, 12.5 × 20.2 cm
Rijksmuseum, Amsterdam

123 James Abbott McNeill Whistler, *The Palaces (Venice)*, c.1880
Etching, 25.1 × 35.9 cm
National Galleries of Scotland, Edinburgh

Daubigny, Méryon, Bracquemond, Jacquemart – a wonderful period in etching, as in painting. Here during the 'fifties, the art of etching was neglected or misunderstood. A few artists and amateurs practised etching and formed an Etching Club in London, which issued various publications beginning with a set of illustrations to Goldsmith's 'Deserted Village' in [1841] [...] In [1858], therefore, the art of true etching crossed the Channel, and set firm foot on English soil, and Whistler – American-born, but surely to be reckoned, with fairness in the British School of Etching – rose as the greatest master, the greatest personality, in the history of modern etching. Are we to go further? For there are some who set him beside Rembrandt, perhaps above Rembrandt, as the greatest master of all time.[4]

Hardie's perspective is respectful of the British scene. It is accurate in naming Whistler as central figure, and in linking him with his paragon Rembrandt; but his view was limited. Aesthetic ties between Britain and France were close, hence his main focus was France, where Haden and Whistler both worked and exhibited. Hardie excludes avant-garde printmakers; or, more accurately, the generally old-fashioned 'etching revival' style of printmaking, harking back to seventeenth-century masters, had successfully drowned them out. He also seems unaware of the fact that Germany, which by 1900 was emerging as the largest economy in Europe, had an equally fertile market for the graphic arts. Artists such as Max Klinger (1857–1920) and Käthe Kollwitz (1867–1945) achieved fame comparable to that of Whistler and Haden, but with very different kinds of print. Rembrandt's art, including his etchings, had an undeniable effect on the artists of German Expressionism. British and German printmakers, however, excelled in different subject matter: the British in landscape, while German artists focused on the human figure. Whereas Rembrandt's etchings had the greater influence on British art, it was the extraordinary brushwork and monumental figures of Rembrandt the painter, along with Frans Hals (c.1580/85–1666), that made the greatest impact on expressionist painters, including those who were prolific printmakers such as Lovis Corinth (1858–1925) and Max Beckmann (1884–1950).

The etching revival was in reality one of several fads in print collecting. Prints – especially engravings made as decoration rather than as works of art – were commodities

124 Hablot Knight Browne ('Phiz'), *Steerforth and Mr Nell,*
Illustration to *David Copperfield* by Charles Dickens, 1849–50
Etching, 13.3 × 21 cm
Victoria and Albert Museum, London

125 William Powell Frith, *The Derby Day*, 1856–58
Oil on canvas, 101.6 × 223.5 cm
Tate

126 Auguste Blanchard, after William Powell Frith, *Derby Day*,
1862–63
Engraving, 60 × 118 cm
The Hunterian, University of Glasgow, Glasgow

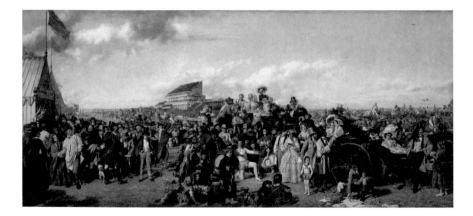

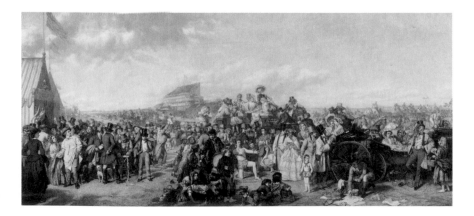

with which earlier painters, publishers and engravers had
made fortunes. The revival was a small, highbrow offshoot
of the expanding Victorian market for inexpensive works
of art. 1850 was indeed the heyday of printed images of all
sorts. The most numerous were journal or book illustrations,
including vast numbers of travel books illustrated with
engravings after Joseph Mallord William Turner (1775–1851).
More influential on the development of etching were the
illustrations to Charles Dickens's amazingly popular novels
etched by 'Phiz' (Hablot Knight Browne, 1815–1882) and
George Cruikshank (1792–1878) [fig.124]. Multiple plates of
each image were needed for the later instalments of *Pickwick
Papers* (1836–37), which were published in series to more
than 40,000 subscribers. The market for prints intended for
the wall was also larger than ever. There were now millions
interested in art. They could not buy a Rembrandt or a
Pre-Raphaelite painting, but for them a new kind of indus-
trial print publisher invested in making engravings which
translated best-sellers into affordable black-and-white prints.

Prints were big business. Ernest Gambart, the pluto-
cratic publisher of Auguste Blanchard's 1862–63 engraving
after Frith's *Derby Day* painting, which was exhibited to
a rapturous public at the Royal Academy of Arts in 1858,
may not seem to have much in common with Rembrandt
[figs 126 & 125]. Yet, while the scale of business had
increased dramatically since Rembrandt's times, printsellers'
practices had changed little. Rembrandt's etchings allowed
his hand-printed works of art to be enjoyed on the other side
of Europe, and multiple sales brought him a valuable income.
Rembrandt was famous for his sharp commercial nose, as
we know from the treatise on painting by his pupil Samuel
van Hoogstraten (1627–1678). Hoogstraten urges painters
to 'publish your works as prints as in this way your name
will fly that much more swiftly around the world. Albrecht
Dürer and Lucas van Leyden were wonderful painters, but
they acquired their greatest fame though their work with the
burin.'[5] As nineteenth-century artists became more familiar
with Rembrandt the printmaker, they realised that he too
was a businessman who 'played' the market, consciously
using devices such as printing on rare oriental paper, or
re-issuing an existing print in a new state, to stimulate
demand for his products. It was Whistler, as he prepared to
exhibit his 'First Venice Set' at the Fine Art Society in 1880,
who invented several of the presentation techniques which

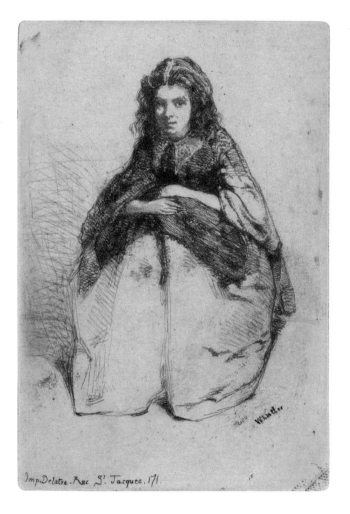

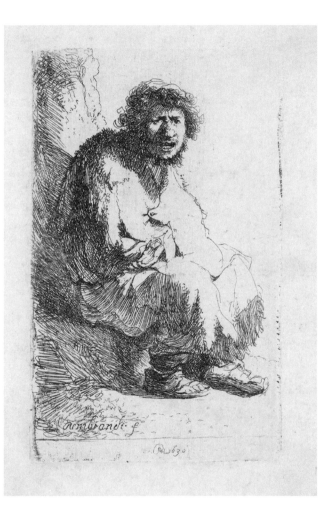

are still standard among printmakers, including adding a signature by hand and the limiting of editions. Mindful of Gambart as much as Rembrandt, he chose fine old papers, printed the etchings himself and exhibited sets of cancelled plates to demonstrate that no more impressions could be printed. In this way, he created a sense that his prints were special works of art and gave them the artificial rarity that was a device already used in pricing prints such as *Derby Day*, which was issued in various editions on different qualities of paper, a smaller number categorised as 'proofs' to justify a higher price than ordinary 'prints'.

Rembrandt's work had reached an extraordinary level of popularity, prompting the great Romantic painter Eugène Delacroix (1798–1863) to muse, 'blasphemously'

as he put it, in 1851: 'Perhaps they will discover that Rembrandt is a far greater painter than Raphael'.[6] The impact of Rembrandt's rising reputation, both as a painter and etcher, can be seen in the selection of the 1857 Manchester *Art Treasures* exhibition, which was 'the largest and most spectacular art exhibition ever mounted in Britain'.[7] Many thousands of paintings were the main attraction, but there was also a substantial display of prints: 1,859 of them were exhibited in the north-west and south-west transept galleries, including 'commercial' engravings after Turner, who had died only a few years earlier; but the display focused on prints as works of art, providing what the expert Edward Holmes called 'a complete chronological series of prints from the commencement of the art up to the

present time'.[8] With seventy-three works (nos 1149–1221), Rembrandt was the best represented of the etchers, but his individual contribution was still outstripped by the eighty-eight prints (nos 202–289) of the Renaissance engraver Marcantonio Raimondi (c.1480–c.1534), whose reputation, resting on his association with Delacroix's god Raphael, was at its peak. As etching gained in popularity, the reputations of even consummate engravers suffered. Appreciating that Rembrandt's etchings were produced with a remarkable economy of effort, etchers distinguished their own 'intellectual' activity from the mechanical labour of the 'reproductive engraver'. According to Haden in a lecture to the Royal Institution: 'It is the power of selection that marks the great etcher, and the amount of time expended is of no account, as the greater the effort the less interesting the result.'[9]

Visitors came from all over Europe to see the Manchester exhibition, including the young Whistler, who travelled from Paris where he was training as an artist. He may have created one of his first etchings, *The Dutchman Holding a Glass*, 1857, in response to Dutch genre subjects he saw at Manchester.[10] Certainly he soon embarked on the twelve etchings of his 'French Set', of 1858, which Hardie noted as the first British landmark of the etching revival. Seven subjects are monumental figures, partly inspired by Rembrandt's plates of beggars – *Fumette* [fig.127] crouches with hunched shoulders in a manner reminiscent of Rembrandt's *Beggar Seated on a Bank* [fig.128].[11] One of three landscapes, *Street at Saverne*, 1858, is a richly inked 'nocturne', printed with a dark layer of surface ink to create the night sky. Significantly, Whistler was already emulating Rembrandt's effects of surface inking.[12] The 'French Set' was printed by Auguste Delâtre (1822–1907), who worked for established artists such as Charles Méryon (1821–1868), Charles-Émile Jacque (1813–1894) and Jean-François Millet (1814–1875). According to the critic Philippe Burty, writing in 1864: 'Delâtre is an artist rather than a printer, and he is *par excellence* the man to print etchings'.[13] Delâtre was close to art dealers as well as artists and had clearly put into practice what he had learnt from studying Rembrandt's printing technique. His expertise is certainly the explanation for a touching dedication to Delâtre which Haden inscribed in a presentation copy of his book *The Etched Work of Rembrandt, a Monograph* (1879): 'To Delâtre. If he

had lived in Rembrandt's time, Rembrandt would certainly have used him to print his etchings.'[14] And Delâtre seems to have enjoyed Haden's compliment, which was repeated by the critic Jules-Antoine Castagnary in his preface to Delâtre's own book on etching, *Eau-forte, pointe sèche et vernis mou par Auguste Delâtre* (1887).

The book which Haden dedicated to Delâtre was the culmination of his research into Rembrandt the etcher.[15] It followed an exhibition that Haden organised in 1877 at the Burlington Fine Arts Club, in which for the first time Rembrandt's prints were arranged in chronological order. Haden explained that replacing 'an unintelligent and incoherent classification' with 'a more consecutive method of arrangement' meant that 'new matter, yet unsuspected in regard to the Etched Work of Rembrandt might be brought to light, and grave errors of attribution, especially in some of his larger published plates, be both proved and rectified.'[16] Of *Christ before Pilate* [fig.129], which is now universally believed to be by Rembrandt and his pupil Jan Gillisz van Vliet (1605–1668), he wrote perceptively that it 'is no more than an able copy, largely touched upon by Rembrandt and published by him solely for commercial purposes'.[17]

At this point, just before his apotheosis as first President of the Society of Painter-Etchers in 1880, Haden had abandoned making etchings, while Whistler was producing a series of masterpieces which form one of the greatest contributions to the history of printmaking. Whistler's two Venice sets, which Sickert described as 'triumphs of selection and summary expression in pure line', are the greatest etchings of Impressionism.[18] In contrast, much etching of the period seems stranded beside the mainstream of art history. More than anything, it was their absorption in the excellence of their work as etchings that has kept the 'etching revival' artists in quarantine. While Whistler seems to have made only creative use of Rembrandt, damage was done by critics who took too seriously the idea that the etchers might outdo their paragon. One of the worst offenders was the etcher Joseph Pennell, who published with his wife Elizabeth a fine biography of Whistler in 1908 but went on to publish *Etchers and Etching* (1920), in which he heaps exaggerated praise on Whistler at Rembrandt's expense. He describes Rembrandt's *The Windmill*, 1641, as 'The only really good landscape and architectural subject

129 Rembrandt and Jan Gillisz van Vliet, *Christ before Pilate* (the large plate), 1636
Etching and engraving, 54.3 × 44.7 cm
Museum Boijmans Van Beuningen, Rotterdam

Rembrandt ever did – and yet this does not for a moment compare with Whistler's *The Unsafe Tenement* [fig.130] or numbers of the *Thames* series'.[19]

While Delâtre was known as a printer worthy of Rembrandt, Whistler was soon above comparison. So, it was the excellence of Whistler's printing that struck Camille Pissarro, when he wrote to his son Lucien at the time of the 1883 Fine Art Society exhibition: 'Whistler mainly works in drypoint, and sometimes in plain etching, but the versatility which you identify, the velvety quality, the shimmer which charms you is a kind of wiping-out done by the printer, who is Whistler himself: no professional printer could replace him'.[20]

The etching revival owed a great deal to Haden but more to Whistler. Their love of Rembrandt would be shared by many artists after them, including the Glasgow artist Sir David Young Cameron (1865–1945), who donated his fine collection of Rembrandt etchings to the National Galleries of Scotland. Cameron's career was in some ways modelled on Whistler's, publishing his etchings in sets, and undertaking sketching trips for the purpose, a tradition that went back to Turner. Haden's and Whistler's influence on Cameron and others was cruelly but elegantly summed up by Walter Sickert, who wrote:

> *I think we must attribute much of the confusion that reigns in this country on the subject of etching to the fact that it is still the children of the founders of the loosely called revival of 1850 who have the ear of the country. And it is time to say that the English revival of 1850–60, though transplanted from Paris to London with zeal, much, far too much, eloquence, and some remarkable talent, which no one appreciates more than I do, was essentially an amateur's revival, with all the characteristic defects and vices of amateurishness.*[21]

Another whose life and career benefited enormously from the etching revival was the Edinburgh artist Ernest Lumsden (1883–1948). His *Art of Etching* (1924) provides a particularly useful manual for artists, and includes a substantial account of the most prominent etchers. His final section is titled 'the Moderns', and although he presents Sir Muirhead Bone (1876–1953), Augustus John (1878–1961), Sir Frank Brangwyn (1867–1956), Cameron, Sir George Clausen (1852–1944), Edmund

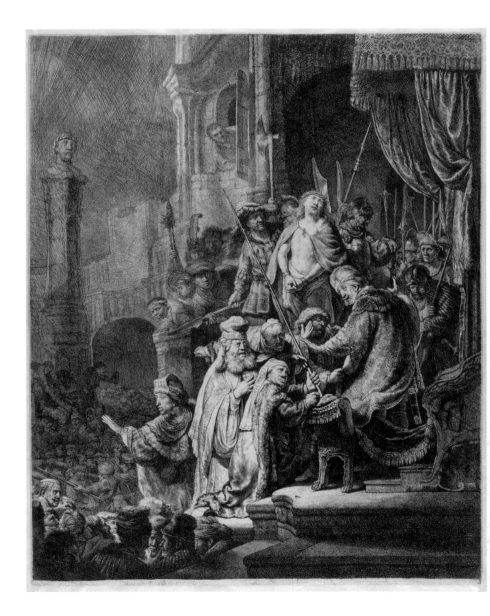

Blampied (1886–1966) and James McBey (1883–1959) as great draughtsmen, his writing is defensive, and we can glimpse the anxiety he feels about describing as 'moderns' artists whose work he knew to be old-fashioned. To justify his enthusiasm, he resorts to the familiar paragon, saying: 'None of these men showed the slightest trace of the modern movement, and every one of them has been – more or less directly – influenced by Rembrandt.'[22]

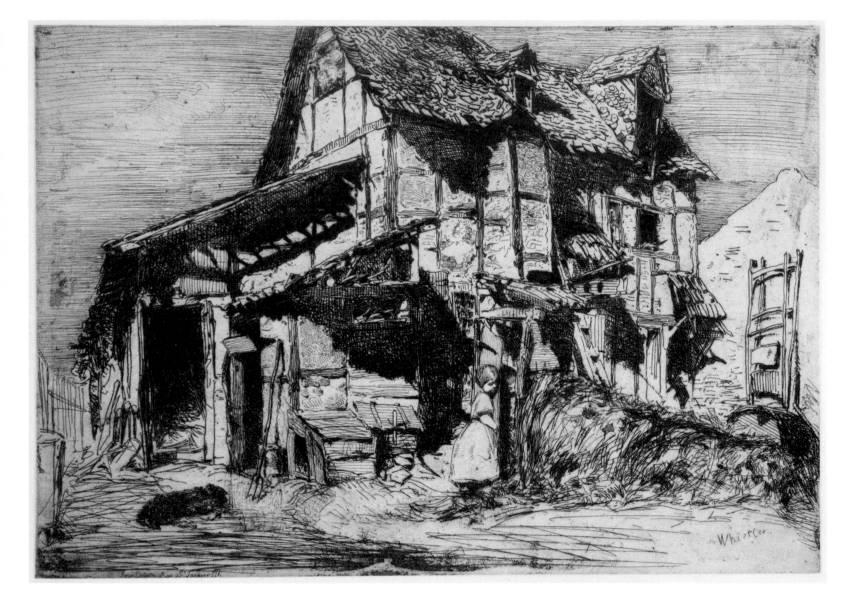

130 James Abbott McNeill Whistler, *The Unsafe Tenement*, 1858

Etching, 15.8 × 22.6 cm

The Hunterian, University of Glasgow, Glasgow [cat.132]

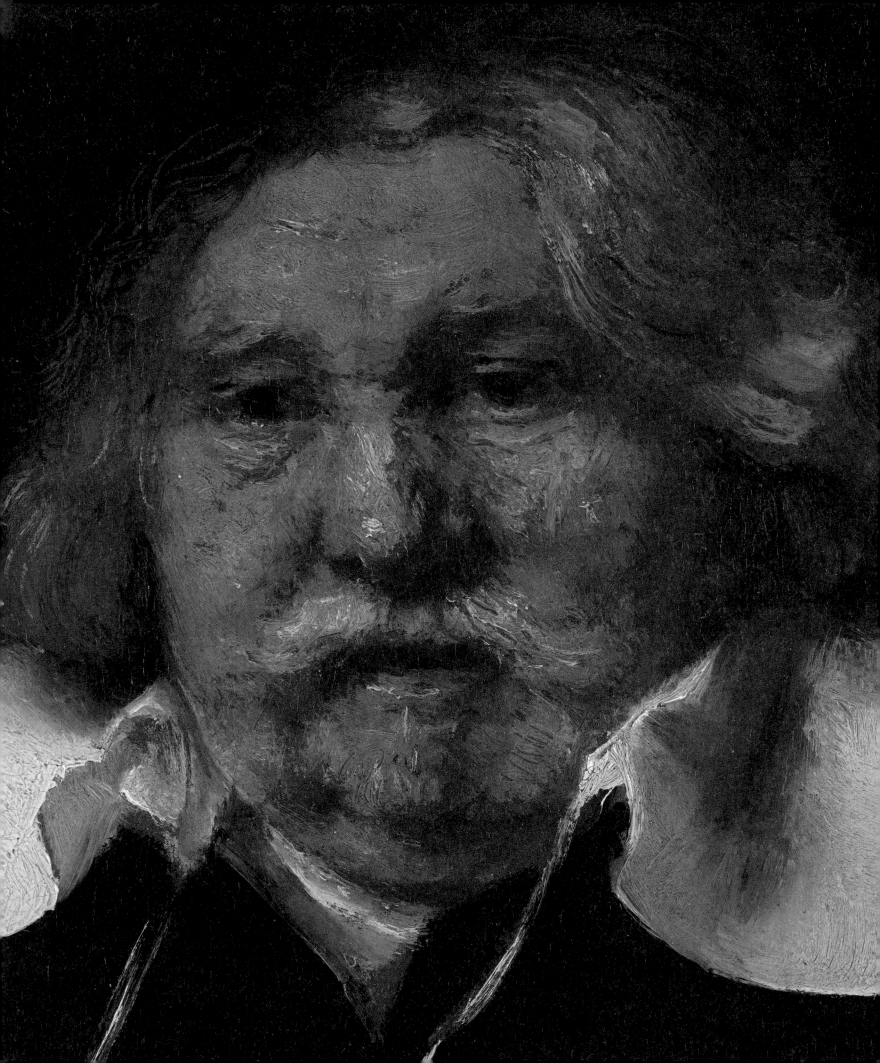

7

REMBRANDT AND BRITAIN:
A 'PICTURE FLIGHT' IN THREE STAGES, 1850–1930
M.J. RIPPS

The years 1850–1930 marked an especially dynamic period in the sale of Dutch old masters from Great Britain. Calling attention to various illustrious cases, this essay takes the fundamental position that the geographical distribution of pictures by Rembrandt, as it exists today, is deeply wedded to the public and private sales of Rembrandts within Great Britain during the eighty years under review. In the period, four principal factors ultimately coincided to alter the geography of seventeenth-century Dutch masterpieces – and above all works by Rembrandt – irrevocably.

In the first place, agricultural hardship within Britain precipitated changes in inheritance laws, which in turn enabled major sales of aristocratic collections at public auction and by private treaty. That hardship, coupled with the concomitant rise of old-master exhibitions at the Royal Academy of Arts every winter from 1870 onwards, signalled precisely what fabled treasures might soon become available, thus underscoring the second key factor: an appealing picture supply.[1]

Succinctly and simply put, the Settled Land Acts of 1882 forever changed the destiny of Rembrandt pictures. As the new laws allowed land and chattels to be sold – with the proviso that the proceeds were held in trust – they catalysed a series of high-profile picture sales: privately through the leading dealers of the day, and at public auction. The sale of thirty pictures by Lord Lansdowne to Thos. Agnew & Sons (a venerable firm in London's Bond Street) in April 1883, for instance, and the Hamilton and Blenheim Palace sales at Christie's in King Street, St James's (July 1882 and July 1886 respectively), are illustrative of the burgeoning flood of top-flight works onto the market.[2]

In addition to these two vital factors, the period saw the emergence of art-historical scholarship on the Continent (mainly by the German museum official Wilhelm von Bode (1845–1929) and the Dutch scholars Abraham Bredius (1855–1946) and Cornelis Hofstede de Groot (1863–1930)) and of public exhibitions devoted to the Golden Age, whose

intellectual foundations were rooted in the French critic Théophile Thoré-Bürger's (1807–1869) canon of Dutch art. The canon that scholar espoused in the commentaries he penned during the 1850s and 1860s increasingly shifted taste towards the Rembrandt–Hals–Vermeer triumvirate, thereby causing a steep rise in picture prices.[3] Lastly, the arrival of an exceptionally wealthy, competitive set of new collectors ambitious to acquire such trophies – particularly in Germany and America (but also in Belgium, France and even in the Netherlands), where Rembrandt achieved cult-like status as *the* artistic genius of his time and place – proved the final essential element in catalysing the flight of Rembrandt pictures from Britain.[4]

The convergence of these four factors altered the geography of old masters appreciably, resulting in a long-standing loss of national patrimony in Great Britain – later inadequately, albeit sincerely, addressed in part by the establishment of the National Art Collections Fund (1903). The Art Fund, as it is known today, might be perceived as an organic response to a certain degree of public furore and press polemics that had arisen in Britain whenever significant old masters were relinquished.[5]

In any event, these eighty years can be divided into three distinct periods where the flight of Rembrandt pictures from Great Britain is concerned: 1850–1880 marked a slow trickle – owing to modest interest, rather than a lack of supply; 1880–1914 marked a veritable exodus of choice works, which rivalled the Napoleonic period in commercial activity; while 1914–1930 saw a (comparative) trickle return, but nonetheless with greater appetite than the mid-nineteenth century. In this last period, after all, a number of very significant sales occurred, and the waning market appears to have been more a function of a dwindling supply of masterpieces than of any lack of desire for such works. What is more, these discernible demarcations in the Rembrandt picture chase were far from localised patterns in the London trade; rather, as noted above, they were linked

132 Rembrandt, *Portrait of a Man Rising from his Chair*, 1633
Oil on canvas, 124.1 × 98.4 cm
Taft Museum of Art, Cincinnati

133 Rembrandt, reworked by Joshua Reynolds,
Susanna and the Elders, c.1635–47
Oil on panel, 76.7 × 92.9 cm
Gemäldegalerie, Staatliche Museen zu Berlin, Berlin

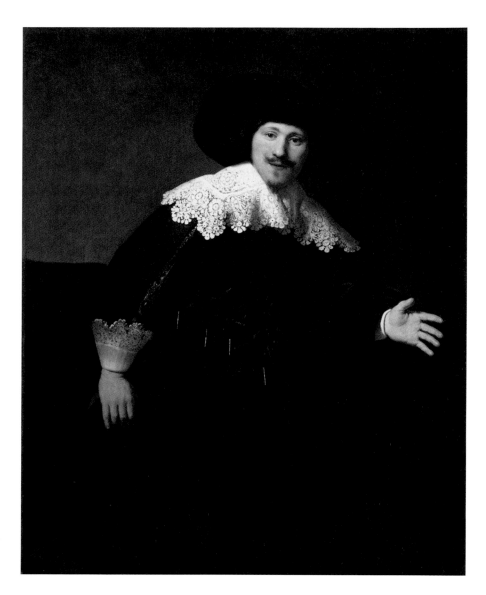

to national and indeed international economic – and even political – conditions.

Unsurprisingly given the British aristocracy's depreciating fortunes throughout the nineteenth century, many iconic Rembrandt pictures, which had in fact crossed the Channel during the Napoleonic era, were to cross the Atlantic in the time of the so-called robber barons.[6]

This essay endeavours to provide a broad feeling for themes and patterns. For instance, in the key period (about 1880–1914), Germany is perceived as the early beneficiary of the Rembrandt picture flight, while America became its swift successor. On the other hand, the Netherlands – the veritable cradle of the subject in question – becomes understood as a rather unanticipated beneficiary of the redistribution of Rembrandt pictures, particularly in the last fifty years under consideration.

It is perhaps appropriate that a Rembrandt portrait whose presence in Britain precedes the Napoleonic period, and indeed had been in the collection of the earls of Ashburnham since the mid-eighteenth century, is the first picture whose sale is worth noting in this essay. The *Portrait of a Man Rising from his Chair* [fig.132] was sold at Christie's in July 1850. Subsequently acquired by the Paris-based counts of Pourtalès, the portrait would remain within that family until it was purchased by the artist and picture agent Charles Fairfax Murray (1849–1919) in March 1909, on behalf of Agnew's; but it would not remain long with any British concern, and was placed with another dealer, Scott & Fowles of New York, bound for the Ohio collection of Charles Phelps Taft (1843–1929), which included major pictures by Frans Hals (c.1580/85–1666), Jan Steen (1626–1679), Gerard ter Borch (1617–1681) and Meindert Hobbema (1638–1709) among others.[7]

Another significant sale in these relatively quiet years was the acquisition of the pendants of 1634, *Johannes Elison* [fig.3] and *Maria Bockenolle* [fig.4] (now in the Museum of Fine Arts, Boston), by the French collector Eugène Schneider.[8] Both had been in Norfolk since 1680 and did not come under the hammer until June 1860.

In the course of the 1860s, the self-portrait of *Rembrandt as Zeuxis*, c.1662 (Wallraf-Richartz-Museum, Cologne), left the collection of the Smith baronets of Belvedere, Erith, Kent, having been in Britain without interruption since before 1758. Subsequently in the possession of Léopold Double in Rouen, *Zeuxis* came to the saleroom again in 1881. Thereafter in a German collection, the self-portrait was never to return to Britain.[9]

The case of *Bellona*, 1633, which left Britain after 1872 – having been here since at least 1797 – feels an appropriate place to conclude the first phase of the picture flight. Sold to the comte de l'Espine, of Brussels, and shortly thereafter to the baron de Beurnonville, *Bellona* changed hands a third time in 1885, at which date it was acquired by the legendary picture dealer Charles Sedelmeyer (1837–1925) – future publisher of Bode's Rembrandt catalogue raisonné (1897–1906). Later still in the London trade, with George Donaldson (1845–1925), and then Sir Joseph Duveen (1869–1939), *Bellona* eventually made its way to America (purchased in 1924 by Colonel Michael Friedsam, cousin of the major Rembrandt collector Benjamin Altman (1840–1913)), and was bequeathed to New York's Metropolitan Museum of Art upon Friedsam's death in 1931 – thus

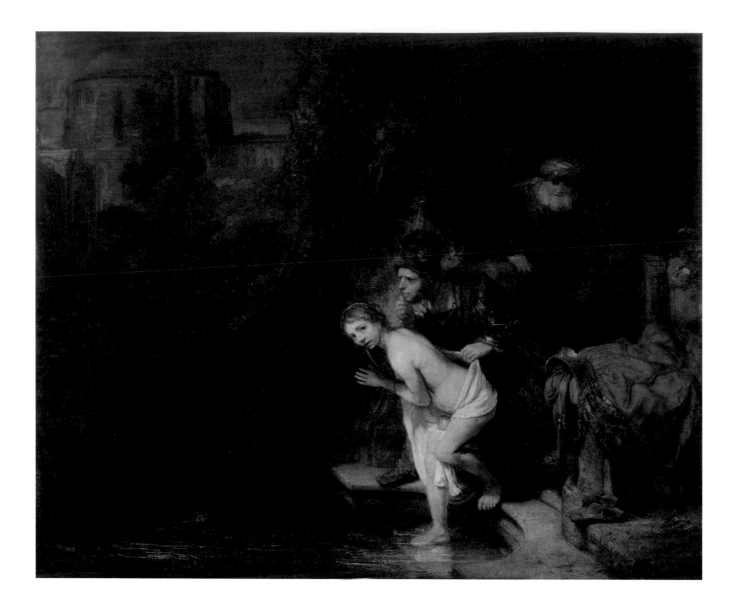

encapsulating the broad trajectory of the changing geography of Rembrandt pictures: first, Continental collectors had taken hold, only to be eclipsed by the limitless American purse. Perhaps if more collectors in Britain had made civic gestures like Jane Graham-Gilbert, widow of the Scottish painter John Graham-Gilbert (Rembrandt's *A Man in Armour* ('*Achilles*') [fig.110] was presented by her to Glasgow's Kelvingrove Art Gallery and Museum in 1877), the narrative sketched here would be a different one altogether. As it happened, though, most owners desired money when relinquishing heirlooms.[10]

A harbinger of the mounting foreign threat is perhaps encapsulated in the young Wilhelm von Bode's successful pursuit in 1881 of the *Parable of the Rich Man*, 1627, for Berlin's Gemäldegalerie. As it happened, the picture was actually given to Berlin on account of Bode's friendship with Sir John Charles Robinson (1824–1913), redoubtable connoisseur and surveyor of the Queen's pictures. As noted, sometime before America proved a significant menace to

the British patrimony, Germany dominated the Rembrandt raid – and that cannot be altogether surprising given Bode's intense scholarly interest in the artist, his support from the German Hohenzollern dynasty, and his uncanny ability to raise private patronage – later memorialised in the Kaiser Friedrich Museumsverein (1897), Bode's ingenious association, which he had established to fund major museum acquisitions.[11]

Susanna and the Elders [fig.133] and *The Vision of Daniel* [fig.134] – two pictures then attributed to Rembrandt, but now known to have been reworked by Sir Joshua Reynolds (1723–1792) – also came to Berlin of British pedigree, as did *Joseph Accused by Potiphar's Wife*, 1655, in the spring of 1883. All three works had been recently exhibited in the Royal Academy in London, and they appear inextricably linked to Bode's first-hand knowledge of Britain's country houses, which he had visited in the 1870s and early 1880s, and his useful friendships with Sedelmeyer (and Sedelmeyer's presumed intermediary in the matter, Robinson).[12]

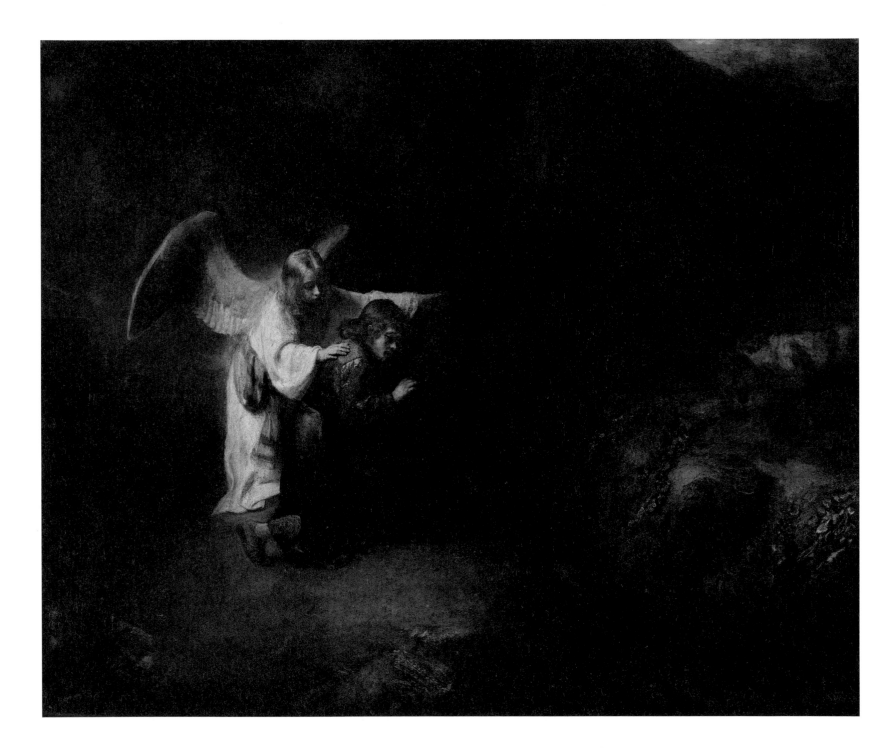

134 Rembrandt (workshop of), reworked by Joshua Reynolds,
The Vision of Daniel, c.1650–52

Oil on canvas, 98 × 119 cm
Gemäldegalerie, Staatliche Museen zu Berlin, Berlin [cat.11]

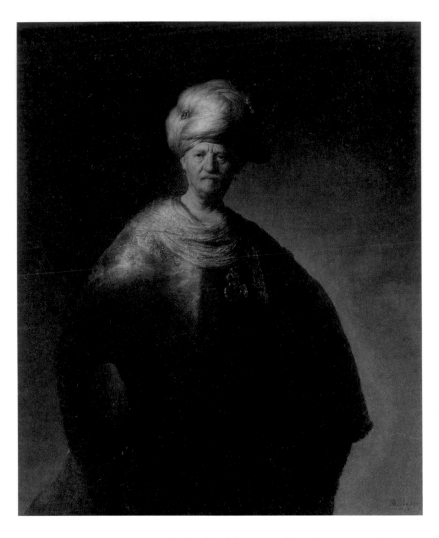

Victoria and Albert Museum, London), in July 1898, to Asher Wertheimer (1843–1918) and P. & D. Colnaghi. Although Bode managed to gain first refusal on numerous iconic Dutch works (not least Vermeer's *Glass of Wine*, *c.*1658/59), it was the scholar and picture agent Bernard Berenson (1865–1959) – acting for the Boston collector Isabella Stewart Gardner (1840–1924) – who secured two fabled Rembrandts, *Christ in the Storm*, 1633, and the *Portrait of a Married Couple*, *c.*1632/33 (the latter remains in the Isabella Stewart Gardner Museum, Boston, while the former was stolen from there in 1990).[14]

Indeed, the rise of American collectors had paralleled Berlin's rise; and collectors like Henry Gurdon Marquand (1819–1902), an early trustee and benefactor of the Metropolitan Museum, and Henry ('Harry') Osborne Havemeyer (1847–1907), who precociously collected the French Impressionists, foreshadowed the Rembrandt mania to come later (which might be measured in the thirty-seven 'Rembrandts' exhibited at the Hudson-Fulton exhibition in the Metropolitan, in autumn 1909).[15] Chronologically paralleling Bode's activity, the painter Julian Alden Weir (1852–1919) – as an agent for Marquand – purchased Rembrandt's *Portrait of a Man*, *c.*1655/60 (ex-Lansdowne) in May 1883, while the far superior *Herman Doomer*, 1640 (now both Metropolitan Museum) – which had a brief spell in Britain in the mid-eighteenth century – was sold to Havemeyer in March 1889.[16] Marquand and Havemeyer were not alone: Charles Wertheimer (1842–1911) appears to have placed *Man in Oriental Costume* ('*The Noble Slav*') (now also in the Metropolitan Museum; fig.135) – which had intermittent British provenance from the mid-eighteenth century onwards – with Mrs W.K. Vanderbilt, of New York, about 1885.[17]

Similarly, the much-esteemed portrait of *Saskia van Uylenburgh*, *c.*1634/35 (completed *c.*1638/40), now in the National Gallery of Art in Washington – which had a British pedigree dating to the mid-eighteenth century – came under the hammer at the Mildmay sale of May 1893. Sold there to Charles Wertheimer, *Saskia* was placed by his occasional partner Sedelmeyer with the Philadelphia collector Peter Arrell Brown Widener (1834–1915) the following year, in June 1894.[18] About or in that same year, *Man with a Red Cap* (now Museum Boijmans Van Beuningen, Rotterdam; fig.106) – formerly in the collection

Fast on the heels of these Rembrandt coups, in the 1890s, Bode chased *John the Baptist Preaching*, *c.*1634/35, which was secured via London art dealers P. & D. Colnaghi, in the Dudley sale at Christie's in June 1892. Two years later, Bode was again assisted by Colnaghi's – where Otto Gutekunst (1866–1947) had just been named junior partner – in the private sale of *Cornelis Anslo and his Wife, Aeltje Schouten*, 1641 (Gemäldegalerie, Berlin), from Lord Ashburnham. That double portrait, which had been brought to Britain by Sir Lawrence Dundas in 1763, was a major coup for Colnaghi's and was seen by the partners there as a bid to challenge the pre-eminent position of Agnew's in Bond Street, even if that self-understanding would prove wishful thinking (and Colnaghi's would, in fact, remain far weaker than Agnew's or the Wertheimer brothers – other leading dealers in the London picture trade – before 1900).[13]

Strong though Bode's grip was in these years of the Rembrandt chase, his fortunes began to shift even with the en bloc sale of the illustrious Pelham-Clinton-Hope pictures (which originally had been formed by various members of the Hope banking family, while living in the Netherlands, but had for decades been on loan to the

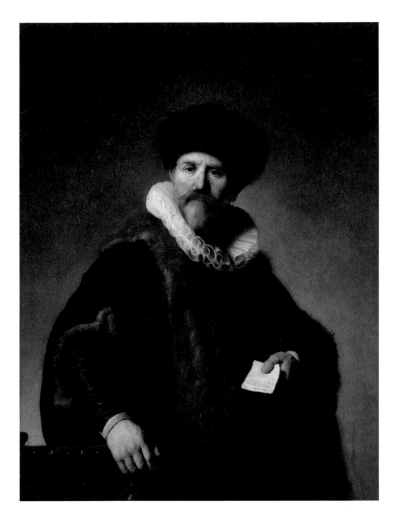

of Joshua Reynolds – was sold by Sedelmeyer to a Chicago collector, P.C. Hanford, indicating that Sedelmeyer's early visits to America were not in vain.[19]

In fact, Sedelmeyer had early deputised his son-in-law, Eugène Fischhof (b.1853), to bring a set of top-flight old masters each winter to New York, where Fischhof habitually encamped in the Waldorf-Astoria hotel. The success of such a shrewd business approach might be measured in Fischhof's sale of the portrait of *Nicolaes Ruts* (now in The Frick Collection, New York; fig.136) – which had hung in Britain for nearly five decades, when it was sold by Fischhof to the French aristocrat Boniface ('Boni') de Castellane (using the dollars of his American wife, the former Anna Gould) – in 1898. In 1899, Charles Wertheimer – who had evidently underbid the painting at the Adrian Hope sale five years earlier – would sell the Ruts portrait to the legendary American banker and collector, John Pierpont (J.P.) Morgan (1837–1913).[20]

Still, despite the activities in Germany and America, it could not all go that way. The formidable Paris-based bankers Rodolphe Kann (1845–1905) and his brother Maurice (1839–1906), advised by Bode, were representative of another robust set of Continental and British collectors (including E.C. Guinness, various Rothschilds and Alfred Beit) who would, in turn, purchase important works long stowed away in aristocratic British collections. Not least of Rodolphe Kann's such purchases was the iconic *Aristotle with a Bust of Homer* [fig.137], which appears to have come through the agency of Sir Lionel Cust (1859–1929) – cousin of *Aristotle*'s then owner, Lord Brownlow – probably around 1894.[21] A memorable unpublished letter in Berlin indicates that the picture, which started its life as a commission for the Sicilian nobleman Don Antonio Ruffo (1610–1678) and came to Britain before 1810, had been offered to Bode by Cust in 1893 (in the same year, it had also been offered to Bode by William McKay of Colnaghi's).[22] It might well be presumed that Bode, strapped for cash, recommended it to Rodolphe Kann, hoping it would later be bequeathed to the Gemäldegalerie. This was not to be, and by a circuitous route *Aristotle* eventually found its way into the Metropolitan Museum decades later.[23]

Beyond Bode and his coterie of collectors (he advised from Berlin to Boston), there was a growing desire in the Netherlands to reclaim the country's cultural patrimony

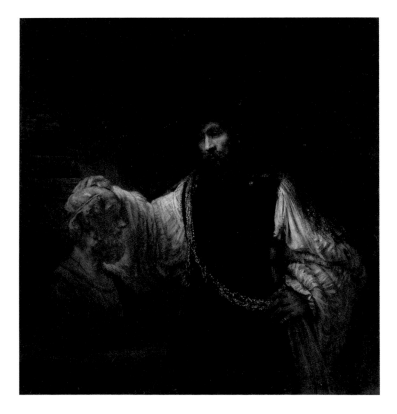

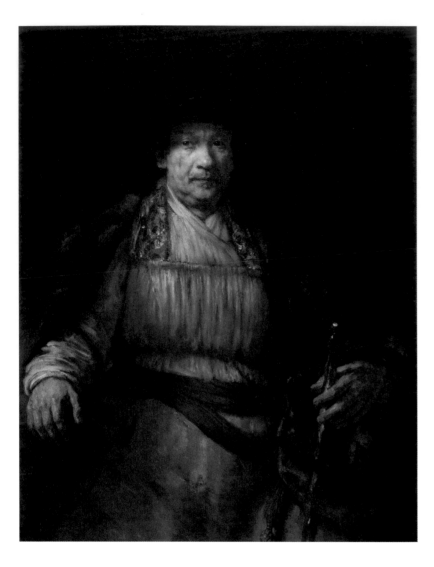

138 Rembrandt, *Self-portrait*, 1658
Oil on canvas, 133.7 × 103.8 cm
The Frick Collection, New York

Returning to Bode, his Gemäldegalerie agenda – which he perceived as a nationalistic competition with London's National Gallery – was increasingly menaced by various Americans. The Philadelphia collector Peter Arrell Brown Widener, whose stellar collection became a cornerstone of the National Gallery of Art, Washington, and Benjamin Altman, the above-mentioned Metropolitan benefactor, spring to mind as conspicuous rivals; but perhaps the single greatest threat to Bode's ambitions was embodied in the aspirational tycoon Henry Clay Frick (1849–1919). That this man of decidedly modest origins – famously unpopular and undereducated – would come to own, according to Bode, the most dignified of all self-portraits by Rembrandt [fig.138], underlines precisely the kind of American success tale that imperilled Britain's cultural patrimony in the decades after the American Civil War of 1861–65 and until the First World War.[26]

The fact that Bode coveted Lord Ilchester's Rembrandt self-portrait for Berlin (which had been lent to London's Royal Academy for the winter exhibitions in 1889 and 1899), and that in the November 1906 tug-of-war between the Colnaghi–Knoedler, Anglo-American alliance, Knoedler's Charles Carstairs (1865–1928) bested Otto Gutekunst for the trophy (i.e. the Ilchester Rembrandt), was the proverbial 'proof of the pudding' that Berlin had been eclipsed by New York after 1900.[27]

This surpassing was codified in swift succession by several sales. Firstly, there was that by Sedelmeyer via the London dealer Arthur Joseph Sulley (1853–1930), of the 1660 *Self-portrait* (Metropolitan Museum) – which had previously belonged to Francis Denzil Edward Baring, 5th Baron Ashburton (1866–1938) – to Benjamin Altman in 1909. Lord Beauchamp's *Portrait of a Man, Probably Pieter Seijen*, 1633 (Norton Simon Museum, Pasadena), was then sold in December 1910 to Frick (albeit a short-lived placement). Finally, and above all, was the sale of *The Mill* [fig.91], again via Sulley, to Widener when London's National Gallery did not raise the £95,000 Lord Lansdowne demanded for the picture to remain in Britain. Bode had dubbed *The Mill* 'the greatest picture in the world'.[28]

Widener's mighty purchasing power was irrefutable, and indeed within 1911–12 no fewer than three additional Rembrandts came from British collections to Widener

– ultimately symbolised in the landmark Rembrandt exhibition at Amsterdam's Stedelijk Museum in autumn 1898 (of mainly British loans).[24] The rise of wealthy Dutch scholar-collectors like Abraham Bredius (director of the Mauritshuis, The Hague, from 1889 to 1909) also had certain consequences for the redistribution of Rembrandt pictures in the decades straddling 1900.

For Bredius was not only a trustee in the Vereniging Rembrandt (the Rembrandt Association, established in 1883 to protect the Netherlands' heritage), but, during his tenure as director of the Mauritshuis, he would also purchase works such as *Homer*, 1663 – like *Aristotle*, another former Ruffo picture in Britain since at least 1810 – through T. Humphry Ward (1845–1926) in 1894, and *Two Moors*, 1661, through Charles Wertheimer and George Donaldson, in 1902.[25] Although these works were purchased by Bredius for his personal collection, they would ultimately be bequeathed to the Mauritshuis, and it is legitimate to imagine that such purchases were always intended as gifts to the museum – especially in view of the fact that they were lent from the date they were acquired.

139 Rembrandt, *Portrait of an Elderly Man*, 1667
Oil on canvas, 81.9 × 67.7 cm
Mauritshuis, The Hague [cat.19]

140 Rembrandt, *Self-portrait*, 1669
Oil on canvas, 65.4 × 60.2 cm
Mauritshuis, The Hague

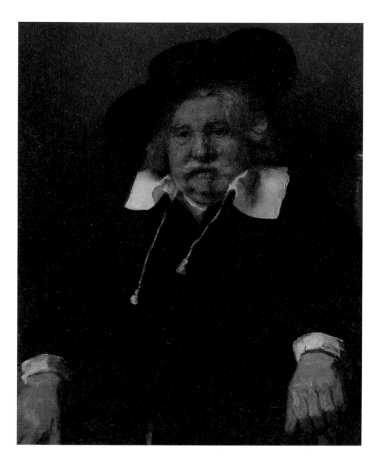

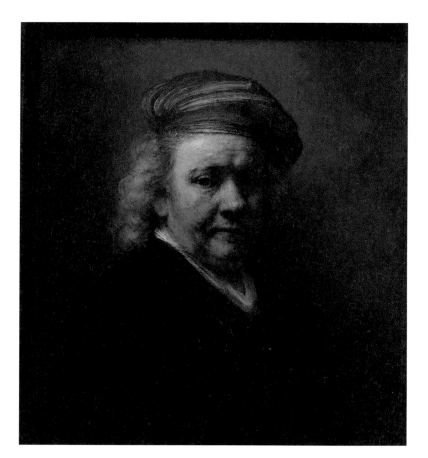

through Sulley's agency (two from Lord Wimborne, via Agnew's, and one from the Earl Spencer).[29] In such a context, it seems altogether fitting that Sulley concluded many of these storied Rembrandt sales from his set of rooms in Manhattan's Plaza Hotel, perched over Central Park.

Not that it would, or should, have appeared all losses for Bode by the measure of the era. For example, Bode must have been buoyed, in 1911, that Gutekunst successfully placed Rembrandt's final *Self-portrait* (now in the Mauritshuis; fig.140) with the Berlin collector Marcus Kappel (1839–1919). Unfortunately for Bode, in the aftermath of the First World War and with hyperinflation the scourge of the Weimar Republic, Kappel's widow found herself in no position to donate the picture to the Gemäldegalerie.[30]

Although the First World War admittedly disrupted the halcyon days of the picture trade in Bond Street (perhaps to the tacit relief of the well-born in Britain), definitively ending the fervour of what can be rightly described as the richest moment in the redistribution of Dutch pictures besides the Napoleonic era, that did not mean significant pictures by Rembrandt were not lost by Britain in the inter-war period. Indeed, to a certain degree, the Rembrandt attrition continued.

No sooner had the peace papers been signed in 1919 than Sulley and Joseph Duveen were, in tandem, removing *Flora*, c.1654 (Metropolitan Museum) from the Northamptonshire house of Althorp, where it had long been in the collection of the earls Spencer. Perhaps the loss of *Flora* was softened by Agnew's sale, in November 1919, of the *Portrait of an Elderly Man* (now Mauritshuis;

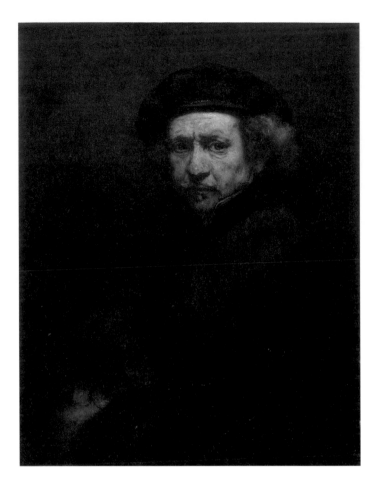

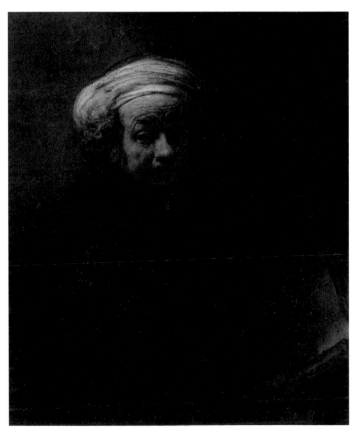

141 Rembrandt, *Self-portrait*, 1659
Oil on canvas, 84.5 × 66 cm
National Gallery of Art, Washington

142 Rembrandt, *Self-portrait as the Apostle Paul*, 1661
Oil on canvas, 91 × 77 cm
Rijksmuseum, Amsterdam

fig.139), which had been in Britain since at least 1761, to a British industrialist, Lord Cowdray; it was sold away from Britain as late as 1999. However, such minor victories were certainly the exception rather than the rule.[31]

In 1927, the celebrated *Visitation*, 1640 – formerly in the collection of the dukes of Westminster, and later with National Gallery trustee Alfred de Rothschild – was sold by Colnaghi's to Wilhelm Reinhold Valentiner (1880–1958) for the Detroit Institute of Arts, of which he was then director.[32]

Following the renowned Holford sale, in May 1928, the *Portrait of Marten Looten*, 1632 (Los Angeles County Museum of Art, Los Angeles) made its return to the Netherlands. Although after being sold at Mensing, Amsterdam, in November 1938 – where it was acquired by the American expatriate collector Jean Paul Getty (1892–1976) – it had a reprieve on British soil, at Sutton Place, that reprieve was decidedly short-lived, and the picture was given to the aforementioned California institution in 1953. Yet another British casualty of 1928 was the magisterial Rembrandt *Self-portrait* [fig.141], now in Washington, but in that case by private purchase. After nearly two centuries in the collection of the dukes of Buccleuch, the Colnaghi–Knoedler alliance pried it from Montagu House, London, on behalf of Andrew Mellon (1855–1937) – rather appropriately, a Scots–Irish American intent on building a national gallery along the lines of British models. It can be assumed that this earnest self-portrait, with its entrancing confrontation of spectator and sterling provenance, must have been among Mellon's most-prized pictures.[33]

Surely, though, the proper coda to this necessarily brief account of the picture exodus from Great Britain (and especially fitting for an exhibition set in Scotland) must be the sale of *Self-portrait as the Apostle Paul* [fig.142] – which had been in the Kinnaird collection, at Rossie Priory in Perthshire, since the buccaneering picture agent William Buchanan (1777–1864), a Glaswegian by birth, active in Edinburgh, had placed it with Lord Kinnaird before 1809 – to Amsterdam's Rijksmuseum in May 1936.[34] If this probing portrait, wherein Rembrandt identifies himself with the Pauline legacy, was lost to Britain, then at least the subject of that portrait – and the subject of this essay – had come the long way home; the picture flight from Britain, on occasion, returned Rembrandt himself to Amsterdam.

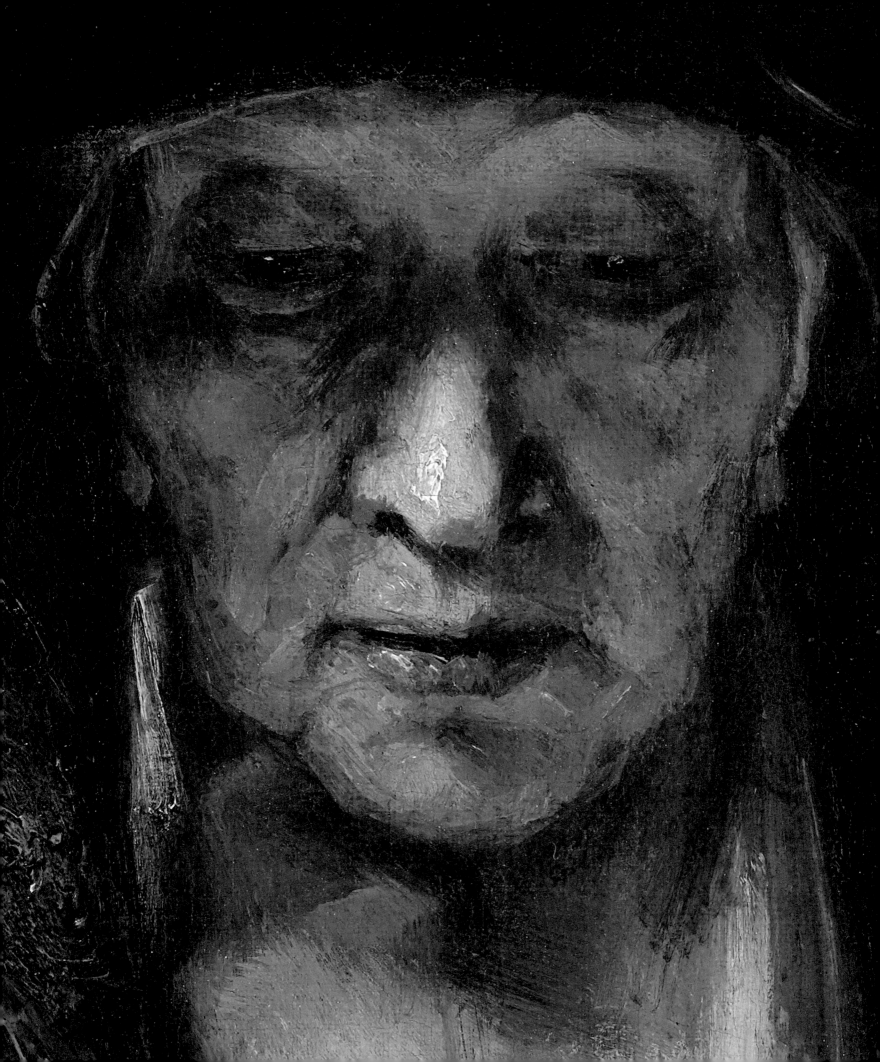

CATALOGUE

I · Works by Rembrandt

PAINTINGS

Compiled by Charlotte Hoitsma and Christian Tico Seifert.

Works by Rembrandt are listed in chronological order; works by other artists are listed in alphabetical order.

Occasions when works by Rembrandt have been exhibited in Britain are indicated at the end of their respective entries. The absence of the 'Exhibited in Britain' heading signifies that the work concerned is not known to have been displayed here previously. Similarly, the absence of the 'References' heading indicates that the work appears to be unpublished.

1

REMBRANDT HARMENSZ VAN RIJN (1606–1669), ATTRIBUTED TO

Self-portrait, c.1629 [fig.2]

Oil on panel, 72.3 × 57.8 cm
National Museums Liverpool, Walker Art Gallery, Liverpool (WAG 1011)

PROVENANCE Acquired in the Netherlands by Robert Kerr (from 1633 1st Earl of Ancrum), probably in 1629; given to Charles I, probably before June 1633; sold during the Commonwealth to Edward Bass, 19.12.1651; Sidney family, Penshurst, Kent, since the (early?) 18th century; sale William Sidney, 1st Viscount De Lisle, London (Sotheby's), 14.04.1948, lot 144 (to Clifford Duits); by whom sold to Mrs E.S. Borthwick Norton, Purbrook, Hampshire; presented by the Directors of the Ocean Steam Ship Co. Ltd as Trustees of Funds, 1953.

REFERENCES Corpus, vol.1 (1982), A 33; Corpus, vol.4 (2005), pp.91–93

EXHIBITED IN BRITAIN London/The Hague 1999–2000, no.26

2 A & B

REMBRANDT

Reverend Johannes Elison (c.1581–1639), 1634 [fig.3]

Oil on canvas, 174 × 124.5 cm

Maria Bockenolle (c.1590–1652, Wife of Johannes Elison), 1634 [fig.4]

Oil on canvas, 174.9 × 124.1 cm
Museum of Fine Arts, Boston (56.510 and 56.511)

PROVENANCE Probably commissioned by Joan (Johannes) Elison [the Younger], Amsterdam, 1634; by inheritance to his sister, Anne Elison Dover and her husband, Daniel Dover, Ludham, Norfolk, 1677; by descent through their daughter, Mary Dover Colby, Yarmouth; by descent to Samuel Colby, Little Ellingham Rectory, Norfolk; his sale, London (Christie's), 30.06.1860 [Lugt 25681], lots 22 and 23 (to Fisher, 1850gns); sold by Fisher to Eugène Schneider, Paris, 1863; his sale, Paris (Hôtel Drouot), 06.04.1876 [Lugt 36375], lots 29 and 30, bought in and sold by the estate to Schneider's son, Henri Schneider, Paris; by descent; sold to Rosenberg and Stiebel, New York, 1956; purchased 1956.

REFERENCES Smith 1807, p.266 [A]; Smith 1836, no.487 [A]; *The Art Journal* 1860, p.247 [B]; Norwich 1988, pp.3–6; Corpus, vol.2 (1986), A 98 and A 99; Corpus, vol.6 (2015), nos 121a and 121b

EXHIBITED IN BRITAIN London 1929, nos 84 [a] and 90 [b]

3

REMBRANDT

The Lamentation over the Dead Christ, c.1635 [fig.65]

Oil on paper and pieces of canvas, mounted on oak panel, 31.9 × 26.7 cm
The National Gallery, London (NG 43)

PROVENANCE J. Bary [Jean or Jacob de Bary?], Amsterdam, by 1730; Consul Joseph Smith, Venice, by 1738; sold to King George III, 1762; sale Richard Dalton, Surveyor of the King's Pictures, London (Christie's), 09–11.04.1791 [Lugt 4704], 2nd day, lot 19 (to Grosier, for Joshua Reynolds, 24gns); by descent to his niece Lady Inchiquin; sale Joshua Reynolds, London (Christie's), 13–17.03.1795 [Lugt 5284], 3rd day, lot 38 (to George Beaumont, 41gns); given by George Beaumont to the British Museum for the proposed National Gallery, 1823; transferred to the National Gallery, 1828.

REFERENCES Smith 1836, no.96; MacLaren & Brown 1991, no.43; Corpus, vol.3 (1989), A 107; Rutgers 2008, pp.69–80; Corpus, vol.6 (2015), no.113

EXHIBITED IN BRITAIN London 1823, no.95; London 1988–89, no.6; Glasgow 2012, no.23

4

REMBRANDT

Belshazzar's Feast, c.1636–38 [fig.20]

Oil on canvas, 167 × 209.2 cm
The National Gallery, London (NG 6350)

PROVENANCE Acquired by Hamlet Winstanley for the 10th Earl of Derby, Knowsley Hall, 1729–30 (£125); by descent; purchased with assistance of the National Art Collections Fund, 1964.

REFERENCES Corpus, vol.3 (1989), A 110; MacLaren & Brown 1991, no.6350; Corpus, vol.6 (2015), no.143

EXHIBITED IN BRITAIN London 1822, no.21; London 1852, no.24; Manchester 1857b, no.695; London 1899a, no.58; London 1952–53, no.160; Manchester 1957, no.131; London 1988–89, no.7; Berlin/Amsterdam/London 1991–92a, no.22

5

REMBRANDT

A Man in Oriental Costume (King Uzziah), c.1639 (dated on work 163[9?]) [fig.21]

Oil on panel, 102.8 × 78.8 cm
Chatsworth House Trust (PA 548)

PROVENANCE Possibly acquired for Cardinal Mazarin, but received after his death, 1661; probably sold from Palais Mazarin to Hugues Noël, Paris; by whom sold to Count Charles Henry de Hoym, Paris, 01.06.1723 (1,500 livres); Jacques-André du Pille, Vicomte de Monteil, Paris, by 17.05.1740; his sale, London (Geminiani), 29–30.04.1742 [Lugt 555a], lot 36, where purchased by the 3rd Duke of Devonshire (£78/15/0); by descent to the present owner.

REFERENCES Vertue, vol.v, p.23; Corpus, vol.3 (1989), A 128; Corpus, vol.6 (2015), no.164

EXHIBITED IN BRITAIN London 1878, no.169; London 1894b, no.47; London 1899a, no.83; London 1929, no.169; London 1948, no.24; London 1952–53, no.168; Sheffield 1956, no.41; Manchester 1957, no.110; London 1976, no.86; Berlin/Amsterdam/London 1991–92a, no.28

6

REMBRANDT, WORKSHOP OF

The Holy Family at Night ('The Cradle'), c.1642–48 [fig.107]

Oil on panel, 66.5 × 78 cm
Rijksmuseum, Amsterdam (SK-A-4119) [On loan to Museum Het Rembrandthuis, Amsterdam]

PROVENANCE Possibly Jan Six (1618–1700), Amsterdam; possibly his daughter Margaretha Six (1666–1718), Amsterdam; Philippe, Duc d'Orléans (1674–1723), Palais Royal, Paris; his sale, Paris (D'Argenson), 09.06.1727 [Lugt 359a], lot 57 (unsold); by descent to Louis-Philippe-Joseph, Duc d'Orléans (1747–1793), Paris; from whom purchased through Thomas Moore Slade, by Lord Kinnaird, Mr Morland and Mr Hammersley, 1792 and exhibited for sale at 125 Pall Mall, London, 1793; from whom acquired by Richard Payne Knight, Downton Castle, Herefordshire (1,000gns); by descent; acquired through Thos. Agnew & Sons Ltd, London, with support from the Vereniging Rembrandt, the Prins Bernhard Fonds and the Fotocommissie (£610,000), 1965.

REFERENCES Richardson & Richardson 1722, p.21; Smith 1836, no.145; Dibbits 2006; Corpus, vol.5 (2011), no.5

EXHIBITED IN BRITAIN London 1793, no.125; London 1815, no.40; London 1882, no.101; London 1899a [not in catalogue]; London 1912, no.51; London 1929, no.172; Birmingham 1934, no.166; London 1949b, no.9; Edinburgh 1950, no.23; London/Paris/Madrid 2009–10, no.41

7

REMBRANDT

Girl at a Window, 1645 [fig.33]

Oil on canvas, 81.8 × 66.2 cm
Dulwich Picture Gallery, London (DPG 163)

PROVENANCE Probably Roger de Piles, acquired in Amsterdam in 1693 and brought to Paris in 1697; Roger de Piles, 1709; possibly Adolphe Saint-Vincent Duvivier, Paris; probably Charles Jean-Baptiste Fleuriau, Comte de Morville and Seigneur d'Armenonville,

Paris, May 1732; probably Count Charles Henry de Hoym, Paris, June 1732; sale Louis-Auguste Angran, Vicomte de Fonspertuis, Paris (Gersaint), 04.03.1748 [Lugt 682]), lot 435 (to Augustin Blonder de Gagny, 2,750 livres, together with lot 434); his sale, Paris (Remy), 10.12.1776 [Lugt 2616], lot 70 (to Jean-Baptiste-Pierre Lebrun, 6,000 francs, 'for England'); probably sale Noel Desenfans, London, 08.04.1786 [Lugt 4022], lot 390 (sold or bought in, £10/10/0); Bourgeois Bequest, 1811.

REFERENCES Sparkes 1876, no.206; Corpus, vol.6 (2015), no.200; Jonker & Bergvelt 2016, pp.165–68

EXHIBITED IN BRITAIN London 1815, no.14; London 1843–44, no.107; London 1899a, no.32; London 1947–48b, no.37; Edinburgh 1950, no.21; London 1952–53, no.122; London/Washington/Los Angeles 1985–86, no.26; London 1993a, no.1; Edinburgh/London 2001, no.104; London/Paris/Madrid 2009–10, no.43

8

REMBRANDT

The Mill, 1645/48 [fig.91]

Oil on canvas, 87.6 × 105.6 cm
National Gallery of Art, Washington (1942.9.62)

PROVENANCE Philippe, Duc d'Orléans (1674–1723), Paris; by descent to Louis-Philippe-Joseph, Duc d'Orléans (1747–1793), Paris; from whom purchased through Thomas Moore Slade, by Lord Kinnaird, Mr Morland and Mr Hammersley, 1792 and exhibited for sale at 125 Pall Mall, London, 1793; sold to William Smith, until at least 1815; Henry Petty-Fitzmaurice, 3rd Marquess of Lansdowne, Bowood House, Wiltshire, by 1824; by descent; sold April 1911 through Arthur J. Sulley & Co., London, to Peter A.B. Widener, Lynnewood Hall, Elkins Park, Pennsylvania; inheritance from Estate of Peter A.B. Widener by gift through power of appointment of Joseph E. Widener, Elkins Park, Pennsylvania; gift 1942 to NGA.

REFERENCES Buchanan 1824, pp.195–96; Smith 1836, no.601; Corpus, vol.6 (2015), no.206

EXHIBITED IN BRITAIN London 1793; no.91; London 1806 [no catalogue]; London 1815, no.37; London 1864, no.112; London 1878, no.172; London 1888, no.74; London 1899a, no.40; London/Paris/Madrid 2009–10, no.70

9

REMBRANDT

*A Woman in Bed (Sarah), c.1647
(dated on work 164[7?])* [fig.29]

Oil on canvas, 81.1 × 67.8 cm (arched top)
National Galleries of Scotland, Edinburgh
(NG 827)

PROVENANCE Possibly bartered for boat supplies in Amsterdam, 1647; François Tronchin, Geneva, by 1757; given in exchange to Count Vitturi, Venice, by 1765; Thomas Moore Slade, by about 1776; sold to Viscount Maynard before 1777; sale London (Clayton & Parys), 05–06.05.1780 [Lugt 3137], lot 62; Lady Mildmay, Dogmersfield Park, Hampshire, by 1819; by descent; sold by Henry St John Mildmay to Samson Wertheimer, London; his sale, London (Christie's), 19.03.1892 [Lugt 50610], lot 706 (to Haynes, for Charles J. Wertheimer, 5,000gns); from whom purchased by William McEwan (£5,775), 1892; by whom gifted, 1892.

REFERENCES Sydney 2015, no.12; Corpus, vol.6 (2015), no.194

EXHIBITED IN BRITAIN London 1865, no.109; London 1883, no.235; London 1929, no.62; London 1952–53, no.167; Berlin/Amsterdam/London 1991–92a, no.36; Edinburgh 1992b, no.50; Edinburgh/London 2001, no.100

10

REMBRANDT

Landscape with the Rest on the Flight into Egypt, 1647 [fig.23]

Oil on panel, 34 × 48 cm
National Gallery of Ireland, Dublin (NGI.215)

PROVENANCE Henry Hoare, Stourhead, Wiltshire, by 1749 (when A. Pond commissioned J. Wood's engraving); by descent; Stourhead

Heirlooms sale, London (Christie's), 02.06.1883 [Lugt 43108], lot 68, where purchased (£514).

REFERENCES Smith 1836, no.603; Corpus, vol.5 (2011), no.13; Corpus, vol.6 (2015), no.214

EXHIBITED IN BRITAIN London 1870, no.29; London 1894a, no.91; London 1899a, no.51; London 1929, no.140; London 1985, no.24; London/Paris/Madrid 2009–10, no.8

11

REMBRANDT, WORKSHOP OF (REWORKED BY JOSHUA REYNOLDS)

The Vision of Daniel, c.1650–52 [fig.134]

Oil on canvas, 98 × 119 cm
Gemäldegalerie, Staatliche Museen zu Berlin, Berlin (828 F)

PROVENANCE Probably sale London (Motteux), about 1714–17 [not in Lugt], no.41; Joshua Reynolds, London, before 1791; by descent to his niece Lady Inchiquin; sale Joshua Reynolds, London (Christie's), 13–17.03.1795 [Lugt 5284], 4th day, lot 81 (bought in for the heirs by Wilson, 170gns, here and subsequently together with Rembrandt's *Susanna and the Elders*); sold to Charles Offley, 22.03.1795 (280gns); sold to Joseph Berwick, Hallow Hall, 31.01.1796 (350gns); by descent to Edmund, 2nd Baron Lechmere, Rhydd Court, Hanley Castle, Worcestershire; by whom sold to Charles Sedelmeyer, Paris, 1883; sold to Oscar Hainauer, Berlin, 1883; purchased 1884 (214,000Mark, together with Rembrandt's *Susanna and the Elders*).

REFERENCES Williams 1831, vol.1, p.166; Smith 1836, no.55; Berlin 2015, pp.71–72; Kleinert & Laurenze-Landsberg 2016

EXHIBITED IN BRITAIN London 1791, no.48; Worcester 1882, no.68 [under Fine Arts – Old Masters]; London 1883, no.234; Berlin/Amsterdam/London 1991–92a, no.82

12

REMBRANDT

*A Woman Bathing in a Stream
(Hendrickje Stoffels?)*, 1654 [fig.63]

Oil on oak panel, 61.8 × 47 cm
The National Gallery, London (NG 54)

PROVENANCE Possibly sale Andrew Hay, London (Cock), 04–05.05.1739 [Lugt 504], 1st day, lot 20 (£6/19/0); sale London (Langford), 18–19.03.1756 [Lugt 909], 1st day, lot 60 (to Raymond, £19/8/6); Peter Burrell, Baron Gwydyr, London, possibly acquired after 1811; sale Lord Gwydyr, London (Christie's), 08–09.05.1829 [Lugt 12041], 2nd day, lot 72 (to William Holwell Carr, 165gns); Holwell Carr Bequest, 1831.

REFERENCES Smith 1836, no.165; MacLaren & Brown 1991, no.54; Corpus, vol.5 (2011), no.19; Corpus, vol.6 (2015), no.229

EXHIBITED IN BRITAIN London 1947–48a, no.68; London 1988–89, no.11; Berlin/Amsterdam/London 1991–92a, no.40; London/Amsterdam 2014–15, no.95

13

REMBRANDT

A Man in Armour ('Achilles'), 1655
[fig.110]

Oil on canvas, 137.5 × 104.4 cm
Glasgow Life (Glasgow Museums) on behalf of Glasgow City Council, Glasgow (601)

PROVENANCE Joshua Reynolds, London, by 1764; from whom purchased by George Greville, 2nd Earl of Warwick, 1790; sale London (Christie's), 29 June 1833 [Lugt 13356], lot 93 (to Woodburn, £42); John Graham-Gilbert, Glasgow, around 1860; bequest of Jane Graham-Gilbert to the City Art Gallery and Museum, Glasgow, 1877.

REFERENCES Smith 1836, no.309; Corpus, vol.6 (2015), no.239

EXHIBITED IN BRITAIN London 1860–61, no.60; London 1899a, no.85; London 1929, no.112; Manchester 1929, no.16; Bristol 1946, no.4; London 1952–53, no.201; London 1976, no.93; London/Amsterdam 2014–15, no.106

14

REMBRANDT

An Old Woman Reading, 1655 [fig.32]

Oil on canvas, 78.7 × 66 cm
Buccleuch Collection (144)

PROVENANCE Edward Scarlett Jun., London (by 1765, the year the printmaker J. McArdell, who had made a mezzotint after the painting, died); George Brudenell, 4th Earl of Cardigan, later George Montagu, Duke of Montagu, Montagu House, Whitehall, London, by 1767; thence by descent to the present owner.

REFERENCE Corpus, vol.6 (2015), no.241

EXHIBITED IN BRITAIN London 1815, no.27; London 1899a, no.8; Edinburgh/London 2001, no.121; London/Amsterdam 2014–15, no.98

15

REMBRANDT

Titus at his Desk, 1655 [fig.39]

Oil on canvas, 77 × 63 cm
Museum Boijmans Van Beuningen, Rotterdam (St 2)

PROVENANCE Thomas Barnard (1728–1806), Limerick; his son Andrew Barnard (1762–1807), London; his wife Anne Barnard (née Lindsay, 1750–1825); by descent in the Lindsay family; acquired by the Stichting Museum Boijmans with support of the Vereniging Rembrandt and 120 friends of the museum, 1940.

REFERENCE Corpus, vol.6 (2015), no.242

EXHIBITED IN BRITAIN London 1866, no.75; London 1899a, no.23; London 1922, no.13; London 1929, no.108; Berlin/Amsterdam/ London 1991–92a, no.42; Edinburgh 1992b, no.51; London/Amsterdam 2014–15, no.99

16

REMBRANDT

Self-portrait, c.1655 (dated on work 165[5?]) [fig.38]

Oil on canvas, 52.7 × 43 cm
Bridgewater Collection Loan, National Galleries of Scotland, Edinburgh (NGL 072.46)

PROVENANCE Sale Countess of Holderness, London (Christie's), London, 06.03.1802 [Lugt 6370], lot 56 (to Earl Gower, for the 3rd Duke of Bridgewater, 178gns); by descent to the present owner.

REFERENCES Britton 1808, no.134; Corpus, vol.4 (2005), no.15; Corpus, vol.6 (2015), no.273

EXHIBITED IN BRITAIN London 1846, no.60; Edinburgh 1945, no.186; Edinburgh 1950, no.30; London 1952–53, no.180; Edinburgh 1953 [no catalogue]; Edinburgh 1992b, no.52; London/The Hague 1999–2000, no.74 [London only]; Karlsruhe/Lyon/Edinburgh 2016, no.8 [Edinburgh only]

17

REMBRANDT

Head of an Old Man, 1659 [fig.5]

Oil on canvas, 38.1 × 26.8 cm
Collection of Daniel and Linda Bader, Milwaukee

PROVENANCE John Clerk of Penicuik, 2nd Baronet, Penicuik House, Midlothian, by 1740; by descent to George Douglas Clerk of Penicuik (1852–1911), 8th Baronet; Robert Langton Douglas, London, 1909; Marcus Kappel, Berlin; Bachstitz Gallery, The Hague; A.W. Erickson, New York; his sale, New York (Parke-Bernet), 15.11.1961, lot 12; Derek Cotton; by descent; sale London (Christie's), 23.04.1993, lot 9; purchased by Alfred Bader and given to his son Daniel Bader.

REFERENCES Amsterdam/Berlin 2006, pp.196–97; De Witt 2008, no.162; Corpus, vol.6 (2015), no.276

18

REMBRANDT, ATTRIBUTED TO

Man with a Red Cap, c.1660 [fig.106]

Oil on canvas, 102 × 80 cm
Museum Boijmans Van Beuningen, Rotterdam (2113 OK)

PROVENANCE Joshua Reynolds, London, by 1765; by descent to his niece Lady Inchiquin; Joshua Reynolds's sale, London (Christie's),

13–17.03.1795 [Lugt 5284], 4th day, lot 50 (to William Hardman, 50gns); by descent; sale Thomas Hardman, London (Winstanley), 29.10–1.11.1838 [Lugt 15185], lot 52 (£73/10/0); sale Thomas Green, London (Christie's), 20.03.1874 [Lugt 34661], lot 93; Mrs Owen Roe, London; Charles Sedelmeyer, Paris, 1894; P.C. Hanford, Chicago; Eugène Fischhof, Paris; Charles M. Schwab, Pittsburgh, around 1909–31; Lord Duveen of Millbank, New York, around 1935; D. Katz, The Hague; donated by the Vereniging Rembrandt and 100 friends of the museum, 1937.

REFERENCES Smith 1836, no.275; Smith 1842, no.9; Giltaij 2009

EXHIBITED IN BRITAIN London 1791, [Great Room] no.2; London 1929, no.85

19

REMBRANDT

Portrait of an Elderly Man, 1667 [fig.139]

Oil on canvas, 81.9 × 67.7 cm
Mauritshuis, The Hague (1118)

PROVENANCE Possibly sale John Rawdon, London (Cock), 1744 [not in Lugt], lot 51 (to Robert Bragge, £141/15/0, together with lot 52); Sampson Gideon, Belvedere House, Erith, Kent, by 1761; by descent to Francis Edward Fremantle; by whom sold to Thos. Agnew & Sons, London, 14.07.1919; sold to Scott & Fowles, London, 24.07.1919; sold to Duveen Brothers, New York and London; sold to Thos. Agnew & Sons, London, 21.11.1919, from whom purchased on the same day by Lord Cowdray, Cowdray Park, Midhurst, Sussex; by descent; purchased 1999.

REFERENCES Broos & Van Suchtelen 2004, no.49; Corpus, vol.6 (2015), no.316

EXHIBITED IN BRITAIN London 1821, no.112; London 1845, no.78; London 1876, no.255; London 1938, no.128; Edinburgh 1950, no.35; Worthing 1951, no.179; London 1952–53, no.165; Manchester 1957, no.105; London 1976, no.97; London 2014–15, no.102

20

REMBRANDT

Three Studies of an Old Man, c.1635
[fig.113]

Pen and brown ink on light brown prepared paper, 17.4 × 16 cm
Fondation Custodia – Collection Frits Lugt, Paris (1922)

PROVENANCE Jonathan Richardson Jun., London [L.2170]; probably his sale, London (Langford), 05–12.02.1772 [not in Lugt]; Joshua Reynolds, London [L.2364]; his sale, London (De Poggi), 26.05.1794 [Lugt 5213a], probably part of album QQ, lots 960–985, or album RR, lots 987–1009; Samuel Woodburn, London [L.2584]; his sale, London (Christie's), 12–14.06.1860 [Lugt 25649], lot 1407 (to Money or Roupell, £1/11/6); Barron Grahame, Morphie, Aberdeenshire; his sale, London (Sotheby's), 15.03.1878 [Lugt 38136], probably part of lot 132 (to Noseda, £3/8/0); John Postle Heseltine, London [L.1507]; his sale, Amsterdam (F. Muller & Cie), 27–28.05.1913 [Lugt 72829], lot 4 (to Kappel, Dfl.4200); Marcus Kappel, Berlin; Paul Cassirer, Berlin; acquired by Frits Lugt, Maartensdijk and Paris [L.1028], 19.10.1924.

REFERENCES Ben.87; Starcky 1999, pp.38–39; Paris 2006, no.10, pp.52–53; Schatborn 2010, no.1, pp.22–25

EXHIBITED IN BRITAIN London 1929, no.590; London/Paris/Cambridge 2002–3, no.44

21

REMBRANDT

A Black Drummer and Commander Mounted on Mules, c.1638

Pen and brown ink and red chalk with brown wash, touched with white and yellow, 23 × 17.1 cm
British Museum, London (Oo,10.122)

PROVENANCE Jonathan Richardson Sen. (1667–1745), London [L.2184]; sale Arthur Pond, London (Langford), 01.05.1759 [Lugt 1048], lot 72 (£8, to Hudson); Thomas Hudson [L.2432]; his sale, London (Langford), 16.03.1779 [Lugt 2972], lot 52 (£6/15/0, to Willet, together with two other unspecified lots); Ralph Willet; his anon. sale London (Philipe), 13–16.06.1808 [Lugt 7431], 4th day, lot 426 (to Allen, £26/5/0); bequeathed by Richard Payne Knight, 1824.

REFERENCES Ben.365; Royalton-Kisch 2010, no.17

EXHIBITED IN BRITAIN London 1899b, no.A15; London 1938, no.8; London 1956, no.12; London 1972–73, no.209; London 1992, no.21; London 2000–1, no.30; London 2011b [no catalogue]

22

REMBRANDT

Two Studies of Old Men's Heads, c.1639
[fig.18]

Pen and brown ink, 8.1 × 9.4 cm
British Museum, London (1895,0915.1265)

PROVENANCE Jonathan Richardson Sen., London [L.2183]; Joshua Reynolds, London [L.2364]; Edward V. Utterson (1775–1856), London [L.909]; his sale, London (Christie's), 17.02.1848 [Lugt 18906], part of lot 122; Louis de Gassi, Paris, by 1858 [L.1729]; his sale, Paris (Drouot/Delbergue-Cormont), 06.04.1858 [Lugt 24139], lot 89; John Charles Robinson, London [L.1433]; John Malcolm, Poltalloch, Argyllshire [L.1489]; purchased with his collection, 1895.

REFERENCES Robinson 1876, no.793; Ben.687; Royalton-Kisch 2010, no.22

EXHIBITED IN BRITAIN London 1895, no.377a; London 1899b, no.A23; London 1938, no.19; London 1956, no.3; London 1992, no.25

23

REMBRANDT

Jacob and his Sons, c.1640 [fig.117]

Pen and brown ink, brown wash, white bodycolour and traces of red and black chalk, 20 × 27.6 cm
Musée du Louvre, Départment des Arts Graphiques, Paris (RF 4703)

PROVENANCE Jonathan Richardson Sen., London [L.2184]; his sale, London (Cock), 02.02.1747 [Lugt 653], lot 60 (to Hudson); Thomas Hudson, London [L.2432]; Léon Bonnat, Paris [L.1714]; gifted in 1919 [L.1886].

REFERENCES Paris 1970, p.87, no.197; Starcky 1999, p.77; Paris 2006, no.28

24

REMBRANDT, WORKSHOP OF

View of London with Old St Paul's, c.1640 [fig.8]

Pen and brown ink, brown wash, some white bodycolour, 16.4 × 31.8 cm
Kupferstichkabinett, Staatliche Museen zu Berlin, Berlin (KdZ 1150)

PROVENANCE Probably acquired after 1831, but certainly before 1878.

REFERENCES Ben.788; Bevers 2012, pp.402–4; Amsterdam 2014, pp.108–9

25

REMBRANDT, ATTRIBUTED TO

View of St Albans Cathedral, 1640 [fig.6]

Pen and brown ink, brown wash, some black
chalk, 18.4 × 29.5 cm
Teylers Museum, Haarlem (O+ 062b)

PROVENANCE Narcisse Revil, Paris; his sale,
Paris (Roussel and Defer), 29.03.1842 [Lugt
16528], lot 230 (Fr 101); A. Sensier; his sale,
Paris (Féral and Petit), 10.12.1877 [Lugt 37802],
lot 554 (possibly to Marquis de Bailleul);
possibly Maurice Marignane, Paris; acquired by
Cornelis Hofstede de Groot, 1920; by whom
presented, 1930.

REFERENCES Ben.785; Plomp 1997, no.333;
Bevers 2012, pp.402–4; Amsterdam 2014, no.34

EXHIBITED IN BRITAIN London 1964, no.108

26

REMBRANDT, WORKSHOP OF

View of London with Old St Paul's, c.1640
[fig.9]

Pen and brown ink, brown wash, some black
chalk, 17.7 × 32.1 cm
The Albertina Museum, Vienna (8893)

PROVENANCE Moritz von Fries (1777–1826),
Vienna and Paris [Lugt 2903]; Duke Albert of
Saxe-Teschen, by 1822.

REFERENCES Ben.787; Bevers 2012, pp.402–4;
Amsterdam 2014, pp.106–9

EXHIBITED IN BRITAIN London 1929, no.643

27

REMBRANDT, ATTRIBUTED TO

View of Windsor Castle, 1640 [fig.7]

Pen and brown ink, brown wash, traces of black
chalk, 18.3 × 29.7 cm
The Albertina Museum, Vienna (8894)

PROVENANCE A.-J. Dezallier d'Argenville
[L.2951], by 1765; Moritz von Fries, Vienna and
Paris [Lugt 2903]; Duke Albert of Saxe-Teschen,
by 1822.

REFERENCES Ben.786; Bevers 2012, pp.402–4;
Amsterdam 2014, pp.106–9

EXHIBITED IN BRITAIN London 1929, no.646

28

REMBRANDT

*The Grain Mill 'De Bok' on the Bulwark
'Het Blauwhoofd'*, c.1645

Pen and brown ink, brown wash, 11.6 × 19.8 cm
Fondation Custodia – Collection Frits Lugt,
Paris (5174)

PROVENANCE Possibly Richard Houlditch
Sen., London; Richard Houlditch Jun. [L.2214];
his sale, London (Langford), 12.02.1760 [Lugt
1078], probably lot 50 (£2/23/0) or lot 71 (to
Howard, £5/5/0); Christine Spencer, Viscountess
Churchill of Wychwood (née McRae Sinclair);
her sale, London (Sotheby's), 29.04.1937, lot 97
(to Lugt, for Dfl 6850); Frits Lugt, The Hague
and Paris [L.1028].

REFERENCES Ben.1333; Paris 2006, no.31;
Schatborn 2010, no.11

29

REMBRANDT

*A Man Sculling a Boat on the Bullewijk,
with a View toward Ouderkerk*, c.1648–50
[fig.19]

Reed pen and brown ink, brown wash and
touches of white bodycolour, 13.3 × 20 cm
Trustees of the Chatsworth Settlement (OMD
1033)

PROVENANCE Nicolaes A. Flinck [L.959]; from
whom presumably acquired by William, 2nd
Duke of Devonshire, 1723–24; by descent to the
present owner.

REFERENCES Ben.1232; Jaffé 2002, no.1489

EXHIBITED IN BRITAIN London 1929,
no.604; London 1938, no.554; London 1973–74,
no.94; London 1993b, no.180

30

REMBRANDT

The Amsteldijk near Meerhuizen,
c.1648–50 [fig.40]

Pen and brown ink, brown wash, some white
bodycolour, 14.8 × 26.9 cm
Musée du Louvre, Départment des Arts
Graphiques, Paris, Edmond de Rothschild collec-
tion (186 DR)

PROVENANCE Philips Koninck (1619–1688),
Amsterdam; Valerius Röver (1686–1739), Delft
[L.2984b/c]; sold by his widow, Cornelia van
der Dussen, to Hendrik de Leth, 24.03.1761;
Johann Goll van Franckenstein and sons
[L.2987]; by descent; sale Pieter Hendrik
Goll van Franckenstein, Amsterdam (de
Vries *et al.*), 01.07.1833 [Lugt 13358], possibly
A. lot 8 (to Woodburn); Thomas Lawrence
[L.2445]; Samuel Woodburn, London; sold
to William Esdaile, 1835 [L.2617]; his sale,
London (Christie's), 17.06.1840 [Lugt 15863],
lot 102 (to Woodburn); his sale, London
(Christie's), 12.06.1860, lot 1426 (to Roupell);
R.P. Roupell, London [L.2234]; his sale, London
(Christie's), 12.07.1887 [Lugt 46748], lot 1054
(to Thibaudeau); John Postle Heseltine, London
[L.1507]; his sale, Amsterdam (Fr. Muller),
27.05.1913 [Lugt 72827], lot 25 (to Strölin);
bequest Edmond de Rothschild, 1934.

REFERENCES Ben.1220; Paris 2000, pp.154–55;
Paris 2006, no.46

EXHIBITED IN BRITAIN London 1835, no.75;
London 1899a, no.150

31

REMBRANDT

A Thatched Cottage by a Large Tree,
c.1648–50 [fig.22]

Reed pen and brown ink, 17.5 × 26.7 cm
Trustees of the Chatsworth Settlement
(OMD 1046)

PROVENANCE Nicolaes A. Flinck [L.959]; from
whom presumably acquired by William, 2nd
Duke of Devonshire, 1723–24; by descent to the
present owner.

REFERENCES Ben.1282; Jaffé 2002, no.1482

EXHIBITED IN BRITAIN London 1929, no.612, London 1938, no.555; London 1949b, no.42; London 1969, no.96; London 1993b, no.177

32

REMBRANDT

The Angel Leaving Manoah and his Wife,
c.1652 [fig.114]

Pen and brown ink, with brown wash,
20.8 × 18 cm
Fondation Custodia – Collection Frits Lugt,
Paris (5803)

PROVENANCE Jonathan Richardson Sen.,
London [L.2184, 2983]; his sale, London
(Cock), 11.02.1747 [Lugt 653], lot not identi-
fied; Charles Rogers, London [L.624]; his sale,
London (Philipe), 15.04.1799 [Lugt 5901], lot
536; John MacGowan, Edinburgh [L.1496];
his sale, London (Philipe), 26.01.1804 [Lugt
6733], lot 549; Samuel Woodburn, London;
his sale, London (Christie's), 16–27.06.1854
[Lugt 21988], lot 2196; Gerald M. Fitzgerald,
Little Shelford, Cambridgeshire; sale London
(Sotheby's), 23–24.05.1922 [Lugt 83711], lot 37
(to Kempe, £52); Schaeffer Galleries, New York;
F. Stern (Cosmos Art), New York; Frits Lugt,
Paris [L.1028], acquired 07.11.1943.

REFERENCES Ben.980; Schatborn 2010, no.18

33

REMBRANDT, AFTER ANDREA MANTEGNA
(C.1431–1506)

The Calumny of Apelles, c.1652–54 [fig.17]

Pen and brown ink with brown wash on paper
prepared with brown wash, 26.3 × 43.2 cm
British Museum, London (1860,0616.86)

PROVENANCE Salomon Gautier, Paris;
Jonathan Richardson Sen., London [L.2184]; his
sale, London (Cock), 03.02.1747 [Lugt 653], 11th
day, lot 37 (to Price, £1/10/0, together with three
other drawings); Arthur Pond, London [L.2038];
John Barnard, London [L.1419]; his sale,
London (Greenwood), 16.02.1787 [Lugt 4145],
1st night, lot 88 (with the Mantegna drawing,

to West, £15/15/0); Benjamin West, London
[L.419]; his sale, London (Christie's), 13.06.1820
[Lugt 9819], 4th day, lot 53 (to Woodburn, £10);
Thomas Lawrence, London [L.2445]; William
Esdaile, London; his sale, London (Christie's),
17.06.1840 [Lugt 15863], lot 120 (to Woodburn,
£27/6/0, together with the Mantegna drawing);
Samuel Woodburn, London; his sale, London
(Christie's), 07.06.1860 [Lugt 25634], lot 762,
where acquired.

REFERENCES Ben.687; Royalton-Kisch 2010,
no.46

EXHIBITED IN BRITAIN London 1835, no.100;
London 1899b, no.A75; London 1938, no.80;
London 1956, no.1a; London 1972–73, no.125;
London 1981, no.59; London 1992, no.53

34

REMBRANDT

The Incredulity of Saint Thomas,
c.1652–54 [fig.109]

Pen and brown ink, some white bodycolour,
15 × 24 cm
Musée du Louvre, Départment des Arts
Graphiques, Paris (RF 4726)

PROVENANCE Jonathan Richardson Sen.,
London [L.2148]; his sale, London (Cock),
02.02.1747 [Lugt 653], lot 60 (to Hudson);
Thomas Hudson, London [L.2432]; Joshua
Reynolds, London [L.2364]; Edward
V. Utterson, London [L.909]; his sale, London
(Christie's), 17.02.1848 [Lugt 18906], probably
lot 121; William Russell, London [L.2648]; Léon
Bonnat, Paris (by 1885), Bonnat Gift, 1919.

REFERENCES Lugt 1933, no.1142; Ben.1010

35

REMBRANDT

Self-portrait in a Heavy Fur Cap: Bust,
1631

Etching, 6.7 × 6 cm
The Hunterian, University of Glasgow, Glasgow
(GLAHA 292)

PROVENANCE Duke of Richmond and Gordon;
donated by Dr James A. McCallum, Glasgow
[L.1409b], 1948.

REFERENCES B.16 I; NHD 80 (only state)

36

REMBRANDT

Portrait of the Preacher Jan Cornelis
Sylvius, 1633

Etching, 16.6 × 14.1 cm
British Museum, London (1843,0513.265)

PROVENANCE Purchased from W. & G. Smith,
London, 1843.

REFERENCES B.266 I; NHD 124 I

37

REMBRANDT

Portrait of the Preacher Jan Cornelis
Sylvius, 1633

Etching, counterproof touched with black chalk,
16.6 × 14.1 cm
British Museum, London (1855,0414.270)

PROVENANCE Heneage Finch, 5th Earl
of Aylesford (1786–1859), London [L.58];
purchased from Colnaghi, London, 1855.

REFERENCES B.266 I; NHD 124 I

38

REMBRANDT

Portrait of the Preacher Jan Cornelis Sylvius, 1633 (this impression printed c.1700-50) [fig.27]

Etching, printed in red ink, 16.4 × 14 cm
National Galleries of Scotland, Edinburgh
(P 6592)

PROVENANCE Unknown.

REFERENCES B.266 I; NHD 124 II

39

REMBRANDT

The Strolling Musicians, c.1635

Etching, 13.6 × 11.5 cm
British Museum, London (1843,0607.79)

PROVENANCE Purchased from W. & G. Smith, London, 1843.

REFERENCES B.119 I; NHD 141 I

40

REMBRANDT

The Strolling Musicians, c.1635 (this impression printed c.1750-90)

Etching, on silk, 14.1 × 11.5 cm
British Museum, London (F,5.59)

PROVENANCE Bequeathed by Revd Clayton Mordaunt Cracherode, 1799.

REFERENCES B.119 I; NHD 141 I

41

REMBRANDT

Bearded Man Wearing a Velvet Cap with a Jewel Clasp, 1637 [fig.14]

Etching, 9.4 × 8.2 cm
The Hunterian, University of Glasgow, Glasgow
(GLAHA 325)

PROVENANCE Donated by Dr James A. McCallum, Glasgow [L.1409b], 1948.

REFERENCES B.313 (only state); NHD 163 (only state)

42

REMBRANDT

Young Man in a Velvet Cap (Ferdinand Bol?), 1637

Etching, 9.7 × 8.4 cm
National Galleries of Scotland, Edinburgh
(P 549)

PROVENANCE S. Scheickevitch, Moscow [L.2264]; David Young Cameron, Edinburgh; Sir David Young Cameron Gift through the Art Fund, 1943.

REFERENCES B.223 II; NHD 164 II

43

REMBRANDT

The Artist Drawing from the Model ('Het Beeldt van Pigmalion'), c.1639

Etching, 23.2 × 18.4 cm
Fondation Custodia – Collection Frits Lugt, Paris (503)

PROVENANCE Pierre II Mariette, Paris, 1681 [L.1790]; Pierre Remy, Paris, 1749 [L.2173]; Arthur Pond (c.1701–1758), London; Edward Astley, Norfolk [L.2775]; his sale, London (Langford), 27.03.1760 [Lugt 1090], lot not identified; Ambroise Firmin-Didot, Paris [L.119]; his sale, Paris (Delestre *et al.*), 16.04–12.05.1877 [Lugt 37349], lot 948 (Fr 95); Edward Smith Jun., London [L.2897]; his sale, London (Sotheby's), 20.11.1880 [Lugt 40477], lot 83 (to Noseda, £6/5/6); sale J. Kneppelhout, Amsterdam (De Vries), 09.03.1920 [Lugt 80172], lot 954 (to Lugt, fl.500); Frits Lugt, Blaricum and Paris [L.1028].

REFERENCES B.192 II; NHD 176 II; Hinterding 2008, no.149

44

REMBRANDT

Cornelis Claesz Anslo, Preacher, 1641 (this impression printed 1826)

Etching and drypoint, 18.8 × 15.8 cm
British Museum (1924,0828.6)

PROVENANCE Walter Benjamin Tiffin, London, 1826; purchased from Craddock & Barnard, London, 1924.

REFERENCE NHD 197 V

45

REMBRANDT

Landscape with a Cottage and a Hay Barn, 1641 [fig.77]

Etching, 12.9 × 32.1 cm
National Galleries of Scotland, Edinburgh
(P 615)

PROVENANCE Purchased by Alexander Maitland, Edinburgh, 1916; from whom purchased, 1945.

REFERENCES B.225 (only state); NHD 199 (only state)

EXHIBITED IN BRITAIN Edinburgh 1938 [no catalogue]

46

REMBRANDT

The Three Trees, 1643 [fig.43]

Etching, drypoint and engraving, 21.3 × 27.9 cm
British Museum, London (F,5.164)

PROVENANCE Bequeathed by Revd Clayton Mordaunt Cracherode, 1799; Robert Dighton [L.727] (stolen and recovered, 1806).

REFERENCES B.212 (only state); NHD 214 (only state)

EXHIBITED IN BRITAIN London 1986, no.112; Berlin/Amsterdam/London 1991–92b, no.19

47

REMBRANDT

Beggar Woman Leaning on a Stick, 1646

Copper plate with etching and drypoint,
8.2 × 6.5 cm
National Galleries of Scotland, Edinburgh
(PLATE.42)

PROVENANCE Clement de Jonghe, Amsterdam,
1679; sale Pieter de Haan, Amsterdam (de
Winter *et al.*), 09.03. 1767 [Lugt 1594], lot 49
(to Fouquet, Dfl.3, together with lot 48); sale
Claude-Henri Watelet, Paris (Paillet), 12.06.1786
[Lugt 4061], lot 365 (to Basan); Pierre-François
Basan (died 1797), Paris; by descent to Henry-
Louis Basan, Paris; sold to Auguste Jean (died
1820), Paris, *c.*1809; by descent to his widow,
Paris; probably her sale, Paris, 09.03.1846
[Lugt 18063], lot 540 (to Auguste Bernard);
by descent to his son, Michel Bernard, Paris;
sold to Alvin-Beaumont, Paris, 1906; sold to
Robert Lee Humber (1898–1970), Greenville,
North Carolina; his heirs, sold in 1993 through
Artemis London in association with R.M. Light;
purchased by the Patrons of the National
Galleries of Scotland, 1993.

REFERENCES B.170; NHD 229; Hinterding
1993–94, p.298

EXHIBITED IN BRITAIN Edinburgh 2002–3
[no catalogue]; Edinburgh 2005 [not in
catalogue]; Edinburgh 2007 [no catalogue];
Edinburgh 2014 [no catalogue]; Banff 2016 [no
catalogue]

48

REMBRANDT

Portrait of Jan Six, 1647 [fig.78]

Etching, drypoint and engraving on Japanese
paper, 24.6 × 19.1 cm
British Museum, London (F,6.70)

PROVENANCE Bequeathed by Revd Clayton
Mordaunt Cracherode, 1799; Robert Dighton
[L.727] (stolen and recovered, 1806).

REFERENCES B.III; NHD 238 IV

EXHIBITED IN BRITAIN Berlin/Amsterdam/
London 1991–92b, no.23

49

REMBRANDT

Cottage with a White Paling, 1648

Etching, 13 × 15.8 cm
National Galleries of Scotland, Edinburgh
(P 614)

PROVENANCE Hermann Weber (1817–1854),
Bonn [L.1383]; his sale, Leipzig (Weigel),
28.04.1856 [Lugt 22965], lot 352 (42 Taler);
August Sträter (1810–1897), Aachen [L.787]; his
sale, Stuttgart (Gutekunst), 10–14.05.1898 [Lugt
56298], lot 816; P. von Seidenberg-Baldinger
(died 1911), Stuttgart [L.212]; purchased by
Alexander Maitland, Edinburgh, 1916; from
whom purchased, 1945.

REFERENCES B.232 II; NHD 246 II

50

REMBRANDT

The Hundred Guilder Print, c.1648

Etching, drypoint and engraving, 27.8 × 38.8 cm
National Galleries of Scotland, Edinburgh
(P 378)

PROVENANCE Mr Thomas Barclay Bequest,
1940.

REFERENCES B.74 II; NHD 239 II

EXHIBITED IN BRITAIN Edinburgh 1938
[no catalogue]; Banff 2007–8 [no catalogue];
Glasgow 2012, no.20

51

REMBRANDT, REWORKED BY
WILLIAM BAILLIE (1723-1810)

The Hundred Guilder Print, c.1648 and
1775 [fig.28]

Etching and engraving, 28.2 × 39.8 cm
Lent by Nicholas Stogdon

PROVENANCE Acquired by the present owner
in 1994.

REFERENCES B.74; NHD 239 III; Stogdon
1996; Butler 2005, vol.1, no.74

52

REMBRANDT,
REWORKED AND CUT BY WILLIAM BAILLIE

The Hundred Guilder Print (fragment),
c.1648 and 1775 [fig.81]

Etching and engraving, 19.5 × 12.6 cm
National Galleries of Scotland, Edinburgh
(P 6611)

PROVENANCE Purchased 1951.

REFERENCES B.74; NHD 239 IV D; Butler
2005, vol.1, no.74

53

REMBRANDT

The Blindness of Tobit (the large plate),
1651

Etching, 16 × 12.1 cm
The Hunterian, University of Glasgow, Glasgow
(GLAHA 3641)

PROVENANCE Jonathan Richardson Sen.,
London [Lugt 2183]; Tracy Dows (1871–1937),
New York [Lugt 2427]; donated by Dr James
A. McCallum, Glasgow [L.1409b], 1948.

REFERENCES B.42 I; NHD 265 I

54

REMBRANDT

*Landscape with a Farm Building and the
'House with the Tower'*, c.1651

Etching and drypoint, 12.3 × 31.9 cm
National Galleries of Scotland, Edinburgh
(P 609)

PROVENANCE Adalbert von Lanna (1836–
1909), Prague [L.2773]; David Young Cameron,
Edinburgh; purchased 1945.

REFERENCES B.223 IV; NHD 256 IV

EXHIBITED IN BRITAIN Banff 2007–8 [no
catalogue]

55

REMBRANDT

Christ Crucified between the Two Thieves ('The Three Crosses'), 1653

Drypoint, 38.5 × 45 cm
National Galleries of Scotland, Edinburgh (P 113)

PROVENANCE Purchased from Messrs. Obach & Co., London (£100), 1910.

REFERENCES B.78 IV; NHD 274 IV

EXHIBITED IN BRITAIN Edinburgh 1938 [no catalogue]; Banff 2007–8 [no catalogue]; Glasgow 2012, no.14

56

REMBRANDT

Christ Presented to the People (oblong plate), 1655 [fig.10]

Drypoint on Japanese paper, 38.3 × 45.5 cm
Fondation Custodia – Collection Frits Lugt, Paris (2086)

PROVENANCE Possibly Otto (1612–1665) or Dirck van Cattenburgh (c.1616–1704), Amsterdam; Arthur Pond (c.1701–1758), London [L.2038]; Edward Astley, Norfolk [L.2775]; his sale, London (Langford), 27.03.1760 [Lugt 1090], day 5, part of lot 78; Edward Rudge (1763–1846) [L.900], Abbey Manor, Evesham, Worcestershire; by descent to John Edward Rudge (1903–1970), Abbey Manor, Evesham; his sale, London (Christie's), 16–17.12.1924, lot 101 (to Lugt, 420gns); Frits Lugt, Maartensdijk and Paris [L.1028].

REFERENCES B.76 VII; NHD 290 VII; Hinterding 2008, no.62a; Paris 2010, no.43

EXHIBITED IN BRITAIN London 1877, no.41

57

REMBRANDT

Abraham Entertaining the Angels, 1656 [fig.116]

Etching and drypoint on Japanese paper, 15.9 × 13.1 cm
National Galleries of Scotland, Edinburgh (P 541)

PROVENANCE Edward Astley (1729–1802), Norfolk [L.2775]; his sale, London (Langford), 27.03–14.04.1760 [Lugt 1090], lot not identified; Joshua Reynolds (1723–1792), London [L.2364]; Edward V. Utterson, London [L.909]; his sale, London (Christie's), 17.02.1848 [Lugt 18906], lot 41 (to Hodges, £2/0/0); Émile Galichon (1829–1875), Paris [L.1058]; John Webster (1810–1891), Aberdeen [L.1554]; David Young Cameron (1865–1945), Edinburgh; Sir David Young Cameron Gift through the Art Fund, 1943.

REFERENCES B.29 (only state); NHD 295 (only state)

EXHIBITED IN BRITAIN Banff 2007–8 [no catalogue]

58

REMBRANDT

A Nude Woman at the Bath, 1658

Etching and drypoint on Japanese paper, 15.6 × 12.9 cm
British Museum, London (1835,0613.7)

PROVENANCE John Barnard, London [L.219]; his sale, London (Philipe), 16.04.1798 [Lugt 5741], lot 241 (to Hibbert, £1/4/0); George Hibbert, London [L.2849]; his sale, London (Philipe), 02.05.1809 [Lugt 7561], lot 170 (to Claussin, £3/2/0); Reginald Pole Carew, Antony House, Cornwall; his sale, London (Wheatley's), 14.05.1835 [Lugt 13998], lot 189 (£21); where acquired.

REFERENCES B.199 I; NHD 310 I

59

REMBRANDT, FORGERY, POSSIBLY BY JEAN DE BARY (d.1759)

Self-portrait with Saskia (with Saskia replaced by the Portrait of the artist's mother), before 1751

Etching (printed from two Rembrandt plates), 10.4 × 9.5 cm
British Museum, London (F,4.20)

PROVENANCE Bequeathed by Revd Clayton Mordaunt Cracherode in 1799; Robert Dighton [L.727] (stolen and recovered, 1806).

REFERENCES B.349 II and B.19 III; NHD 87 II and NHD 158 III; NHD, vol.1, pp.lix–lx; Hinterding & van der Coelen 2016, pp.72–76

II · Works by Other Artists

60

FRANK AUERBACH (BORN 1931)
Portrait of E.O.W. IV, 1961

Oil on plywood, 59.8 × 56.8 cm
National Galleries of Scotland, Edinburgh
(GMA 1537)

PROVENANCE Purchased 1976.

REFERENCES London/Edinburgh 1978, no.36;
Hughes 1990, p.152; Feaver 2009, no.121

61

FRANK AUERBACH
Tree at Tretire, 1975

Chalk, charcoal and gouache, 77 × 72.5 cm
National Galleries of Scotland, Edinburgh
(GMA 2848)

PROVENANCE Presented by Miss Dorothy
Claire Weicker, 1984.

REFERENCES London/Edinburgh 1978,
no.126; Feaver 2009, p.277; London/Amsterdam
2013–14, p.19

62 A & B

FRANK AUERBACH
*Drawing after Rembrandt's
'A Woman Bathing in a Stream
(Hendrickje Stoffels?)'*, 1988 [fig.62]

Felt-tip pen, 38.9 × 29.4 cm
The National Gallery, London (H150)

*Drawing after Rembrandt's
'A Woman Bathing in a Stream'
(Hendrickje Stoffels?)*, 1988

Felt-tip pen and correction fluid, 38.7 × 29.5 cm
The National Gallery, London (H151)

PROVENANCE Gifted by James Kirkman, 2000.

63

WILLIAM BAILLIE (1723-1810),
AFTER REMBRANDT
Portrait of an Old Man, 1761

Black and coloured chalks on vellum,
16.1 × 12.7 cm
National Galleries of Scotland, Edinburgh (RSA
230)

PROVENANCE David Laing Bequest to the
Royal Scottish Academy, 1878; on loan, 1966.

REFERENCES Butler 2005, vol.1, no.D6; Baker
2011, p.34

64

WILLIAM BAILLIE, AFTER REMBRANDT
Head of an Old Man, 1761 (in: *The Works
of Captain William Baillie after Paintings
and Drawings by the Greatest Masters*,
London: Boydell & Co. [1770s], no.35)

Etching, 14.4 × 11.8 cm
National Galleries of Scotland, Edinburgh
(P 2163)

PROVENANCE Purchased 1951.

REFERENCE Butler 2005, vol.1, no.64

65

JOHN BELLANY (1942-2013)
Danae: Homage to Rembrandt II, 1991
[fig.69]

Oil on canvas, 183 × 213.5 cm
The Bellany Estate

PROVENANCE The artist; by descent to the
present owner.

REFERENCE Edinburgh 2012, no.52

66

GEORGE BICKHAM THE YOUNGER
(c.1706-1771), AFTER REMBRANDT
*The Two Crosses first thought by
Rembrant this by Bickham*, 1769

Etching and engraving, 34.6 × 25.7 cm
Lent by Nicholas Stogdon

PROVENANCE Acquired by the present owner
in London.

REFERENCE NHD 274, copy b II

67

CHARLES BROOKE BIRD (1856-1916),
AFTER REMBRANDT
The Mill, 1911

Colour mezzotint on chine collé, 32.8 × 40.5 cm
Private collection

PROVENANCE Purchased from Sanders of
Oxford, 2017.

REFERENCE Charrington & Alexander 1983,
no.31

68

PIETER VAN BLEECK (1697-1764),
AFTER A WORK FORMERLY ATTRIBUTED TO
REMBRANDT
Rembrandt, 1747 [fig.25]

Mezzotint, 35.2 × 25.7 cm
David Alexander

PROVENANCE Unknown.

REFERENCE Charrington & Alexander 1983,
no.32

69

ADOLPHE BRAUN (1812-1877)
*Rembrandt: View of London with Old
St Paul's* (in: *Album of Great Masters:
Albertina*, Vienna, vol.6, 1877, no.718)

Album of autotypes, 48.4 × 64.7 cm
Lent by the Royal Academy of Arts, London
(10/2204)

PROVENANCE Purchased 1877.

70

JAMES BRETHERTON (c.1730–1806), AFTER REMBRANDT

Young Man in a Velvet Cap, c.1770–80

Etching, 9.5 × 8.2 cm
The Hunterian, University of Glasgow, Glasgow (GLAHA 370)

PROVENANCE Bequeathed by Dr James A. McCallum, Glasgow [L.1409b], 1948.

REFERENCE NHD 164, copy a

71

GLENN BROWN (BORN 1966)

Unknown Pleasures, 2016 [fig.73]

Oil on panel, 164 × 105.5 cm
Courtesy the artist

REFERENCE Amsterdam 2017, pp.26–27, 71

72 A–F

GLENN BROWN

Half-Life (after Rembrandt), 2017 [fig.71]

Series of six etchings, each 89.4 × 68.2 cm
Courtesy the artist and Paragon | Contemporary Editions Ltd

PROVENANCE Remains with the publisher.

REFERENCE Amsterdam 2017, pp.26–27, 60–65

73

DAVID YOUNG CAMERON (1865–1945)

Nithsdale, 1911

Drypoint, 15.3 × 31.9 cm
National Galleries of Scotland (P 2802)

PROVENANCE Purchased 1980.

REFERENCE Rinder 1932, no.435 IV

74

ALFRED EDWARD CHALON (1780–1860)

Students at the British Institution, 1806 [fig.89]

Pen and brown ink, with watercolour, 31.5 × 53.1 cm
British Museum, London (1879,0614.757)

PROVENANCE Purchased from Joseph Hogarth, London, 1879.

REFERENCE Binyon 1898–1907, no.4

75

IGNACE-JOSEPH DE CLAUSSIN (1766–1844), AFTER REMBRANDT

Jacob and his Sons, 1799

Etching, 20 × 27.3 cm
National Galleries of Scotland, Edinburgh (P 6645)

PROVENANCE Unknown.

76

RICHARD COOPER THE YOUNGER (C.1740–1814), AFTER REMBRANDT

A Young Woman Leaning Forward ('Rembrandt's Mistress'), c.1781 [fig.30]

Pencil, incised, verso blackened for transfer, 27.6 × 20.4 cm
National Galleries of Scotland, Edinburgh (D 4823 II F. XVIII)

PROVENANCE Miss M. Eyre Gift, 1959.

REFERENCE Edinburgh/London 2001, under no.100

77

RICHARD COOPER THE YOUNGER, AFTER REMBRANDT

A Young Woman Leaning Forward ('Rembrandt's Mistress'), 1781

Mezzotint, 23.7 × 22.9 cm
British Museum, London (1861,1109.287)

PROVENANCE Purchased from A.E. Evans & Sons, London, 1861.

REFERENCE Charrington & Alexander 1983, no.39 I

78

KEN CURRIE (BORN 1960)

Rembrandt's Carcass, 1991 [fig.70]

Etching, 41.6 × 30.6 cm
National Galleries of Scotland, Edinburgh (GMA 3644)

PROVENANCE Purchased 1992.

REFERENCE Normand 2002, pp.70–71

79 A,B & C

EDWARD T. DANIELL (1804–1842)

Craigmillar Castle (the small plate), 1831 [fig.45]

Etchings (three impressions, states I, II and III/III), each 9.1 × 15.3 cm
The Hunterian, University of Glasgow, Glasgow (GLAHA 40151, GLAHA 40152, GLAHA 40153)

PROVENANCE Charles Sackville Bale, London [L.640], 1833; Chambers Hall (1786–1855), London [L.551]; John Postle Heseltine (1843–1929), London [L.1507]; P. & D. Colnaghi, London; purchased from N.W. Lott and H.J. Gerrish Ltd, 1992.

REFERENCE Thistlethwaite 1974, no.35

80

DAVID DEUCHAR (1743-1808),
AFTER REMBRANDT
Beggar Woman Leaning on a Stick,
c.1784-88 (in: 'Deuchar's Etchings': Album
of prints, c.1800)

Etching, 8.1 × 5.7 cm
National Galleries of Scotland (P 1667)

PROVENANCE On permanent loan from the
National Museum of Antiquities of Scotland,
1949.

REFERENCE NHD 229, copy d

81

WILLIAM DICKINSON (1746-1823), AFTER
MATTHEW WILLIAM PETERS (1742-1814)
Lydia, 1776 [fig.31]

Mezzotint, 30.4 × 33.3 cm
Lent by William Zachs

PROVENANCE Christopher Lennox-Boyd
(1941–2012); purchased at Sanders of Oxford,
2017.

REFERENCE Sammern 2016, pp.20–31

82

WILLEM DROST (1633-1659), FORMERLY
ATTRIBUTED TO REMBRANDT
Portrait of a Young Scholar, c.1654 [fig.95]

Oil on canvas, 83 × 64.5 cm
Musée du Louvre, Départment des Peintures,
Paris (RF 1751)

PROVENANCE Jonathan Richardson Sen.,
London; his sale, London (Cock) 22.01.1747
[Lugt 653], lot 55 (£24/3/0); where probably
acquired by Thomas Hudson, London; his sale,
London (Christie's) 25.02.1785 [Lugt 3835],
2nd day, lot 110 (£34/13/0); sale Charles Bagot,
London (Christie's), 18.06.1836 [Lugt 14401], lot
42 (£30/9/0); purchased 1909.

REFERENCE Bikker 2005, no.23

83

THOMAS DUNCAN (1807-1845)
Self-portrait, 1844

Oil on canvas, 128.7 × 102 cm
National Galleries of Scotland, Edinburgh
(NG 182)

PROVENANCE The artist; purchased and gifted
by fifty Scottish artists to the Royal Scottish
Academy, 1845; transferred and gifted to the
National Galleries of Scotland in 1910.

REFERENCE Perth 1995, no.19

84

JACOB EPSTEIN (1880-1959)
Albert Einstein, 1933 [fig.57]

Bronze, 43.5 × 30 × 25.5 cm
National Galleries of Scotland, Edinburgh
(GMA 13)

PROVENANCE Gifted by the children of James
Watt, LLD WS, 1958.

REFERENCE Silber 1986, no.234

85

RICHARD GAYWOOD (ACTIVE C.1644-
1677), AFTER JAN VAN VLIET (C.1600/1610-
1668?), AFTER REMBRANDT
Democritus Laughing and Heraclitus
Weeping in front of a Globe, c.1650-60
[fig.12]

Etching, 24 × 32.3 cm
British Museum, London (F,6.158)

PROVENANCE Acquired before 1837.

REFERENCES Globe 1985, no.423; London
1998, no.108

86

ANDREW GEDDES (1783-1844)
'Dull Reading' with Daniel Terry (c.1780-
1829) and Elizabeth (Nasmyth) Terry
(1793-1862), c.1826

Etching, 13.8 × 17.6 cm
National Galleries of Scotland, Edinburgh
(P 1972)

PROVENANCE Purchased 1949.

REFERENCE Edinburgh 2001, no.87

87

ANDREW GEDDES
Landscape in the Manner of Rembrandt,
c.1839 [fig.46]

Oil on paper, laid on mahogany panel,
20 × 29.6 cm
National Galleries of Scotland, Edinburgh
(NG 2320)

PROVENANCE William Seguier (1772–1843),
London; Kenneth Sanderson, Edinburgh,
to at least 1939; given to his godson Charles
Ballantyne, Selkirk, before 1943; gifted by
Charles Ballantyne, 1973.

REFERENCE Edinburgh 2001, no.39

88

JOHN GILBERT (1817-1897)
Rembrandt's Studio, 1869 [fig.41]

Oil on canvas, 121.9 × 152.5 cm
York Museums Trust, York (YORAG 351)

PROVENANCE Joseph Craven, York; his sale,
London (Christie's) 27.03.1874 [Lugt 34699],
lot 178; purchased by John Burton, by whom
bequeathed, 1882.

REFERENCE Froyen 2011, pp.171–72

89

HENRYK GOTLIB (1890–1966)

Rembrandt in Heaven, c.1948–58 [fig.60]

Oil on canvas, 133.3 × 163.2 cm
Tate (T03185)

PROVENANCE Purchased 1980.

REFERENCE London 1984, p.102

90

G. GRAY (ACTIVE MID-19TH CENTURY),
AFTER REMBRANDT AND WORKSHOP

Portrait of a Lady, c.1863

Painted porcelain plaque, 25.4 × 20.3 cm
Victoria and Albert Museum, London
(145–1864)

PROVENANCE Unknown.

91

FRANCIS SEYMOUR HADEN (1818–1910)

On the Test, 1859

Drypoint, 15 × 22.5 cm
National Galleries of Scotland, Edinburgh
(P 2370)

PROVENANCE George H. Liston-Foulis
Bequest, 1958.

REFERENCE Harrington 1910, no.20

92

FRANCIS SEYMOUR HADEN

The Little Boathouse, 1877

Drypoint, 15 × 22.3 cm
National Galleries of Scotland, Edinburgh
(P 385)

PROVENANCE Mr Thomas Barclay Bequest,
1940.

REFERENCE Harrington 1910, no.177

93

WILLIAM HOGARTH (1697–1764)

Paul Before Felix Burlesqued, 1751 [fig.26]

Etching with some mezzotint, 26.7 × 35.6 cm
National Galleries of Scotland, Edinburgh
(P 6767)

PROVENANCE Unknown.

REFERENCES New Haven 1983, no.13; Paulson
1989, no.191 IV

94

RICHARD HOUSTON (c.1721–1775),
AFTER REMBRANDT

Jan Six (the large plate), 1761

Mezzotint, 35.5 × 25 cm
David Alexander

PROVENANCE Unknown.

REFERENCES Charrington & Alexander 1983,
no.88; NHD 238, copy c II

95

RICHARD HOUSTON, AFTER REMBRANDT

Jan Six (the small plate), 1762

Mezzotint, 15.3 × 11.3 cm
David Alexander

PROVENANCE Unknown.

REFERENCE Charrington & Alexander 1983,
no.89; NHD 238, copy c III (erroneously identi-
fied as the reduced plate of copy c I/II)

96

THOMAS HUDSON (1701–1779)

Charles Erskine (1716–1749), 1747 [fig.99]

Oil on canvas, 75.5 × 62.2 cm
National Galleries of Scotland, Edinburgh
(NG 2131)

PROVENANCE By descent to Alastair Erskine-
Murray, later Lord Elibank; from whom
purchased, 1950.

REFERENCES London 1979, no.35; New Haven
1983, no.20

97

JOHN BAPTIST JACKSON (1701–C.1780),
AFTER REMBRANDT

The Descent from the Cross, 1738

Chiaroscuro woodcut from four blocks, 44 × 27.5 cm
The Hunterian, University of Glasgow, Glasgow
(GLAHA 40731)

PROVENANCE Roger Newdigate (1719–1806);
by descent; sale Newdigate Settlement, London
(Christie's), 01.07.1987, lot 321; purchased with
support from the National Fund for Acquisitions,
1991.

REFERENCE Kainen 1962, no.13

98

AUGUSTUS JOHN (1878–1961)

Tête Farouche (Portrait of the Artist), c.1901
[fig.53]

Etching, 21.3 × 17.1 cm
National Galleries of Scotland, Edinburgh
(GMA 1190)

PROVENANCE D.J. Macaulay; his sale
London (Sotheby's), 26–27.10.1921 (£15/10/0);
purchased 1949.

REFERENCE London 2004, no.12

99

PHILIPS KONINCK (1619–1688),
FORMERLY ATTRIBUTED TO REMBRANDT

The Coach Landscape, c.1650–60 [fig.76]

Etching, with additions of black wash and touches
of brown, 6.3 × 17.8 cm
British Museum, London (F,5.172)

PROVENANCE Edward Astley (1729–1802),
London [L.2775]; his sale, London (Langford),
27.03–14.04.1760 [Lugt 1090], day 14, part of lot
76; John Barnard (1709–1784), London [L.1419];
his sale, London (Philipe), 08.05.1798, lot 250 (to
J. Thane for Cracherode, £19/18/6); bequeathed by
Revd Clayton Mordaunt Cracherode [L.607], 1799;
Robert Dighton [L.727] (stolen and recovered,
1806).

REFERENCES White & Boon 1969, no.215; Van
Camp 2013, pp.89, 91, 94

100

LEON KOSSOFF (BORN 1926)

From Rembrandt: A Woman Bathing in a Stream, 1982 [fig.61]

Oil on board, 58.4 × 48.3 cm
Private collection

PROVENANCE Purchased 2009.

REFERENCE London 2007, fig.1

101

ROBERT SCOTT LAUDER (1803–1869)

A Study for 'Christ Teacheth Humility', c.1847

Oil on canvas, 32.5 × 57.6 cm
National Galleries of Scotland (NG 2316)

PROVENANCE Purchased 1972.

REFERENCE Edinburgh 1983, no.23

102

RICHARD COCKLE LUCAS (1800–1883), AFTER REMBRANDT

The Descent from the Cross, c.1840–65 [fig.48]

Ivory, 13.3 × 9.7 cm
Victoria and Albert Museum, London (190–1865)

PROVENANCE Gifted by Richard Cockle Lucas, 1865.

REFERENCE Trusted 2013, no.170

103

EDWARD LUTTERELL (C.1650–BEFORE 1737), AFTER REMBRANDT

Self-portrait of Rembrandt, c.1700 [fig.15]

Coloured chalks and bodycolour, 32.8 × 25 cm
British Museum, London (1957,0214.1)

PROVENANCE Acquired 1957.

REFERENCES Croft-Murray & Hulton 1960, no.7; Jeffares 2017, no.J.506.233

104

JAMES MCARDELL (1728/29–1765), AFTER REMBRANDT

Rembrandt's Mother, c.1765

Mezzotint, 35.3 × 25 cm
David Alexander

PROVENANCE Unknown.

REFERENCES Charrington & Alexander 1983, no.108 III; New Haven 1983, no.107

105

JAMES MCARDELL, AFTER REMBRANDT, WORKSHOP OF

A Dutch Interior ('The Cradle'), c.1765

Mezzotint, 34 × 46.6 cm
David Alexander

PROVENANCE Unknown.

REFERENCE Charrington & Alexander 1983, no.105 II

106

JAMES MCARDELL, AFTER WILLIAM HOGARTH (1697–1764)

Mr Pine, c.1755 [fig.101]

Mezzotint, 33.4 × 22.5 cm
David Alexander

PROVENANCE Unknown.

REFERENCES New Haven 1983, under no.14; Einberg 2016, under no.219

107

JAMES MCBEY (1883–1959)

The Isle of Ely, 1915

Etching and drypoint, 20.6 × 34.1 cm
National Galleries of Scotland, Edinburgh (GMA 422)

PROVENANCE Purchased 1961.

REFERENCE Hardie 1962, no.162

108

JAMES MCBEY

Letter to Frank [Short (1857–1945)], 11 April 1928

Fondation Custodia – Collection Frits Lugt, Paris (1978-A.2821)

PROVENANCE Acquired at sale, London (Sotheby's), 26.04.1978, part of lot 188.

109

DAVID OCTAVIUS HILL (1802–1870) AND ROBERT ADAMSON (1821–1848)

Spencer Compton, 2nd Marquess of Northampton (1790–1851), President of the Royal Society, 1843–47 [fig.51]

Salted paper print, 20 × 15 cm
National Galleries of Scotland, Edinburgh (PGP HA 1744)

PROVENANCE Unknown.

REFERENCE Edinburgh 2002, no.20

110

WILLIAM ORPEN (1878–1931)

Self-portrait, c.1895

Pen and brown ink, 20.4 × 14.4 cm
National Galleries of Scotland, Edinburgh (GMA 4352)

PROVENANCE Purchased from E.S. Lumsden, 1949.

111

EDUARDO PAOLOZZI (1924–2005)

Copies from Rembrandt, 1945 [fig.58]

Pen and black ink, 26.9 × 36.8 cm
National Galleries of Scotland, Edinburgh (GMA 4011)

PROVENANCE Given to Gabrielle Keiller by the artist, 1962; bequeathed by Gabrielle Keiller, 1995.

REFERENCE Miles 1977, no.203

112

EGLINGTON MARGARET PEARSON
(DIED 1823), AFTER REMBRANDT

Samson Upbraiding his Father-in-law,
c.1800 [fig.47]

Stained glass, 22 × 18.5 cm
Victoria and Albert Museum, London
(C.102–1924)

PROVENANCE Gifted by Wilfred Drake.

REFERENCE Petzold 2000, p.56

113

WILLIAM PETHER (*c.*1738–1821),
AFTER REMBRANDT

A Jew Rabbi, 1764

Mezzotint, 50.8 × 35.5 cm
National Galleries of Scotland (P 9659)

PROVENANCE Unknown.

REFERENCE Charrington & Alexander 1983,
no.119

114

MATTHEW PILKINGTON (1701–1774)

The Gentleman's and Connoisseur's
Dictionary of Painters […], London, 1770

Printed book, 28.5 × 22.4 cm
David Alexander

PROVENANCE William Baillie (1723–1810, with
his annotations); Robert Raines (1909–1986).

REFERENCE Butler 2005, vol.1, p.77

115

ARTHUR POND (*c.*1701–1758),
AFTER REMBRANDT

Saint Peter's Prayer before the Raising of
Tabitha, 1736 [fig.92] (in: Arthur Pond and
George Knapton, *Estampes qui imitent le*
desseins […], London: John Boydell, [no
date, *c.*1773-76] (re-issued from the first
edition 1736), fol.53)

Etching and aquatint, 20.7 × 21.7 cm
Lent by Nicholas Stogdon

PROVENANCE Purchased 1983.

REFERENCE Hake 1922, no.64

116 A & B

ARTHUR POND, IN PART AFTER JOHN
VANDERBANK (1694-1739)

Self-portrait, 1739 [fig.24]

Drypoint (two impressions, Stogdon state V and
VII), each 18.8 × 14.1 cm
Lent by Nicholas Stogdon

PROVENANCE Horace Walpole (1717–1797),
Strawberry Hill; his sale, London (Robins),
13–23.06.1842 [Lugt 16640], probably part of
lot 1270 (to Evans, £61/19/0); sale London
(Sotheby's), 29.10.1987, lot 132.

REFERENCE Hake 1922, p.337

117

HENRY RAEBURN (1756–1823)

Portrait of a Jew, 1814 [fig.34]

Oil on canvas, 76.2 × 63.5 cm
National Galleries of Scotland, Edinburgh (NG
2108)

PROVENANCE Peter Holland (1766–1855),
Knutsford, Cheshire; by descent; gifted by Mrs
F.C. Holland, 1948.

REFERENCE Edinburgh 1957, p.215; Mackie
1993, no.766

118

DAVID CHARLES READ (1790–1851)

John Glenie's Vale, c.1834

Etching, 8.1 × 14.9 cm
David Alexander

PROVENANCE Unknown.

REFERENCE Read 1874, no.142

119

JOSHUA REYNOLDS (1723–1792)

Portrait of Giuseppe Marchi, 1753 [fig.36]

Oil on canvas, 77.2 × 63.6 cm
Lent by the Royal Academy of Arts, London
(03/677)

PROVENANCE Bequeathed by Henry Edridge
ARA, 1821.

REFERENCE Mannings 2000, no.1219

120

JOSHUA REYNOLDS

Self-portrait when Young, c.1753-58
[fig.35]

Oil on canvas, 73.7 × 61.6 cm
Tate (N0099)

PROVENANCE Possibly sale Caleb Whitefoord,
London (Christie's). 04.05.1810 [Lugt 7772],
lot 76 (with 'an officer'); Thomas Lawrence,
London; his sale, London (Christie's), 15.05.1830
[Lugt 12373], lot 72 (to Peacock, 205gns); sale
Philip Reinagle, London (Christie's), 07.06.1834
[Lugt 13697], lot 66 (to Lake, 154gns); Edward
W. Lake sale, London (Christie's), 12.07.1845
[Lugt 17853], lot 103 (to Nieuwenhuys for
Robert Peel); purchased with most of the Peel
collection by the National Gallery, 1871.

REFERENCE Mannings 2000, no.4

121

JOSHUA REYNOLDS

Manuscript journal of his travels in the Netherlands, 1781 [fig.119]

Pen and brown ink and red chalk, 19.4 × 31 cm (double page)
Fondation Custodia – Collection Frits Lugt, Paris (6169)

PROVENANCE Acquired at sale, London (Christie's), 09.12.1949, lot 196.

REFERENCE Mount 1996, pp.xix–xxii

122

SAMUEL WILLIAM REYNOLDS (1773-1835), AFTER REMBRANDT

Rembrandt's Mill, 1822

Etching and mezzotint, 35 × 40 cm
The Hunterian, University of Glasgow, Glasgow (GLAHA 1058)

PROVENANCE Donated by Dr James A. McCallum, Glasgow [L.1409b], 1939.

REFERENCE Charrington & Alexander 1983, no.153a

123

JONATHAN RICHARDSON THE ELDER (1667-1745)

Self-portrait at the Age of Thirty, 1734-35 [fig.16]

Graphite on parchment, 14.7 × 11.6 cm
The Samuel Courtauld Trust, The Courtauld Gallery, London (D.1952.RW.1660)

PROVENANCE Jonathan Richardson Sen. [L.2184]; Jonathan Richardson Jun. [L.2170]; presumably his sale, London (Langford), 18.02.1772 [L.1999]; John Barnard (1709–1784), London [L.1419]; Robert E. Graves, London; his sale, London (Sotheby's), 25–26.06.1934, lot 40; where purchased by Robert Witt [Lugt 2228b]; by whom bequeathed to the Courtauld Institute of Art, 1952.

REFERENCE London 2015, no.11

124

WILLIAM SAY (1768-1834), AFTER JOSEPH MALLORD WILLIAM TURNER (1775-1851)

Windmill Lock, 1811

Etching and mezzotint, 21 × 29.1 cm
The Hunterian, University of Glasgow, Glasgow (GLAHA 1190)

PROVENANCE Bequeathed by Dr James A. McCallum, Glasgow [L.1409b], 1948.

REFERENCE Finberg 1924, no.27 II

125 A & B

GEORGE (1713/14-1776) AND JOHN SMITH (1717-1764), AFTER REMBRANDT

The Second Oriental Head

Etching, 14.6 × 12.4 cm

Christ and the Woman of Samaria among Ruins (both in: *Collection of Fifty-three Prints [...]*, London, 1770, on one page)

Etching, 11.8 × 10.7 cm
David Alexander

PROVENANCE Unknown.

REFERENCES NHD 150, copy a; NHD 127, copy d

126

WILLIAM STRANG (1859-1921)

Thunderstorm, 1889

Drypoint, 30.9 × 35.5 cm
National Galleries of Scotland (P 2333.285)

PROVENANCE David Strang Gift, 1955.

REFERENCE Strang 1962, no.161

127

WILLIAM STRANG

Self-portrait, 1910

Drypoint, 20.3 × 14.2 cm
National Galleries of Scotland (P 2333.654)

PROVENANCE David Strang Gift, 1955.

REFERENCE Strang 1962, no.633

128

WILLIAM STRANG

Rembrandt's Mill, 1911 [fig.49]

Drypoint, 30.3 × 37.8 cm
National Galleries of Scotland, Edinburgh (P 2333.643)

PROVENANCE David Strang Gift, 1955.

REFERENCE Strang 1962, no.646

129

UNKNOWN ARTIST

Portrait of Fabian Smith (Ulyanov), Agent for the English Merchants to the Emperor of Muscovia, c.1666-80 [fig.13]

Oil on canvas, 76 × 64 cm
Guildhall Art Gallery, City of London (1725)

PROVENANCE Alfred Rishton, London, by 1884; sold to D.J. Morgan, London, 1884 (£3/3/o); gifted by The Russia Company, 1966.

REFERENCE London 1991, no.15

130

SIMON WATTS (ACTIVE 1765-87), AFTER REMBRANDT

Joseph Interpreting Pharaoh's Dreams, 1766 [fig.118] (in: Charles Rogers, *A Collection of Prints in Imitation of Drawings*, London, 1778, vol.2, fol.59)

Etching, 29 × 35.5 cm
National Galleries of Scotland (P 8159.2.59)

PROVENANCE Royal Institution, Edinburgh; transferred to the National Gallery of Scotland, probably about 1859.

REFERENCE Griffiths 1993, p.21

131

JAMES ABBOTT MCNEILL WHISTLER
(1834–1903)

Fumette, 1858 [fig.127]

Etching, 16.7 × 10.9 cm
National Galleries of Scotland, Edinburgh
(P 1752)

PROVENANCE Purchased 1949.

REFERENCE G.12

132

JAMES ABBOTT MCNEILL WHISTLER

The Unsafe Tenement, 1858 [fig.130]

Etching, 15.8 × 22.6 cm
The Hunterian, University of Glasgow, Glasgow
(GLAHA 46699)

PROVENANCE Bequeathed by Dr James
A. McCallum, Glasgow [L.1409b], 1948.

REFERENCE G.18

133

DAVID WILKIE (1785–1841)

The Burying of the Scottish Regalia, c.1836
[fig.50]

Pen and brown ink, black chalk and watercolour,
28.1 × 23.1 cm
National Galleries of Scotland, Edinburgh
(D 4931)

PROVENANCE Purchased 1968.

REFERENCE Edinburgh 1999, no.76

134

DAVID WILKIE

*The Artist's Niece (Sophia Wilkie, later Mrs
James Winfield)*, 1829

Oil on canvas, 60 × 45 cm
National Galleries of Scotland (NG 2103)

PROVENANCE Gifted by the artist to James
Winfield, the sitter's husband, 1831; by descent
in the family; gifted by Miss M. Florence
Nightingale, 1948.

REFERENCE Edinburgh 1957, pp.297–98

135

BENJAMIN WILSON (1721–1788)

*Landscape with a Road and Two Houses in
the Centre*, 1751 [fig.75]

Etching and drypoint, 6.1 × 17.3 cm
British Museum, London (1907,0701.14)

PROVENANCE Presented by Anglo-Saxon Art
Gallery, 1907.

REFERENCES New Haven 1983, no.153;
Paulson 1993, pp.35–41

136

THOMAS WORLIDGE (1700–1766),
AFTER REMBRANDT

Self-portrait, c.1747–50 [fig.100]

Etching, 21 × 15.9 cm
National Galleries of Scotland, Edinburgh
(P 6643)

PROVENANCE Unknown.

REFERENCES Dack 1907, no.190; Gerson 1970,
p.304

137

THOMAS WORLIDGE

Self-portrait, 1754

Etching, 19.7 × 15.5 cm
David Alexander

PROVENANCE Unknown.

REFERENCE Dack 1907, no.234

138

THOMAS WORLIDGE, AFTER WILLEM DROST,
FORMERLY ATTRIBUTED TO REMBRANDT

Portrait of a Young Scholar, c.1750–60
[fig.96]

Oil on canvas, 108 × 83.8 cm
Elton Hall Collection

PROVENANCE Acquired before 1924.

REFERENCES Dack 1907, under no.131;
Borenius & Hodgson 1924, no.80

139

THOMAS WORLIDGE, AFTER WILLEM DROST,
FORMERLY ATTRIBUTED TO REMBRANDT

Portrait of a Young Scholar, c.1757–58
[fig.97]

Etching, 19.5 × 14.3 cm
National Galleries of Scotland, Edinburgh
(P 8664)

PROVENANCE Unknown.

REFERENCES Dack 1907, no.131; London 1979,
no.75

140

THOMAS WORLIDGE

Portrait of Edward Astley as Jan Six, 1762
[fig.79]

Etching and drypoint, 23.6 × 15.4 cm
Lent by Nicholas Stogdon

PROVENANCE Joseph Gulston (1745–1786),
London [L.1113, 2986]; his sale, London
(Greenwood), 16.01.1786 [Lugt 3975], 14th night,
part of lot 6 (to John Manson, £14); Christopher
Lennox-Boyd (1941–2012), Oxford.

REFERENCES Dack 1907, no.10; NHD 238,
copy d

ACKNOWLEDGEMENTS

Any exhibition of the scale and ambition of *Rembrandt: Britain's Discovery of the Master* is very much a result of teamwork, and I would like to thank all colleagues across the National Galleries of Scotland who were involved for their contribution. A few of them I would like to single out for their crucial assistance: Patricia Allerston, Christopher Baker, Julie Duffy, Graeme Gollan, Sam Lagneau, Alastair Patten and his team, Louise Rowlands and Lesley Stevenson. Many thanks go to Michael Clarke for his encouragement and support from the earliest stages of this show until his retirement in 2016. Patrick Elliott has not only contributed a superb essay to this catalogue but has also helped enormously to shape the modern and contemporary section of the exhibition, and by advising on loans and liaising with lenders. Charlotte Hoitsma and Pieter Duits, interns in 2017–18, tirelessly helped with the preparations of the catalogue and the exhibition, and I am immensely grateful for their patience and diligence and their excellent work. Beyond the Galleries, I would like to thank Cavan Convery and Robert Dalrymple for beautifully designing the exhibition and the catalogue respectively.

The external authors of the five rich essays in this volume, Peter Black, Stephanie Dickey, Donato Esposito, M.J. Ripps and Jonathan Yarker, have generously shared their knowledge on various occasions. Stephanie Dickey, moreover, facilitated an important loan and provided many welcome comments on my essay. David Alexander and Nicholas Stogdon have generously lent to this exhibition and kindly shared their vast expertise. Peter Schatborn discussed the 'English views' with me on a delightful trip to Vienna and provided useful comments on my essay. William Zachs has, as always, been an enthusiastic supporter. I would like to thank them all warmly.

A curatorial fellowship at the Yale Center for British Art was vital for research towards the exhibition and the publication, and I would like to thank staff for their friendly and generous support. The Center's superb exhibition catalogue *Rembrandt in Eighteenth Century England* (1983) inspired our show and was always on my desk.

CODART has been crucial in establishing and maintaining a curatorial network in the field that proved essential for the preparations and loan negotiations of this exhibition.

Many colleagues and friends have provided support, advice and information, and I would like to thank them wholeheartedly: Ann Jensen Adams, Wentworth Beaumont, Helen Bellany, Holm Bevers, Rhea Sylvia Blok, Terry Bloxham, Xavier Bray, Kate Brindley, Xanthe Brooke, Glenn Brown, Quentin Buvelot, Caroline Collier, Bart Cornelis, Sabine Craft-Giepmans, Ana Debenedetti, Duncan Dornan, Blaise Ducos, Bas Dudok van Heel, Michael Eissenhauer, Mark Evans, Sjarel Ex, Nina Fellmann, Gabriele Finaldi, Michiel Franken, Hannah Freedberg, Peter Fuhring, Emilie Gordenker, Ketty Gottardo, Antony Griffiths, Grégoire Hallé, Kate Heard, Karen Hearn, Erik Hinterding, Olenka Horbatsch, Jeremy Johnson, David Juda, Katja Kleinert, Armin Kunz, William Laborde, Edgar Laguinia, Friso Lammertse, Catherine Lampert, Justus Lange, Neil Lebeter, Séverine Lepape, Lowell Libson, Bernd Wolfgang Lindemann, Elenor Ling, Julia Lloyd Williams, Ger Luijten, Anne Lyles, Isobel MacLellan, Volker Manuth, Eva Michel, Charles Noble, Geoffrey Parton, Vera Pavlova, Michiel Plomp, Lord and Lady Polwarth, Sir William and Lady Meredith Proby, Henriette Rahusen, Angela Roche, Andrea Rose, Martin Royalton-Kisch, Per Rumberg, Jaco Rutgers, Xavier Salmon, Olivia Savatier, Marjan Scharloo, Steph Scholten, Charles Sebag-Montefiore, Catharina Slautterback, Pippa Stephenson, Catherine Sutherland, Jacqueline Thalmann, Holly Trusted, Ilona van Tuinen, Laura Turner, Simon Turner, Robert Upstone, Helen Valentine, An Van Camp, Adriaan Waiboer, Gary Waterston, Gregor Weber, Arthur Wheelock, Christopher White, Betsy Wieseman, David de Witt and Tim Young. Special thanks go to Hugo Chapman and Ronni Baer.

My final and enormous thanks go to Iris, Viktor and Klara, who had to bear with my 'Rembrandt-mania' for what felt like a very long time.

TICO SEIFERT

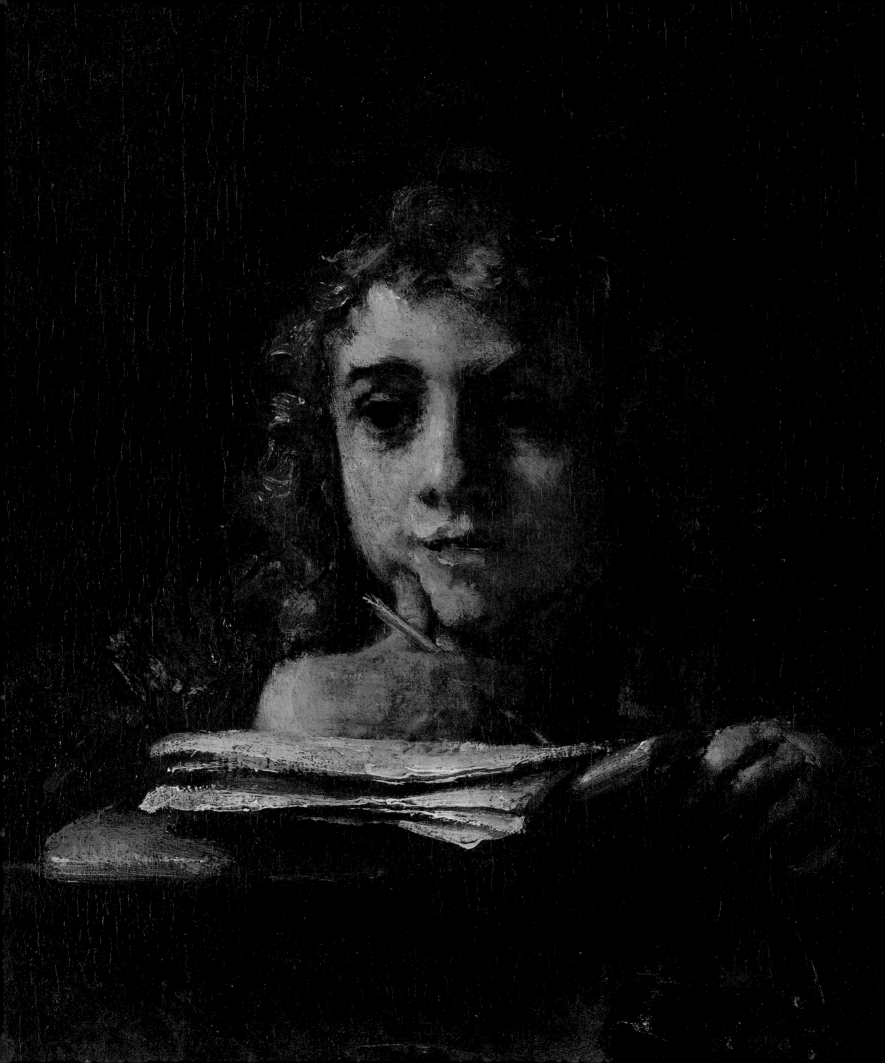

BIBLIOGRAPHY

ABRAMOVA 2013 Natalya Abramova, 'Sixteenth-century and seventeenth-century English silver in the Kremlin', in: Olga Dimitrieva and Tessa Murdoch (eds), *Treasures of the Royal Courts: Tudors, Stuarts and the Russian Tsars*, exh. cat., London (Victoria and Albert Museum), 2013, pp.69–105

ALEXANDER 1983 David Alexander, 'Rembrandt and the reproductive print in eighteenth-century England', in: New Haven 1983, pp.46–62

AMSTERDAM 1996 Christiaan Schuckman, Martin Royalton-Kisch and Erik Hinterding, *Rembrandt & Van Vliet: A Collaboration on Copper*, exh. cat., Amsterdam (Museum Het Rembrandthuis), 1996

AMSTERDAM/BERLIN 2006 Ernst van de Wetering *et al.*, *Rembrandt: Quest of a Genius*, exh. cat., Amsterdam (Museum Het Rembrandthuis) and Berlin (Gemäldegalerie), 2006

AMSTERDAM 2014 Peter Schatborn and Leonore van Sloten, *Old Drawings, New Names: Rembrandt and his Contemporaries*, exh. cat., Amsterdam (Museum Het Rembrandthuis), 2014

AMSTERDAM 2017 David de Witt (ed.), *Glenn Brown: Rembrandt After Life*, exh. cat., Amsterdam (Museum Het Rembrandthuis), 2017

ARNOLD 1981 Bruce Arnold, *Orpen: Mirror to an Age*, London, 1981

ASPITAL 1980 A.W. Aspital, *Catalogue of the Pepys Library at Magdalene College, Cambridge*, vol.3, part 1: *Prints and Drawings (General)*, Woodbridge/Totowa, 1980

ASTLEY 1760 *A Catalogue of the Genuine, Entire and Well-known Collection of Etchings and Prints, by Masters of the Greatest Eminence, Purchased by Sir Edward Astley, Bart. of Mr. Arthur Pond, Lately Deceas'd; (Among Which are Those Very Scarce and Valuable Prints by Rembrandt, Which Mr. Pond Had, with the Greatest Care, Been Many Years in Collecting.) ... Sold ... by Mr. Langford ... Covent Garden ... 27th ... March 1760, and the Eighteen Following Evenings ...*, London, 1760

B. See: Bartsch 1797

BAILLY-HERZBERG 1980 Janine Bailly-Herzberg, *Correspondence de Camille Pissarro*, 5 vols, Paris, 1980–91, vol.1: *1865–1885*, Paris, 1980

BAKER 2003 Christopher Baker, 'The Aldrich Prints: A late seventeenth-century collection, its sources and arrangement', in: Edward Chaney (ed.), *The Evolution of British Collecting: Receptions of Italian Art in the Tudor and Stuart Period* (Studies in British Art 12), New Haven and London, 2003, pp.397–426

BAKER 2011 Christopher Baker, *English Drawings and Watercolours 1600–1900: National Gallery of Scotland*, Edinburgh, 2011

BAKER ET AL. 2003 Christopher Baker, Caroline Elam and Genevieve Warwick (eds), *Collecting Prints and Drawings in Europe, c.1500–1750*, Aldershot/Burlington, 2003

BANN 2011 Stephen Bann (ed.), *Art and the Early Photographic Album*, Washington, 2011

BARKER 2004 Ian Barker, *Anthony Caro: Quest for the New Sculpture*, Aldershot, 2004

BARNARD 1798 *Catalogue of the Superb and Entire Collection of Prints, and Books of Prints, of John Barnard, Esq. of Berkeley Square, Deceased, Formed with Infinite Taste and Judgment During a Period Exceeding Fifty Years, Comprehending the Choicest Works of the Greatest Masters, from the Earliest Period to the Present Time; And Almost Entire Works of the Most Esteemed Artists, Particularly Rembrandt, Hollar, Marcantonio [Raimondi], Parmeggiano, Vandyck, Rubens, &c. &c. ... Sold by Auction ... Thomas Philipe ... 16th of April, 1798 and Twenty-Six Following Days ...*, London, 1798

BARTSCH 1797 (ALSO B.) Adam von Bartsch, *Catalogue de toutes les Estampes qui forment l'Oeuvre de Rembrandt, et ceux de ses principaux Imitateurs*, 2 vols, Vienna, 1797

BATH 1996 Susan Sloman, *Thomas Worlidge and the Influence of Rembrandt in 18th Century Bath*, exh. cat., Bath (Victoria Art Gallery), 1996

BECKETT 1949 R.B. Beckett, 'Hogarth and Rembrandt', *The Burlington Magazine*, 1949, vol.91, no.556, pp.198–201

144 Rembrandt, *Titus at his Desk*, 1655
Detail of fig.39

BECKETT 1970 R.B. Beckett (ed.), 'John Constable's discourses', *The Suffolk Record Society*, 1970, vol.XIV

BECKETT 1995 Oliver Beckett, *The Life and Work of James Ward RA 1769–1859: The Forgotten Genius*, Lewes, 1995

BEDBURG-HAU/AMSTERDAM 2005 Robin Garton, Gerald Volker Grimm and Gerhard Vincent van der Grinten, *Rembrandt und die englischen Malerradierer des 19. Jahrhunderts / Rembrandt and the English Painter-Etchers of the 19th Century*, exh. cat., Bedburg-Hau (Museum Schloss Moyland) and Amsterdam (Museum Het Rembrandthuis), 2005

BELL 1899 Malcolm Bell, *Rembrandt van Rijn and His Work*, London, 1899

BENESCH (ALSO BEN.) Otto Benesch, *The Drawings of Rembrandt*, 6 vols, London, 1954–57, 2nd edn, enlarged and edited by Eva Benesch, London and New York, 1973

BENTLEY 2015 Gerald E. Bentley, *The Edwardses of Halifax: The Making and Selling of Beautiful Books in London and Halifax, 1649–1826*, Toronto, 2015

BERLIN/AMSTERDAM/LONDON 1991–92A Christopher Brown, Jan Kelch and Pieter van Thiel (eds), *Rembrandt: The Master and His Workshop – Paintings*, exh. cat., Berlin (Altes Museum), Amsterdam (Rijksmuseum) and London (National Gallery), 1991

BERLIN/AMSTERDAM/LONDON 1991–92B Peter Schatborn, Barbara Welzel and Holm Bevers, *Rembrandt: The Master and His Workshop – Drawings and Etchings*, exh. cat., Berlin (Altes Museum), Amsterdam (Rijksmuseum), London (National Gallery and British Museum), 1991

BERLIN 2012 Cilly Kugelmann, Eckart Gillen and Hubertus Gassner (eds), *R.B. Kitaj 1932–2007: Obsessions*, exh. cat., Berlin (Jewish Museum), 2012

BERLIN 2015 Holm Bevers, Katja Kleinert and Claudia Laurenze-Landsberg, *Rembrandts Berliner 'Susanna und die beiden Alten': Die Schaffung eines Meisterwerks*, exh. cat., Berlin (Gemäldegalerie), 2015

BEVERS 2012 Holm Bevers, Review of [Schatborn 2010], *Master Drawings*, 2012, vol.50, no.3, pp.397–408

BIKKER 2005 Jonathan Bikker, *Willem Drost: A Rembrandt Pupil in Amsterdam and Venice*, New Haven and London, 2005

BINYON 1898–1907 Laurence Binyon, *Catalogue of Drawings by British Artists and Artists of Foreign Origin Working in Great Britain*, 4 vols, London, 1898–1907

BIRMINGHAM 1934 Solomon Charles Kaines Smith, *Commemorative Exhibition of the Art Treasures of the Midlands*, exh. cat., Birmingham (Birmingham Museum and Art Gallery), 1934

BLACK 2001 Peter Black, 'Andrew Geddes: Herald of the etching revival', in: Edinburgh 2001, pp.85–96

BLACKBURNE 1786 *A Catalogue of a Most Curious and Valuable Collection of Prints, Drawings, Books of Prints, and Portfolios; Collected with Great Care, and at a Great Expence, by the Late Jonathan Blackburne, Esq. of Liverpool … the Sale to be in London, in the Beginning of March …*, Leeds, 1786

BLANC 1859–61 Charles Blanc, *L'Oeuvre complet de Rembrandt décrit et commenté*, 2 vols, Paris, 1859–61

BLOK 2011 Rhea Sylvia Blok, 'Francis Seymour Haden (1818–1910), collectionneur et artiste sur les pas de Rembrandt', in: Peter Fuhring and Cordélia Hattori (eds), *Les Marques de collections II*, Paris, 2011, pp.85–102

BODE ET AL. 1897–1906 Wilhelm Bode, with text by W.R. Valentiner, with the assistance of C. Hofstede de Groot and translated from the German by Florence Simmonds, *The Complete Work of Rembrandt: History, Description, and Heliographic Reproduction of all the Master's Pictures*, 8 vols, Paris, 1897–1906

BOLTEN 1967 Jaap Bolten, *Dutch Drawings from the Collection of Dr. Hofstede de Groot*, Utrecht, 1967

BOON 1956 Karel G. Boon, 'De herkomst van Rembrandts prenten in het Rijksprentenkabinet', *Bulletin van het Rijksmuseum*, 1956, vol.4, no.1, pp.42–54

BORENIUS & HODGSON 1924 Tancred Borenius and J.V. Hodgson, *A Catalogue of the Pictures at Elton Hall in Huntingdonshire in the Possession of Colonel Douglas James Proby*, London, 1924

BOSTON 1981 Clifford S. Ackley, *Printmaking in the Age of Rembrandt*, exh. cat., Boston (Museum of Fine Arts), 1981

BRACKEN 2013 Susan Bracken, 'Copies after old masters at Ham in the context of Caroline patronage and collecting', in: Christopher Rowell (ed.), *Ham House: 400 Years of Collecting and Patronage*, New Haven and London, 2013, pp.37–48

BRAGGE 1757 *A Catalogue of the Genuine and Capital Collection of Fine Italian, Dutch, Flemish and French Pictures, Collected by Doctor [Robert] Bragge … Which will be Sold by Auction, by Mr. Prestage, … on Tuesday and Wednesday the 8th and 9th of February 1757*, London, 1757

BRÉAL 1900 Auguste Bréal, *Rembrandt: 1606–1699*, Paris, 1900

BRÉAL 1902 Auguste Bréal, *Rembrandt: A Critical Essay*, London, 1902

BRISTOL 1946 Robert Witt, *Souvenir Catalogue of the Exhibition of Dutch Old Masters*, exh. cat., Bristol (Red Lodge), 1946

BRITISH INSTITUTION 1824 British Institution (anon.), *An Account of all the Pictures Exhibited in the Rooms of the British Institution, from 1813 to 1823, Belonging to the Nobility and Gentry of England: with Remarks, Critical and Explanatory*, London, 1824

BRITTON 1808 John Britton, *Catalogue Raisonné of the Pictures Belonging to the Most Honourable The Marquis of Stafford, in the Gallery of Cleveland House*, London, 1808

BRONKHURST 2006 Judith Bronkhurst, *William Holman Hunt: A Catalogue Raisonné*, 2 vols, New Haven and London, 2006

BROOS & VAN SUCHTELEN 2004 Ben Broos and Ariane van Suchtelen, *Portraits in the Mauritshuis 1430–1790*, Zwolle and The Hague, 2004

BROUN 1987 Francis Broun, *Sir Joshua Reynolds' Collection of Paintings*, 3 vols, unpublished PhD thesis, Princeton University, 1987

BROWNE 1660 Alexander Browne, *The Whole Art of Drawing, Painting, Limning and Etching*, London, 1660

BROWNE 1669 Alexander Browne, *Ars Pictoria: or, An Academy Treating of Drawing, Painting, Limning and Etching*, London, 1669

BUCHANAN 1824 William Buchanan, *Memoirs of Painting*, London, 1824

BUTLER 2005 Nesta Butler, *William Baillie (1723–1810): Printmaker, Connoisseur and Dealer*, 2 vols, unpublished PhD thesis, University College Dublin, 2005

BUTLER 2007 Nesta Butler, 'Nathaniel Hone the Elder and William Baillie: Irish artists in late 18th-century London and their shared admiration for Rembrandt', *British Art Journal*, 2007, vol.8, no.2, pp.39–52

BUVELOT 2004 Quentin Buvelot, with contributions by Carola Vermeeren, *Royal Picture Gallery Mauritshuis: A Summary Catalogue*, Zwolle, 2004

CAMBRIDGE 1992 Marjorie B. Cohn, *A Noble Collection: The Spencer Albums of Old Master Prints*, exh. cat., Cambridge, Massachusetts (Fogg Art Museum), 1992

VAN CAMP 2013 An Van Camp, 'Robert Dighton and his spurious collectors' marks on Rembrandt prints in the British Museum, London', *The Burlington Magazine*, 2013, vol.155, no.1319, pp.88–94

CANNADINE 1990 David Cannadine, *The Decline and Fall of the British Aristocracy*, New Haven, 1990

CANNADINE 2014 David Cannadine, 'Pictures across the pond: Perspectives and retrospectives', in: Inge Reist (ed.), *British Models of Art Collecting and the American Response: Reflections Across the Pond*, Farnham, 2014, pp.9–26

CANNON-BROOKES 1984 Peter Cannon-Brookes, 'The London art market: 1882–1931', in: D. Garstang (ed.), *Art, Commerce and Scholarship: A Window onto the Art World, Colnaghi 1760–1984*, London, 1984, pp.39–41

CARDIFF 1958 Philip John Barlow, *Dutch Genre Paintings*, exh. cat., Cardiff (Arts Council of Great Britain), 1958

CHALCOGRAPHIMANIA 1814 Satiricus Sculpter (William Henry Ireland), *Chalcographimania: or, The Portrait Collector and Printseller's Chronicle with Infatuations of Every Description*, London, 1814

CHAMBERS 1999 Emma Chambers, *An Indolent and Blundering Art? The Etching Revival and the Redefinition of Etching in England 1838–1892*, Aldershot, 1999

CHAPEL 2008 Jeannie Chapel, 'The old master collection of John, Thomas, and Henry Philip Hope', in: D. Watkin and P. Hewat-Jaboor (eds), *Thomas Hope: Regency Designer*, London, 2008, pp.167–92

CHARRINGTON & ALEXANDER 1983 John Charrington (compiled) and David Alexander (revised), *Appendix C: A Catalogue of the Mezzotints After, or Said to be After, Rembrandt*, in: New Haven 1983, pp.119–47

DE CLAUSSIN 1824/1828 Ignace-Joseph de Claussin, *Catalogue raisonné de toutes les estampes qui forment l'oeuvre de Rembrandt, et des principales pièces de ses élèves*, Paris, 1824; *Supplément*, Paris, 1828

COHN 1924 Albert Mayer Cohn, *George Cruikshank: A Catalogue Raisonné of the Work Executed During the Years 1806–1877 …*, London, 1924

CORK 1987 Richard Cork, *David Bomberg*, New Haven and London, 1987

CORPUS Josua Bruyn et al., *A Corpus of Rembrandt Paintings*, 6 vols, The Hague, Boston and Dordrecht, 1982–2015

CORSE 1993 Taylor Corse, 'The ekphrastic tradition: Literary and pictorial narrative in the epigrams of John Elsum, an eighteenth-century connoisseur', *Word and Image*, 1993, vol.9, no.4, pp.383–400

COWAN 1998 Brian Cowan, 'Arenas of connoisseurship: Auctioning art in later Stuart Britain', in: Michael North and David Ormrod (eds), *Art Markets in Europe 1400–1800*, Aldershot/ Brookfield, 1998, pp.153–66

COXE 1922 *Catalogue of Engravings and Drawings by Old Masters, and Oil Paintings … Properties of the Rev. Hilgrove Coxe, of Watlington, Oxon (from the Collection of the late General Sir Hilgrove Turner, K.C.B.) … which will be Sold by Auction by Messrs. Sotheby, Wilkinson & Hodge. … Wednesday, March 8th, 1922 …*, London, 1922

CRENSHAW 2006 Paul Crenshaw, 'Did Rembrandt travel to England?', in: Amy Golahny, Mia M. Mochizuki and Lisa Vergara (eds), *In His Milieu: Essays on Netherlandish Art in Memory of John Michael Montias*, Amsterdam, 2006, pp.123–132

CROFT-MURRAY & HULTON 1960 Edward Croft-Murray and Paul Hulton, *Catalogue of British Drawings in the British Museum, XVI and XVII Centuries*, London, 1960

CUNDALL 1867 Joseph Cundall (ed.), *The Life and Genius of Rembrandt: The Most Celebrated of Rembrandt's Etchings – Thirty Photographs Taken from the Collections of the British Museum, and in the Possession of Mr. Seymour Haden, with Descriptions, and a Discourse on the Life and Genius of Rembrandt by Dr. Scheltema*, London and Cambridge, 1867

DACK 1907 Charles Dack, *Sketch of the Life of Thomas Worlidge, Etcher and Painter, with a Catalogue of his Works*, Peterborough, 1907

DAULBY 1796 Daniel Daulby, *A Descriptive Catalogue of the Works of Rembrandt and of his Scholars Bol, Livens, and Van Vliet, compiled from the Original Etchings, and from the Catalogues of De Burgy, Gersaint, Helle and Glomy, Marcus, and Yver*, Liverpool, 1796

DAULBY 1798 *A Catalogue of a Superlatively Fine Collection of Capital Pictures, by the Most Celebrated Masters of the English, Flemish, and Italian Schools … Property of the late Daniel Daulby… Sold by Auction, by T. Vernon …*, Liverpool, 1798

DAULBY 1799 *A Catalogue of Drawings, Prints, Books of Prints, and Books, Belonging to the Late Daniel Daulby, Esq.: Consisting of the Works of the Most Celebrated Masters of the Italian, Flemish, Dutch, French and English Schools, Particularly*

of a Most Extensive and Valuable Collection of the Works of Rembrandt, which will be Sold by Auction, by T. Vernon … Liverpool, on Monday, August 12th 1799 and the Eight Following Days …, Liverpool, 1799

DAULBY 1800 *A Catalogue of the Whole of the Capital, Genuine, and Singularly Valuable Collection of Etchings, by Rembrandt, and His Scholars of the Late Daniel Daulby, Esq. of Liverpool, Deceased: Which will be sold by Auction, by Mr. Christie … Wednesday, May 14, 1800, and Three Following Days*, London, 1800

DELACROIX 1932 Eugène Delacroix (ed. André Joubin), *Journal*, 3 vols, Paris, 1932

DETHLOFF 2003 Diana Dethloff, 'Sir Peter Lely's collection of prints and drawings', in: Baker *et al.* 2003, pp.123–39

DIBBITS 2006 Taco Dibbits, 'Ooit Rembrandts "vermaarde schilderij": De Receptiegeschiedenis van *Heilige Familie bij avond*', *Bulletin van het Rijksmuseum*, 2006, vol.54, no.2, pp.100–21

DICKEY 2006 Stephanie S. Dickey, 'Thoughts on the market for Rembrandt's portrait etchings', in: Amy Golahny, Mia Mochizuki and Lisa Vergara (eds) *In his Milieu: Essays on Netherlandish Art in Memory of John Michael Montias*, Amsterdam, 2006, pp.149–64

DICKEY 2017 Stephanie S. Dickey, 'Disgust and desire: Responses to Rembrandt's nudes', in: Debra Cashion, Ashley West and Henry Luttikhuizen (eds), *The Primacy of the Image in Northern European Art 1400–1700: Essays in Honor of Larry Silver*, Leiden, 2017, pp.447–60

D'OENCH 1983 Ellen D'Oench, '"A madness to have his prints": Rembrandt and Georgian taste 1720–1800', in: New Haven 1983, pp.63–81

DRAKE 1880 William Richard Drake, *A Descriptive Catalogue of the Etched Work of Francis Seymour Haden*, London, 1880

DUBLIN 1964 John White *et al.*, *Centenary Exhibition: 1864–1964*, exh. cat., Dublin (National Gallery of Ireland), 1964

DUBLIN 2005 Adriaan E. Waiboer and Michiel Franken, *Northern Nocturnes: Nightscapes in the Age of Rembrandt*, exh. cat., Dublin (National Gallery of Ireland), 2005

DUDOK VAN HEEL 1977 S.A.C. Dudok van Heel, 'Jan Pietersz Zomer (1641–1724): Makelaar in schilderijen (1690–1724)', *Jaarboek Amstelodamum*, 1977, vol.69, pp.89–106

DURO 1983 Paul Duro, *The Copy in French Nineteenth Century Painting*, unpublished PhD thesis, University of Essex, 1983

DURO 2009 Paul Duro, '"The surest measure of perfection": Approaches to imitation in seventeenth-century French art and theory', *Word and Image*, 2009, vol.25, no.4, pp.363–83

EDINBURGH 1945 *A Selection of Pictures from the Bridgewater House Collection*, exh. cat., Edinburgh (National Gallery of Scotland), 1945

EDINBURGH 1950 *An Exhibition of Paintings by Rembrandt*, exh. cat., Edinburgh (National Gallery of Scotland), 1950

EDINBURGH 1957 *National Gallery of Scotland: Catalogue of Paintings and Sculpture*, Edinburgh, 1957

EDINBURGH 1978 Sara Stevenson and Helen Bennett, *Van Dyck in Check Trousers: Fancy Dress in Art and Life 1700–1900*, exh. cat., Edinburgh (Scottish National Portrait Gallery), 1978

EDINBURGH 1983 Lindsay Errington, *Master Class: Robert Scott Lauder and his Pupils*, exh. cat., Edinburgh (National Gallery of Scotland), 1983

EDINBURGH 1992A Alastair Smart and Rosalind K. Marshall, *Allan Ramsay, 1713–1784*, exh. cat., Edinburgh (Scottish National Portrait Gallery), 1992

EDINBURGH 1992B Julia Lloyd Williams, *Dutch Art and Scotland: A Reflection of Taste*, exh. cat., Edinburgh (National Gallery of Scotland), 1992

EDINBURGH 1999 Michael Clarke *et al.*, *The Draughtsman's Art: Master Drawings from the National Gallery of Scotland*, exh. cat., Edinburgh (National Gallery of Scotland), 1999

EDINBURGH 2001 Helen Smailes, Peter Black and Lesley A. Stevenson, *Andrew Geddes 1783–1844: Painter-Printmaker – 'A man of pure taste'*, exh. cat., Edinburgh (National Gallery of Scotland), 2001

EDINBURGH/LONDON 2001 Julia Lloyd Williams, *Rembrandt's Women*, exh. cat., Edinburgh (National Gallery of Scotland) and London (Royal Academy of Arts), 2001

EDINBURGH 2002 Sara Stevenson, *Facing the Light: The Photography of Hill & Adamson*, exh. cat., Edinburgh (Scottish National Portrait Gallery), 2002

EDINBURGH 2005 Timothy Clifford, *Choice: Twenty-one Years of Collecting for Scotland*, exh. cat., Edinburgh (National Gallery of Scotland), 2005

EDINBURGH 2012 Keith Hartley *et al.*, *John Bellany*, exh. cat., Edinburgh (Scottish National Portrait Gallery), 2012

EELES 1998 Adrian Eeles, 'Rembrandt's *Ecce Homo*: A census of impressions', *Print Quarterly*, 1998, vol.15, no.3, pp.290–96

EINBERG 2016 Elizabeth Einberg, *William Hogarth: A Complete Catalogue of the Paintings*, New Haven and London, 2016

EISLER 1996 Colin Eisler, Bode's Burden: Berlin's Museum as an Imperial Institution, supplement to: *Jahrbuch der Berliner Museen* vol.38, 1996, pp.23–32

ELSUM 1700 John Elsum, *Epigrams upon the Paintings of the Most Eminent Masters, Ancient and Modern: With Reflexions upon the Several Schools of Painting*, London, 1700

EPSTEIN 1942 Jacob Epstein, *Let There be Sculpture*, London, 1942

ESPOSITO 2009 Donato Esposito, '"Care, taste and judgement": Reynolds's collection of works on paper', in: Plymouth 2009–10, pp.102–8

ESPOSITO 2011 Donato Esposito, 'The print collection of Sir Joshua Reynolds', *Print Quarterly*, 2011, vol.28, no.4, pp.376–81

ESPOSITO 2018 Donato Esposito, 'Artist in residence: Joshua Reynolds at No.47 Leicester Fields', in: Susanna Avery-Quash and Kate Retford (eds), *The Georgian London Town House:*

Building, Collecting and Display, London and New York, forthcoming

EVELYN 1662 John Evelyn, *Sculptura, or the History and Art of Chalcography and Engraving in Copper, with an Ample Enumeration of the Most Renowned Masters and Their Works*, London, 1662

FARSON 1993 Daniel Farson, *The Gilded Gutter Life of Francis Bacon*, London, 1993

FAWCETT 1974 Trevor Fawcett, *The Rise of English Provincial Art: Artists, Patrons, and Institutions Outside London, 1800–1830*, Oxford, 1974

FEAVER 2009 William Feaver, *Frank Auerbach*, New York, 2009

FECHNER 1977 Jan-Ulrich Fechner, 'Die Einheit von Bibliothek und Kunstkammer im 17. und 18. Jahrhundert, dargestellt an Hand zeitgenössischer Berichte', in: P. Raane (ed.), *Öffentliche und private Bibliotheken im 17. und 18. Jahrhundert. Raritätenkammern, Forschungsinstrument oder Bildungsstätten?*, Bremen/Wolffenbüttel, 1977, pp.11–31

FÉLIBIEN 1685 André Félibien, *Entretiens sur la vie et les ouvrages des plus excellents peintures*, Paris, 1685

FILEDT KOK & FUCCI 2013-14 Jan Piet Filedt Kok and Robert Fucci, Review of [Hinterding & Rutgers 2013], *Simiolus*, 2013–14, vol.37, no.2, pp.141–49

FINBERG 1924 Alexander J. Finberg, *The History of Turner's Liber Studiorum With a New Catalogue Raisonné*, London, 1924

FINCH 1986 Jeremiah S. Finch, *A Catalogue of the Libraries of Sir Thomas Browne and Dr Edward Browne, His Son: A Facsimile Reproduction with an Introduction, Notes, and Index*, Leiden, 1986

FLETCHER 2012 Stella Fletcher (ed.), *Roscoe and Italy: The Reception of Italian Renaissance History and Culture in the Eighteenth and Nineteenth Centuries*, Farnham and Burlington, 2012

FOOTE 1752 Samuel Foote, *Taste, a Comedy of Two Acts: As It is Acted in at the Theatre-Royal in Drury-Lane*, London, 1752

FRIEDENTHAL 2013 Antoinette Friedenthal, 'John Smith, his *Catalogue Raisonné of the Works of the most Eminent Dutch, Flemish, and French Painters* (1829–1842) and the "stigma of PICTURE DEALER"', *Journal of Art Historiography*, 2013, vol.9, pp.1–20

FROYEN 2011 Kathleen Froyen, 'Sir John Gilbert and the old masters', in: Spike Bucklow and Sally Woodcock (eds), *Sir John Gilbert: Art and Imagination in the Victorian Age*, exh. cat., London (Guildhall Art Gallery), 2011, pp.152–79

G. See: MacDonald *et al.* 2012

GARLICK ET AL. 1978-84 Kenneth Garlick, Angus Mackintyre and Kathryn Cave (eds), *The Diary of Joseph Farington*, 16 vols, New Haven and London, 1978–84

VAN GELDER 1973 Jan Gerrit van Gelder, 'Frühe Rembrandt-Sammlungen', in: Otto von Simson and Jan Kelch (eds), *Neue Beiträge zur Rembrandt-Forschung*, Berlin, 1973, pp.189–206

GEORGE 1954 Mary Dorothy George, *Catalogue of Political and Personal Satires in the British Museum*, 12 vols, London, 1870–1954, vol.11: *1828–1832*, London, 1954

GERARD 1759 Alexander Gerard, *An Essay on Taste*, London and Edinburgh, 1759

GERSAINT 1751 Edme-François Gersaint, *Catalogue raisonné de toutes les pièces Qui forment l'Oeuvre de Rembrandt, composé par feu M. Gersaint; & mis au jour, avec les Augmentations nécessaires, Par les Sieurs Helle & Glomy. Dédié aux Amateurs des beaux Arts*, Paris, 1751

GERSAINT 1752 Edme-François Gersaint, *A Catalogue and Description of the Etchings of Rembrandt Van-Rhyn, With Some Account of his Life. To Which is Added, a List of the Best Pieces of this Master for the Use of Those Who Would Make a Select Collection of His Works. Written Originally by the Late M. Gersaint, and Published by Mess. Helle and Glomy; with Considerable Additions and Improvements. Translated from the French …*, London, 1752

GERSON 1970 Horst Gerson, 'Imitaties naar Rembrandt door Thomas Worlidge (1700–1766)', *Nederlands Kunsthistorisch Jaarboek*, 1970, vol.21, pp.301–7

GETTY PROVENANCE INDEX http://www.getty.edu/research/tools/provenance/search.html (accessed 4 December 2017)

GIBSON-WOOD 1997 Carol Gibson-Wood, 'Classification and value in a seventeenth-century museum: William Courten's collections', *Journal of the History of Collections*, 1997, vol.9, no.1, pp.61–77

GIBSON-WOOD 2000 Carol Gibson-Wood, *Jonathan Richardson, Art Theorist of the English Enlightenment*, New Haven and London, 2000

GIBSON-WOOD 2003 Carol Gibson-Wood, '"A judiciously disposed collection": Jonathan Richardson Senior's cabinet of drawings', in: Baker *et al.* 2003, pp.155–71

GILPIN 1768 William Gilpin, *An Essay upon Prints: Containing Remarks upon the Principles of Picturesque Beauty, the different Kinds of Prints, and the Characters of the Most Noted Masters …*, London, 1768

GILTAIJ 1988 Jeroen Giltaij, *The Drawings by Rembrandt and his School in the Museum Boymans-van Beuningen*, Rotterdam, 1988

GILTAIJ 2009 Jeroen Giltaij, 'Observations on the *Man in the Red Cap*', in: Holm Bevers *et al.*, *Rembrandt: Wissenschaft auf der Suche. Beiträge des Internationalen Symposiums, Berlin, 4. und 5. November 2006*, supplement to: *Jahrbuch der Staatlichen Museen zu Berlin*, vol.51, 2009, pp.157–60

GLASGOW 2012 Peter Black and Erma Hermens, *Rembrandt and the Passion*, exh. cat., Glasgow (Hunterian Museum), 2012

GLENDINNING & MACARTNEY 2010 Nigel Glendenning and Hilary Macartney (eds), *Spanish Art in Britain and Ireland 1750–1920*, Woodbridge, 2010

GLEW 2001 Adrian Glew, *Stanley Spencer: Letters and Writings*, London, 2001

GLOBE 1985 Alexander Globe (ed.), *Peter Stent, London Printseller, 1642–65: A Catalogue Raisonné of*

His Engraved Prints and Books with an Historical and Bibliographical Introduction, Vancouver, 1985

GLORIEUX 2002 Guillaume Glorieux, *À l'enseigne de Gersaint: Edme-François Gersaint, marchand d'art sur le pont Notre Dame (1694–1750)*, Mayenne, 2002

GOLAHNY 2018 Amy Golahny, 'Rembrandt's *One Guilder Print*: Value and invention in "the most beautiful [print] that ever came from the burin of this master"', in: Stephanie S. Dickey (ed.), *Rembrandt and his Circle: Insights and Discoveries*, Amsterdam, 2018, pp.230–51

GRACIANO 2012 Andrew Graciano, 'The memoir of Benjamin Wilson, FRS (1721–88), painter and electrical scientist', *Walpole Society*, 2012, vol.74, pp.165–243

GRIEG 2013 Geordie Grieg, *Breakfast with Lucian: The Astounding Life and Outrageous Times of Britain's Greatest Painter*, New York, 2013

GRIFFITHS 1991 Antony Griffiths, 'The prints and drawings in the library of Consul Joseph Smith', *Print Quarterly*, 1991, vol.8, no.2, pp.127–39

GRIFFITHS 1993 Antony Griffiths, 'The Rogers Collection in the Cottonian Library, Plymouth', *Print Quarterly*, 1993, vol.10, no.1, pp.19–36

GRIFFITHS 1994 Antony Griffiths, 'Print collecting in Rome, Paris and London in the early eighteenth century', *Harvard University Art Museums Bulletin*, 1994, vol.2, no.3, pp.37–58

GRIFFITHS 1996 Antony Griffiths, 'William Smith (1808–76) and the rise of interest in early engraving', in: London/Houston 1996, pp.90–101

GRIFFITHS 2003 Antony Griffiths, 'John Evelyn and the print', in: Frances Harris and Michael Hunter (eds), *John Evelyn and His Milieu*, London, 2003, pp.95–114

GRIFFITHS 2016 Antony Griffiths, *The Print Before Photography: An Introduction to European Printmaking 1550–1820*, London, 2016

HADEN 1877 Sir Francis Seymour Haden, *The Etched Work of Rembrandt Critically Reconsidered*, London, 1877

HADEN 1879A Sir Francis Seymour Haden, *The Etched Work of Rembrandt: A Monograph*, London, 1879

HADEN 1879B Sir Francis Seymour Haden, *About etching. Part I, Notes by Mr. Seymour Haden on a Collection of Etchings and Engravings by the Great Masters, Lent by Him to the Fine Art Society to Illustrate the Subject of Etching. Part II, An Annotated Catalogue of the Examples Exhibited of Etchers and Painter-Engravers' Work*, London, 1879

HADEN 1895 Sir Francis Seymour Haden, *The Etched Work of Rembrandt: True and False – A Lecture Delivered at the London Institution*, London, 1895

HAKE 1922 Henry M. Hake, 'Pond's and Knapton's imitations of drawings', *Print Collector's Quarterly*, 1922, vol.9, no.4, pp.325–49

HALLETT 2014 Mark Hallett, *Reynolds: Portraiture in Action*, New Haven and London, 2014

HAMBER 1996 A.J. Hamber, *'A Higher Branch of the Art': Photographing the Fine Arts in England, 1839–1880*, Amsterdam, 1996

HARDIE 1921 Martin Hardie, *The British School of Etching, being a Lecture Delivered to the Print Collectors' Club by Martin Hardie on July 8th 1921*, London, 1921

HARDIE 1962 Martin Hardie, *Etchings and Dry Points from 1924 by James McBey (1883–1959)*, Aberdeen, 1962

HARRINGTON 1910 Samuel H. Nazeby Harrington, *The Engraved Work of Sir Francis Seymour Haden: An Illustrated and Descriptive Catalogue*, Liverpool, 1910

HASKELL 1976 Francis Haskell, *Rediscoveries in Art: Some Aspects of Taste, Fashion, and Collecting in England and France*, Ithaca, 1976

HAZLITT 1998 Duncan Wu (ed.), *The Selected Writings of William Hazlitt*, 9 vols, London, 1998

HECK 2010 Michèle-Caroline Heck, 'La réception de Rembrandt en France à travers l'adaptation de la pratique du "houding" par les peintres de la fin du Grand Siècle', in: Gaëtane Maës and Jan Blanc (eds), *Les échanges artistiques entre les anciens Pays-Bas et la France, 1482–1814*, Turnhout, 2010, pp.317–29

HERRMANN 1999 Frank Herrmann, *The English as Collectors: A Documentary Sourcebook*, 2nd edn, London, 1999

HIND 1923 Arthur M. Hind, *A Catalogue of Rembrandt's Etchings*, 2nd edn, 2 vols, London, 1923

HINTERDING 1993-94 Erik Hinterding, 'The history of Rembrandt's copperplates, with a catalogue of those that survive', *Simiolus*, 1993–94, vol.22, no.4, pp.253–315

HINTERDING 2008 Erik Hinterding, *Rembrandt Etchings from the Frits Lugt Collection*, 2 vols, Bussum, 2008

HINTERDING & HORBATSCH 2016 Erik Hinterding and Olenka Horbatsch, 'Selling prints to the Rijksmuseum in 1827: Christiaan Josi and Cornelis Apostool', *The Rijksmuseum Bulletin*, 2016, vol.64, no.4, pp.348–81

HINTERDING & RUTGERS 2013 (ALSO NHD) Erik Hinterding and Jacob Rutgers (comps), Ger Luijten (ed.), *The New Hollstein Dutch and Flemish Etchings, Engravings, and Woodcuts c.1450–1700, Rembrandt*, 7 vols, Ouderkerk aan den Ijssel/Amsterdam, 2013

HINTERDING & VAN DER COELEN 2016 Erik Hinterding and Peter van der Coelen, 'Rembrandts grafiek in de achttiende eeuw: Over koperplaten bij Jean de Bary en een oeuvrelijst met prijsannotaties van Michiel van den Bergh', *De Kroniek van het Rembrandthuis*, 2016, pp.46–82

HOFF 1935 Ursula Hoff, *Rembrandt und England*, PhD thesis, Hamburg, 1935

HOFSTEDE DE GROOT 1906 Cornelis Hofstede de Groot, *Die Handzeichnungen Rembrandts: Versuch eines beschreibenden und kritischen Katalogs*, Haarlem, 1906

'HOLLAR' 1879 'Hollar', 'Mr. Haden on etching', *The Art Amateur*, 1879, vol.1, no.2, p.31

HOLLSTEIN 1949-2010 F.W.H. Hollstein's *Dutch and Flemish Etchings, Engravings, and Woodcuts, c.1450–1700*, 72 vols, Amsterdam/Roosendaal/Oudekerk aan den Ijssel, 1949–2010

VAN HOOGSTRATEN 1678 Samuel van Hoogstraten, *Inleyding tot de hooge schoole der schilderkonst*, Rotterdam, 1678

HOPKINSON 2007 Martin Hopkinson, 'Printmaking and print collectors in the North-West 1760–1800', in: Liverpool/New Haven 2007, pp.85–104

HOUBRAKEN 1718-21 Arnold Houbraken, *De groote schouburgh der Nederlantsche konstschilders en Schilderessen*, 3 vols, Amsterdam, 1718–21

HUGHES 1990 Robert Hughes, *Frank Auerbach*, London, 1990

HULL 2002 Christopher Wright, *From Medieval to Regency: Old Masters in the Collection of the Ferens Art Gallery*, exh. cat., Hull (Ferens Art Gallery), 2002

HUMFREY 2013 Peter Humfrey (ed.), *The Reception of Titian in Britain: From Reynolds to Ruskin*, Turnhout, 2013

JAFFÉ 2002 Michael Jaffé, *The Devonshire Collection of Northern European Drawings*, 5 vols, Turin, 2002

JEFFARES 2017 Neil Jeffares, 'Luttrell, Edward', *Dictionary of Pastellists Before 1800*, http://www.pastellists.com/Articles/Lutterell.pdf (accessed 24 November 2017)

JOACHIMIDES 2011 Alexis Joachimides, 'Rembrandt als Vorbild englischer Künstler im 18. Jahrhundert: Eine kontroverse Entscheidung', *Zeitschrift für Kunstgeschichte*, 2011, vol.74, pp.217–36

JOHN 1954 Augustus John, *Chiaroscuro: Fragments of Autobiography*, London, 1954

JONKER & BERGVELT 2016 Michiel Jonker and Ellinoor Bergvelt, *Dutch and Flemish Paintings: Dulwich Picture Gallery*, London, 2016

KAINEN 1962 Jacob Kainen, *Smithsonian Institution United States National Bulletin*, vol.222: *John Baptist Jackson: 18th-Century Master of the Color Woodcut*, Washington, 1962

KARLSRUHE/LYON/EDINBURGH 2016 Michael Clarke *et al*., *Facing the World: Self-Portraits from Rembrandt to Ai Weiwei*, exh. cat., Karlsruhe (Staatliche Kunsthalle), Lyon (Musée des Beaux-Arts) and Edinburgh (National Galleries of Scotland), 2016

KENT 1926 Ernest A. Kent, 'Notes on the Blackfriars' Hall or Dutch Church, Norwich', *Norfolk Archaeology*, 1926, vol.22, pp.86–108

KEYES 2011 George S. Keyes, 'Rembrandt paintings and America', in: George S. Keyes *et al*, *Rembrandt in America: Collecting and Connoisseurship*, New York, 2011, pp.61–88

KEYES ET AL. 2004 George S. Keyes, Susan Donahue Kuretsky, Axel Rüger and Arthur K. Wheelock, Jr., *Masters of Dutch Painting: The Detroit Institute of Arts*, Detroit, 2004

KITSON 1988 Michael Kitson, 'Turner and Rembrandt', *Turner Studies*, 1988, vol.8, no.1, pp.2–18

KLEINERT & LAURENZE-LANDSBERG 2015 Katja Kleinert and Claudia Laurenze-Landsberg, 'Der korrigierte Rembrandt', in: Berlin 2015, pp.61–73

KLEINERT & LAURENZE-LANDSBERG 2016 Katja Kleinert and Claudia Laurenze-Landsberg, 'Rembrandts erste Aktdarstellung?: das Gemälde "Susanna und die beiden Alten" aus Rembrandts Werkstatt neu analysiert', *Jahrbuch der Berliner Museen*, 2016, vol.55, pp.31–42

KNACKFUSS 1895 Hermann Knackfuss, *Künstler-Monographien*, vol.3: *Rembrandt*, Bielefeld/Leipzig, 1895

KOREVAAR 2005 Gerbrand Korevaar, 'Rembrandt's mother: Rise and fall of a myth', in: Christiaan Vogelaar and Gerbrand Korevaar (eds), *Rembrandt's Mother: Myth and Reality*, exh. cat., Leiden (Stedelijk Museum de Lakenhal), 2005, pp.33–52

KORTHALS ALTES 2014 Everhard Korthals Altes, 'De verzamel-en waarderingsgeschiedenis van Rembrandts artistieke nalatenschap in de achttiende eeuw', in: Rutgers & Rijnders 2014, pp.41–71

KUSUKAWA 2017 Sachiko Kusukawa, 'William Courten's list of "things bought" from the late seventeenth century', *Journal of the History of Collections*, 2017, vol.29, no.1, pp.1–17

L. See: Lugt online

LAING 1993 Alastair Laing, 'Sir Peter Lely and Sir Ralph Bankes', in: David Howarth (ed.), *Art and Patronage in the Caroline Courts: Essays in Honour of Sir Oliver Millar*, Cambridge, 1993, pp.107–37

LEAHY 2005 Helen Rees Leahy, 'Introduction: The 1857 Manchester Art-Treasures Exhibition revisited', *Bulletin of the John Rylands University Library of Manchester*, 2005, vol.87, no.2, pp.7–19

VAN LEEUWEN & RUHE 2017 Rudi van Leeuwen and Lilian Ruhe, 'De receptie en reproductie van Rembrandts geëtste portret van Jan Six', in: Menno Jonker (ed.), *Rembrandt en Jan Six: De ets, de vriendschap*, exh. cat., Amsterdam (Museum Het Rembrandthuis), 2017, pp.37–46

LEIDEN 2006 Jep Schaeps (ed.), *Rembrandt in prent gebracht*, exh. cat., Leiden (University Library Leiden), 2006

LEWIS 1914 Wyndham Lewis, 'Our Vortex', *Blast I*, 1914, p.147

LIEDTKE 1990 Walter A. Liedtke, 'Dutch paintings in America: The collectors and their ideals', in: Ben Broos *et al*, *Great Dutch Paintings from America*, The Hague and Zwolle, 1990, pp.14–59

LIEDTKE 1995 Walter A. Liedtke, 'Seventeenth-century Dutch and Flemish paintings [catalogue]', in: Edward J. Sullivan (ed.), *The Taft Museum: Its History and Collections*, New York, 1995, pp.140–78

LIEDTKE 2007 Walter A. Liedtke, *Dutch Paintings in the Metropolitan Museum of Art*, 2 vols, New York, 2007

LIPPINCOTT 1983 Louise Lippincott, *Selling Art in Georgian London: The Rise of Arthur Pond*, New Haven and London, 1983

LIPPINCOTT 1988 Louise Lippincott, 'Arthur Pond's Journal of Receipts and Expenses 1734–1750', *Walpole Society*, 1988, vol.54, pp.220–333

LIVERPOOL/LONDON 1998 Xanthe Brooke, *Mantegna to Rubens: The Weld-Blundell Drawings*

Collection, exh. cat., Liverpool (Walker Art Gallery) and London (British Museum), 1998

LIVERPOOL/NEW HAVEN 2007 Elizabeth E. Barker, Alex Kidson *et al.*, *Joseph Wright of Derby in Liverpool*, exh. cat., Liverpool (Walker Art Gallery) and New Haven (Yale Center for British Art), 2007

LLOYD 2016 Stephen Lloyd (ed.), *Art, Animals and Politics: Knowsley and the Earls of Derby*, London, 2016

LLOYD WILLIAMS 1996 Julia Lloyd Williams, 'The import of art: The taste for Northern European goods in Scotland in the seventeenth century', in: Juliette Roding and Lex Heerma van Voss (eds), *The North Sea and Culture 1550–1800*, Hilversum, 1996, pp.298–322

LOCHNAN 1984 Katharine A. Lochnan, *The Etchings of James McNeill Whistler*, New Haven and London, 1984

LONDON 1791 *A Catalogue of Ralph's Exhibition of Pictures*, exh. cat., London (Great Room in the Haymarket), 1791

LONDON 1793 *The Orleans Gallery, Now Exhibiting, at the Great Rooms, Late the Royal Academy*, exh. cat., London (125 Pall Mall), 1793

LONDON 1815 *Catalogue of Pictures by Rubens, Rembrandt, Vandyke, and Other Artists of the Flemish and Dutch Schools*, exh. cat., London (British Institution), 1815

LONDON 1821 *Pictures of the Italian, Spanish, Flemish and Dutch Schools*, exh. cat., London (British Institution), 1821

LONDON 1822 *Pictures of the Italian, Spanish, Flemish and Dutch Schools with Which the Proprietors Have Favoured the Institution*, exh. cat., London (British Institution), 1822

LONDON 1823 *Catalogue of Pictures by Ancient and Modern Masters*, exh. cat., London (British Institution), 1823

LONDON 1835 *A Catalogue of One Hundred Original Drawings by Sir Ant. Vandyke and Rembrandt van Ryn, Collected by Sir Thomas Lawrence …*, exh.cat., London (S. & A. Woodburn's Gallery), 1835

LONDON 1843-44 *Catalogue of the Works of Sir Joshua Reynolds, Together with a Selection of Pictures by Ancient, and Deceased English Masters*, exh. cat., London (British Institution), 1843

LONDON 1845 *Pictures by the Italian, Spanish, Flemish, Dutch, French and English Masters, with Which the Proprietors Have Favoured the Institution*, exh. cat., London (British Institution), 1845

LONDON 1846 *Catalogue of Pictures by Italian, Spanish, Flemish, Dutch, and English Masters with Which the Proprietors Have Favoured the Institution*, exh. cat., London (British Institution), 1846

LONDON 1852 *Catalogue of the Works of British Artists in the Gallery of the British Institution*, exh. cat., London (British Institution), 1852

LONDON 1856 *Catalogue of Pictures by Italian, Spanish, Flemish, Dutch, French and English Masters, with Which the Proprietors Have Favoured the Institution*, exh. cat. London (British Institution) 1856

LONDON 1860-61 *Catalogue of Pictures by Italian, Spanish, Flemish, Dutch, French, and English Masters*, exh. cat., London (British Institution), 1860

LONDON 1864 *Exhibition of the Works of Ancient Masters and Deceased British Artists*, exh. cat., London (British Institution), 1864

LONDON 1865 *Catalogue of Pictures by Italian, Spanish, Flemish, Dutch, French and English Masters*, exh. cat., London (British Institution), 1865

LONDON 1866 *Exhibition of the Works of Ancient Masters and Deceased British Artists*, exh. cat., London (British Institution), 1866

LONDON 1870 *Exhibition of the Works of the Old Masters, Associated with a Collection from the Works of Charles Robert Leslie, R.A., and Clarkson Stanfield, R.A.*, exh. cat., London (Royal Academy of Arts), 1870

LONDON 1876 *Exhibition of Works by the Old Masters and by Deceased Masters of the British School*, exh. cat., London (Royal Academy of Arts), 1876

LONDON 1877 *Catalogue of the Etched Work of Rembrandt Selected for Exhibition at the Burlington Fine Arts Club*, exh. cat., London (Burlington Fine Arts Club), 1877

LONDON 1878 *Exhibition of Works by the Old Masters and by Deceased Masters of the British School*, exh. cat., London (Royal Academy of Arts), 1878

LONDON 1882 *Exhibition of Works by the Old Masters and by Deceased Masters of the British School*, exh. cat., London (Royal Academy of Arts), 1882

LONDON 1883 *Exhibition of Works by the Old Masters and by Deceased Masters of the British School*, exh. cat., London (Royal Academy of Arts), 1883

LONDON 1888 *Exhibition of Works by the Old Masters and by Deceased Masters of the British School*, exh. cat., London (Royal Academy of Arts), 1888

LONDON 1894A *Exhibition of Works by the Old Masters and by Deceased Masters of the British School*, exh. cat., London (Royal Academy of Arts), 1894

LONDON 1894B *Guildhall Loan Exhibition: Masterpieces of Art*, exh. cat., London (Guildhall Art Gallery), 1894

LONDON 1895 Sidney Colvin, *Guide to an Exhibition of Drawings and Etchings by Rembrandt and Etchings by other Masters in the British Museum*, exh. cat., London (British Museum), 1895

LONDON 1899A *Exhibition of Works by Rembrandt*, exh. cat., London (Royal Academy of Arts), 1899

LONDON 1899B Sidney Colvin, *Guide to an Exhibition of Drawings and Etchings by Rembrandt and Etchings by Other Masters in the British Museum*, exh. cat., London (British Museum), 1899

LONDON 1912 *Exhibition of Works by the Old Masters and Deceased Masters of the British School, Including a Collection of Pictures and Drawings by Edwin Austin Abbey*, exh. cat. London (Royal Academy of Arts), 1912

LONDON 1922 *Loan Exhibition of Pictures by Old Masters on Behalf of Lord Haig's Appeal for Ex-service Men*, exh. cat., London (Thomas Agnew & Sons), 1922

LONDON 1929 Robert Witt, *Exhibition of Dutch Art 1450–1900*, exh. cat., London (Royal Academy of Arts), 1929

LONDON 1938 *Exhibition of Seventeenth Century Art in Europe*, exh. cat., London (Royal Academy of Arts), 1938

LONDON 1947-48A Sir Philip Hendy, *An Exhibition of Cleaned Pictures (1936–1947)*, exh. cat., London (National Gallery), 1947

LONDON 1947-48B *Some Pictures from the Dulwich Gallery*, exh. cat., London (National Gallery), 1947

LONDON 1948 *Exhibition from the Devonshire Collection*, exh. cat., London (Thomas Agnew & Sons), 1948

LONDON 1949A *Old Masters: Painters of the 17th, 18th and 19th Century Including Rembrandt Van Rijn 'The Cradle'*, exh. cat., London (Leger Galleries), 1949

LONDON 1949B Arthur E. Popham, *Old Master Drawings from Chatsworth*, exh. cat., London (Arts Council), 1949

LONDON 1952 *An Exhibition of Etchings by Rembrandt, 1606–1669*, exh. cat., London (Arts Council), 1952

LONDON 1952-53 *Dutch Pictures 1450–1750*, exh. cat., London (Royal Academy of Arts), 1952

LONDON 1956 *Rembrandt and His Succession*, exh. cat., London (British Museum), 1956

LONDON 1964 A.G.H. Bachrach (ed.), *The Orange and the Rose: Holland and Britain in the Age of Observation 1600–1750*, exh. cat., London (Victoria and Albert Museum), 1964

LONDON 1969 A.E. Popham and T.S. Wragg, *Old Master Drawings from Chatsworth*, exh. cat., London (Royal Academy of Arts), 1969

LONDON 1972-73 Edward Croft-Murray, *The Art of Drawing*, exh. cat., London (British Museum), 1972

LONDON 1973-74 James Byam Shaw, *Old Master Drawings from Chatsworth*, exh. cat., London (Victoria and Albert Museum), 1973

LONDON 1976 Christopher Brown, *Art in Seventeenth Century Holland*, exh. cat., London (National Gallery), 1976

LONDON/EDINBURGH 1978 *Frank Auerbach*, exh. cat., London (Hayward Gallery) and Edinburgh (Fruitmarket Gallery), 1978

LONDON 1979 Ellen G. Miles, *Thomas Hudson 1701–1799, Portrait Painter and Collector: a Bicentenary Exhibition*, exh. cat., London (Kenwood House), 1979

LONDON 1981 Susan Lambert, *Drawing Technique and Purpose*, exh. cat., London (Victoria and Albert Museum), 1981

LONDON 1984 *The Tate Gallery: Illustrated Catalogue of Acquisitions*, London, 1984

LONDON 1985 *Masterpieces from The National Gallery of Ireland*, exh. cat., London (National Gallery), 1985

LONDON/WASHINGTON/LOS ANGELES 1985-86 *Collection for a King: Old Master Paintings from the Dulwich Picture Gallery*, exh. cat., London (Dulwich Picture Gallery), Washington (National Gallery of Art) and Los Angeles (Los Angeles County Museum of Art), 1985

LONDON 1986 Christopher Brown, *Dutch Landscape: The Early Years, 1590–1650*, exh. cat., London (National Gallery), 1986

LONDON 1988-89 David Bomford *et al.*, *Art in the Making: Rembrandt*, exh. cat., London (National Gallery), 1988

LONDON 1991 *English Silver Treasures from the Kremlin*, exh. cat., London (Sotheby's), 1991

LONDON 1992 Martin Royalton-Kisch, *Drawings by Rembrandt and His Circle*, exh. cat., London (British Museum), 1992

LONDON 1993A Kate Bomford, Anne Sumner and Giles Waterfield, *Rembrandt van Rijn: Girl at a Window*, exh. cat., London (Dulwich Picture Gallery), 1993

LONDON 1993B Michael Jaffé, *Old Master Drawings from Chatsworth*, exh. cat., London (British Museum), 1993

LONDON 1993C *The Cottonian Collection: An Exhibition from the Collection of Charles Rogers and the William Cotton Bequest on Loan from Plymouth City Museum and Art Gallery*, exh. cat., London (Royal Academy of Arts), 1993

LONDON 1995 Colin Wiggins, *Frank Auerbach and the National Gallery: Working after the Masters*, exh. cat., London (National Gallery), 1995

LONDON/HOUSTON 1996 Antony Griffiths (ed.), *Landmarks in Print Collecting*, exh. cat., London (British Museum) and Houston (Museum of Fine Arts), 1996

LONDON 1998 Antony Griffiths (with Robert A. Gerard), *The Print in Stuart Britain 1603–1689*, exh. cat., London (British Museum), 1998

LONDON/THE HAGUE 1999-2000 Christopher White and Quentin Buvelot (eds), *Rembrandt by Himself*, exh. cat., London (National Gallery) and The Hague (Mauritshuis), 1999

LONDON 2000 Richard Morphet, *Encounters: New Art From Old*, exh. cat., London (National Gallery), 2000

LONDON/AMSTERDAM 2000 Erik Hinterding, Ger Luijten and Martin Royalton-Kisch, *Rembrandt the Printmaker*, exh. cat., London (British Museum) and Amsterdam (Rijksmuseum), 2000

LONDON 2000-1 Jonathan King (ed.), *The Human Image*, exh. cat., London (British Museum), 2000

LONDON/PARIS/CAMBRIDGE 2002-3 *Bruegel to Rembrandt: Dutch and Flemish Drawings from the Maida and George Ahrams Collection*, exh. cat., London (British Museum), Paris (Institut Néerlandais) and Cambridge, Massachusetts (Fogg Art Museum), 2002

LONDON 2003 Richard Verdi (ed.), *Saved!: 100 Years of the National Art Collections Fund*, exh. cat., London (Hayward Gallery), 2003

LONDON 2004 David Fraser Jenkins and Chris Stephens, *Gwen John and Augustus John*, exh. cat., London (Tate), 2004

LONDON 2005 Hugo Chapman, *Michelangelo Drawings: Closer to the Master*, exh. cat., London (British Museum), 2005

LONDON 2007 Colin Wiggins with Philip Conisbee and Juliet Wilson-Bareau, *Leon Kossoff: Drawing from Painting*, exh. cat., London (National Gallery), 2007

LONDON/PARIS/MADRID 2009-10 David H. Solkin *et al.*, *Turner and the Masters*, exh. cat., London (Tate Britain), Paris (Grand Palais) and Madrid (Museo del Prado), 2009

LONDON 2011A Pilar Ordovas, Taco Dibbits and Martin Harrison, *Irrational Marks: Bacon and Rembrandt*, exh. cat., London (Ordovas), 2011

LONDON/NEW HAVEN 2011 Cassandra Albinson, Peter Funnell and Lucy Peltz, *Thomas Lawrence: Regency Power and Brilliance*, exh. cat., London (National Portrait Gallery) and New Haven (Yale Center for British Art), 2011

LONDON/AMSTERDAM 2013-14 *Raw Truth: Auerbach-Rembrandt*, exh. cat., London (Ordovas) and Amsterdam (Rijksmuseum), 2013

LONDON 2014 Andrea Rose, *Leon Kossoff: Drawing Paintings*, exh. cat., London (Annely Juda Fine Art / Frieze Masters), 2014

LONDON 2014-15 Mark Evans, Stephen Calloway and Susan Owens, *John Constable: The Making of a Master*, exh. cat., London (Victoria and Albert Museum), 2014

LONDON/AMSTERDAM 2014-15 Jonathan Bikker *et al.*, *Rembrandt: The Late Works*, exh. cat., London (National Gallery) and Amsterdam (Rijksmuseum), 2014

LONDON 2015 Susan Owens, *Jonathan Richardson: By Himself*, exh. cat., London (Courtauld Institute Gallery), 2015

LOS ANGELES 2014 Anne M. Lyden, *A Royal Passion: Queen Victoria and Photography*, exh. cat., Los Angeles (J. Paul Getty Museum), 2014

LUGT Frits Lugt, *Répertoire des catalogues de ventes publiques*, 4 vols, vols 1–3: The Hague, 1938–64, vol.4: Paris and Los Angeles, 1987

LUGT 1933 Frits Lugt, *Musée du Louvre: Inventaire général des dessins des écoles Du Nord – École hollandaise. Rembrandt, ses élèves, ses imitateurs, ses copistes*, Paris, 1933

LUGT ONLINE (ALSO L.) Frits Lugt, *Les Marques de Collections,* http://www.marquesdecollections.fr/introduction.cfm (accessed 2 February 2018)

LUMSDEN 1924 Ernest Stephen Lumsden, *The Art of Etching*, London, 1924

MACDONALD ET AL. 2012 (ALSO G.) Margaret F. MacDonald, Grischka Petri, Meg Hausberg and Joanna Meacock, *James McNeill Whistler: The Etchings, a Catalogue Raisonné*, University of Glasgow, 2012, online at http://etchings.arts.gla.ac.uk (accessed 1 February 2018)

MACGREGOR 1995 Neil MacGregor, 'To the Happier Carpenter': Rembrandt's War-Heroine Margaretha de Geer, the London Public and the Right to Pictures*, Groningen, 1995

MACKIE 1993 David Alexander Thomson Mackie, *Raeburn, Life and Art*, unpublished PhD thesis, University of Edinburgh, 1993

MACLAREN & BROWN 1991 Neil MacLaren, revised and expanded by Christopher Brown, *The Dutch School: 1600–1900*, 2 vols, London, 1991

MAITLAND 1689 *Pinacotheca Maitlandiana or, a Catalogue of the Lord Maitland's Prints and Drawings by the Most Eminent Masters of Europe …*, sale London (Ben J. Walford), 20 January 1689

MALONE 1797 Edmond Malone, *The Works of Sir Joshua Reynolds*, 2 vols, London, 1797

MALVERN 2004 Sue Malvern, *Modern Art, Britain, and the Great War: Witnessing, Testimony and Remembrance*, New Haven and London, 2004

MANCHESTER 1857A W. Blanchard Jerrold, *Jerrold's Guide to the Exhibition: How to See the Art Treasures [of Great Britain] Exhibition – A Guide, Systematically Arranged*, Manchester, 1857

MANCHESTER 1857B George Scharf, *The Art Treasures of the United Kingdom*, exh. cat., Manchester (Art Treasures Palace), 1857

MANCHESTER 1929 *Dutch Old Masters*, exh. cat., Manchester (Manchester Art Gallery), 1929

MANCHESTER 1957 *European Old Masters: Art Treasures Centenary*, exh. cat., Manchester (Manchester Art Gallery), 1957

MANCHESTER 1982 Michael Clarke and Nicholas Penny, *The Arrogant Connoisseur: Richard Payne Knight, 1751–1824*, exh. cat, Manchester (Whitworth Art Gallery), 1982

MANDELBROTE 2013 G. Mandelbrote, 'The library of the Duke of Lauderdale', in: Christopher Rowell (ed.), *Ham House: 400 Years of Collecting and Patronage*, New Haven and London, 2013, pp.222–31

MANNINGS 2000 David Mannings, *Sir Joshua Reynolds: A Complete Catalogue of his Paintings*, 2 vols, New Haven and London, 2000

DE MARCHI 2004 Neil de Marchi, 'Auctioning paintings in late seventeenth-century London: Rules, segmentation and prices in an emergent market', in: Victor A. Ginsburgh (ed.), *Economics of Art and Culture: Invited Papers at the 12th International Conference of the Association of Cultural Economics International (Contributions to Economic Analysis*, vol.260), Amsterdam, 2004, pp.97–128

MCBEY 1993 James McBey, *The Early Life of James McBey: An Autobiography*, Edinburgh, 1993

MCQUEEN 2003 Alison McQueen, *The Rise of the Cult of Rembrandt: Reinventing an Old Master in Nineteenth-Century France*, Amsterdam, 2003

MEADOWS 1988 Anne Meadows, *Collecting Seventeenth-Century Dutch Painting in England 1689–1760*, unpublished PhD thesis, University College London, 1988

MENPES 1905 Mortimer Menpes, *Rembrandt: With an Essay on the Life and Work of Rembrandt by Lewis C. Hind*, London, 1905

MIDDLETON 1878 Charles Henry Middleton, *A Descriptive Catalogue of the Etched Work of Rembrandt van Rhyn*, London, 1878

MIDDLETON 1879 Charles Henry Middleton, *Reply to a Letter and a Pamphlet Published by Francis Seymour Haden Esq., FRCS, under the Title of The 'Etched Work of Rembrandt'*, London, 1879

MILES 1977 Rosemary Miles, *The Complete Prints of Eduardo Paolozzi*, London, 1977

MILLAR 1960 Oliver Millar, 'Abraham van der Doort's catalogue of the collections of Charles I', *Walpole Society*, 1958-60, vol.37

MONKS 2009 Sarah Monks, 'Turner goes Dutch', in: London/Paris/Madrid 2009–10, pp.73–85

MOUNT 1996 Joshua Reynolds, edited by Harry Mount, *A Journey to Flanders and Holland*, Cambridge, 1996

MOUNT 2002 Harry Mount, '"Our British Teniers": David Wilkie and the heritage of Netherlandish art', in: Nicholas Tromans, *David Wilkie*, London, 2002, p.30–39

MURPHY 1982 Mary C. Murphy, *Samuel Foote's Taste and the Orators: A Modern Edition with Five Essays*, Annapolis, 1982

NEW HAVEN 1983 Christopher White, David Alexander and Ellen D'Oench, *Rembrandt in Eighteenth-Century England*, exh. cat., New Haven (Yale Center for British Art), 1983

NEW HAVEN/LONDON 2006 Natalya Abramova and Olga Dmitrieva (eds), *Britannia and Muscovy: English Silver at the Court of the Tsars*, New Haven and London, 2006

NEW YORK 2011 Colin Bailey *et al.*, *Rembrandt and his School: Masterworks from the Frick and Lugt Collections*, exh. cat., New York (The Frick Collection), 2011

NEW YORK 2017 Joanna Sheers Seidenstein, *Divine Encounter: Rembrandt's Abraham and the Angels*, exh. cat., New York (The Frick Collection), 2017

NHD See: Hinterding & Rutgers 2013

NIEUWENHUYS 1834 Christianus Johannes Nieuwenhuys, *A Review of the Lives and Works of Some of the most Eminent Painters with Remarks on the Opinions and Statements of Former Writers*, London, 1834

NORMAND 2002 Tom Normand, *Ken Currie: Details of a Journey*, Aldershot, 2002

NORTHCOTE 1819 James Northcote, *The Life of Sir Joshua Reynolds*, 2 vols, 2nd edn, London, 1819

NORWICH 1988 Andrew W. Moore, *Dutch and Flemish Painting in Norfolk: A History of Taste and Influence, Fashion and Collecting*, exh. cat., Norwich (Norwich Castle Museum), 1988

ORMROD 1998 David Ormrod, 'The origins of the London art market, 1660–1730', in: Michael North and David Ormrod (eds), *Art Markets in Europe 1400–1800*, Aldershot/Brookfield, 1998, pp.167–86

ORMROD 2002 David Ormrod, 'Dealers, collectors and connoisseurship in seventeenth & eighteenth-century London 1660–1760', in: Michael North (ed.), *Kunstsammeln und Geschmack im 18. Jahrhundert*, Berlin, 2002, pp.15–23

PARIS 1970 Geneviève Monnier, *Rembrandt et son temps: dessins des collections publiques et privées conservées en France*, exh. cat., Paris (Musée du Louvre), 1970

PARIS 2000 Pierrette Jean-Richard (ed.), *Rembrandt: gravures et dessins de la collection Edmond de Rothschild et du Cabinet des dessins*, exh. cat., Paris (Musée du Louvre), 2000

PARIS 2006 Peter Schatborn *et al.*, *Rembrandt Dessinateur: Chefs-d'oeuvre des collections en France*, exh. cat., Paris (Musée du Louvre), 2006

PARIS 2010 Stijn Alsteens *et al.*, *Un cabinet particulier: Les estampes de la Collection Frits Lugt*, exh. cat., Paris (Fondation Custodia), 2010

PARSHALL 1994 Peter Parshall, 'Art and the theater of knowledge: The origins of print collecting in Northern Europe', *Harvard University Art Museums Bulletin*, 1994, vol.2, no.3, pp.7–36

PAULSON 1971 Ronald Paulson, *Hogarth: His Life, Art, and Times*, 2 vols, New Haven, 1971

PAULSON 1989 Ronald Paulson, *Hogarth's Graphic Works*, London, 1989

PAULSON 1993 Ronald Paulson, *Hogarth: Art and Politics, 1750–64*, Cambridge, 1993

PEARS 1988 Iain Pears, *The Discovery of Painting: The Growth of Interest in the Arts in England 1680–1768*, London, 1988

PENNELL 1920 Joseph Pennell, *Etchers and Etching*, London, 1920

PENNELL & PENNELL 1908 Elizabeth Robins Pennell and Joseph Pennell, *The Life of James McNeill Whistler*, London, 1908

PERTH 1995 Robert H. Rodger, *The Brightest Ornament. Thomas Duncan – Portrait and History Painter (1807–1845)*, exh. cat., Perth (Perth Museum and Art Gallery), 1995

PETZOLD 2000 Andreas Petzold, 'Stained glass in the age of Neoclassicism: The case of Eglington Margaret Pearson', *British Art Journal*, 2000, vol.2, no.1, pp.54–60

DE PILES 1699 Roger de Piles, *Abrégé de la vie des peintres*, Paris, 1699

DE PILES 1706 Roger de Piles, *The Art of Painting*, London, 1706

PILKINGTON 1770 Matthew Pilkington, *The Gentleman's and Connoisseur's Dictionary of Painters: Containing a Complete Collection, and Account, of the Most Distinguished Artists, … Extracted from the Most Authentic Writers … To Which are Added, Two Catalogues; the One, a Catalogue of the Disciples of the Most Famous Masters, … the Other, a Catalogue of Those Painters, who Imitated the Works of the Eminent Masters …*, London, 1770

PLOMP 1997 Michiel C. Plomp, *Artists Born between 1575 and 1630*, vol.2: *The Dutch Drawings in the Teyler Museum*, Haarlem, 1997

PLYMOUTH 2009-10 Sam Smiles (ed.), *Sir Joshua Reynolds: The Acquisition of Genius*, exh. cat., Plymouth (Plymouth Museum and Art Gallery), 2009

POLE CAREW 1835 *A Catalogue of a Very Beautiful Collection of the Etchings by Rembrandt, the Property of the Late Right Hon. Reginald Pole Carew, Consisting of his Various Works, Scriptural, Fancy, Landscapes, and Portraits, Including the Hundred Guilder Print, Raising of Lazarus, Christ before Pilate, Advocate Tolling, Burgomaster Six, and Other Celebrated Works … Sold by Auction, by Mr. Wheatley, at his Great Room, 191, Piccadilly, on Wednesday, May 13, 1835, and Two Following Days…*, London, 1835

POSTLE 1995 Martin Postle, *Sir Joshua Reynolds: The Subject Pictures*, Cambridge, 1995

QUODBACH 2004 Esmée Quodbach, '"Rembrandt's 'Gilder' is here": How America got its first Rembrandt and France lost many

of its old masters', *Simiolus*, 2004–5, vol.31, pp.90–107

QUODBACH 2007 Esmée Quodbach, *The Age of Rembrandt: Dutch Paintings in the Metropolitan Museum of Art*, New Haven, 2007

QUODBACH 2011 Esmée Quodbach, 'Henry Clay Frick collects Rembrandt', in: New York 2011, pp.11–28

RAVERAT 1953 Gwen Raverat, *Period Piece: A Cambridge Childhood*, London, 1953

READ 1874 Raphael W. Read, *Descriptive Catalogue of the Etchings, Landscapes and Portraits, of the Late David Charles Read of Salisbury*, Salisbury, 1874

REMBRANDT DATABASE http://www. rembrandtdatabase.org/Rembrandt (accessed 23 October 2017)

REMBRANDT DOCUMENTS *RemDoc: The Rembrandt Documents Project*, Radboud University Nijmegen, http://remdoc.huygens. knaw.nl/ (accessed 4 December 2017)

REYNOLDS 1792 *A Catalogue of the Duplicate Prints, and the Whole Collection of Elegant Plaister Figures, Terra Cota Models ... of Sir Joshua Reynolds, Deceased: Which Will be Sold by Auction (by Order of the Executors), by Mr. Greenwood, at his Room in Leicester Square, on Monday the 16th of April, 1792, and Following Days [16–18 April 1792] ...*, London, 1792

REYNOLDS 1794 *A Catalogue of the First Part of the Cabinet of Ancient Drawings, which Belonged to Sir Joshua Reynolds ... Which, by Order of the Executors, Will be Sold at the Prices Marked ... by A.C. de Poggi ... on Monday, May 26, 1794, and to Continue till All the Drawings are Sold*, London, 1794

REYNOLDS 1795 *A Catalogue of the Capital, Genuine, and Valuable Collection of Pictures, Late the Property ... Sir Joshua Reynolds, late President of the Royal Academy ... Greatest Masters of the Roman, Florentine, Bolognese, Venetian, French, Flemish and Dutch Schools ... Sold by Auction (by Order of the Executors) by Mr. Christie, on Wednesday 11th, and Thursday 12th of March, 1795 ... and on Friday*

13th, *and Saturday 14th of March 1795 [13–14, 16–17 March 1795] ...*, London, 1795

REYNOLDS 1798 *Unique Collection of Drawings & Prints, A Catalogue of all the Great and Valuable Collection of Ancient Drawings, Scarce Prints, and Books of Prints, Which Belonged to Sir Joshua Reynolds ... Which ... will be Sold by Auction by Mr. H. Phillips, at his Great Room, 67, New Bond Street, on Monday, March 5, 1798, and Seventeen Successive Days ...*, London, 1798

REYNOLDS 1996 Graham Reynolds, *The Early Paintings and Drawings of John Constable*, 2 vols, New Haven and London, 1996

RICHARDSON 1725 Jonathan Richardson the Elder, *An Essay on the Theory of Painting*, 2nd edn, London, 1725

RICHARDSON 1792 Jonathan Richardson the Elder, *The Works of Jonathan Richardson, containing I. The Theory of Painting. II. Essay on the Art of Criticism (So Far as it Relates to Painting). III. The Science of a Connoisseur. A New Edition, Corrected, with the Additions of An Essay on the Knowledge of Prints, and Cautions to Collectors*, London, 1792

RICHARDSON & RICHARDSON 1722 Jonathan Richardson the Elder and Jonathan Richardson the Younger, *An Account of Some of the Statues, Bas-reliefs, Drawings and Pictures in Italy, &c. with Remarks*, London, 1722

RICHTER 1817 Henry Richter, *Day-light: A Recent Discovery in the Art of Painting – With Hints on the Philosophy of the Fine Arts, and on That of the Human Mind, as First Dissected by Emanuel Kant*, London, 1817

RIEGER 2013 Rudolf Rieger, *Adam von Bartsch (1757–1821): Leben und Werk des Wiener Kunsthistorkers und Kupferstechers unter besonderer Berücksichtigung seiner Reproduktionsgraphik nach Handzeichnungen*, 2 vols, Petersberg, 2013

RINDER 1932 Frank Rinder, *D.Y. Cameron: An Illustrated Catalogue of his Etchings and Dry-Points, 1887–1932*, Glasgow, 1932

RIPPS 2010 M.J. Ripps, *Bond Street Picture Dealers and the International Trade in Dutch Old*

Masters, 1882–1914, unpublished PhD thesis, University of Oxford, 2010

RIPPS 2014A M.J. Ripps, 'A Faustian bargain? Charles Sedelmeyer, Wilhelm Bode, and the expansion of Rembrandt's painted corpus, 1883–1914', *33rd Congress of the International Committee of the History of Art*, Nuremberg, 2014, pp.745–47

RIPPS 2014B M.J. Ripps, 'The London picture trade and Knoedler & Co.: Supplying Dutch old masters to America, 1900–1914', in: Inge Reist (ed.), *British Models of Art Collecting and the American Response: Reflections Across the Pond*, Farnham, 2014, pp.163–80

ROBINS 2000 Anna Gruetzner Robins, *Walter Sickert: The Complete Writings on Art*, Oxford, 2000

ROBINSON 1876 Sir John Charles Robinson, *Descriptive Catalogue of Drawings by Old Masters Forming the Collection of John Malcolm of Poltalloch*, 1876

ROBINSON 1981 William W. Robinson, '"This passion for prints": Collecting and connoisseurship in Northern Europe during the seventeenth century', in: Boston 1981, pp.xxvii–xlvii

ROGERS 1778 Charles Rogers, *A Collection of Prints in Imitation of Drawings, to which are annexed the lives of their authors with explanatory and critical notes*, 2 vols, London, 1778

ROSCAM ABBING 1999 Michiel Roscam Abbing, *Rembrant toont sijn konst: bijdragen over Rembrandt-documenten uit de periode 1648–1756*, Leiden, 1999

ROSCAM ABBING 2006 Michiel Roscam Abbing (ed.), *Rembrandt 2006: New Documents*, Leiden, 2006

ROSCOE 1833 Henry Roscoe, *The Life of William Roscoe*, 2 vols, London and Edinburgh, 1833

ROVINSKI 1894 Dmitri Rovinski, *L'oeuvre gravé des élèves de Rembrandt*, St Petersburg, 1894

ROYALTON-KISCH 1978 Martin Royalton-Kisch, 'Reynolds as a collector', in: Timothy Clifford, Antony Griffiths and Martin Royalton-Kisch, *Gainsborough and Reynolds in the British*

Museum, exh. cat., London (British Museum), 1978, pp.61–75

ROYALTON-KISCH 1993 Martin Royalton-Kisch, 'Rembrandt, Zomer, Zanetti and Smith', *Print Quarterly*, 1993, vol.10, no.2, pp.111–22

ROYALTON-KISCH 1996 Martin Royalton-Kisch, 'The Reverend Clayton Mordaunt Cracherode (1730–99)', in: London/Houston 1996, pp.43–64

ROYALTON-KISCH 2007 Martin Royalton-Kisch, 'Les artistes collectionneurs de dessins en Angleterre: une étude', in: Catherine Monbeig-Goguel and Cordélia Hattori (eds), *L'artiste collectionneur de dessin II: de Giorgio Vasari à aujourd'hui. Rencontres internationales du Salon du dessin*, Paris, 2007, pp.37–45

ROYALTON-KISCH 2010 Martin Royalton-Kisch, *Catalogue of Drawings by Rembrandt and his School in the British Museum*, 2010, http://www.britishmuseum.org/research/publications/online_research_catalogues/rembrandt_drawings/drawings_by_rembrandt.aspx (accessed 15 March 2018)

ROYALTON-KISCH ONLINE Martin Royalton-Kisch, *The Drawings of Rembrandt: a revision of Otto Benesch's catalogue raisonné*, http://rembrandt-catalogue.net/about/4571905042 (accessed 23 October 2017)

RUSSELL 2016 Susan Russell, 'Dr Robert Bragge (1700–1777), Gentleman Dealer', *British Art Journal*, 2016, vol.17, no.2, pp.68–76

RUTGERS 2008 Jaco Rutgers, *Rembrandt en Italië: Receptie en verzamelgeschiedenis*, unpublished PhD thesis, Universiteit Utrecht, 2008

RUTGERS & RIJNDERS 2014 Jaco Rutgers and Mieke Rijnders, *Rembrandt in perspectief: de veranderende visie op de meester en zijn werk*, Zwolle, 2014

SALAMAN 1932 Malcolm Salaman, *Modern Masters of Etching: C.R.W. Nevinson*, London, 1932

SALOMON AREL 1995 Maria Salomon Arel, *The Muscovy Company in the First Half of the Seventeenth Century: Trade and Position in the Russian State – A Reassessment*, unpublished PhD thesis, Yale University, 1995

SALTZMAN 2008 Cynthia Saltzman, *Old Masters, New World: America's Raid on Europe's Great Pictures*, New York, 2008

SAMMERN 2016 Romana Sammern, 'Woman in Bed by Matthew William Peters (1742–1814): Titian, Reynolds and a painted revenge', *British Art Journal*, 2016, vol.16, no.3. pp.20–31

SAVAGE 1830 James Savage, *History of the Hundred of Carhampton, in the county of Somerset, from the best authorities*, Bristol, 1830

SCALLEN 2004 Catherine B. Scallen, *Rembrandt, Reputation, and the Practice of Connoisseurship*, Amsterdam, 2004

SCHATBORN 1981 Peter Schatborn, 'Van Rembrandt tot Crozat: Vroege verzamelingen met tekeningen van Rembrandt', *Nederlands Kunsthistorisch Jaarboek*, 1981, vol.32, pp.1–54

SCHATBORN 2010 Peter Schatborn, *Rembrandt and his Circle: Drawings in the Frits Lugt Collection*, Paris, 2010

SCHATBORN & ROBINSON 2009 Peter Schatborn and William W. Robinson, 'The history of the attribution of drawings by Rembrandt and his pupils', in: Holm Bevers *et al.*, *Drawings by Rembrandt and His Pupils: Telling the Difference*, exh. cat., Los Angeles (J. Paul Getty Museum), 2009, pp.31–42

SCHELLER & BOOMGAARD 1991 Robert W. Scheller and Jeroen Boomgaard, 'A delicate balance: A brief survey of Rembrandt criticism', in: Berlin/Amsterdam/London 1991–92a, pp.106–23

SCHLENKER 2009 Ines Schlenker, *Marie-Louise von Motesiczky 1906–1996: A Catalogue Raisonné of the Paintings*, London, 2009

SCHNACKENBURG 2016 Bernhard Schnackenburg, *Jan Lievens: Friend and Rival of the Young Rembrandt*, Petersberg, 2016

SCHNEIDERMAN 1983 Richard S. Schneiderman, *A Catalogue Raisonné of the Prints of Sir Francis Seymour Haden*, London, 1983

SCHWARTZ 2014 Gary Schwartz, 'The meanings of Rembrandt', in: Ildikó Ember (ed.), *Rembrandt and the Dutch Golden Age*, exh. cat., Budapest (Szépművészeti Múzeum), 2014, pp.36–57

SCOTT 1816 Sir Walter Scott, *The Antiquary*, London, 1816

SEBAG-MONTEFIORE & ARMSTRONG-TOTTEN 2013 Charles Sebag-Montefiore with Julia I. Armstrong-Totten, *A Dynasty of Dealers: John Smith and Successors 1801–1924 – A Study of the Art Market in Nineteenth-Century London*, London, 2013

SHANES 2016 Eric Shanes, *Young Mr. Turner: The First Forty Years 1775–1815*, New Haven and London, 2016

SHEFFIELD 1956 *Dutch Masterpieces*, exh. cat., Sheffield (Graves Art Gallery), 1956

SICKERT 1915 Walter R. Sickert, 'The future of engraving', *The Burlington Magazine*, 1915, vol.27, no.150, pp.224–31

SILBER 1986 Evelyn Silber, *The Sculpture of Epstein, with a Complete Catalogue Raisonné*, Oxford, 1986

SIMON 2007 Robin Simon, *Hogarth, France and British Art: The Rise of the Arts in 18th-Century Britain*, London, 2007

SIMPSON 1953 Frank Simpson, 'Dutch paintings in England before 1760', *The Burlington Magazine*, 1953, vol.95, no.599, pp.39–42

SLIVE 1953 Seymour Slive, *Rembrandt and His Critics 1630–1730*, The Hague, 1953

SLUIJTER 2006 Eric Jan Sluijter, *Rembrandt and the Female Nude*, Amsterdam, 2006

SMITH 1693 Marshall Smith, *The Theory of Painting*, London, 1693

SMITH 1807 James Edward Smith, *Sketch of a Tour on the Continent*, 2nd edn, London, 1807

SMITH 1829 John Thomas Smith, *Nollekens and His Times: A Life of the Celebrated Sculptor and Memoirs of Several Contemporary Artists, from the Time of Roubiliac, Hogarth and Reynolds to that of Fuseli, Flaxman and Blake*, 2 vols, London, 1829

SMITH 1836 John Smith, *A Catalogue Raisonné of the Works of the Most Eminent Dutch, Flemish, and French Painters*, 9 vols, London, 1829–42, vol.7: *Rembrandt*, London, 1836

SMITH 1842 John Smith, *A Catalogue Raisonné of the Works of the Most Eminent Dutch, Flemish, and French Painters*, 9 vols, London, 1829–42, vol.9: *Supplement*, London, 1842

SMITH 1860 Thomas Smith, *Recollections of the British Institution with Some Account of the Means Employed for that Purpose and Biographical Notices of the Artists who have Received Premiums*, London, 1860

SPARKES 1876 John C.L. Sparkes, *A Descriptive Catalogue of the Pictures in the Dulwich College Gallery*, London, 1876

STALEY 1900 Edgcumbe Staley, *The Charm of Rembrandt*, Edinburgh, 1900

STARCKY 1999 Emmanuel Starcky, *Le cabinet des dessins: Rembrandt – Les Figures*, Paris, 1999

STOGDON 1996 Nicholas Stogdon, 'Captain Baillie and *The Hundred Guilder Print*', *Print Quarterly*, 1996, vol.13, no.1, pp.53–56

STOGDON 2011 Nicholas Stogdon, *A Descriptive Catalogue of the Etchings by Rembrandt in a Private Collection in Switzerland*, Verona, 2011

STOURTON & SEBAG-MONTEFIORE 2012 James Stourton and Charles Sebag-Montefiore, *The British as Art Collectors, from the Tudors to the Present*, London, 2012

STRANG 1962 David Strang (revised), *Catalogue of Printed Work of William Strang*, Glasgow, 1962

STRAUSS & VAN DER MEULEN 1979 Walter L. Strauss and Marjon van der Meulen *et al.*, *The Rembrandt Documents*, New York, 1979

STRIEN 1993 Cornelius Daniël van Strien, *British Travellers in Holland During the Stuart Period: Edward Browne and John Locke as Tourists in the United Provinces*, Leiden, 1993

STRONG 1968 Roy Strong, 'Rembrandt and English Art', *Journal of the Royal Society of Arts*, 1968, vol.116, no.5147, pp.906–23

SUTTON 2011 Peter C. Sutton, *Rembrandt van Rijn, 'Portrait of a Man with Arms Akimbo'*, New York, 2011

SUTTON & ROBINSON 2011 Peter C. Sutton and William W. Robinson, *Drawings by Rembrandt, His Students and Circle from the Maida and George Abrams Collection*, New Haven and London, 2011

SYDNEY 2015 Michael Clarke *et al.*, *The Greats: Masterpieces from the National Galleries of Scotland*, exh. cat., Sydney (Art Gallery of New South Wales), 2015

SYLVESTER 1987 David Sylvester, *The Brutality of Fact: Interviews with Francis Bacon* (1975), 3rd edn, London, 1987

SYLVESTER 1988 David Sylvester, *Looking Back at Francis Bacon*, London, 1988

TALLEY 1981 Mansfield Kirby Talley, *Portrait Painting in England: Studies in the Technical Literature before 1700*, London, 1981

TATE WEBSITE http://www.tate.org.uk/art/artists/henryk-gotlib-1194 (accessed 12 December 2017)

TAYLOR 1853 Tom Taylor, *Life of Benjamin Robert Haydon, Historical Painter: From His Autobiography and Journals*, 2 vols, New York, 1853

VAN THIEL 1992 Pieter J.J. van Thiel, 'De Rembrandt-tentoonstelling van 1898', *Bulletin van het Rijksmuseum*, 1992, vol.40, no.1, pp.11–92

THISTLETHWAITE 1974 Jane Thistlethwaite, 'The etchings of E.T. Daniell (1804–1842)', *Norfolk Archaeology*, 1974, vol.36, pp.1–22

TINGAY 1932 J.O. Tingay, 'Portraits of John Elison and his wife by Rembrandt', *Norfolk Archaeology*, 1932, vol.24, pp.1–6

TONKOVICH 2005 Jennifer Tonkovich, '"Rymsdyk's Museum": Jan van Rymsdyk as a collector of old master drawings', *Journal of the History of Collections*, 2005, vol.17, no.2, pp.155–71

TRUSTED 2013 Marjorie Trusted, *Baroque and Later Ivories, Victoria and Albert Museum*, London, 2013

TURNER 2003 Simon Turner, 'Samuel Woodburn', *Print Quarterly*, 2003, vol.20, no.2, pp.131–44

UGLOW 1997 Jenny Uglow, *Hogarth: A Life and a World*, London, 1997

VAN UITERT 2014 Evert van Uitert, 'Rembrandts roem: hoe hij werd opgenomen in de kring van de grootste genieën aller tijden', in: Rutgers & Rijnders 2014, pp.135–69

VERTUE *The Notebooks of George Vertue*, 7 vols, published in *Walpole Society*, 1929–30, vol.18 (Vertue vol.I); 1931–32, vol.20 (Vertue vol.II); 1933–34, vol.22 (Vertue vol.III); 1935–36, vol.24 (Vertue vol.IV); 1937–38, vol.26 (Vertue vol.V); 1940–42, vol.29 (Vertue vol.VI); 1951–52, vol.30 (Vertue vol.VII)

VAN DER WAALS 1984A Jan van der Waals, 'The print collection of Samuel Pepys', *Print Quarterly*, 1984, vol.1, no.4, pp.236–57

VAN DER WAALS 1984B Jan van der Waals, Review of [Aspital 1980], *Simiolus*, 1984, vol.14, no.2, pp.143–47

WALPOLE 1763 Horace Walpole, *Anecdotes of Painting in England*, vol.3, Strawberry Hill, 1763

WALPOLE CORR. Horace Walpole, *Correspondence*, 48 vols, New Haven, 1937–83, http://images.library.yale.edu/hwcorrespondence/ (accessed 27 November 2017)

WARK 1975 Robert Wark (ed.), *Sir Joshua Reynolds: Discourses on Art*, New Haven and London, 1975

WASHINGTON 2005 Arthur K. Wheelock, Jr., with contributions by Peter C. Sutton, Volker Manuth and Anne T. Woollett, *Rembrandt's Late Religious Portraits*, exh. cat., Washington (National Gallery of Art), 2005

WASHINGTON/MILWAUKEE/AMSTERDAM 2008-9 Arthur K. Wheelock, Jr. *et al.*, *Jan Lievens: A Dutch Master Rediscovered*, exh. cat., Washington (National Gallery of Art), Milwaukee (Milwaukee Art Museum), Amsterdam (Museum Het Rembrandthuis), 2008

WEGNER 1970 Wolfgang Wegner, 'Symposium und Ausstellung "Rembrandt after Threehundred Years" in Chicago', *Kunstchronik*, 1970, no.23, pp.29–34

WEIR 1899 Irene Weir, *Rembrandt*, New York, 1899

VAN DE WETERING 2017 Ernst van de Wetering, *A Reprint of A Corpus of Rembrandt Paintings, VI: Rembrandt's Paintings Revisited – A Complete Survey*, Dordrecht, 2017

WHEELOCK 1995 Arthur K. Wheelock, Jr., *Dutch Paintings of the Seventeenth Century* [systematic catalogue of the National Gallery of Art], Washington, 1995

WHEELOCK 2017 Arthur K. Wheelock, Jr., 'Rembrandt van Rijn/*The Circumcision/1661*', *Dutch Paintings of the Seventeenth Century*, NGA Online Editions, https://purl.org/nga/collection/artobject/1199 (accessed 30 November 2017).

WHITE 1957 Christopher White, 'Rembrandt and England', *Britain and Holland*, 1957, vol.9, no.1, pp.13–22

WHITE 1962 Christopher White, 'Did Rembrandt ever visit England?', *Apollo*, 1962, vol.76, no.3, pp.177–84

WHITE 1983A Christopher White, 'Rembrandt: Reputation and collecting', in: New Haven 1983, pp.1–16

WHITE 1983B Christopher White, 'Rembrandt's influence on English painting', in: New Haven 1983, pp.20–24

WHITE 1999 Christopher White, *Rembrandt as an Etcher: A Study of the Artist at Work*, 2nd edn, New Haven and London, 1999

WHITE 2015 Christopher White, *Dutch Pictures in the Collection of Her Majesty The Queen*, London, 2015

WHITE & BOON 1969 Christopher White and Karel G. Boon, *Rembrandt's Etchings: An Illustrated Critical Catalogue*, 2 vols, Amsterdam/London/New York, 1969

WHITLEY 1928 William T. Whitley, *Art in England, 1800–1820*, New York, 1928

WIEBEL 2011 Christiane Wiebel, *Rembrandts Erben*, Coburg, 2011

WIJNMAN 1934 Hendrik Frederik Wijnman, 'Een drietal portretten van Rembrandt (Joannes Elison, Maria Bockenolle en Catrina Hoogsaet)', *Jaarboek Amstelodamum*, 1934, vol.31, pp.81–96

WIJNMAN 1957 Hendrik Frederik Wijnman, 'Rembrandts portretten van Joannes Elison en zijn vrouw Maria Bockenolle naar Amerika verkocht', *Maandblad Amstelodamum*, 1957, vol.44, pp.65–72

WILKINSON 2002 Alan Wilkinson (ed.), *Henry Moore: Writings and Conversations*, Aldershot, 2002

WILLIAMS 1831 D.E. Williams, *The Life and Correspondence of Sir Thomas Lawrence, Kt.*, 2 vols, London, 1831

WILSON 1828 [Thomas Wilson], *A Catalogue Raisonné of the Select Collection of Engravings of an Amateur*, London, 1828

WILSON 1836 [Thomas Wilson], *A Descriptive Catalogue of the Prints of Rembrandt by an Amateur*, London, 1836

WILSON & BORROW 1973 Shirley C. Wilson and Keith T. Borrow, *The Bridge over the Ocean: Thomas Wilson (1787–1863), Art Collector and Mayor of Adelaide*, Adelaide, 1973

DE WINKEL 2006 Marieke de Winkel, *Fashion and Fancy: Dress and Meaning in Rembrandt's Paintings*, Amsterdam, 2006

DE WITT 2008 David de Witt, *The Bader Collection: Dutch and Flemish Paintings*, Kingston, Ontario, 2008

WORCESTER 1882 *Worcestershire Exhibition*, exh. cat., Worcester (Worcester Engine Works), 1882

WORNUM 1848 Ralph N. Wornum (ed.), *Lectures on Painting, by the Royal Academicians, Barry, Opie and Fuseli*, London, 1848

WORTHING 1951 *Treasures from Sussex Houses*, exh. cat., Worthing (Worthing Art Gallery), 1951

YARKER 2018 Jonathan Yarker, 'Thomas Gainsborough's copies after old master paintings', in: Hugh Belsey, *Thomas Gainsborough: A Complete Catalogue of his Paintings*, New Haven and London, forthcoming

YVER 1756 Pierre Yver, *Supplément au Catalogue Raisonné de MM. Gersaint, Helle et Glomy*, Amsterdam, 1756

Exhibitions without catalogue

BANFF 2007-8 *Rembrandt – Duff House*, Banff (Duff House), 2007–8

BANFF 2016 *Rembrandt Masterpiece Loan*, Banff (Duff House), 2016

EDINBURGH 1938 *Rembrandt Etchings, Loan Exhibition*, Edinburgh (National Gallery of Scotland), 1938

EDINBURGH 1953 *Exhibition of Dutch Paintings from the Collection of the Earl of Ellesmere*, Edinburgh (National Gallery of Scotland), 1953

EDINBURGH 2002-3 *Pleasures of Patronage*, Edinburgh (National Gallery of Scotland), 2002–3

EDINBURGH 2007 *Drawing to an End*, Edinburgh (National Gallery of Scotland), 2007

EDINBURGH 2014 *Unique Rembrandt Etching Rediscovered*, Edinburgh (Scottish National Gallery), 2014

LONDON 1806 *British Institution for Promoting the Fine Arts in the United Kingdom*, London (British Insitution), 1806

LONDON 2011B *Exploration, Slavery and Abolition: Images of Africans in the Sixteenth to Nineteenth Centuries*, London (British Museum), 2011

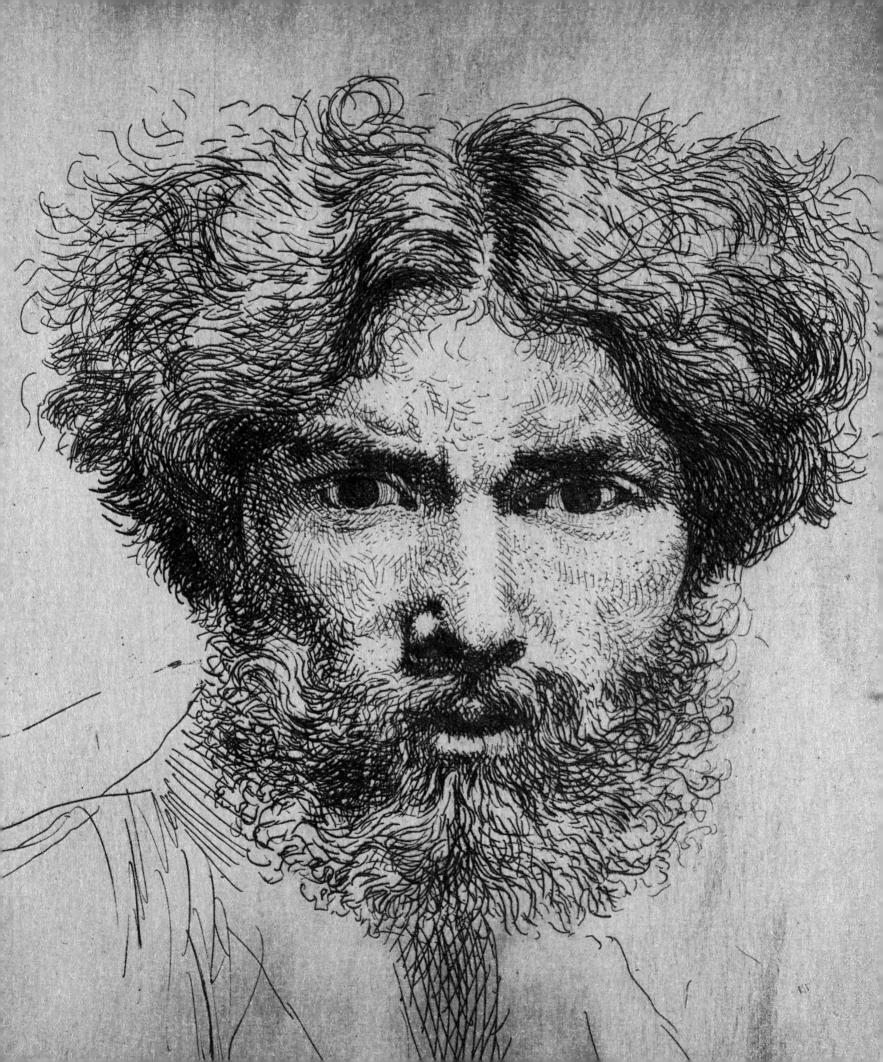

NOTES & REFERENCES

Introduction

Christian Tico Seifert page 9

1 Hoff 1935; Slive 1953; White 1957; White 1962; Strong 1968; New Haven 1983; Scheller & Boomgaard 1991; Joachimides 2011; Rutgers & Rijnders 2014, pp.64–67. On collecting in Britain, see Herrmann 1999 and Stourton & Sebag-Montefiore 2012. On collecting Dutch paintings, see Simpson 1953 and Meadows 1988.

Rembrandt's Fame in Britain, 1630-1900: An Overview

Christian Tico Seifert pages 11-49

1 Millar 1960, p.xx.

2 Hoff 1935, pp.40–41 was the first to identify the *Self-portrait* with the painting now in Liverpool.

3 Millar 1960, p.57, nos.84, 87; p.60, no.101; White 2015, pp.21–23, 302–6, under no.158.

4 This label is now much damaged but was first described by Horace Walpole in 1774; Walpole Corr., vol.1 p.329, note 11; vol.42, p.13. Walpole was the first to publish Van der Doort's catalogue in print, in 1757.

5 But see Schnackenburg 2016, p.125.

6 Corpus, vol.2 (1986), A 32 Corrigenda; Schnackenburg 2016, no.206. Corpus, vol.4 (2005), pp.91–93.

7 White 1962, p.180; Schnackenburg 2016, no.73. Many years later, in 1654, Lievens portrayed Kerr, who spent his last years in exile in Amsterdam (National Galleries of Scotland, Edinburgh, inv.PG 3663); he was buried in the Oude Kerk on 12 August 1655 (Stadsarchief Amsterdam, DTB 1047, fol.4).

8 Suggested by Xanthe Brooks in an audio talk in 2006: http://www.liverpoolmuseums.org.uk/podcasts/transcripts/rembrandt.aspx (accessed 23 March 2017).

9 Similarly, an *Old Woman Reading* was acquired under Rembrandt's name by Thomas Herbert, 8th Earl of Pembroke, before 1685, and is now attributed to Lievens; Schnackenburg 2016, no.167.

10 De Winkel 2006, pp.55–57.

11 Kent 1926, Tingay 1932.

12 She was buried in the Oude Kerk on 22 October 1652 from the Oude Turfmarkt, where Joan lived (Stadsarchief Amsterdam, DTB 1046, fol.123v–124).

13 Wijnman 1934, pp.81–90; Wijnman 1957, pp.70–72.

14 Walpole 1763, pp.3–4.

15 There were, of course, opportunities to see Rembrandt's works abroad. Peter Mundy visited the Netherlands in 1640; the only painter he mentioned in his journal was 'Rimbrantt', then approaching the peak of his career in Amsterdam; Slive 1953, p.28.

16 Lloyd Williams 1996, pp.310–14; Roscam Abbing 2006, docs 21, 73, 86 (with incorrect context).

17 De Witt 2008, no.162.

18 Laing 1993, p.122, doc.3, no.4. On collecting copies in Caroline England, see Bracken 2013.

19 Hoff 1935, pp.43–49; White 1962; Plomp 1997, pp.333–34; Bevers 2012, pp.402–4; Amsterdam 2014, no.34. On Rembrandt's purported visit to Hull in 1660–61, see later in the essay, pp.32–37.

20 Lugt 1933, under no.1340; Bevers 2012, pp.402–4.

21 Compare, for example, Strauss & Van der Meulen 1979, pp.128, 132, 160, 164, 169, 170, 172, 188, dating from 1636–40, and Ben. 443, 445, 446, 457, dating from 1635–37. S A C. Dudok van Heel has suggested that the signature on the Haarlem drawing is genuine and that the one on the Vienna view, modelled on the former, has been added by a different hand, not achieving the same degree of fluidity and ligatures (oral communication, 28 July 2017).

22 White 1962, pp.182–84.

23 For a view of Westminster by Lievens from about 1633–35, see Washington/Milwaukee/Amsterdam 2008-9, no.101. Jonny Yarker kindly drew my attention to an engraving of St Albans, published in 1790 and, according to the inscription, after a drawing by Lievens (British Museum, London, inv.1868,0822.6172).

145 Augustus John, *Tête Farouche (Portrait of the Artist)*, c.1901
Detail of fig.53

However, it is based on a drawing by Michiel van Overbeek (active 1663–1709), British Library, London, inv.Maps K.Top.15.49.a.

24 Strauss & Van der Meulen 1979, doc.1656/12.

25 Evelyn 1662, p.81; Slive 1953, pp.58–59.

26 Amsterdam 1996, no.44. Evelyn's impression of Jan Gillisz van Vliet's *Saint Jerome Under a Tree* was sold in London (Christie's), 26 July 1977, lot 198. There were no prints or drawings by Rembrandt in the sales of what must have been the remnants of Evelyn's collection; Griffiths 2003. The interest in technique is also reflected in Browne 1660, p.33, the earliest reference to Rembrandt's etching ground; D'Oench 1983, p.63.

27 Strien 1993, p.255. On Browne's travel, see ibid. pp.237–97; Hinterding 1993–94, p.264, note 62.

28 Their library was sold at auction in 1711, but no albums of prints or drawings were included and they may have been sold separately; Finch 1986.

29 I owe these classifications to Nicholas Stogdon.

30 Robinson 1981; Cambridge 1992, p.36, note 69; Griffiths 1994; Griffiths 2016, pp.436–45.

31 Aspital 1980; Van der Waals 1984a; Van der Waals 1984b.

32 Aspital 1980, nos 2984, ii, 198–99 (NHD 290), 202–3 (NHD 155), 214–15 (NHD 274), 234–35 (NHD 119), 282–83 (by Jan Gillisz van Vliet, Amsterdam 1996, no.2), 286–87 (Amsterdam 1996, no.2), and nos 2985, i, 60 (by Pieter de Bailliu, Hollstein 34), 136 (NHD 173).

33 *Ecce Homo*: NHD 274, *The Three Crosses*: NHD 290.

34 Rembrandt's *Death of the Virgin*, 1639 (NHD 173), a trimmed impression and therefore without the signature, likewise remained anonymous, and Pepys described the subject as 'The […] office to a dying Person', putting it at the very end of the volume as it would not fit into the sequence of the New Testament.

35 Baker 2003.

36 *Joannes Wtenbogaert, Preacher of the Remonstrants* (NHD 153), album O; *Self-portrait Etching at a Window* (NHD 240), album P; *Jan Lutma, Goldsmith* (NHD 293), album R; *The Blindness of Tobit: The Larger Plate* (NHD 265).

37 London/Houston 1996, pp.21–29.

38 Ibid., p.29, note 20.

39 Ibid., pp.258, 261.

40 Ibid., pp.23–27, 269–73; Gibson-Wood 1997; Kusukawa 2017. Tantalisingly, most of these were dismantled in 1806, and no Rembrandt etchings from Courten's collection have been identified with any certainty yet.

41 NHD 153 or 172.

42 Robinson 1981, pp.xliii–xliv; Maitland 1689, p.13, lot 326. It contained two more Rembrandt lots: '18 Heads after Reinbranck' and '16 Prints of Reinbranck and others'; ibid., p.3, lots 20,21. For the complicated history of the dispersal of Richard Maitland's as well his uncle's, John Maitland, Duke of Lauderdale's, libraries, including the prints and drawings, see Mandelbrote 2013. It seems possible that parts of Richard Maitland's collection of prints and drawings had been assembled by John Maitland.

43 For the so-called Spencer album of Rembrandt etchings compiled by the Mariettes, the leading print dealers in Europe, in Paris in the early eighteenth century, see Cambridge 1992, p.31.

44 London 1998, no.108. Gaywood inscribed three etchings as being after Rembrandt: Globe 1985, nos.239 (after Lievens; Schnackenburg 2016, no.106), 417, 423 (both after Jan Gillisz van Vliet (after Rembrandt); Amsterdam 1996, nos.7–9, figs 108, 166, 168. John Overton reprinted this etching, replacing Gaywood's name with Wenceslaus Hollar's, and Robert Vaughan copied the *Heraclitus* for a title page in 1658. Hollar made his two copies after Rembrandt etchings (NHD 88, 136) in Cologne, in 1635, before he moved to London.

45 Abramova 2013, pp.82–83, fig.88. On Smith, see also New Haven/London 2006, pp.43, 47, 191–92, and Salomon Arel 1995. *Bearded Man Wearing a Velvet Cap with a Jewel Clasp*: NHD 163.

46 Jeffares 2017.

47 Smith 1693, p.22. William Gandy, a portrait painter, advised in 1673: 'you must not paint the face light nor so dark as Mr. Rembrandt all black shadows'; Talley 1981, p.310; White 1983a, p.2. On Martin Lister's notes on three paintings by Rembrandt he saw in Paris in 1698, see Slive 1953, pp.143–47.

48 Slive 1953, pp.147–48; Corse 1993.

49 Elsum 1700, p.92.

50 Broos & Van Suchtelen 2004, no.49.

51 Of the ninety-six Rembrandt lots (including some described as after the master) in London sales listed in the Getty Provenance Index for 1689–92, sixty per cent are 'heads'.

52 Pears 1988; Cowan 1998; Ormrod 1998; Ormrod 2002; De Marchi 2004.

53 Slive 1953, pp.122–133. For France as the model for British taste and source for paintings, see Pears 1988, pp.16, 82–84; Haskell 1976; Meadows 1988.

54 De Piles 1706, pp.316–20.

55 Gibson-Wood 2000.

56 Gibson-Wood 2003.

57 The drawing copies a lost self-portrait by Richardson that was dated 1697; London 2015, no.11.

58 Richardson 1725, pp.66–67; New Haven 1983, no.3; Gibson-Wood 2000, pp.156–57. In his 1747 sale, this print sold for £18. On Richardson, see the essay by Jonathan Yarker on pp.81–91 of this volume (especially pp.84–85).

59 On British artist-collectors of drawings, see Royalton-Kisch 2007.

60 See the essays by Donato Esposito and Jonathan Yarker, respectively on pp.93–105 and pp.81–91 of this volume.

61 See below, p.45.

62 Schatborn 1981, pp.16–21; Jaffé 2002, vol.1, pp.16–17. The Richardsons were asked to arrange the collection; White 1983a, p.9.

63 Van Gelder 1973; Schatborn 1981; Korthals Altes 2014, p.50. The earliest reference to Rembrandt drawings at auction in London is from 1689; Schatborn 1981, p.12.

64 *Self-portrait*: Corpus, vol.4 (2005), no.27; Corpus, vol.6 (2015), no.321. *The Circumcision*: Corpus, vol.5 (2011), no.30; Corpus, vol.6

(2015), no.286; Wheelock 2017. *Belshazzar's Feast*: Corpus, vol.3 (1989), A 110; Lloyd 2016, p.22.

65 Corpus, vol.3 (1989), A 108; Corpus, vol.6 (2015), no.136.

66 Roscam Abbing 1999, pp.157–60.

67 Vertue vol.V, p.23.

68 Lippincott 1983, pp.88–92, 106–8, 118–23; Stogdon 2011, pp.367–69.

69 Vertue vol.VI, p.194; New Haven 1983, no.149; London 1993c, nos 31, 32; Stogdon 2011, p.368.

70 Vertue vol.III, p.126; New Haven 1983, p.91; Joachimides 2011, pp.232–36.

71 See the essay by Stephanie Dickey on pp.69–79 of this volume.

72 Lippincott 1983, pp.128–48.

73 Hake 1922.

74 Richardson 1725, p.252–53; New Haven 1983, no.2; Gibson-Wood 2000, pp.176–77. The drawing, no longer universally accepted as by Rembrandt, is in the Musée Bonnat-Helleu, Bayonne (Ben.949). See the essay by Jonathan Yarker on pp.81–91 of this volume (p.85).

75 Lippincott 1988, p.308. The plate was re-issued by John Boydell in 1774.

76 Alexander 1983. Van Bleeck's print, illustrated here, is the first British mezzotint after a painting (then believed to be) by Rembrandt; ibid., p.49.

77 D'Oench 1983, pp.64–66, 71.

78 Also, guidebooks to private houses (including their collections) were published; the first was for Wilton House in 1731; see Stourton & Sebag-Montefiore 2012, p.21.

79 D'Oench 1983, pp.67–70.

80 Vertue vol.III, p.159.

81 See the essay by Stephanie Dickey on pp.69–79 of this volume (p.71).

82 New Haven 1983, no.13; Paulson 1989, no.191. On Hogarth and Rembrandt, see Beckett 1949; Paulson 1993, pp.36–47.

83 Foote 1752, p.3. The play was reprinted seven times before 1787 and performed in London at least forty-five times before 1776; Murphy 1982, pp.lxi–lxii.

84 See the essay by Stephanie Dickey on pp.69–79 of this volume.

85 Hinterding & Van der Coelen 2016.

86 D'Oench 1983, pp.74–78.

87 Alexander 1983, p.50; Van Leeuwen & Ruhe 2017.

88 New Haven 1983, pp.84 (Bretherton), 93–96 (Worlidge); D'Oench, pp.72–75 (on amateur etchers). On copying Rembrandt's etchings, see NHD, *Copies*, vol.1, pp.vii–xxiii. NHD lists 275 copies made in Britain, more than in any other country; only one included a nude female figure (NHD 128d). On Worlidge, see the essay by Jonathan Yarker on pp.81–91 of this volume (especially pp.87–88) and Dack 1907.

89 Stogdon 1996; Butler 2005, pp.178–87, 275–76, no.74; Butler 2007; Wiebel 2011, pp.29–36.

90 Manuscript annotation, dated 1785, in Baillie's copy of Pilkington 1770, p.506.

91 NHD 214a–d, f, g. Baillie also produced prints after drawings and paintings by Rembrandt, for example the *Old Man's Head* in the Clerk of Penicuik collection [fig.5 & cat.63].

92 Rogers 1778, vol.2, p.215; D'Oench 1983, p.63.

93 Walpole 1763, p.4; D'Oench 1983, p.71. Walpole was probably referring to *The Good Samaritan*, 1633 (NHD 116); Rembrandt shaded the horse's white tail in the second state.

94 Walpole 1763, vol.3, pp.3–4, n.†. Vertue's note from 1713 reads: 'Renbrant van Rhine was in England liv'd at Hull in Yorkshire about sixteen or eighteen months (reported by old Larroon who in his youth knew Rembrant at York) where he painted several Gentlemen & sea faring mens pictures. one of them is in the possession of Mr Dahl, a sea captain with the Gentlemans name. Renbrants name. & York. & the year 1661/2. Christian'; Vertue vol.I, p.29; Hoff 1935, pp.50–58; Hull 2002, pp.16–17; Crenshaw 2006.

95 Vertue's source was the gem engraver Charles Christian Reisen, whom he elsewhere described as 'a Man of Sarcastical humour [who] highly pleasd with his Oddities most of his companions' and 'was continually jokeing upon others'; Vertue vol.III, pp.26–27 (with thanks to Jonny Yarker).

96 *Conspiracy of the Batavians under Claudius Civilis*: Corpus, vol.6 (2015), no.298; 'The Syndics' ('Staalmeesters'): Corpus, vol.6 (2015), no.299.

97 Pilkington 1770, p.508; White 1983a, p.6.

98 Korevaar 2005.

99 Gilpin 1768, pp.200–202.

100 Alexander 1983, pp.51–52.

101 White 1983b, pp.21–23. Rare examples of history or genre painters taking inspiration from Rembrandt include Benjamin West's sketch for *The Installation of the Order of the Garter*, 1787 (Tate, London, inv.N00315) and Thomas Rowlandson's watercolour *The Return*, 1787 (Yale Center for British Art, inv.B2001.2.1147); New Haven 1983, p.40; D'Oench 1983, pp.76–77. On *The Mill*, see the essay by Jonathan Yarker on pp.81–91 of this volume.

102 For Wright of Derby, see Liverpool/ New Haven 2007, nos 50, 53; for Ramsay, see Edinburgh 1992a, no.92; for Lawrence, see London/New Haven 2011, p.87, nos 1, 5, 51.

103 White 1983a, p.15.

104 Ibid., pp.11–14.

105 See the essays by Donato Esposito and Jonathan Yarker, respectively on pp.93–105 and pp.81–91 of this volume.

106 Mannings 2000, nos 4, 1219. For the impact of Rembrandt's works on Reynolds, see New Haven 1983, pp.32–39; Postle 1995, pp.108, 112, 138; Mannings 2000, nos 2030, 2072–76; Hallett 2014, pp.68–69, 97–98. Reynolds's 'two fancy pictures' of young boys (1747, Mannings 2000, nos 2022, 2025) bear strong resemblances to Rembrandt's *Titus*, 1655 [fig.39] – which, however, is first documented in Britain in 1806 (not in 1747, as has frequently been claimed); New Haven 1983, no.32. For Reynolds's copies after Rembrandt, see the essay by Jonathan Yarker on pp.81–91 of this volume.

107 Berlin 2015; Kleinert & Laurenze-Landsberg 2016; Van de Wetering 2017, no.213.

108 White 1983a, pp.13–14; Mount 1996, pp.l–lii, 91. *The Night Watch*: Corpus, vol.3 (1989), no.146; Corpus, vol.6 (2015), no.190.

109 The Getty Provenance Index lists the following numbers of Rembrandt lots (including copies after): 1700–40: 170; 1740–50: 165; 1750–1800: 1644.

110 Daulby 1796, p.xiv; London 1992, p.9.

111 *London Chronicle*, 12 July 1792, p.38.

112 Stourton & Sebag-Montefiore 2012, p.187; White 2015, pp.36–50.

113 White 2015, pp.34–35. *The Concord of the State*, *c*.1637 (Corpus, vol.3 (1989), A 135; Corpus, vol.6 (2015), no.153) and the *Deposition*, *c*.1633–34 (Corpus, vol.3 (1989), A 107; Corpus, vol.6 (2015), no.113) left the Royal Collection in mysterious circumstances. The latter was later owned by Reynolds and Sir George Beaumont, who presented it to the National Gallery.

114 White 2015, no.160; Corpus, vol.2 (1986), A 77; Corpus, vol.6 (2015), no.89.

115 Herrmann 1999, pp.189–92; London 2005, pp.37–41.

116 London 1992, p.11; on Knight as a collector, see Manchester 1982, pp.93–109.

117 See the essay by Stephanie Dickey on pp.69–79 of this volume.

118 Royalton-Kisch 1993.

119 For the Christiaan Josi sale, see Hinterding & Horbatsch 2016. For the flight of Rembrandt works from Britain, see the essay by M.J. Ripps on pp.115–23 of this volume.

120 Van Uitert 2014.

121 Wornum 1848, p.473.

122 Hazlitt 1998, p.37.

123 Wornum 1848, p.311.

124 Scott 1816, p.160 (with thanks to Richard Kopley).

125 An early example is Samuel William Reynolds's mezzotint *Rembrandt's Marriage*, 1811, after a spurious painting by Rembrandt; Charrington & Alexander 1983, no.152, fig.60.

126 Edinburgh 1978, no.103.

127 See the essay by M.J. Ripps on pp.115–23 of this volume.

128 London/Houston 1996, pp.43–51.

129 Van Camp 2013. A satirical poem on the theft was included in *Chalcographimania* 1814, pp.81–82.

130 Taylor 1853, vol.1, p.277.

131 Richter 1817, p.1. The National Galleries of Scotland's copy of this curious book was owned by David Young Cameron.

132 See the essays by Peter Black and Patrick Elliott, respectively on pp.107–13 (p.110) and pp.51–67 (p.51) of this volume.

133 Stourton & Sebag-Montefiore 2012, p.26.

134 Smith 1836.

135 Cundall 1867; Schwartz 2014, pp.41–42. Nieuwenhuys 1834, pp.3–43 had published Rembrandt's inventory of 1656 in English, which for the first time documented the artist's extensive collection and damaged the myth of nature being Rembrandt's exclusive inspiration.

136 See the essay by Peter Black on pp.107–13 of this volume.

137 Hamber 1996; Bann 2011; Los Angeles 2014.

138 Bode *et al.* 1897–1906.

139 New Haven 1983, no.6.

140 For Turner and Rembrandt, see Kitson 1988; Monks 2009, pp.78–82; London/Paris/Madrid 2009–10, nos 8–9, 39–44, 57–59.

141 See the essay by Jonathan Yarker on pp.81–91 of this volume.

142 Black 2001.

143 Edinburgh 2001, pp.34, 37–38, 57–58; Black 2001.

144 Hinterding 1993–94.

145 Mount 2002, pp.38–39; Glasgow 2012, pp.31–32; Corpus, vol.3 (1989), no.A 105; Corpus, vol.6 (2015), no.114.

146 Edinburgh 1983, nos 23–24.

147 Corpus, vol.5 (2011), no.3; Corpus, vol.6 (2015), no.196.

148 Bronkhurst 2006, no.31.

149 Edinburgh 2002, p.38, no.20 (with thanks to Patricia Allerston).

150 See the essays by Peter Black and Patrick Elliott, respectively on pp.107–13 and pp.51–67 of this volume.

151 *The Times*, 27 March 1911, p.10.

Rembrandt and Britain: The Modern Era

Patrick Elliott pages 51–67

My thanks to Sacha Llewellyn and Peyton Skipwith for reading this essay and making valuable suggestions.

1 Scallen 2004, pp.129–79.

2 John 1954, p.28.

3 Raverat 1953, pp.44–45.

4 Ibid.

5 *The Night Watch*: Corpus, vol.3 (1989), no.146; Corpus, vol.6 (2015), no.190; *The Anatomy Lesson of Dr Nicolaes Tulp*: Corpus, vol.2 (1986), A 51; Corpus, vol.6 (2015), no.76.

6 *The Studio*, vol.16, no.71, p.51.

7 Arnold 1981, p.51.

8 Scallen 2004, p.133.

9 London 1899b.

10 *Jacob Trip*: Corpus, vol.6 (2015), no.297; *Margaretha de Geer*: Corpus, vol.6 (2015), no.297b.

11 Arnold 1981, p.51.

12 *Bathsheba at her Bath*: Corpus, vol.6 (2015), no.231 (as *Bathsheba at her Toilet*).

13 Spencer, letter to Jacques and Gwen Raverat, 12, 15 and 17 July 1914, in Glew 2001, p.49 (with thanks to Sacha Llewellyn for this reference).

14 Lewis 1914.

15 Malvern 2004, p.103 (with thanks to Sacha Llewellyn for this reference).

16 'The Rembrandt Exhibition at Amsterdam', *Apollo*, no.16, 1932, p.116, quoted in Scallen 2004, p.309.

17 On Rembrandt and the so-called 'etching revival' in Britain, see the essay by Peter Black on pp.00–00 of this volume; see also, in particular, Bedburg-Hau/Amsterdam 2005 and Chambers 1999.

18 Salaman 1932, p.10.

19 Bedburg-Hau/Amsterdam 2005, p.32, note 40.

20 Cameron's Rembrandt etchings were left to the National Galleries of Scotland and Shannon's to the Fitzwilliam Museum, Cambridge; McBey sold his.

21 McBey 1993, p.101. In a letter to Frank Short, dated 11 April 1928 (Fondation Custodia – Collection Frits Lugt, Paris), McBey writes of his discovery and sent Short an etching printed on the 'Rembrandt' paper [cat.108]. The original covers of the volume are also in the Collection Frits Lugt, Paris. There is no evidence that the album belonged to Rembrandt.

22 As reported by Reginald H. Wilenski in 'Epstein on Rembrandt', *Britannia and Eve*, 26 October 1928, p.421.

23 Epstein 1942.

24 Ibid., pp.70–71.

25 Ibid., p.78.

26 My thanks to Peyton Skipwith for pointing this out.

27 MacGregor 1995; smaller version: Corpus, vol.6 (2015), no.296.

28 Other similar sheets of drawings after Rembrandt are in the University College London and Arts Council of Great Britain Collections.

29 *A Woman Bathing in a Stream*: Corpus, vol.5 (2011), no.19; Corpus, vol.6 (2015), no.229.

30 Tate website, www.tate.org.uk/art/artists/ henryk-gotlib-1194 (accessed 15 November 2017).

31 Cork 1987, p.313. Corpus, vol.4 (2005), no.26; Corpus, vol.6 (2015), no.319.

32 Sylvester 1987, pp.37–38.

33 See ibid., pp.58–59. The self-portrait is in the Musée Granet, Aix-en-Provence; its authenticity has been questioned, but current opinion accepts the authorship. See also London 2011a; Corpus, vol.4 (2005), no.16; Corpus, vol.6 (2015), no.275.

34 Farson 1993, p.103.

35 Sylvester 1988, p.241.

36 Anon., 'Obituary: Lucian Freud OM', *Daily Telegraph*, 21 July 2011.

37 Grieg 2013, p.7.

38 London/Amsterdam 2013–14, repr. p.28; Corpus, vol.2 (1986), A 66; Corpus, vol.6 (2015), no.108.

39 London 2007, cats 20–26. See also London 2014. *The Lamentation over the Dead Christ*: Corpus, vol.3 (1989), A 107; Corpus, vol.6 (2015), no.108; *Ecce Homo*: Corpus, vol.2 (1986), A 89; Corpus, vol.6 (2015), no.112.

40 London 2000, p.225.

41 Hughes 1990, p.7.

42 *Belshazzar's Feast*: Corpus, vol.3 (1989), A 110; Corpus, vol.6 (2015), no.143.

43 London/Amsterdam 2013–14, p.22.

44 Hannah Rothschild, 'Man of Many Layers', *Daily Telegraph*, 28 September 2013.

45 London/Amsterdam 2013–14; see also London 1995.

46 Conversation with J.P. Hodin, 12 July 1957, quoted in Wilkinson 2002, p.174. *An Old Man in an Armchair*: Corpus, vol.6 (2015), no. 221.

47 *Conspiracy of the Batavians under Claudius Civilis*: Corpus, vol.6 (2015), no.298; *Descent from the Cross*: Corpus, vol.2 (1986), A 65.

48 Phyllis Tuchman, 'An Interview with Anthony Caro', *Art in America*, October 1984, quoted in Barker 2004, p.284.

49 Corpus, vol.5 (2011), no.20; Corpus, vol.6 (2015), no.236.

50 Berlin 2012, p.139, quoting a handwritten note in the Kitaj Estate.

51 Corpus, vol.1 (1982), A 25, Corpus, vol.6 (2015), no.38.

52 Schlenker 2009, pp.292–93, cat.158.

53 *Slaughtered Ox*: Corpus, vol.3 (1989), no.122.

54 Phil Miller, 'John Bellany: Approaching the Almighty', *The Herald*, 10 November 2012.

55 On Brown and Rembrandt, see particularly Amsterdam 2017.

56 Workshop of Rembrandt, *A Boy in a Fanciful Costume*, c.1633, London, The Wallace Collection, Corpus, vol.2 (1986), p.701.

57 *Self-Portrait at the Age of Sixty-Three*: Corpus, vol.4 (2005), no.27; Corpus, vol.6 (2015), no.321.

'The Finest Possible State': Cataloguing and Collecting Rembrandt's Prints, c.1700–1840

Stephanie S. Dickey pages 69-79

For consultation and sharing of valuable information, I am grateful to Xanthe Brooke, Antony Griffiths, Martin Hopkinson, Martin Royalton-Kisch, Paul Sternberg, Nicholas Stogdon and Peter Urquhart. Research for this essay was made possible by a grant from the Social Sciences and Humanities Research Council of Canada.

1 See, for example, Slive 1953; Roscam Abbing 2006, pp.23–25, 52–55; Rutgers 2008.

2 Evelyn 1662, p.81, lists key works by 'the incomparable Reinbrand, whose Etchings and gravings are of a particular spirit'.

3 On the origins of print collecting, see, for example, Robinson 1981; Parshall 1994; Gibson-Wood 1997; Baker *et al.* 2003; Kusukawa 2017.

4 Pepys Library, Magdalene College, album 2984, Part 2, pp.214–15, *The Three Crosses*, 1655, first state on vellum (B.78i; NHD 290); the index calls it a drawing. Aspital 1980, cat.190; see also 188, 189, 191, 192, 200, 206; Van der Waals 1984a and 1984b.

5 Fitzwilliam's collection was recently the subject of an exhibition curated by Elenor Ling at the Fitzwilliam Museum; see https:// enfilade18thc.com/2016/08/14/exhibition-an-amateurs-passion-lord-fitzwilliams-print-collection/ (accessed 11 July 2017). While a remarkable number of albums remain, his prints by Rembrandt and other major artists such as Albrecht Dürer (1471–1528) are now mounted and stored according to modern standards.

6 On Gersaint, see esp. Glorieux 2002.

7 On shell collecting in England, see Lippincott 1983, pp.120–21.

8 On Rembrandt as printmaker, see esp. White 1999; London/Amsterdam 2000.

9 Gilpin 1768, pp.243–44, cautions collectors against worn impressions. Extant plates: Hinterding 1993–94; Hinterding & Rutgers 2013, esp. vol.7, pp.378–82.

10 Hinterding & Rutgers 2013, esp. vol.1, p.lxiii, and vols 6–7.

11 How much the editors altered Gersaint's text is unclear. Schatborn & Robinson 2009, pp.34–35, describe Gersaint's methodology.

12 Gersaint 1752. The translator is unknown. The text indicates knowledge of the London art market.

13 Smith 1836. On Smith, see Sebag-Montefiore & Armstrong-Totten 2013; Friedenthal 2013.

14 Hofstede de Groot 1906; Schatborn & Robinson 2009, pp.35–36, also crediting Woldemar von Seidlitz.

15 Haden 1877, 1879a; Middleton 1878, 1879. See the essay by Peter Black on pp.107–13 of this volume.

16 Hinterding & Rutgers 2013 (NHD); see vol.1, pp.xvlii–xliii, on methodology. Review: Filedt Kok and Fucci 2013–14.

17 Smith 1829, vol.2, pp.223–25; Whitley 1928, vol.1, pp.123–25; Paulson 1971, vol.2, pp.113–15; Lippincott 1983, pp.122–23; Uglow 1997, pp.510–12; Simon 2007, p.140.

18 Hollstein vol.9 (Koninck), cat.4; first catalogued as Rembrandt by Gersaint 1751, cat.20; first rejected by Blanc 1859–69, cat.317; first attributed to Koninck by Middleton 1878, cat.R.1. In Barnard's sale, the impression shown here, listed as 'on India paper', sold for £19 18s od to the dealer John Thane for Revd Cracherode, while Rembrandt's *The Omval*, 1641 (B.209; NHD 221), 'remarkably fine', brought only £3 os od and *The Three Trees*, 1643 (B.212; NHD 214), 'a most brilliant impression', £8 8s od; *Barnard* 1798, Day 20, lots 250, 244, 247 (published pricelist). See further Boston 1981, cat.161; London/Houston 1996, cat.18.

19 *Landscape with a Cottage and a Hay Barn*, 1641: B.225; NHD 199; see also London/Amsterdam 2000, pp.185–86.

20 Houbraken 1718–21, vol.1, p.271; Slive 1953, pp.177–97, esp.190; cf. Gilpin 1768, pp.231–32. See also Rogers 1778, vol.2, p.215 (D'Oench 1983, p.63, mistakes this for a comment on Georgian collecting).

21 Rembrandt, *Portrait of Jan Six*, 1647: B.285; NHD 238. The collection came not from Jan Six, as thought by Gersaint 1752, A2, but from his nephew, Willem; Lippincott 1983, pp.118–19; Stogdon 2011, pp.368–69, 374. Some impressions might still have belonged earlier to Jan.

22 Gilpin 1768, pp.58–59; Rogers 1778, vol.2, p.215; Slive 1953, pp.189–90; D'Oench 1983, pp.64–65, 90, 93–97; Stogdon 2011, pp.349–50. Richard Houston's 1761 mezzotint copy [cat.94] notes Rembrandt's prints 'frequently sold for 30 Pounds and upwards'; Hinterding & Rutgers 2013, cat.238, copies c and d. See also London/Amsterdam 2000, pp.235–43.

23 Gersaint 1752, A2.

24 Wilson & Borrow 1973; Stogdon 2011, p.366.

25 For Pond's collaboration with Houbraken, see Lippincott 1983, esp. pp.150–56. For Pond's collection, see *Astley* 1760; Lippincott 1983, pp.42, 119, 181; Stogdon 2011, pp.349–50.

26 See, for example, Boon 1956; New Haven 1983; Griffiths 1991; Griffiths 1993; Royalton-Kisch 1993; London/Houston 1996; Gibson-Wood 2000; Dickey 2006; Stogdon 2011. On Reynolds, see the essay by Donato Esposito on pp.93–105 of this volume. The present author is preparing a publication on early print connoisseurship with focus on Daulby, Wilson and Haden.

27 Three albums passed from Antonio Maria Zanetti in Venice to Baron Dominique Vivant Denon in Paris, where Woodburn purchased them from Denon's heirs for Wilson; Royalton-Kisch 1993 (tracing them to Zomer and possibly Rembrandt's daughter-in-law, Magdalena van Loo); Griffiths 1996, p.92. On Zomer, see Dudok van Heel 1977; on Woodburn, see Turner 2003.

28 Many celebrated impressions are now in the British Museum, London, for example, *Woman Seated with a Hat beside Her*, 1658 (B.199; NHD 310), first state, ex.coll. John Barnard, George Hibbert, Ignace-Joseph de Claussin, and Reginald Pole Carew (inv.1835,0613.7), and the Rijksmuseum, Amsterdam; see Boon 1956; London/Houston 1996. Early connoisseurs admired the effects of Rembrandt's 'India' paper; see, for example, Rogers 1778, vol.2, p.218.

29 Daulby 1796, p.51, cat.75.

30 B.74; NHD 239. Price first documented 1654; Roscam Abbing 2006, pp.54–55. Gersaint 1752, p.43, cat.75; Rogers 1778, vol.2, p.215; Wilson 1836, pp.76–77, cat.78. See also London/Amsterdam 2000, pp.253–58; Golahny 2018.

31 Stogdon 1996; Butler 2007, pp.43–44; NHD 239iii.

32 *Barnard* 1798, Day 18, 6 impressions, lots 91–96 (published pricelist).

33 *Pole Carew* 1835, lot 80, £163 16s od (presumably a first state), priced copy British Library (RB.23 b.3129). C.J. Palmer sale 1868, £1100, ex.coll. Thomas Wilson; document, RKD, The Hague (Wilson 1828, inv.nr.963544).

34 *Barnard* 1798, n.p.

35 On Barnard, see Stogdon 2011, pp.351–53. The auctioneer, Thomas Philipe (c.1770–c.1817), may also have contributed ideas.

36 B.197; NHD 307. See Houbraken 1718–21, vol.1, p.271; Gilpin 1768, pp.239–40.

37 As described by Daulby in a manuscript annotation to his copy of Daulby 1796, under cat.189 (Liverpool, Athenaeum); see also *Barnard* 1798, lots 227–33. For early state descriptions, see Gersaint 1751 and Gersaint 1752, cat.189; Yver 1756, cat.77; B.197; Daulby 1796, cat.189; Wilson 1836, cat.194; for current assessment, see B.197, NHD 310.

38 Gersaint 1751, cat.189, lists three states in which the key disappears and reappears; Daulby 1796, cat.189, thinks the cap comes and goes. The sequence in *Barnard* 1798, 20th day, lots 227–33, agrees in principle with B.197, followed by NHD 307: cap appears in states 1–3, key added in 4–5, cap removed in 6. NHD 307 adds a seventh state by a later hand. See also London/Amsterdam 2000, pp.347–52.

39 Wilson 1836, pp.iii–iv; see also Wilson 1828.

40 Daulby owned Barnard's copy of Gersaint (British Library, 1043e27). Barnard's copy of Daulby 1796 is described in *Barnard* 1798, lot 489, as: 'A large-paper copy of Mr. Daulby's catalogue of Rembrandt's works, WITH MANY MS. NOTES on the margins, interesting to collectors'; Hopkinson 2007, p.103, note 83; Stogdon 2011, p.352. There are many anonymous examples as well.

41 Hinterding & Rutgers 2013, vol.1, pp.lxii–lxiv.

42 B.12, NHD 24; British Museum, London, (inv.1848,0911.14; ex.coll. Pond, Astley, Heneage Finch – 5th Earl of Aylesford, Samuel Woodburn), exhibited London/The Hague 1999–2000, pp.102–3, cat.9.

43 Daulby 1796, p.8, cat.16, note in his own copy (Athenaeum, Liverpool).

44 British Museum, London (inv.F,4.13); *Barnard* 1798, lot 16. Two other cut impressions known: Rijksmuseum, Amsterdam (inv.RP-P-OB-23) and the Fondation Custodia – Collection Frits Lugt, Paris (inv.2077).

45 Daulby's prints were auctioned after his death (see *Daulby* 1799, *Daulby* 1800), but he did not use a collector's mark, and few specific impressions have yet been traced. On Blackburne, see Hopkinson 2007, pp.92–97; Stogdon 2011, pp.353–54. *Blackburne* 1786 (over 10,000 prints), Rembrandt lots 803–881, pp.69–72, lot 804: seven self-portraits including 'Another in a Cap coarsly etched in an irregular Oval, no. 16'. For a missing impression without the oval border, see De Claussin 1824, cat.12; Blanc 1859–61, cat.215.

46 Corpus, vol.6 (2015), cat.261; *Daulby* 1798, lot 70; Sutton 2011. On Daulby's collection, see Hopkinson 2007, pp.97–98.

47 For Daulby, Roscoe, and culture in the Midlands, see Roscoe 1833; Fawcett 1974, esp. 92–99, 171–75; Liverpool/London 1998, esp. pp.7–15; Liverpool/New Haven 2007, esp. 97–99; Fletcher 2012. Many of Roscoe's paintings are now in the Walker Art Gallery, Liverpool.

48 Daulby 1796, pp.ii-xxi, esp. iii–v, ix, xv; cf. Gilpin 1768, pp.82–86. For the long history of this critique, see Sluijter 2006; Dickey 2017. Roscoe engaged his publisher, James Edwards, to promote Daulby's book in London; Roscoe 1833, vol.1, p.227; Bentley 2015, pp.94–95, 113.

49 Purchased from the dealer William Ford; Hopkinson 2007, p.98.

50 See also D'Oench 1983.

51 Liverpool Record Office 920 ROS/2840.

52 On Bartsch, see Rieger 2013, esp. vol.1, pp.57–58.

53 Cundall 1867, with biography by the Dutch archivist Pieter Scheltema.

54 Wilson 1836, pp.iii–iv. Begun by 1831 (unpublished first edition, private collection).

55 Wilson 1828, pl.19; Cohn 1924, cat.854. See also George 1954, cat.15612–15616; Griffiths 1996, p.94.

56 Wilson 1836, pp.iii–iv.

57 Ibid., pp.261–65.

58 Ibid., p.241; Haden 1877; Middleton 1878.

59 See Wilson & Borrow 1973. The dispersal of his Rembrandt collection, sold before he emigrated, remains unclear.

60 Gilpin 1768, p.235.

From Studio to Academy: Copying Rembrandt in Eighteenth-century Britain

Jonathan Yarker pages 81-91

1 On 3 October, Joseph Farington recorded in his diary that there were thirteen artists copying at the British Institution ('of the number were Howard, Reynolds, Green of Rathbone Place, Guest &c. &c. Miss Reinagle, Rawlinson'). On 17 November, West described his copy of *The Mill* to Farington, who saw him at work there on 18 November. See Garlick *et al.* 1978–84, vol.8, pp.2883 and 2909. For Constable's copy, see Reynolds 1996, 06.287, pp.111–12. See also Whitley 1928, pp.111–12.

2 Two recent studies of the reception of European art in Britain are dominated by literary criticism, rather than the practical interest of painters in the form of copies. See Humfrey 2013 and Glendenning & Macartney 2010. For a similar bias in the reception of Rembrandt, see Heck 2010, pp.317–29 and New Haven 1983.

3 Beckett 1970, p.62. When Constable came to make his comments on Rembrandt, he relied not on his own copy of *The Mill* but on the copy made by the landscape painter and engraver Samuel William Reynolds, who was recorded by both Farington and Chalon at work in the British Institution in 1806. In Chalon's drawing, Reynolds is identified as the figure seated in profile in the foreground. Farington records

him at work in October 1806. See Garlick *et al.* 1978–84, vol.8, p.2883.

4 See White 1983a.

5 Duro 1983, particularly pp.27–80.

6 Duro 2009.

7 For Félibien on Rembrandt, see Félibien 1685, pp.150–57 and De Piles 1699, pp.433–38.

8 Gibson-Wood 2000, p.96.

9 Richardson 1725, p.68.

10 Ibid., pp.252–53. *Saint Peter's Prayer before the Raising of Tabitha*, Musée Bonnat, Bayonne; Ben.949.

11 Pond's print was part of his hugely popular series *Prints in Imitation of Drawings* published in collaboration with George Knapton in 1734. See Lippincott 1983, pp.128–30.

12 Vertue vol.III, pp.134–35.

13 British Museum, London (inv.T,14.6); Ben.17. A previously unknown, partially priced copy of Richardson's sale catalogue survives in a private collection; it identifies Hudson as the purchaser of *The Entombment*.

14 Vertue noted in 1733: 'Mr […] Hudson Face Painter a scholar of Richardson, and married to his daughter. is a good ingenious man really great of merit. has abundance of Persons of Quality & worth sat to him for their pictures – wherein he has had great success.' Vertue vol.III, p.111.

15 Vertue noted that Hudson and 'Mr Van Aken jointly bought also drawings paintings &c.' The fact that Hudson and van Aken purchased lots together suggests that they were appreciative that their purchases had a practical application in the lives of their respective studios. At the sale of Richardson's paintings the same year, a priced copy in the Houlditch MS reveals, van Aken purchased £36 12s 6d worth of paintings and Hudson £92 15s. London, National Art Library, NAL, ML/1938/867, I, ff.1–5. Van Aken's collection of paintings was not inconsiderable. The catalogue entitled 'Mr Van Haecken's sale of Pictures, 1758' is contained in London, National Art Library, ML/1938/867, II, f.169.

16 British Museum, London (inv.1918,0608.1–316). Phelps was born in Porlock in Somerset in 1710 to a family of artists, his father, Richard,

having also practised as a painter. The Phelpses are described by James Savage: 'A respectable family of the name of Phelps, has long resided at Porlock; many of the individuals of which seem to possess an hereditary talent for drawing and painting.' Savage 1830, pp.145–46 and 400.

17 Northcote 1819, vol.1, p.18. For several of Reynolds's drawings after Guercino, see London 1979, cat.69–70, and Plymouth 2009–10, cats 80 and 81.

18 Ben.289.

19 Vertue vol.III, p.159.

20 Paulson 1971, vol.1, pp.112–14 and Graciano 2012, pp.191–92. See also the essay by Stephanie Dickey on pp.69–79 of this volume.

21 Bikker 2005, p.100, cat.23.

22 For Worlidge's etching, see New Haven 1983, p.95, cat.158; see also Bath 1996 and the essay by Stephanie Dickey on pp.69–79 of this volume.

23 Gerard 1759, p.49.

24 Worlidge made his print after a painting in a private collection (Bredius 13), probably an eighteenth-century copy of a painting then thought to be by Rembrandt.

25 On Reynolds, see the essay by Donato Esposito on pp.93–105 of this volume.

26 Wark 1975, p.31.

27 Postle 1995, pp.121–60.

28 Wark 1975, p.223.

29 For Gainsborough copies, see Yarker 2018.

30 In 1785 Gainsborough borrowed a canvas attributed to Velázquez which had been acquired in Spain by Thomas Robinson, 2nd Baron Grantham, during his time as British Ambassador. A letter from Grantham's wife, Mary, to her mother, Jemima Yorke, Marchioness Grey, dated 10 October, 1785, records the loan of the painting: 'Ld Grantham had lent it to Mr Gainsborough to copy, who returned it a little time ago, with a letter expressing his high opinion of the Picture & his modest opinion of himself, as he said he had only taken a slight sketch of it, being convinced no copy he could take would do it justice.' Bedfordshire and Luton Archive Service, Grey Papers, L30/9/81/100,

letter from Mary Grantham to Jemima, Marchioness Grey, Newby, 10 October 1785.

31 Smith 1860, pp.41–43.

32 British Institution 1824, p.18. This was consolidated by the awarding of premiums of '£100' for 'the best original picture, prepared in point of subject & manner to be a companion to either of such pictures'. NAL, RC.V.II. f.189.

33 Wark 1975, p.31.

34 Beckett 1995, p.57.

35 Kitson 1988, p.7.

36 Shanes 2016, pp.357–59.

37 London, Royal Academy Archives, Council Minutes, IV, ff.245–6. For a further account, see Garlick *et al.* 1978–84, vol.13 (1984), p.4743 (19 December 1815). The gallery itself at Dulwich did not in fact open until 1817.

38 Corpus, vol.6 (2015), no.200. London, Royal Academy Archive, Council Minutes, V, p.249, 10 January 1816.

Regarding Rembrandt: Reynolds and Rembrandt

Donato Esposito pages 93–105

I would like to thank Albert Godycki, Kate Heard, Erik Hinterding, Tico Seifert, Richard Stephens, Simon Turner and Jack Wakefield for valuable assistance and encouragement.

1 http://www.rembrandtdatabase.org/ Rembrandt/painting/2934/the-holy-family-at-night (accessed 20 June 2017); Dibbits 2006.

2 Richardson & Richardson 1722, p.21.

3 The first sale of prints and drawings was *Reynolds* 1792 (described as containing 'duplicate prints': *The Times*, 10 April 1792, p.4). The main sale was *Reynolds* 1798, but see also *Reynolds* 1794. See Broun 1987 for the paintings; see Royalton-Kisch 1978, Esposito 2009 and Esposito 2011 for the prints and drawings.

4 Malone 1797, vol.1, p.li.

5 www.rembrandtdatabase.org/Rembrandt/ painting/262746/the-vision-of-daniel (accessed 20 June 2017).

6 Broun 1987, vol.2, p.55, note 1.

7 *Public Advertiser*, 11 May 1791, p.3, quoted in Broun 1987, vol.2, p.54.

8 Garlick *et al.* 1978–84, vol.2 (1978), p.316.

9 *Ibid.*

10 *Reynolds* 1795 [fourth day], lot 81.

11 Broun 1987, vol.2, p.55, note 3.

12 Garlick *et al.* 1978–84, vol.2 (1978), p.318.

13 Kleinert & Laurenze-Landsberg 2015.

14 Wark 1975, p.162.

15 http://www.rembrandtdatabase.org/ Rembrandt/painting/38132/portrait-of-floris-soop (accessed 20 June 2017); Corpus, vol.6 (2015), no.234, fig.234; Broun 1987, vol.2, pp.52–53, no.8.

16 www.rembrandtdatabase.org/Rembrandt/ painting/ 2936/man-with-red-beret (accessed 20 June 2017); *Reynolds* 1795 [fourth day], lot 50 (50 guineas to William Hardman); Broun 1987, vol.2, pp.47–48, no.5; Peter C. Sutton in Washington 2005, pp.114–16, no.13.

17 Corpus, vol.6 (2015), no.255, fig.255; *Bragge* 1757, lot 48; Anne T. Woollett in Washington 2005, pp.78–80, no.3; Broun 1987, vol.2, pp.45–47, no.4. The work did not appear in any of Reynolds's posthumous sales. For a recent study of Bragge, see Russell 2016.

18 See Esposito 2018 for a discussion of Reynolds's home in Leicester Fields.

19 *Reynolds* 1798, part of lot 238 (with four others) as '5 [prints] by ditto [Rembrandt], the Little Tomb, &c.'; B.67; NHD 298.

20 See the essay by Christian Tico Seifert, on pp.11–49 of this volume (p.32).

21 *Coxe* 1922, lot 22; B.28; NHD 168. I am grateful to Kate Heard for this information.

22 Schatborn 2010, pp.22–25, no.1; Ben.87. Royalton-Kisch online.

23 Library of Congress, Washington (inv. FP.XVII.R.385.A.1); B.113; NHD 263 – I am grateful to Erik Hinterding for this information; Groninger Museum, Groningen (inv.1931–203); Bolten 1967, p.104, no.74 (as 'School of Rembrandt'); undescribed by Benesch.

24 British Museum, London (inv.Oo,9.103); Ben.154.

25 Smith 1836, p.41, no.96.

26 *Reynolds* 1795 [third day], lot 38 (41 guineas to Sir George Beaumont); Broun 1987, vol.2, pp.44–45, no.3.

27 Northcote 1819, vol.1, pp.261–62.

28 Yale Center for British Art, New Haven (inv.B1982.24.20 and B.1982.24.27); *Abraham Casting out Hagar and Ishmael*: B.30, NHD 166; *The Persian*: B.152, NHD 110; *Cornelis Claesz. Anslo, Preacher*: B.271, NHD 197; *Ephraim Bonus, Jewish Physician*: B.278, NHD 237.

29 Yale Center for British Art, New Haven (inv. B1982.24.20); *Self-portrait with Saskia*: B.19, NHD 158; *Self-portrait Etching at a Window*: B.22, NHD 240.

30 Schatborn 2010, pp.73–76, no.18; Ben.980.

31 Giltaij 1988, pp.44–45, no.5 (as Rembrandt); Ben.78.

32 Smith 1836, p.2, no.2. See New York 2017 for a thorough discussion of the painting.

33 Rijksmuseum, Amsterdam (inv.RP-T-1930–13); see Tonkovich 2005 for a discussion of Rymsdyk's collection.

34 *A Boy Telling his Story*, undescribed by Benesch; *An Old Man Knocking at a Door*: inv.1573, Ben.1078; *An Old Woman Reflecting On What She Has Been Reading*: inv.R 10 (PK), Ben.757; *Turks Drinking Coffee*: inv.1895,0915.1275, Ben.1187; *A Monk Sitting in his Cell, in Devout Meditation*, undescribed by Benesch. The latter is almost certainly not by Rembrandt.

35 Gibson-Wood 2000, p.96.

36 Mount 1996, pp.127–28.

37 Ibid., p.91.

38 Fondation Custodia, Paris (inv.6196, fol.37r); ibid., note f.

39 Ibid., p.85.

40 Musée du Louvre, Paris (Rothschild Collection; inv.201 DR); Ben.609.

41 Mannings 2000, nos.2230–2233.

42 Northcote 1819, vol.2, p.305.

43 Mannings 2000, p.51, no.21.

44 http://www.rembrandtdatabase. org/Rembrandt/painting/53707/

aristotle-with-a-bust-of-homer (accessed 20 June 2017); Corpus, vol.6 (2015), no.228, fig.228.

Rembrandt: Paragon of the Etching Revival

Peter Black pages 107–13

1 Haden 1895, p.6. On Haden, see Blok 2011; on the etching revival, see Chambers 1999 and Bedburg-Hau/Amsterdam 2005.

2 Cundall 1867.

3 From 1888 it was known as the Royal Society of Painter-Etchers, and from 1898 as the Royal Society of Painter-Etchers and Engravers. In 1991 the name was changed to Royal Society of Painter-Printmakers.

4 Hardie 1921, pp.16–18. I have corrected two dates given incorrectly by Hardie.

5 'Wanneer gy nu uwe vindingen in ordening hebt uitgevoert, en gy het oordeel van vriend en vyand derft uitwachten, laet dan vry uwe werken in print uitkomen, zoo zal uwen naem te spoediger al de werelt over vliegen. Albert Durer en Lukas van Leyden, wondere Schilders, hebben nochtans hun grootste gerucht door het graef-yzer verkreegen.' Van Hoogstraten 1678, pp.195–96.

6 'Peut-être découvrira-t-on que Rembrandt est un beaucoup plus grand peintre que Raphaël'. Delacroix 1932, vol.1, p.439.

7 Leahy 2005, p.7.

8 Manchester 1857a, pp.60–61.

9 'Hollar' 1879.

10 G.4. The observation was made by Lochnan 1984, pp.24–25.

11 Whistler, *Fumette* (G.12). *Beggar (Self-portrait of Rembrandt?) Seated on a Bank*: B.174; NHD 50.

12 Whistler, *Street at Saverne* (G.14).

13 'Delâtre, artiste autant qu'imprimeur, est par excellence, l'imprimeur des eaux-fortes'. Philippe Burty, *Gazette des Beaux-Arts*, Paris 1864, quoted in Haden 1879b, p.16.

14 'A Delâtre. S'il eut vécu dans le temps de Rembrandt, celui-ci certainement l'eut employé a tirer ses eaux-fortes.' McQueen 2003, p.334, note 458.

15 Haden's collection included several of Rembrandt's greatest prints, including the *Three Trees* (B.212; NHD 214), *Ecce Homo* (B.76; NHD 290) and the *Three Crosses* (B.78; NHD 274). On the latter, see Eeles 1998.

16 Haden 1879a, pp.1–2.

17 Ibid., p.29. *Christ before Pilate* (the large plate): B.77; NHD 155. For the modern view, see London/Amsterdam 2000, cat.24.

18 'Impressionism True and False', *Pall Mall Gazette*, London, 2 February 1889. See Robins 2000, pp.10–11.

19 Pennell 1920, p.108, *The Windmill*: B.233; NHD 200.

20 Bailly-Herzberg 1980, p.178.

21 Sickert 1915, p.224. See Robins 2000, p.390.

22 Lumsden 1924, p.310.

Rembrandt and Britain: A 'Picture Flight' in Three Stages, 1850–1930

M.J. Ripps pages 115–23

I should like to thank Tico Seifert, Gillian Achurch and Abigail Grater for reading an earlier draft of this essay. Christopher Brown, Otto Naumann and Carlo van Oosterhout merit thanks for their encouragement.

1 On the role of the RA, see Ripps 2010, pp.19, 22; on the role of middlemen, see Ripps 2010, pp.15–16.

2 Cannon-Brookes 1984, p.39; Ripps 2010, pp.25–26; Agnew's stockbooks: Lansdowne pictures, nos 2695–2723.

3 On Thoré-Bürger's canon, see Ripps 2010, pp.21–25; Scallen's 2004 monographic study masterfully probes the relationship among these three leading Rembrandt scholars.

4 On collectors, see Ripps 2010, pp.28–32; Keyes 2011, pp.66–75; and especially Liedtke 1990, pp.30–50.

5 See London 2003.

6 See Cannadine 1990 and, with specific regard to the transatlantic picture flight, Cannadine 2014.

7 *Man Rising*: Christie's, London, 20 July 1850, lot 47; Corpus, vol.2 (1986), A 78; Ripps 2010, p.63, note 47; on Taft as a collector, see Liedtke 1995.

8 *Johannes Elison* and *Maria Bockenolle*: Corpus, vol.2 (1986), A 98–99.

9 *Zeuxis*: Christie's, London, 6 June 1868, lot 81; Corpus, vol.4 (2005), no.25.

10 *Bellona*: Corpus, vol.2 (1986), A 70; Bode *et al.* 1897–1906 (8 vols); see Liedtke 2007, no.147; *A Man in Armour*: Berlin/Amsterdam/London 1991–92a, no.43; Corpus, vol.6 (2015), no.239.

11 *Parable of the Rich Man*: Corpus, vol.1 (1982), A 10; Ripps 2010, p.86; Scallen 2004, p.166.

12 *Susanna*: Corpus, vol.5 (2011), no.1; *Daniel*: Berlin/Amsterdam/London 1991–92a, no.82; *Joseph*: Corpus, vol.5 (2011), no.22. Ripps 2014b, p.746.

13 *John the Baptist*: Corpus, vol.3 (1989), A 106; Ripps 2010, p.165; *Anslo*: Corpus, vol.3 (1989), A 143; Ripps 2010, pp.166–68.

14 *Christ in the Storm*: Corpus, vol.2 (1986), A 68; *Married Couple*: Corpus, vol.6 (2015), no.67. For a detailed analysis of the complex en bloc purchase, see Ripps 2010, pp.125–31, 175–6, and Chapel 2008.

15 Quodbach 2007, pp.27–29, 35.

16 *Portrait*: Liedtke 2007, no.155, but altogether omitted by the Rembrandt Research Project; *Doomer*: Corpus, vol.3 (1989), A 140; Quodbach 2004; Ripps 2010, p.32.

17 'Noble Slav': Corpus, vol.2 (1986), A 48; Ripps 2010, pp.114, 116.

18 *Saskia*: Wheelock 1995, pp.210–14; Amsterdam/Berlin 2006, p.192; Ripps 2010, pp.86, 116, 117n25.

19 *Man with a Red Cap*: Washington 2005, no.13; Ripps 2010, pp.88, 144.

20 *Nicolaes Ruts*: Corpus, vol.2 (1986), A 43; Ripps 2010, pp.44, 62, 117.

21 *Aristotle*: Liedtke 2007, no.151; Corpus, vol.6 (2015), no.228.

22 See Cust to Bode, 19 July 1893; McKay to Bode, 24 October 1893 (Zentralarchiv – Staatliche Museen zu Berlin, Wilhelm von Bode papers).

23 Bode *et al.* 1897–1906, no.385; Ripps 2010, pp.165, 202.

24 See Van Thiel 1992.

25 Ripps 2010, p.32, note 83; *Homer*: Buvelot 2004, p.258; Ripps 2010, p.57; Corpus, vol.6 (2015), no.301; *Two Moors*: Buvelot 2004, p.260; Ripps 2010, p.118; Corpus, vol.6 (2015), no.295.

26 On Bode's nationalistic agenda, see Eisler 1996, pp.23–32; Bode *et al.* 1897–1906, no.428; Ripps 2010, p.181.

27 *Self-portrait*: Corpus, vol.4 (2005), no.14; Saltzman 2008, pp.179–92; Ripps 2010, pp.181–82, note 68; Bailey *et al.* 2011, pp.47–53. On the essential Colnaghi–Knoedler relationship, see Ripps 2014b.

28 *Self-portrait*: Corpus, vol.4 (2005), no.20; Liedtke 2007, no.157; *Pieter Seijen*: Corpus, vol.2 (1986), A 86; Quodbach 2011, pp.18–19; *The Mill*: Bode *et al.* 1897–1906, no.345; Wheelock 1995, pp.230–41; Ripps 2010, pp.150–51.

29 *Apostle Paul*: Wheelock 1995, pp.241–47; Ripps 2010, pp.65, 149; *Tall Hat*: Wheelock 1995, pp.276–79, Ripps 2010, pp.65, 149; *Circumcision*: Wheelock 1995, pp.270–76; Ripps 2010, p.149; Corpus, vol.5 (2011), no.30.

30 *Self-portrait*: Corpus, vol.4 (2005), no.29; Ripps 2010, pp.183–84; regarding Kappel, see the Douglas–Bode correspondence, 1919–20, Zentralarchiv – Staatliche Museen zu Berlin (Wilhelm von Bode papers), Berlin.

31 *Flora*: Liedtke 2007, no.153; Ripps 2010, pp.149, 160; Corpus, vol.6 (2015), no.269; *Elderly Man*: Buvelot 2004, p.262; Corpus, vol.6 (2015), no.316.

32 *Visitation*: Corpus, vol.3 (1989), A 138; Keyes *et al.* 2004, no.71.

33 *Marten Looten*: Christie's, London, 17 May 1928, lot 34; Corpus, vol.2 (1986), A 52; *Self-portrait*: Wheelock 1995, pp.261–65; Corpus, vol.4 (2005), no.18.

34 *Rembrandt as Paul*: Corpus, vol.4 (2005), no.24.

INDEX

COPYRIGHT & PHOTOGRAPHIC CREDITS

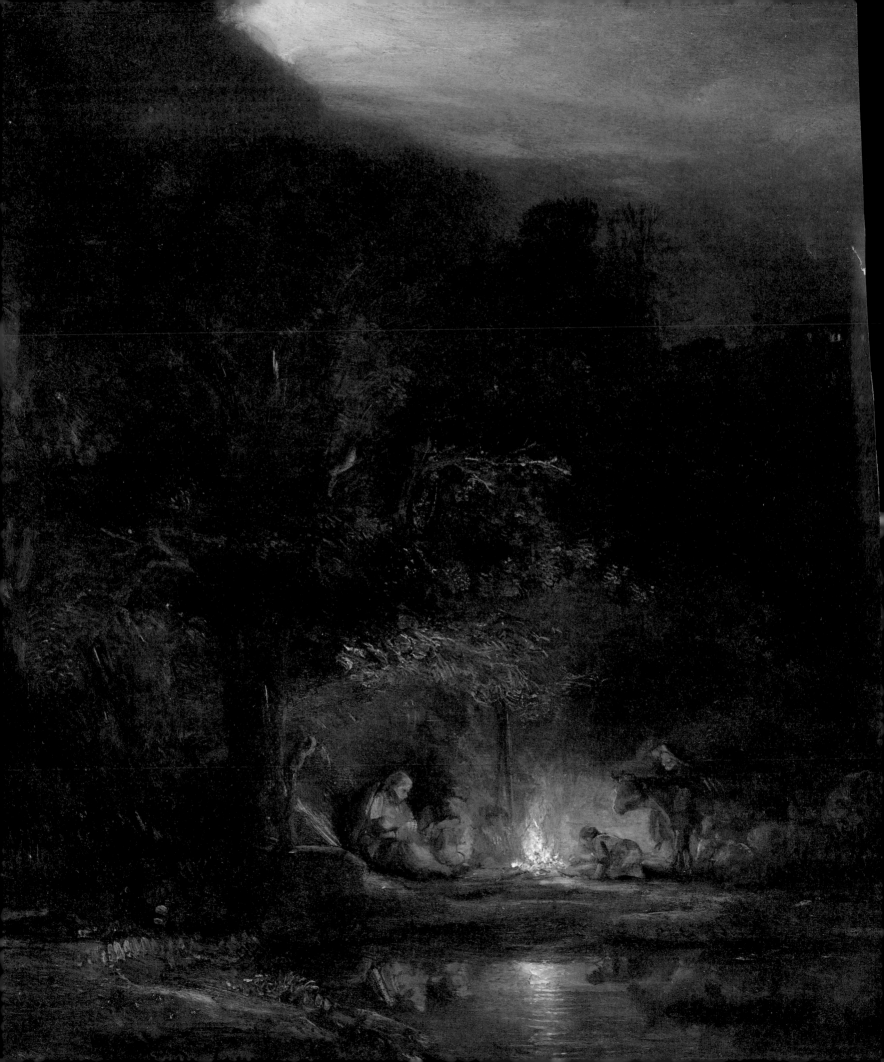

Rembrandt
Britain's Discovery of the Master